Understanding Heritage in Practice

This book is part of a series published by Manchester University Press in association with The Open University. The three books in the *Understanding Global Heritage* series are:

Understanding the Politics of Heritage (edited by Rodney Harrison)

Understanding Heritage in Practice (edited by Susie West)

Understanding Heritage and Memory (edited by Tim Benton)

This publication forms part of the Open University course AD281 *Understanding global heritage*. Details of this and other Open University courses can be obtained from the Student Registration and Enquiry Service, The Open University, PO Box 197, Milton Keynes MK7 6BJ, United Kingdom (tel. +44 (0)845 300 60 90, email general-enquiries@open.ac.uk).

www.open.ac.uk

Manchester University Press
Manchester and New York
Distributed exclusively in the USA by Palgrave Macmillan
in association with The Open University

UNDERSTANDING
heritage in practice

Edited by Susie West

Published by

Manchester University Press
Oxford Road, Manchester, M13 9NR, UK
and Room 400, 175 Fifth Avenue, New York, NY 10010, USA
www.manchesteruniversitypress.co.uk

in association with

The Open University
Walton Hall, Milton Keynes
MK7 6AA
United Kingdom

First published 2010

The publisher has no responsibility for the persistence or accuracy of URLs for any external or
third-party websites referred to in this book, and does not guarantee that any content on such
websites is, or will remain, accurate or appropriate.

Distributed in the United States exclusively by Palgrave Macmillan, 175 Fifth Avenue,
New York, NY 10010, USA.

Distributed in Canada exclusively by UBC Press, University of British Columbia,
2029 West Mall, Vancouver, BC, Canada, V6T 1Z2.

Edited and designed by The Open University.

Typeset in India by Alden Prepress Services, Chennai.

Printed in Malta by Gutenberg Press Limited.

British Library Cataloguing in Publication Data: applied for

Library of Congress Cataloging in Publication Data: applied for

ISBN 978 0 7190 8154 5

1.1

Contents

Figures

Contributors

Jacqueline Ansell lectures at Christie's Education and in most London galleries, working regularly at the National Gallery, where she organises undergraduate study days. Trained as an art historian, she has an MA in history of dress from the Courtauld Institute of Art, and has been an Associate Lecturer with The Open University since 1992. Research interests include the semiotics of dress, dress and the Grand Tour, and the interaction of cloth, clothing and the body in art.

Professor Tim Benton is an architectural historian specialising in the history of modern architecture and design, in particular the work of Le Corbusier. His books include *The Villas of Le Corbusier and Pierre Jeanneret, 1920–1930* (Birkhäuser, 2007) and *The Rhetoric of Modernism: Le Corbusier as a Lecturer* (Birkhäuser, 2009). He has also worked on a number of major exhibitions, including *Art Deco 1910–1930* (2003) and *Modernism Designing a New World* (2006), both at the Victoria and Albert Museum.

Dr Marion Bowman is Senior Lecturer in Religious Studies at The Open University. Currently President of the British Association for the Study of Religions, and past president of the Folklore Society, her research interests include contemporary religion (especially, New Age/Alternative Spirituality, Paganism, New Religious Movements, and Vernacular Christianity). Recent research includes a long-term case study of Glastonbury for the implications of religious pluralism and the contemporary spiritual marketplace and for the theme of religion and locality.

Dr Jason Gaiger is Lecturer in Art History at The Open University. His principal area of research is aesthetics and the philosophy of art, with special emphasis on Kant and post-Kantian German Idealism; he also works on theories of depiction and on twentieth-century art practice and theory. Recent publications include *Aesthetics and Painting* (Continuum Press, 2008) and an English edition of Johann Gottfried Herder's *Sculpture* (Chicago University Press, 2002). He is also co-editor; with Charles Harrison and Paul Wood, of *Art in Theory: 1648–1815* (Blackwell, 2000) and *Art in Theory: 1815–1900* (Blackwell, 1998).

Dr Rodney Harrison is a Lecturer in Heritage Studies at The Open University, who has a broad range of professional experience researching and working in the heritage industry in Australia, the USA and the UK. He has published widely on the topics of community archaeology, museums, heritage and colonialism and is the author of *Shared Landscapes* (University of New South Wales Press, 2004), a critical exploration of the heritage of cattle and sheep ranching in Australia, and co-editor of *The Heritage Reader* (Routledge, 2008).

Dr Matthew Kurtz is Adjunct Assistant Professor in the Geography Department at Queen's University, Ontario. His research interests concern the historical geographies of economic analysis and neo-colonial subject formation in America's colonies in the twentieth century. He has produced an oral history collection about the history of packaged tourism in Kotzebue, Alaska, which was the first 'Eskimo village' ever to be marketed as a tourist destination. The collection is available at the Chukchi Consortium Library in Kotzebue.

Dr Elizabeth McKellar is Lecturer and Staff Tutor in Art History at The Open University. An architectural historian specialising in seventeenth- and eighteenth-century British architecture and culture, she has a particular interest in London's history and is currently researching the relationship between city and country in London's hinterlands in the long eighteenth century. She is the author of *The Birth of Modern London: The Development and Design of the City 1660–1720* (Manchester University Press, 1999) and with Barbara Arciszewska of *Articulating British Classicism: New Approaches to Eighteenth-Century Architecture* (Ashgate, 2004). She also writes regularly on architectural historiography, particularly that of the late nineteenth and twentieth centuries.

Dr Donal O'Donnell is a Teaching Fellow in Life Sciences at The Open University. His main interests are in insect ecology and taxonomy, based on his research experience in the Commonwealth Institute of Biological Control and the Natural History Museum. His teaching specialisms include ecology within environmental science courses.

Dr Jorge Otero-Pailos is Assistant Professor of Historic Preservation at Columbia University's Graduate School of Architecture, Planning and Preservation, in New York City. He is the Founder and Editor of the journal *Future Anterior*. As an architect, historian and theorist, his work rethinks preservation as a radical experimental and intellectual practice. His experimental preservation projects have been exhibited in major international art exhibitions such as the Venice Art Biennial (2009), and Manifesta7 Biennial (2008). His works and writings have been featured in *Art in America*, *Artforum*, *Modern Painters*, *Architectural Record*, *AA Files*, *Volume*, *JSAH*, *Postmodern Culture*, and others. He is the author of *The Search for Experience: Phenomenology and Postmodern Architecture* (University of Minnesota Press, 2010).

Dr Nicola J. Watson is Senior Lecturer in English at The Open University. Her publications range over eighteenth-century, Romantic, and nineteenth-century literature and culture, with special interests in Sir Walter Scott, women's writing, literature and national discourse, and the history of the literary pilgrimage from Shakespeare to Joyce. Her recent publications include

The Literary Tourist: Readers and Places in Romantic and Victorian Britain (Palgrave Macmillan, 2006) and *Literary Tourism and Nineteenth-Century Culture* (Palgrave Macmillan, 2009).

Dr Susie West worked in British field archaeology and regional museums before researching her PhD thesis in architectural history. She became a Senior Properties Historian at English Heritage, contributing to the public understanding of their historic properties. Much of her professional experience has been focused on the interaction between users and providers of heritage as a cultural resource, particularly in the museum and voluntary sectors. She joined The Open University in 2007 as Lecturer in Heritage Studies with a special interest in UK heritage practices and the English country house. Her publications include *The Familiar Past? Archaeologies of Britain from 1550* (co-editor with Sarah Tarlow, Routledge, 1999).

Preface

In recent years 'heritage' has become not only a topic of widespread public interest but also a central concern across a wide range of academic disciplines. This reflects the growth of official processes of heritage conservation into a multi-billion dollar industry throughout the second part of the twentieth century, alongside various developments relating to globalisation and the increased use of heritage in the manufacture of both national and community identity. *Understanding Heritage in Practice* considers the function of heritage within societies, with a global investigation of the processes and practices of heritage. These are found both within official and unofficial heritage, from museums to carnivals. The book's twin themes are the way heritage is produced (and delivered) on the one hand, and the way heritage and its meanings are taken up by consumers (or resisted) on the other. In considering the values which underlie the various practices of heritage it describes, it helps to move heritage studies away from the question of 'how' we conserve heritage, to shine a light on the more critical questions surrounding 'why' different societies think that heritage should be conserved, and the varied uses to which heritage is put in the present.

This is the second of three books in the series *Understanding Global Heritage*, published by Manchester University Press in association with The Open University (OU), which seeks to make a distinctive intellectual and pedagogical contribution to the emerging field of critical heritage studies. Each book is designed to be used either as a free-standing text or in combination with one or both of the other books in the series. The books were developed by a dedicated team of OU scholars together with other published academics representing the range of heritage-related disciplines as part of the development of the OU course that shares the series title. They form the first interdisciplinary series of books to address explicitly the teaching of critical heritage studies as a unified discipline. As such, they aim to provide a comprehensive and innovative introduction to key issues and debates in heritage studies as well as to demonstrate the ways in which the study of heritage can be used to inform our understanding of the global diversity of human societies. The authors form a diverse team chosen to reflect the areas that inform heritage studies, including anthropology, archaeology, architectural history, art history, biodiversity and the natural sciences, geography, history, literature studies, religious studies and sociology.

The use of international case studies is an integral part of the structure of the series. These allow the authors not only to summarise key issues within each topic but also to demonstrate how issues are reflected in heritage practices in real-life situations. The international scope reflects the involvement of heritage in discourses of globalisation and the international nature of heritage practice: the issues discussed should transcend diverse

national approaches to heritage, and the books should be equally valuable in the teaching of heritage studies in any English-speaking country throughout the world.

Each of the books aims to provide a sound introduction to, and detailed summary of, varied aspects of critical heritage studies as a global discipline. They do this through a consideration of official and unofficial heritage objects, places and practices. The books are concerned primarily with, on the one hand, the ways in which the state employs heritage at the national level and, on the other hand, the social role of heritage in community building at the local level. Using the concept of World Heritage they also explore the development of political notions associated with globalisation. This is accomplished by employing the idea that there exists an authorised heritage discourse (AHD) which works to naturalise certain aspects of heritage management while excluding others.

By leading with case studies which reflect on the ways in which wider issues are 'applied' to heritage and examining the theoretical and historical context of these issues, the books reinforce the relevance and value of critical heritage studies as a significant area of intellectual pursuit for understanding and analysing heritage and its contribution to matters of widespread public concern.

Rodney Harrison
Understanding Global Heritage Series Editor and Course Team Chair
The Open University

Abbreviations

AHD	authorised heritage discourse
AIM	Aborigines Inland Mission (Australia)
ATMS	Alaska Tour and Marketing Service (USA)
AONB	Area of Outstanding Natural Beauty
BAP	Biodiversity Action Plan
CCW	Countryside Council for Wales
EC	European Community
ESA	Environmentally Sensitive Area
GSS	Guild of Servants of the Sanctuary (UK)
ICCROM	International Centre for the Study of the Preservation and Restoration of Cultural Property
ICIP	Interpretation and Presentation of Cultural Heritage Sites
ICOM	International Council of Museums
ICOMOS	International Council on Monuments and Sites
IUCN	International Union for Conservation of Nature (also known as the World Conservation Union)
LNR	Local Nature Reserve
MLA	Museums, Libraries and Archives Council (UK)
NCC	National Carnival Commission (Trinidad and Tobago)
NE	Natural England
NGO	non-governmental organisation
NNR	National Nature Reserve
NSW	New South Wales
RSPB	Royal Society for the Protection of Birds (UK)
SNH	Scottish Natural Heritage
SSSI	Site of Special Scientific Interest
UN	United Nations
UNESCO	United Nations Educational, Scientific and Cultural Organization

Introduction

Susie West

Understanding Heritage in Practice explores the variety of ways in which we experience heritage – as professionals, visitors, tourists and spectators, entrepreneurs and performers – and the means by which heritage is defined, delivered and consumed. Process is used in this book as a dynamic and reflexive concept. It stands for the thoughts and actions that join the tangible remains of the past with contemporary meanings and practices. Heritage processes and practices are found at a variety of scales, from international agreements down to informal but socially meaningful and iterative actions. They are all amenable to critical analysis and interrogation; indeed, it is a certainty that asking how something works is an essential preamble to asking why it is so. Process, then, is a powerful route towards understanding why heritage is identified, cherished and celebrated in such diverse ways.

Definitions of heritage remain broad, but a helpful distinction is observed in *Understanding Heritage in Practice* between official and unofficial heritage. Official heritage is self-defining as heritage recognised and protected by states and more local forms of government; member states of the United Nations also participate in the bureaucracy of international official heritage, through UNESCO and its sponsored bodies. The processes for official heritage are characterised by their place within bureaucratic structures and their conformity to the needs of administration: categories, measurements and evaluations are essential to the maintenance of this form of public heritage. This is also discussed as a type of canon formation, where heritage objects and places become selected for their adherence to canonical criteria, such as aesthetic excellence, relevance to national identity or scientific significance.

Unofficial heritage sits outside these bureaucratic processes, lacking formal protection by legislation, under-represented in public collections, under-valued according to canonical criteria. It is also more likely to be intangible, encompassing, for example, living traditions of song, dance, craft and other expressions of what is often called folk or traditional culture. But the chapters here trace an arc of growing recognition and understanding of unofficial heritage such as vernacular buildings or performance traditions like carnival. Unofficial heritage, curated within communities, is a majority practice, unlike, for instance, the minority of official sites accorded World Heritage status. The later twentieth century is notable for how much the official, canonical processes of heritage have been challenged by owners of unofficial heritage, not simply for the potential economic gains that might be involved but also for cultural survival and expression. Heritage in practice, on the ground, is important not because it is something that urbanised Europeans do in their leisure time. Heritage matters because it is an active element of living

communities who need the freedom and the means to be able to access and express their sense of how their past informs their present.

Understanding Heritage in Practice tackles the global scope of heritage processes thematically, using case studies to support wider discussions. Another cross-cutting strand is an interest in the values that underpin how people select and use heritage. Chapters 1 and 2 set up the argument that a critical understanding of the values behind heritage decisions can reveal how dominant groups have set the heritage agendas over time. This understanding can also show how these agendas can be challenged. Indeed, a close attention to the language of heritage shows how words with particular meanings become assimilated into heritage frameworks intended for very disparate understandings: authenticity is probably the most widely used but loosely understood concept, varying hugely in its meaning and relevance between cultures.

Language can, of course, be understood for what it does not express explicitly. *Understanding Heritage in Practice* makes regular reference to Laurajane Smith's *Uses of Heritage* (2006) and her concept of the authorised heritage discourse (AHD). Smith defines the AHD as a set of texts and practices that dictate the ways in which heritage is defined and employed within any contemporary western society. The high-level heritage frameworks have also, in conjunction with the institutions of settler and postcolonial nations, ensured that this official discourse about what heritage is and can be used for is now effectively global. *Understanding Heritage in Practice* takes a more fragmented view of the single AHD that Smith proposes, but it continues to explore her insistence that heritage is defined more by the cultural work that its users create than by official heritage lists.

Chapter 1, 'A history of heritage' introduces a brief survey of the origins of western heritage practices from the early modern period up to the global frameworks of the twentieth century. It uses a three-part chronology, beginning with 'the enthusiasts' as amateur collectors of the Enlightenment period in which the core values of official, canonical heritage emerged. The first professionals of the nineteenth century continued to use heritage as part of the colonising process, until the shattering geo-political effects of the First World War led to a greater interest in shared aims for peace. Heritage continued to be used to promote these new aims, as a global inheritance, expressed most clearly in UNESCO's World Heritage Convention of 1972. However, dissent from the notion of a shared heritage has become increasingly expressed in recent decades, as critiques of the narrowness of official heritage definitions and uses. This resistance to a western view of heritage has had a gradual but significant impact on heritage categories and processes. The case study explores the origins of traditional Welsh female costume

from the representations of English elite travellers and looks at how contemporary Welsh attitudes take the historic construct as part of modern Welsh identity.

Chapter 2, 'Heritage values' is an in-depth consideration of the canonical heritage value of aesthetic worth and its associated but even less well understood value of authenticity. Picking up from Chapter 1's discussion of who historically has made heritage judgements, it investigates how aesthetic judgements are made. Beauty is of particular interest for art and architectural historians, but it is also said to reside in landscapes (discussed in Chapter 3). Notoriously subjective, judgements of beauty also change over time, and are culturally specific. Yet aesthetic value cannot simply be rejected for its effect of limiting heritage designations to categories that conform to expert opinion. Instead, aesthetic theory suggests that the processes of forming an aesthetic judgement can be rendered transparent. The main case study takes a historical view of significant changes in conservation practice that have been led by changes in the consensus over aesthetic value. It looks first at two very different approaches to the conservation of ancient Greek temple sculptures and then at the practices of architectural conservation. The chapter concludes with the hope of a more open dialogue between experts, in this case architects, and the public over how historic buildings are presented as spaces with room for the imagination.

Chapter 3, 'Natural heritage' tackles the relationship between natural heritage and cultural heritage, which historically have been treated as distinct. The scientific value of natural heritage was enshrined in the 1972 World Heritage Convention, which posed an absolute divide between nature and culture. This has now been modified to recognise human contributions to landscape qualities, in the form of cultural landscapes. Ecological understandings of natural heritage are now more familiar, inflected by philosophical positions that insist that human damage to species and environments should be mitigated, to varying degrees. The first case study shows how formal processes of natural conservation tend to manage the relationship between humans and resources (these are generally treated as resources to be exploited, whether for subsistence, profit or leisure) by limiting human actions as well as by intervening in the ecosystem. The second case study draws on the understanding of heritage values developed in previous chapters, in discussing early definitions of heritage landscapes for their appeal to cultural qualities (aesthetic and spiritual) and the role of nationalism in natural heritage. The concluding case study discusses an extreme position, the proposal to reintroduce large mammals to a region in order to take it back to a pre-human occupation period, as a form of heritage action.

Chapter 4, 'Museum practice and heritage' considers how the new museology of the 1960s and 1970s exemplifies many of the heritage debates discussed so far in the book, particularly around the relationship between canonical and unofficial heritage, the expert and the visitor, and the role of museums for national identity making. The case study steps out of the gallery to consider the processes that created 'Shakespeare Country', the town and hinterland of Stratford-upon-Avon in Warwickshire, now an international tourist experience. The museumification of an entire area has taken more than 250 years, from its inception initiated at an unofficial level through a combination of local economic strategies (showing selected buildings and places) and willing consumers of popular guidebooks, to the present-day experience of official Shakespeare heritage places and products.

Chapter 5, 'Interpretation of heritage' draws out the underlying relationship between the heritage expert and the general visitor in the context of the official heritage discussed in Chapters 3 and 4. Interpretation is defined as a particular set of professional practices designed to engage heritage visitors with the meanings of their encounter. As formulated by Freeman Tilden, the originator of US national parks interpretation, this is a reflexive process, intended to reveal and to provoke. It is therefore intended to draw visitors into official heritage, treating them as active rather than passive. The case study uses a recent interpretation scheme at a major official heritage site, the World Heritage Blenheim Palace, Oxfordshire, to see how far non-canonical values and meanings are adopted. Historically, of course, site interpretation has been more limited, and this is discussed here in this chapter as the scholarly tradition, in which selected meanings are endorsed by specialist knowledge communities but are not more widely accessible. However, Tilden's aspirations for interpretation have become widely accepted to the extent that interpretation standards are now within global heritage frameworks. There remains the problem of who selects and defines heritage meanings, particularly for indigenous heritage in settler and postcolonial societies. Newer strategies to invite and share meanings from a broader range of interest groups include recognising the role of emotions in heritage encounters, or 'hot interpretation'.

Chapter 6, 'Heritage and tourism' traces the complex relationship between heritage and the economies of tourism, noting that academic interest has moved from studies of tourism (the practice) to tourists (the people). This shift has brought the roles and impacts of tourists on the places and people they view into new focus. The first case study considers a sociological approach to tourists on board a cruise ship to the Arctic landscape of Norway, comparing their varied responses (and predisposing expectations of their journey) to the official heritage discourses about the historic and natural significance of the landscape. The second case study turns the focus on to tourism entrepreneurs who are themselves the heritage owners, the Alaskan Native (Iñupiat)

community. Although there has been a significant shift here from the early practices of settler tourism to indigenous ownership of the tourist infrastructure, it is not clear that tourists fully understand the new relationship. Messages about the new level of control exercised by the Iñupiat over the presentation of their heritage may not be completely received by their audience.

Chapter 7, 'Heritage as social action' follows up and develops the notion that heritage can be strategically deployed to effect change. Here it is discussed in the context of social action, where unofficial heritage can be used by the owning community to new political effect. This relates to the widening of heritage discourses noted in other chapters, from the recognition of values grouped around social significance (beyond 'high culture' or science) and the opening up of academic disciplines and professional sectors to new questions and wider meanings, such as the new museology. Raphael Samuel's formulation of 'history from below' is an important stage in recognising the expansion of heritage narratives (Samuel, 1994). Two case studies trace out differing uses of unofficial heritage which both assert the value of this heritage against official currents. The first shows how descendants of an Indigenous Australian settlement, now abandoned, actively curate the site, its meanings and memories, as an important part of their recent history and as deserving of formal protection from intrusive elements. The second discusses a heritage entrepreneur's use of walking tours of an area of London that has a recent history of racial tension. The tours commemorate the sociopolitics of that history and re-present the area to visitors, particularly those with black origins. Social action takes up the processes of official heritage and uses it for new ends.

Chapter 8, 'Heritage as performance' conveniently draws together aspects of interpretation, tourism and social action that are discussed in the second half of the book in relation to the social communication role of heritage. 'Performance' is used here in its sociological/anthropological sense of socially communicative action, not just in the sense of a theatrical event. Thus the chapter discusses the range of heritage performances, from forms of staged interpretation such as costumed guides or special events on site, to the reflexive experience that visitors moving around a heritage place create, both for themselves and for other visitors, using the cues provided. Tensions between official and unofficial heritage are discussed in the first short case study on Trinidad Carnival. The main case study moves between official and unofficial heritage, taking the range of spiritual meanings found within the English market town of Glastonbury, Somerset, as the basis for understanding three different processions using the town's streets and its topographical features. These processions are overtly performative, with an audience, and use a range of historical references to reassert old traditions as well as to define contemporary, contested identities. They are

also strongly rooted to place, taking their meanings from the tangible heritage of Glastonbury as much as from the intangible heritage of their diverse spiritual traditions.

The book's chapters work together to open up the dynamics behind how heritage is defined on our behalf and how we can make it for ourselves. If the cumulative effect is to insist that nothing about heritage is value-free, this conclusion is achieved only because nothing about heritage is process-free. Heritage survives because societies make it work hard. *Understanding Heritage in Practice* lifts the lid on the social engine.

Works cited

Samuel, R. (1994) *Theatres of Memory: Volume 1, Past and Present in Contemporary Culture*, London and New York, Verso.

Smith, L. (2006) *Uses of Heritage*, Abingdon and New York, Routledge.

Chapter 1 A history of heritage

Susie West and Jacqueline Ansell[1]

Early conservation legislation and practices were formally defined by intellectual currents of European thought which created a 'world view', or discourse, about what heritage is. Heritage was valued for being tangible and monumental. The dominant discourse also reshapes heritage in its own image, as the case study by Jacqueline Ansell shows. Her investigation, as a dress historian, of the encounters between wealthy English tourists and working Welsh women demonstrates how the idea of 'traditional' Welsh female costume came about. Dominant European heritage discourses were exported with colonialism, but in recent decades international heritage practices have responded to challenges. These include the recognition of a range of cultural values and community knowledge that make tangible heritage significant. Intangible heritage is the most recent field of cultural activity to receive international recognition.

Introduction

> A leading goal of the international heritage movement, expressed in such bodies as UNESCO, ICOMOS and the Australian Heritage Commission, has been to objectify, professionalise and systematise the process of heritage assessment and evaluation. In the hands of professionals and bureaucrats much of the heat and subjectivity – and perhaps some of the enthusiasm too – has been taken out of heritage business.
>
> (Davison, [2000] 2008, p. 36)

A history of heritage can be set out in many ways, perhaps working through a series of notable **conservation** successes in saving sites and landscapes, or detailing the complex development of national and international legal frameworks for conservation. Some recent commentators have offered a more critical review of conservation history, seeing it as overly controlling, exclusive of social diversity and narrow in its judgements of value. Other narratives suggest that conservation movements have a history of vibrant grassroots activity, emphasising the role of communities in making sense of what heritage means to them, and successfully challenging professionals to respond to indigenous peoples' heritage and African-American heritage on a global scale (Byrne, 2008; Samuel, [1994] 2008; Smith, L., 2006). There is considerable divergence, then, across different possible histories of heritage.

[1] Jacqueline Ansell published the research on which the case study is based under her unmarried name Jacqueline Lewis.

This chapter gives you a timeline for a history of heritage, beginning at the phase when there were enthusiasts collecting and representing the past but no professionals. Though museums (private and institutional) have the longest history as heritage institutions, truly public museums emerged only in the mid-nineteenth century in the West. The case study in this chapter is about how the modern idea of 'traditional' Welsh women's costume emerged *unofficially* but became official. It is a reminder of how much we still use inherited ideas of what the past should be. In this case many ideas about 'traditional' Welsh dress come down to us not from its wearers but from the English ruling classes.

There are three major phases to consider on a timeline: the enthusiasts of the seventeenth and eighteenth centuries, the new professionals of the nineteenth century and the rise of world organisations of the twentieth century.

However, this is not just a 'names and dates' history. More interesting is to follow changes in the thinking around how and why objects of heritage have been identified and presented. We will follow early approaches to collecting and categorising the past, the rise of the architectural monument and archaeological site as the dominant types of heritage, the high point of this approach with the establishment of the **World Heritage List** and subsequent challenges to this dominant mode of thinking about heritage. These intellectual positions are **discourses**, or world views, and we will be considering the evolution of an official discourse about what heritage is and who takes responsibility for it.

The enthusiasts

The practice of heritage may be defined as the management and conservation protocols, techniques and procedures that heritage managers, archaeologists, architects, museum curators and other experts undertake. It may also be an economic and/or leisure practice, and/or a social and cultural practice ... of meaning and identity making.

(Smith, L., 2006, p. 13)

The seventeenth and eighteenth centuries in the West are a convenient time to begin this brief history of heritage since these centuries saw the intellectual origins of modern science and its foundation principles of observation and testing. The search for knowledge in the arts and sciences was accompanied by greater interest in collecting and displaying objects, searching out new sources (often as part of colonising expeditions), and circulating descriptions and images through a new range of publications. The activities of collecting, understanding and representing the past were very much in the hands of

those with the private economic means and leisure to pursue their interests. These privileged men (women begin to feature more by the later eighteenth century) were strongly involved in social and cultural practices of meaning and identity making, as the quote above, from the cultural heritage critic Laurajane Smith, reminds us.

Early uses of heritage

A powerful motive for investigating the past came from a desire to write authoritative national histories to account for the origins of a nation and its inhabitants. We might think of this as a desire for national foundation myths. Early researchers working in the British Isles before the mid-sixteenth century based their understanding of the history of the nation (itself a fluctuating construct) on Geoffrey of Monmouth's *History of the Kings of Britain* (Geoffrey of Monmouth, 1973). Writing in the early twelfth century, he asserted that Britain was first settled by a Trojan prince, Brutus, after the sack of Troy. This was not the only foundation myth: Stonehenge and fossilised dinosaur bones were explained as the remains of a race of giants, or else the land was settled by descendants of Noah, neatly tying it in to biblical chronology (Royal Society of Arts, 2007).

The term '**antiquarian**' became an established title for those with a keen interest in collecting, sorting and displaying aspects of the past: the first enthusiasts for heritage. The big questions about national foundation myths and the subsequent development of society through law, custom and institutions were highly political. In England, the first formal society for antiquarians began to meet during the reign of Elizabeth I, at the end of the 1500s. However, the next monarch, James I, suppressed this group by 1607, worried by its potential for finding undesirable answers to contemporary debates over the extent of the power of the Crown and of Parliament.

During the period of the Enlightenment, spanning roughly the later seventeenth century to the early nineteenth century, the interests of British antiquarians extended to all aspects of the known world. As the term implies, contemporary researchers during this period deployed the new scientific methods in a search for light to shed on cultural and natural research problems.

Methods established during this period for collecting and classifying objects survived well into the twentieth century, for instance the sorting of objects from the same region into a chronological order, or the sorting of objects of the same type but different regions into comparative groups. Material culture could be treated in ways similar to the emerging science of botanical classification, to show how the cultures of the world could be understood in a hierarchy of simple to complex, crude to refined.

It is important to bear in mind that sorting, ordering and ranking anything involves methods of selection that may not be based entirely on factual distinctions. This argument is developed in Chapter 2. Western intellectual history identified ancient Greek and Roman societies as the intellectual foundations of their own, later, society, particularly during the Enlightenment. The surviving classical material culture of statuary and architectural ruins were treated as the artistic model for contemporary artists and architects to aspire to (the **canon** of most highly regarded works). Although western knowledge of other societies expanded considerably during this Enlightenment period, through trading contacts and colonisation, other cultures were slotted into this hierarchy of canonical and non-canonical works.

Encyclopedic knowledge

The collections of private collectors and semi-private societies began to be introduced to a wider public during the eighteenth century. In England, King George II and the government supported the creation of the British Museum, which opened to visitors in 1759 and which claimed to be the first public *national* museum in the world. The purpose of the museum was to act as a three-dimensional encyclopedia of the state of all branches of knowledge of the world, demonstrating the Enlightenment view of recognising no division between understanding of the arts or the sciences.

The creation of the national museum, whose purpose was to represent knowledge of the world, came at a time of international battles over which European nation would dominate expanding world trade and colonisation. By 1759 Europe was half-way through the Seven Years War (also known as the French and Indian War, and the War of the Conquest), a global series of battles fought by the major powers of Britain, France, Prussia, Austria, Spain, Russia, their allies in Europe and in their colonies. Colonies at the time were established in North America (USA and Canada), India, the Caribbean islands, the Philippines and coastal Africa. While the treaty that concluded the wars in Europe did not alter the national boundaries, the Treaty of Paris (1763) significantly altered the disposition of colonial lands (and their peoples). The UK emerged as the dominant European (and by extension, colonial) power. We might pause to acknowledge the huge loss of life directly attributable to the wars (Winston Churchill called this period the 'first' world war). However, contemporary politics was not the sort of knowledge to be represented within the collections of the British Museum of the time. Instead, the British colonies and other regions open to travellers were treated as sources of new artefacts which could be research materials for Enlightenment questions.

How could Hindu temple sculptures be understood against Roman portrait busts or an Egyptian sarcophagus, all on display in the British Museum? Were they all artworks or should they be categorised for their place in a history of world religions? The later eighteenth-century philosophy of aesthetics suggested that it was extremely difficult to value objects as artworks away from the established canon of classical Greek, Roman and European masters (see Chapter 2). According to this view, Hindu sculptures, to take one example, could certainly be classified for their religious context but did not have a claim to rank highly in a narrative of progress in the visual arts.

Here we see the origins of a particular view of the 'natural order of things', a view generated inside Enlightenment culture which, this book argues, continues to be influential in heritage decisions in the present. The archaeologist and cultural heritage critic Laurajane Smith calls this world view the authorised heritage discourse (AHD): 'a certain set of Western elite cultural values as being universally applicable' in defining what is heritage (and why) (Smith, L., 2006, p. 11). Towards the end of this chapter we will look more closely at the way in which the AHD might operate and how other world views have challenged it in the later twentieth century. Although Smith prefers to see the AHD as emerging by the late nineteenth century, there is an argument that this is rather late (Smith, L., 2006, p. 17). The dominant categories for understanding heritage emerged because they could be investigated by Enlightenment researchers' techniques for making scientific knowledge: heritage had to be collectable, classifiable and comparable. It had to relate to the big questions in the Enlightenment about the origins of nations, religion and human progress. Eventually, natural heritage began to be used to answer the question of the origin of the world. The reasons for privileging material culture over intangible works, the grand and the elaborate over the small and the plain, the oldest over the newest, the monuments of power over the traces of the powerless, have very old roots, to the mid-eighteenth century at least. It is from this point that western discourses or world views about the inevitable progress made by successive civilisations up to the present (the canonical approach) became dominant.

The following case study acts as a bridge between the eighteenth and nineteenth centuries. It also relates its subject matter to the present, and shows the enduring nature of the cultural work done by the lady and gentlemen tourists of the past. The historic tourists, the English leisured classes, brought their class outlook and values to bear on the objects of their scrutiny. Just like earlier antiquarians, they interpreted what they saw in terms of their pre-existing views of what was appropriate for working women. This is a neat example of the operation of an AHD, the discourse arising from the English elite to create a projection of their **aesthetic** values on to a different group *and have it stand for the group's own values.*

Case study: travellers' tales of Welsh national dress

The history of Wales's warring forefathers is written on the landscape. Its ancient castles – vital to the tourist trade – bear witness to English attempts to subdue the natives by force. Wales and England were peacefully united by the sixteenth century, but the stereotype of the hot-tempered Welshman brandishing a leek was still prevalent, as seen in Shakespeare's play *Henry V* (Act V, Scene 1). Depictions and descriptions tell us that the idea of the Welshman eating cheese and riding a goat lived on until the eighteenth century. By the late twentieth century the daffodil had largely replaced the leek and the red dragon had a rival as the national symbol of Wales. Now girls in Welsh dress smile prettily from postcards, peaceful in the shadow of ruined castles (Figure 1.1).

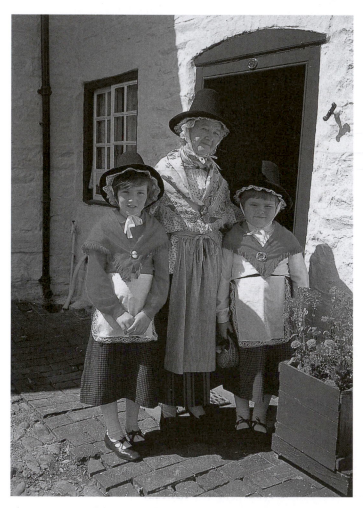

Figure 1.1 Welsh national costume postcard. Unknown photographer. Photo: © Judges of Hastings, www.judges.co.uk.

Visitors to contemporary Wales soon find themselves familiar with the image of the Welsh lady in her 'traditional' costume. Dolls, tea-towels, postcards – even logos – show lace-trimmed bonnets, high-crowned black hats and long skirts of checked or striped wool, usually red. Shawls and aprons complete the costume that many girls wear on St David's Day as an assertion of national pride. When did this 'national dress' emerge? Has it

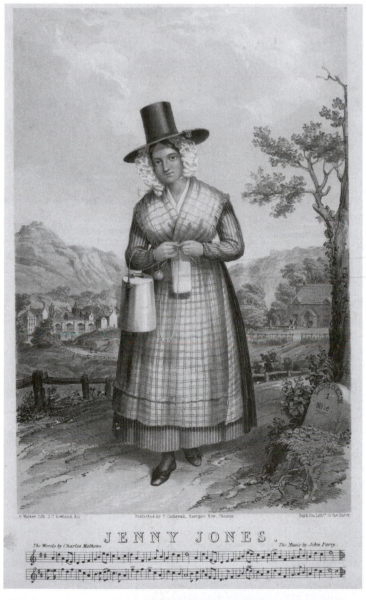

Figure 1.2 J.C. Rowland, *Jenny Jones*, songsheet, The National Library of Wales, P5874. Photo: by permission of Llyfrgell Genedlaethol Cymru/The National Library of Wales.

remained unchanged over centuries – as a fossilised fashion? If not, what factors shaped its revival or re-invention?

Contemporary authors have sought to address these questions and in doing so to interrogate a sense of Welsh identity linked to ideas about the ancient Welsh language and an agrarian past. There are few surviving articles of eighteenth- and nineteenth-century working-class dress, and the voices of the wearers are similarly absent (they were presumably predominantly Welsh speaking and illiterate). We can, however, hear what visitors to Wales thought of this costume. Via their published travelogues we can glean some evidence about the form and function of the dress, but more importantly we can chart the moral, social and aesthetic values that such dress was felt to embody, for the tourist, if not for the wearer (Lewis, 1995).

Most travelogue authors came from England and were first-time visitors to Wales. They struggled to make sense of what they saw in terms of their own experiences and identities of class, gender, profession and nationality. Such responses, then, were structurally 'foreign' and when read together illuminate the tourists' own value systems. The first stage of tourism to Wales (up to 1800) reveals a desire for evidence of 'primitive simplicity' as wealthy visitors sought to muse on the state of mankind and interrogate their own position in the face of increasing 'civilisation'. As tourists looked for traces of the Ancient Briton in the dress and habits of the modern Welsh, they were seeking their own common heritage as inhabitants of modern Britain. The term 'national dress' came to be used increasingly as the nineteenth century and industrialisation progressed, and by the 1820s the idea of dress as 'costume', composed of essential elements worn together at particular times and places, had really taken hold (Lewis, 1995, p. 38). Interest in national dress increased (for example Scottish tartans and Breton costume), and by the 1850s the image of the 'Welsh lady' was complete. Published costume prints, Staffordshire figurines and the popular song sheet image of 'Jenny Jones' meant that you did not need to travel to Wales to be familiar with Welsh costume and customs (Figure 1.2).

'In Search of Wales ...' – the published travelogue

In 1821 a Reverend Newell sought to 'introduce more generally to the public taste ... the natural beauties of our own island' by asserting that 'Wales is indeed, almost a foreign country within our own' (Newell, 1821, p. 2). Other writers endorsed this and stressed the economic advantages to be had when tourists spent their money within Britain. In search of novelties with which to tempt his readers, Newell argued that 'the language, manners, and customs [of Wales] are so very different from those of England, that the Cambrian traveller is abroad – a stranger, yet at home' (Newell, 1821, p. 2). He required the peasants to be as picturesque as their mountains, finding that 'the dress of the

women, a blue cloak and a man's black beaver hat, makes them good figures in a landscape, though a RED cloak would be better' (Newell, 1821, p. 61). Could this preference be a factor in the predominance of red in modern 'Welsh national dress'? Tourists flocking to Wales in search of novelty introduced new fashions, accessories and ideas that were – in some cases – eagerly taken up by the 'unspoilt' natives. The ways in which both tourists and natives were shaped by this encounter is the key theme of this case study.

The fashionable tourist destination was Italy, but in the late eighteenth century continental wars made foreign travel difficult and improved turnpike roads made 'home tourism' easier. Mountainous North Wales was soon christened the 'British Alps' and South Wales received a boost from a visit by the Reverend William Gilpin whose watercolours subsequently inspired a fashion for the 'picturesque'. By 1800 the Royal Academy in London had exhibited thirty Welsh landscapes.

The Napoleonic Wars and industrial revolution meant that much of Britain was in a state of social and economic transition from the late eighteenth century onwards. The Welsh gentry were becoming more international in outlook while the forces of Romanticism were encouraging those from outside Wales (whether Welsh, fellow Celts or English) to examine its language, culture and antiquities with renewed interest. Published accounts of travels in Wales began in the 1770s, proliferated in the 1790s and peaked during the Napoleonic era (when patriotism was a useful selling point). Non-travellers liked to read such accounts and travellers liked to be guided by them. In 1810 one visitor observed that

> Wales and the Wye are visited by all tourists, we are precisely in the tract, and meet them at all the inns, stalking round every ruin ... and climbing every high rock for a prospect; each with his Gilpin or his Cambrian guide in his hand, and each, no doubt, writing a journal.
>
> (Simond, 1817, pp. 272–3)

He found all this 'rather ridiculous and discouraging' – as he noted in *his* journal (Simond, 1817, p. 273).

Dress and value systems

When travellers offer up opinions on costumes or customs they give us valuable insights into their own value systems and norms. Early eighteenth-century visitors to Wales noted distinctions in dress (probably due to extreme poverty); this, combined with a startlingly different language from their own, made them view the Welsh with distrust (Lewis, 1995, p. 31). Late eighteenth-century commentators reveal the influence of Jean-Jacques Rousseau and his fashionable novel *Emile*. Rousseau believed that civilisation had corrupted mankind from an ideal 'state of nature' inhabited by 'noble

savages'. The idea of the noble (or ignoble) savage informs an account by the Reverend J. Evans of entering Merioneth and glimpsing 'human nature in almost its rudest state'. After commenting on the shapeless dress of the females he observed that 'at sight of us they fled to certain distances ... which brought to our recollection, the first reception of the Spaniards by the transatlantic Indians' (Evans, J., 1804, p. 53). Clearly he wished to emphasise the gulf that separated impoverished Welsh native from wealthy English traveller.

Homespun garments formed the whole of the Welsh wardrobe and many tourists were quick to attribute moral superiority to this, stressing its links with the past and pronouncing Welsh women 'Virgin descendants of the ancient Britons' (Lewis, 1995, p. 31). The contrast between high fashion and peasant dress is evoked in J.C. Ibbetson's *The Market*, one of a series of watercolours made when this artist was paid to accompany a wealthy tourist in 1792 (Figure 1.3).

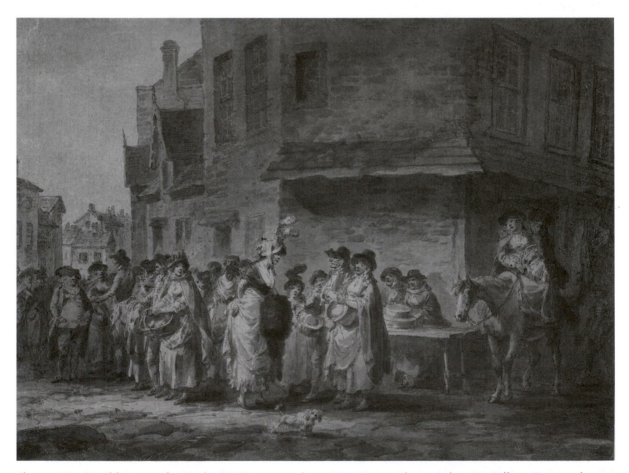

Figure 1.3 J.C. Ibbetson, *The Market*, 1792, watercolour, 22 × 29 cm. Photo: Laing Art Gallery, Tyne and Wear Museums.

In 1793 Viscount Torrington remarked of North Walian churchgoers, 'never did I see a more decent congregation; in manners, looks, and dress, they are sixty years behind the English; while they retain their tongue, they cannot emigrate, and must keep up ancient customs' (quoted in Lewis, 1995, p. 35). Washable cotton garments were thought preferable to uncomfortable wool, and worn by all those who could afford them (in England at least). As part of their wages servants were often given 'cast-off' clothing made of cotton or silk. This they either adapted for their own wear or sold to secondhand clothing dealers. Returning to England from his 1784 tour of North Wales the viscount commented adversely on this custom which he perceived to have the potential to destabilise class distinctions. Meeting with a party of 'gay-dress'd out' folk in England, he noted that 'dress lost with the great – and aspired to by their inferiors – leads to equality – and to put my lord, and the cotton-weaver upon a footing' (quoted in Lewis, 1995, p. 35). That the Welsh poor seemed content, even proud, to wear egalitarian woollens was a potent point in their favour.

The shocking sight of bare feet

One aspect of Welsh dress that drew a very strong moral and aesthetic reaction from many travellers was lack of shoes. Edward Clarke observed in 1773 that 'the generality of the common people despise the use of shoes or stockings', but he admired the economy of this practice: 'I have often met Welsh girls upon the road, who were dressed for a visit to their friends in a clean white petticoat tucked above the knee, trudging along the hard road, barefooted with their shoes and stockings under their arm' (Clarke, 1793, pp. 214–5). To the expensively shod tourist, shoes were a potent symbol of civilisation, and bare feet were signifiers both of poverty and immorality. However, in the wet Welsh climate bare feet were so essential when descending grassy mountains and fording streams that even eminently respectable tourists had to adopt them (Lewis, 1995, p. 34).

One female first-time visitor to Wales aimed to convince her genteel English reader that the display of bare feet had 'not such a disgusting appearance, as persons unacquainted with it are apt to conceive' (Lewis, 1995, p. 33). As the wife of a Welsh cleric she argued defensively that 'the innocence and modesty of their countenance plainly prove that they are as unconscious of any impropriety as we are when we shew our arms' (Lewis, 1995, p. 33). It is possible that lascivious fascination as much as moral indignation caused so many travellers to dwell on what the majority saw as a peculiarly Welsh custom. The first image of a Welsh country woman to appear in a travelogue clearly shows bare feet (Figure 1.4) and the second shows bare legs (Figure 1.5), perpetuating this powerful signifier of difference.

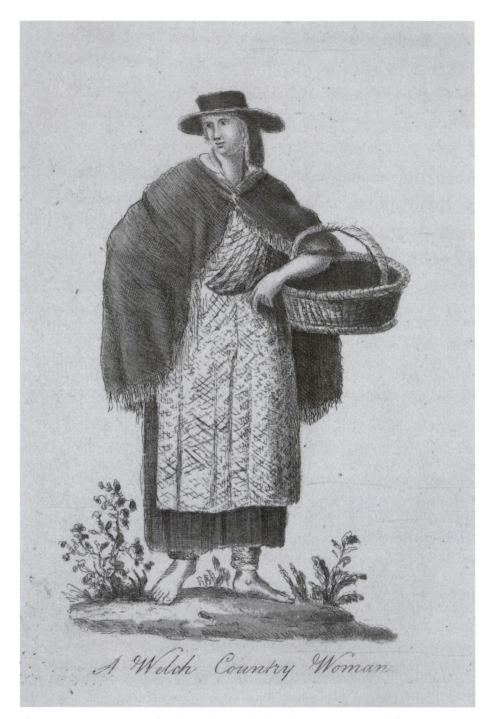

Figure 1.4 A.-L.-B. Maudet de Penhouët, 'A Welch Country Woman', in Maudet de Penhouët, A.-L.-B. (1797) *Letters Describing a Tour through Part of South Wales by a Pedestrian Traveller*, London. British Library, London, 792.h.21. Photo: © British Library Board. All Rights Reserved.

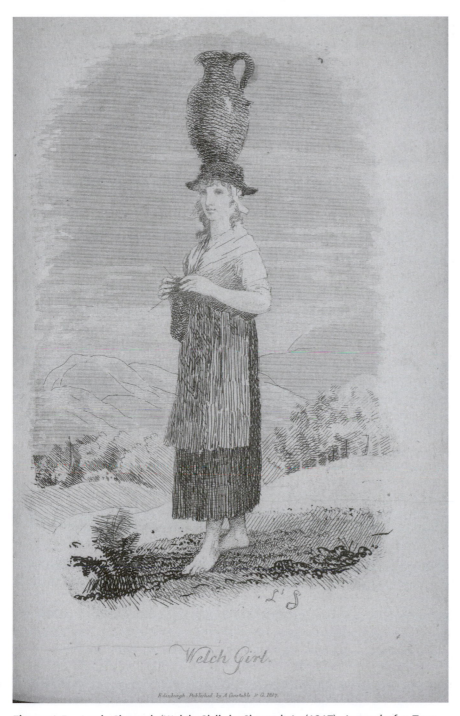

Figure 1.5 Louis Simond, 'Welch Girl', in Simond, L. (1817), *Journal of a Tour and Residence in Great Britain during the Years 1810 and 1817*, Edinburgh. British Library, London, 1609/10. Photo: © British Library Board. All Rights Reserved.

The unisex hat

By the early nineteenth century peasant women in most parts of England wore bonnets. That Welsh women wore the same style of black hat as their menfolk was perceived as *the* distinguishing feature of Welsh dress. In the eighteenth century such hats were often made of felt and low in the crown. If crowns were malleable and low they could offer a convenient shelf on which to steady a load, leaving hands free for knitting (as in Figure 1.5). Men, women and children knitted stockings for their own use or to be sold at market (or even to tourists). Travellers rarely considered the economic necessity of this practice – designating clumps of knitters 'picturesque', and viewing the industrious Welsh peasant as deserving of sympathy and charity. It is not surprising then that 'Jenny Jones' is shown knitting (though her hat is too stiff and high in the crown to help support the pail, which now weighs heavy on her arm).

Costume prints from the 1830s onwards show hats similar to that worn by 'Jenny Jones'. High-crowned beaver hats were fashionable for both men and women in England in the mid- to late seventeenth century and were worn by Quakers well into the eighteenth century in Britain and beyond. The modern Welsh hat is reminiscent of these (and may carry some overtones of dissenting religious sects). In the early twentieth century it was believed that the high-crowned hat represented an unbroken link with the seventeenth-century past, but eighteenth-century travelogues (and surviving visual and documentary records) carry no evidence of a continuous tradition of wear. Hats were practical in the Welsh climate, protecting the wearer from rain, wind and sun. I will continue the story of the distinctive Welsh hat after considering the dynamic of tradition versus innovation in debates about Welsh dress.

Mantles and cloaks

In 1791 a Mrs Morgan was struck by the antiquity of what she termed 'The hereditary dress of the Welsh women' and declared it 'one of the most commodious, comfortable, and simple that I ever saw adopted' (Lewis, 1995, p. 34). Her belief that it was an ancient form of dress appears to have been reinforced by her comments on the women's mantle. She describes this as 'nothing more than a square piece of white flannel, bordered with coloured binding. This they throw carelessly over their shoulders, and fasten with a hook and eye, or tie with a piece of binding'. She added, 'They do not put it on cross-ways as we do a handkerchief, but with the straight side about the neck' (see Figure 1.4). She commented that 'it is very warm, and they can guide a horse, or do any kind of domestic business ... as it does not, like most other warm clothing, impede their motions' (Lewis, 1995, p. 34).

In most of England, and in some areas of Wales, the red hooded cloak had superseded the undyed mantle. This transition was referred to in the journal of

Iolo Morgannwg, who visited Carmarthenshire in 1796. On the issue of comfort he disagreed with Mrs Morgan, claiming 'Llandarrog women wear whittles [mantles], a very old fashion and bad, not for its age, but because the modern rural cloak is much more convenient and comfortable' (Etheridge, 1977, p. 22). In a rush of Rousseauesque sentiment he exclaimed, 'But let the Carmarthenshire lasses, retaining their perfect innocence and simplicity of manners – wear their whittles forever rather than run like some of the Glamorgan hare-brained wenches into the follies of fashion' (Etheridge, 1977, p. 22). Perhaps an idle hope! The cloak required more material and more manufacture and so lent itself to becoming an expensive status symbol.

Blue dye was relatively cheap, so blue cloaks and whittles were often worn in Wales. Red dye, derived from shellfish or imported sources, was more available in the coastal areas and always expensive (and therefore highly prized). An added reason for Welsh women to retain red whittles is described by Samuel Rush Meyrick (in 1810). He referred to 'the oblong piece of red flannel' worn in Pembrokeshire, which had, 'since the taking of the French who landed at Fishguard last war ... been termed the "Frenchman's terror"' (Lewis, 1995, p. 37). There is not space here to describe the last invasion of Great Britain in 1797 (when a small and poorly-equipped group of French soldiers landed, aiming to head inland). Contemporary letters tell how locals repulsed them with pitchforks, but it was peasant women who scared off the invaders (who mistook them for soldiers in their red flannel and tall hats). This tale is often re-told in modern times and adds a patriotic slant to the retention of red clothing and the tall black hat.

Fashion and anti-fashion

By 1803 it was possible to conceive the gulf widening between the Welsh rural poor and their English counterparts. As industrialisation increased so did demand for reminders of the rural past and its supposedly superior moral values. In 1803 J.T. Barber asserted that 'Wales may be considered as exhibiting almost the sole remnant of "the good old times" existing in Britain' (Lewis, 1995, p. 32). Despite extravagant claims for the uniform and unchanging nature of Welsh dress, it is clear that it did admit innovation. Mrs Morgan was disappointed to note that the 'common people in the large towns deviate widely from their primitive simplicity, and imitate, in a very slovenly and awkward manner, the English mode'. In 1796 Catherine Hutton endorsed this, observing townswomen in 'printed cotton gowns' – but still wearing the distinctive beaver hat and blue cloak (Lewis, 1995, p. 36).

It appears that heavy, homespun woollens were fast losing their appeal: though warm and waterproof, they were bulky and appeared unhygienic when contrasted with light-coloured, flimsy and washable fabrics of fashionable circles. In 1803 William Hutton wrote of Welsh dress, 'Ambition seems

wholly excluded. The dress of the inhabitants is of that kind which never changes for ages. It is made to cover, not for show' (Lewis, 1995, p. 36). By 1813 Richard Ayton could not contain his disgust at the dress of the female peasantry (disliking all aspects thought admirable by earlier writers – namely, its uniformity, simplicity, and independence from fashion). He was the first to term these features 'national dress', when he wrote of Welsh women:

> Their beauty is not set off by their national dress, and indeed it is strong proof of its transcendency, that it appears so striking in spite of it. They indulge in no showy and sprightly colours, no gay ribbons, nor finery of any kind, such as distinguishes the country lasses of England: rough, dark, woollen garments form both their summer and winter clothing. Add to these a dark blue or brown cloak of coarse cloth, and a man's hat, and you have a Welsh beauty in all the pride of her dress.

> (Lewis, 1995, p. 36)

It is by no means certain that an impoverished population wedded to work on the land (but not able to travel much around or out of it) would have been able to conceive of 'Wales' as a whole. For a self-conscious transformation of peasant dress into 'national dress' I must introduce Lady Llanover.

From peasant dress to national dress – Lady Llanover's intervention

The 1830s heralded a frivolous and flirtatious phase of fashion that saw Welsh women adopt frilled caps under their hats. Tourists delighted in describing the 'extravagant vanity' (effort and attention) required to keep pristine linen starched and crimped, and beaver hats glossy black (Lewis, 1995, p. 40). It was at this time that the English were introducing cotton manufactories which threatened the native woollen industry, and the rising tide of light cotton garments, frills and ringlets informed Lady Llanover's essay *The Advantages Resulting from the Preservation of the Welsh Language, and National Costumes of Wales* which won a prize at an Eisteddfod in 1834 (Gwent, 1836).

Augusta Hall, who called herself Lady Llanover after her family home, was the wife of industrialist Sir Benjamin Hall and a member of an educated circle who took an active interest in Welsh language and literature. Eisteddfods (from the Welsh for 'to be sitting down') were and still are today celebrations of the best of Welsh culture (including song, poetry and craftsmanship). Under the Welsh pseudonym *Gwenynen Gwent* ('the Bee of Gwent'), Hall was one of two respondents to the topic set by her local Eisteddfod committee. Her essay was subsequently published, though it probably had limited circulation. Clearly, she recognised the value of dress as a tourist attraction, referring to 'the loss "artists" would experience by the destruction of the costumes of

Wales' and 'their value to the traveller, after the "picturesque"' (Lewis, 1995, p. 42). She published watercolours of women in Welsh costumes – interestingly they all dress differently from one another (in brown, black, red and blue), and the unisex hat is the main common feature (Figure 1.6).

Lady Llanover took elements from all the clothes that she observed and sought to preserve them as 'Welsh national dress'. One of her principal aims was to protect the Welsh woollen industry, and to this end she set up a mill on her estate and dressed her servants in 'Welsh costume'. She also wore the costume herself at church and on special occasions, and seems to have encouraged many other 'ladies of quality' to follow suit. She evidently identified strongly with this visible sign of 'Welshness', which reinforced her energetic acquisition and promotion of the Welsh language. She had herself painted in 1862 wearing a hooded cloak and tall-crowned hat over a white-frilled bonnet, evidently understanding the power of leading by example.

Most late nineteenth-century travellers responded positively to Welsh costume. At Builth Wells in 1847 Charles Knight noted that 'Smart damsels from the South and West, in fashionable attire mingle with the steeple-hatted maids and matrons from the inner parts of the principality' (Knight, 1847, vol. 1, p. 254). At Conway Knight found that 'lively groups in their best native costumes ... increase the uncommon character of the scene [and lend it] a genuine antique air'. He observed of the town, 'Here is no modern antique; no smooth-polished and pretty revival or imitation of what an old place might have been; it is the old place itself, decayed indeed but still itself; not defaced by modern embellishment nor softened into insignificance by modern taste' (vol. 3, p. 337). The values that he perceived in the town could equally be those sought by admirers of 'traditional' Welsh dress. Increasingly though, as working garments gave way to prettified versions reserved for the Eisteddfod platform, debates about **authenticity** cast a shadow over the history of Welsh national dress.

A comparison of 'Jenny Jones' in Figure 1.2 and her eighteenth-century counterpart in Figure 1.4 highlights the self-conscious presentation of 'national dress' in the late nineteenth century, from which all signs of poverty have been removed. Neat dancing slippers protect 'Jenny Jones's' feet from the flinty road, and the hat – formerly helping to support a load on market day – is now a hindrance. In 1861 Mr and Mrs Hall were the first to make an explicit link between clothing and Welsh national pride when they noted that 'these hats must be a sad encumbrance to a woman who is laden with a large heavily-freighted market basket on her head; but on such occasions, a genuine daughter of Cambria would not be restrained [...] from the pleasure of wearing her national headdress' (Lewis, 1995, p. 44). They were alluding here to the high cost of the hat – an important factor in its status perhaps?

Figure 1.6 Lady Llanover, *Welsh Girl in the Costume of Cardiganshire* (number 11 in series of Cambrian Costumes), 1843, postcard. The Museum of Welsh Life, St Fagans, Cardiff, PB472. Photo: By permission of Llyfrgell Genedlaethol Cymru/The National Library of Wales.

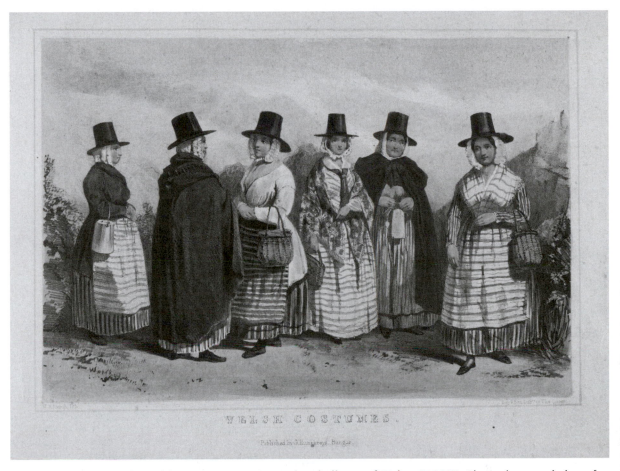

Figure 1.7 W.R. Lynch, *Welsh Costumes*, *c.*1850. National Library of Wales, PA9097. Photo: by permission of Llyfrgell Genedlaethol Cymru/The National Library of Wales. Published as a print by H. Hughes, Bangor.

Prints of 'Welsh costume' aimed at the tourist market proliferated in the 1840s and 1850s, and by the 1860s the image of 'Jenny Jones' was firmly rooted in the public imagination (Figure 1.7). The sketch by Stanton (Figure 1.8) suggests that a glimpse of her was as much a part of the attractions of Wales as the mountains she was believed to inhabit. The railway age meant that tourists flocked to Wales in ever-increasing numbers, giving rise to 'tourism as an industry – an industry which would come to employ more people than the iron and coal industry put together' (Davies, 2007, p. 396). Increasingly tourists recorded with regret that only a few older women could be seen wearing the tall-crowned hat. It is impossible to say whether it was worn as part of an obsolete fashion system (a reminder of fashions of their youth) or as a deliberate assertion of national pride. Modern communications served to consolidate a sense of national consciousness and may therefore have led to a deliberate retention of a fashion that had been imposed in the eighteenth century by poverty and utility.

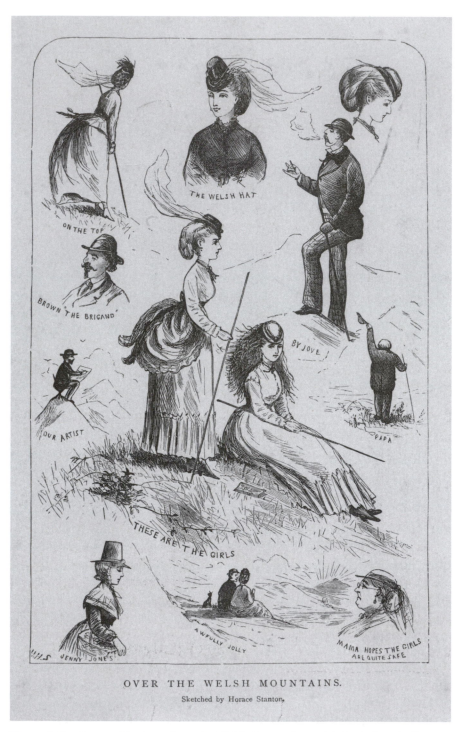

Figure 1.8 Horace Stanton, *Over the Welsh Mountains*, *c.*1870. National Library of Wales, P5269. Photo: By permission of Llyfrgell Genedlaethol Cymru/The National Library of Wales.

As the UK industrialised rapidly Wales became a convenient geographical entity on which to fix images of a peaceful rural past – a past that had once been common, but that was now lost to the urban dweller. The nostalgic value of its supposed historical associations was certainly utilised by the tourist industry, as evidenced by H.V. Morton's reactions when he went *In Search of Wales* in 1932:

> A young woman stood beside a post-card kiosk dressed in the national costume of Wales. She wore a High top-hat and a red cloak and a check apron over her skirt. I believe the Welsh hat dates only from Stewart times. It is exactly the same kind of hat that Guy Fawkes wore.
>
> 'Is that an old hat?' I asked.
>
> 'No' she said, taking it off.
>
> Inside was the name of a well-known London hatter!
>
> (Lewis, 1995, p. 46)

Towards the twenty-first century

The best 'Welsh' beaver hats had probably always come from England, but were they any less 'authentic' for that? In considering the complex question of cultural identity it is the values placed on the clothing that matter, not its origins. In *Wales! Wales?* Dai Smith argues that 'The paradox of nationalism is that it is a future vision wrapped up in the legitimising clothes of the past, real or mythical it scarcely matters' (Smith, D., 1984, p. 43). Although his reference to clothing here is metaphorical it seems a useful concept to apply to so-called Welsh 'national dress'. As the question mark in Smith's book title suggests, much research has been undertaken in the last twenty-five years into Welsh identities and how best to express notions of Welsh nationhood.

By 1900 the tall-hatted, red-shawled female stereotype had been transformed into 'Dame Wales' by J.M. Staniforth (Lord, 2000, p. 165). This was a figure who would have been instantly recognisable in Staniforth's political cartoons (in Britain at least) as a counterpart to 'John Bull' (England) or 'Uncle Sam' (America). By 1909 English-born artist Curnow Vosper's iconic image *Salem* (Figure 1.9) had found an appreciative owner in Lord Lever (after its display at the Royal Academy in London), and prints of the painting made their way into many British homes as a 'free gift' in bulk buys of soap. Its use as the cover of a Welsh language calendar throughout the 1950s further ensured that the image of tall-hatted chapelgoers entered many Welsh homes – and hearts. The costume in this image was not as 'authentic' as it seems. The shawl was borrowed from the wife of one clergyman, the hat from the grandmother of another (Williams, T., 1991, p. 17). The women all wear identical hats, which

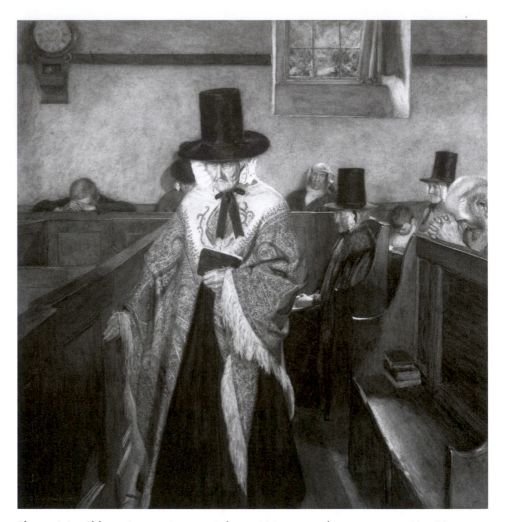

Figure 1.9 Sidney Curnow Vosper, *Salem*, 1908, watercolour on paper, 78 × 70 cm. Photo: Lady Lever Art Gallery. © National Museums Liverpool.

could be read as indicating strict adherence to traditional 'Welsh dress', but in fact all four were painted from one original worn by each model in turn.

In 1964 Ffrancis Payne's definitive account of Welsh costume was published, acknowledging Lady Llanover's contribution. Since 1983, when Hobsbawn and Ranger edited their famous book on this subject, most students of history have become familiar with the concept of *The Invention of Tradition*. Recent research by Helen Forder and Christine Stevens, among others, has sought to re-evaluate and celebrate Augusta Hall's contribution to Welsh heritage. Through research into her own family history, Forder has even uncovered evidence that Lady Llanover's female servants hated wearing their Welsh woollens and would change out of them as soon as they left the estate (Forder, 2004; Stevens, 2002, 2005).

The establishment of the Welsh Assembly in 1999 gave Wales a sense of legal separation from England for the first time since the Acts of Union in the sixteenth century. Marxism and feminism have both offered tools with which to analyse the notion of national dress and the iconic image of the 'Welsh lady' and to evaluate her place in our 'postcolonial' postmodern society in which identities are a key focus for debate (Beddoe, 1986; Lord, 2000; Wood, 1997). The late twentieth century saw an explosion of Brit Art and the concept of Cool Britannia. In response to the Union Jack mini-dress worn by Spice Girl Geri Halliwell, Wales offered its own version of 'girl power' referencing the Welsh flag – a red and green mini-dress emblazoned with a red dragon.

This Cool Cymru dress now finds a home in the former Welsh Folk Museum (re-named in 1995 the Museum of Welsh Life) (Mason, 2004, p. 18). The mini-dress is displayed in Gallery One (which replaced the 35-year-old 'Material Culture Gallery' and opened with an exhibition called 'Belonging' in 2007) with the purpose of involving visitors in 'the process of collecting and reflecting on what Wales means to people today' (Williams, N., 2006, p. 13). Placed alongside an example of 'traditional' red woollen checked dress (worn by the donor on her wedding day), it stimulates debates concerning the relevance of a 'costume' worn to signify the values of the (pre-industrial) rural past in the urban (post-industrial) present (Figure 1.10).

In 2007 National Eisteddfod organiser Hywel Edwards questioned the retention of Welsh national dress when he argued that 'shawls and hats give the impression [to a global audience that] Wales was "stuck in the past"' (Wightwick, 2007, p. 5). His call for Wales to be seen as 'the modern, dynamic country it is' echoes a nineteenth-century cartoon in the satirical periodical *Welsh Punch* which showed a woman in Welsh costume standing in front of a steam engine (impeding progress). Many parents and teachers reacted strongly to Edwards's suggestion, stressing how important it was to 'understand Welsh heritage, especially in multi-cultural schools'. One mother from Cardiff said of her daughter, 'Elin loves dressing up for St David's Day. The costume is 75 years old and was worn by my mother and me. It is nice to pass it on. It's part of our heritage. We know Wales has moved on but this is for fun' (Wightwick, 2007, p. 5).

My own memories as a child growing up in Cardiff are that 'dressing up' in Welsh costume for St David's Day was never just 'fun'. I remember being acutely aware from an early age of the hat and daffodil as potent symbols of nationhood and, as my parents were English, became increasingly troubled by my entitlement to wear them. An acquaintance of mine who describes herself as being from 'North Welsh gentry stock' has said that she never wore 'Welsh costume' growing up in the late 1950s and never would do so, perceiving it to be the product of 'outsider representation'. My ethnically

Figure 1.10 'Cool Cymru' dress (centre), designed and made by Jill Salen, on display next to a 'traditional' dress in Gallery One of The Museum of Welsh Life, 1999. Museum of Welsh Life, F99.28. Unknown photographer. Photo: © National Museum of Wales.

Welsh friends and acquaintances (monoglot English- or Welsh-speaking) express no such anxieties – secure in their sense of self and nationhood, they dress daughters and nieces in such costumes with pride (and perhaps at times with a tiny bit of postmodern irony).

Clothing as a cultural marker has one distinct characteristic (a disadvantage to the historian but sometimes an advantage to the wearer) – its impermanence. The identities that we fashion for ourselves through our dress can change from day to day, depending on place, time and mood, and the desire to rebel or conform, which are influenced in turn by discourses of age, class and gender. It is when such transient images become permanent and reach a wide audience (a photograph, a print, a published comment in a traveller's account, for example) that extreme caution is needed. Hywel Edwards is right to be wary of 'images that are broadcast around the world'. At least now, with a greater understanding of the value systems that underpin Welsh 'national dress', its wearers can begin to make an informed choice about the image they present to the wider world, and to reflect on it as a badge of 'belonging'.

Reflecting on the case study

The story of the way in which working people's dress came to stand for a nation is a powerful reminder that the European heritage discourse of the Enlightenment and later could be found within European societies as well as between Europe and colonised peoples. The political relationship between Wales and England has been a long-contested one and some Welsh citizens might suggest that it has been a colonial experience. Certainly it is possible to read the English re-shaping of Welsh female dress as a form of colonisation of the mind, in that the fashion-driven 'Jenny Jones' image of a Welsh woman has become incorporated into Welsh representations of their own heritage. The components of an unofficial living heritage (hats, mantles, the practicalities of bare feet) became abstracted into an official but no longer contemporary heritage. But as the case study concludes, there are ways of seeing that modern Welsh approaches to costume give it a dynamic element again. This pushes us to consider issues of authenticity: should we conclude that historical investigation produces conclusions that undermine the authenticity of 'traditional' Welsh costume? Or should we recognise that heritage operates as living traditions that are organic and changing? Who is in control of determining when to fossilise these traditions?

The first professionals

Empire and knowledge

By the 1850s a major transition was taking place as newly created public institutions began to take over the lead from private individuals in collecting and displaying the past. The Enlightenment world view of a single time-line of human progress (determined by a Christian god) was becoming increasingly difficult to sustain. Intellectually, the arts and sciences separated out in a way that a seventeenth-century antiquarian would not have recognised.

European colonial expansion was still in progress by the 1850s and would continue until 1939. Britain had already colonised Canada (from 1763), controlled India (it declared direct rule in 1859), formally taken over the Cape Colony at the tip of South Africa (by 1806) and declared Australia to be a colony (in 1829). It would join other European nations in competing to acquire more African territory from the 1880s. By the outbreak of the First World War in 1914 the British empire was administering the lives of over 400 million people. To give just one other example of a colonising nation, France retained some Caribbean islands, and also looked east, to acquire territories in East Asia, South-East Asia, the Indian Ocean and Oceania (towards Australia). It was highly competitive with Britain in Africa, occupying North African territory from 1830 and extending down West and Central Africa by 1900. This list emphasises the ubiquity of European colonisation, except in the Near and Middle East which was emerging from the decline of the Ottoman (Turkish) empire. The political discourses that justified European national interests in constantly extending their claims to other territories acted to normalise this process. Now referred to as colonial discourses, they are a form of colonisation of the mind: the world view of dominant Europeans being made to stand for any indigenous sense of order (after Said, 1979). The near global export of European intellectual hierarchies through the processes of colonialism largely explains the success of western values about *what* objects of heritage could be and *who* would take responsibility for understanding them.

For example, in 1784, soon after the British established economic and political control of Indian provinces, an institution similar to the Society of Antiquaries of London, the Asiatic Society, was founded in Calcutta. The Asiatic Society started publishing its members' researches in a journal from 1788, and by 1814 it was ready to establish a museum for its own natural and cultural collections. These collections were transferred to a new public museum in Calcutta in 1866, the Indian Museum. Back in London the British Museum made clear to curators in the colonies that it had first claim on objects of interest for its own collections (this was before the Natural History Museum housed the natural heritage collections after 1883). The Asiatic Society's

geological collection included meteorites. Meteorites found in India were highly prized by international museums, including the Imperial Museum in Vienna. These fragments offered the only access to tangible evidence from astronomical bodies. The Indian Museum staff became increasingly confident about the quality of their own research and the need to maintain the best possible collections, so they began politely to establish their independence during the 1860s, despite political pressure (Nair, 2006, p. 118).

The oldest government inventory

The European heritage protection story began in France during the 1790s revolutionary government, with a first attempt to survey the national historic assets. This failed venture was revisited in 1830 when a government body was set up to investigate the French nation's stock of historic buildings. This body still exists today. The Commission des Monuments Historique started to make an inventory of buildings in 1837, defining its selection according to date, architectural style or associated historic event. The same **criteria** dominate the twentieth-century approach to selection. This selection process tends to create categories of superlatives: the best, the oldest, the most historically significant. It can be thought of as the establishment of a canon of national monuments (a parallel to literary canons of 'great literature'). Prosper Mérimée took over as the inspector general of historic monuments in 1840. This extraordinary man was a polymath: linguist, writer, traveller and courtier under the re-established French monarchy. He threw his energies into the commission, with a very wide brief to assess buildings, **archives** and museums, and by 1849 nearly 4000 monuments were listed.

> A French critic of the 1920s noted the paradoxical turn of [Mérimée's] life. He had been 'a young man who had put everything into trying to write like Voltaire and dress like Beau Brummell, yet who became the most diligent of bureaucrats and the most zealous of archaeologists'. A further paradox was that this convinced atheist, who had not even been baptised, was responsible for saving large numbers of ecclesiastical buildings – first from falling down, and then from the bright decorative vandalism of know-nothing restorers and proprietorial clergy.
>
> (Barnes, 2007)

The monuments were medieval or earlier, and this again would be a set of values that other nations would follow. Under Mérimée and his protégés, including the renowned medievalist architect Eugène Viollet-le-Duc, the French Gothic style became newly appreciated as an essential expression of national history and character.

The French state was not, at this stage, offering to fund much conservation or indeed to threaten sanctions if the listed buildings were damaged or destroyed.

It hoped to inspire local investment and appreciation of what came to be called the national *patrimoine*, or heritage. Behind the inspectors came the first generation of architects interested in conserving historic buildings, replacing like for like. This followed Mérimée's own conservation philosophy: 'It is better to consolidate than repair, better to repair than restore, better to restore than embellish, and in no circumstances knock down' (Barnes, 2007). Consolidation still means the technique of retaining original material where possible, for instance re-pointing a wall to protect the historic bricks rather than re-building it. This philosophy was to be picked up by British campaigners for the sympathetic treatment of old structures. It is an expression of the value of authenticity, a quality believed to reside in original material that cannot be replicated. Chapter 2 of this book explores this and other conservation values further.

The rise of the 'ancient monument'

Turning to the UK for a more detailed look at the emergence of legislation for heritage, we see that this too focuses on built heritage. Portable works of art and antiquities became part of the story in 1903, when the National Art Collections Fund was set up to distribute grants to public museums trying to purchase objects that were likely to be bought by foreign interests. However, there was no legislation for export controls until the outbreak of the Second World War prompted the first licensing of all exports. Nor was there any UK legislation for **natural heritage**, although public demands for the creation of national parks and wide access to the countryside were strong through the 1930s, including a celebrated mass trespass on an English mountain called Kinder Scout in 1934. UK natural heritage was not legislated for until 1949 (with the exception of earlier bird species protection Acts (Evans, D., 1997)).

The pioneering piece of legislation for the UK came in 1882, the first Ancient Monuments Protection Act, in which a short list (schedule) of medieval and earlier monuments and buildings were named 'ancient monuments' deemed worthy of government inspection and monitoring (regardless of their ownership). The Act also created the role of inspectors of ancient monuments as part of the civil service. The sites were selected as illustrative of national history and gained their place in the canon of 'great historical sites'. Subsequent monuments still have to fulfil the criterion of being nationally significant (although current definitions of this have expanded). These sites gained their legal protection through the presumption that alterations and development were undesirable.

The UK, France and Germany took the lead in further heritage legislation, but western Europe generally adopted similar definitions of ancient monuments and similar processes for defining and protecting them. In 1905 Baldwin Brown published a comparative assessment of European responses to the

acceptance of state care and protection of monuments. He contrasted a British 'laissez-faire' attitude of reluctance to interfere in the rights of property owners (and a refusal to contemplate compulsory purchase for monuments under threat) with 'the right of the community over monuments in which is written the common history, and which in centuries past have been the centres of the common life', expressed particularly strongly in Italian and French legislation (Brown, 1905, p. 5). Brown's short discussion is still well worth reading, as it touches on the range of conservation debates that continue to challenge professionals today. He also argued for the intangible meanings of monuments, citing the importance of the collective memories they can evoke, memories that go beyond references to named individuals and draw in wide associations with an era.

Natural heritage before 1945

We noted above that the UK did not have a system for identifying and protecting landscapes or natural sites before 1945. The Nature Conservancy Council was not established until 1949, the same year that the first national parks in the UK were set up by the National Parks and Access to the Countryside Act. However, a former colony led the way at the end of the nineteenth century. The USA designated the first national park, Yellowstone, by Act of Congress in 1872. It was 'for the benefit and enjoyment of the people' (and is discussed further in Chapter 3). In 1916 the National Park Service was created to provide a single agency for managing the parks. The designation of national parks on federal land was supported by the Antiquities Act 1906, which empowered presidents to declare objects of historic or scientific interest on federal lands as national monuments. This use of the term 'monument' is different from the European tradition, as it views large tracts of land as monuments. Importantly, the Act enabled **indigenous people**'s sites to be recognised as the prehistory of the USA. A quarter of the current national parks were first designated as national monuments, including the Grand Canyon. The Historic Sites Act 1935 made explicit public policy the federal acquisition of historic buildings, sites and lands 'of national significance' (Jameson, 2008). As with European historic buildings legislation, the regional and local scales of **significance** were not yet dealt with. This, then, was a rather crude instrument of protection, but it led the way.

Commentators on the early history of conservation in the USA have variously interpreted the first national parks as economically worthless lands, as a narrow attempt to set limits on refuges for wildlife and wilderness, and as the imposition by an economic elite of particular desires for order and control (Runte, 1997). These critiques need a closer investigation of historical interpretations of the politics of the period than can be supplied in this chapter. However, we should remember that native Americans of the time would

have no representation in the selection, designation and management of nationally significant landscapes, or in determining the criteria for national significance (see Chapter 3). Natural heritage processes are just as open to interrogation for the operation of 'Establishment' discourses or AHDs as are cultural processes.

A different political context, New Zealand's British colonial period, has some parallels with the early natural conservation history of the USA. New Zealand was declared to be a British colony after Māori chiefs signed the Treaty of Waitangi in 1840. The natural resources of the colony, particularly New Zealand's forests, were exploited for the benefit of the empire. In the absence of any forest management, this was simply environmental destruction. Later nineteenth-century Europeans began to realise that extraction needed to be limited to preserve something of the Māori landscapes, but decisive action was taken by the Māori. The country's first national park, Tongariro, was established in 1887, the gift of a Māori chief. It is now a World Heritage cultural landscape. The Land Act 1892 included provision for appreciation of scenery. Today, 27.5 per cent of the land area is officially protected, mostly in mountainous areas. By 1910 New Zealand legislation protected nearly all native birds and there were three reservations. The growing importance of international tourism for New Zealand's natural heritage prompted a focus on animal protection and the extension of landscape protection before 1945 (Young, 2004).

International heritage after 1945

Once we move into the era of recent politics following the Second World War, the canonical approach to **listing** and collecting becomes globalised. The most powerful international body is the United Nations Educational, Scientific and Cultural Organization (UNESCO). This is the executive body for the elected members of the World Heritage Committee and sponsors the other international conservation institutes (and see Donnachie, 2010). Over-arching global heritage frameworks do not have the force of national legal instruments; they are devised for members of international bodies to subscribe to in the expectation that members will monitor each other's behaviour. Agreement that a heritage framework should exist does not guarantee that member states of the UN will sign up to it; the unpopular Convention for Underwater Cultural Heritage (agreed in 2001) only came into force on 2 January 2009 after a sufficient number of member states eventually subscribed to it.

The era of global frameworks is an expansion of the processes we observed above, facilitated by new international discussions that result in agreed standards for professional activities. As you can see from Table 1.1, international agreements take their names from the location of the conferences

Table 1.1 Summary of international conservation bodies and agreements

International Museums Office (1922–46), League of Nations (1920–46)	Athens Charter for the Restoration of Historic Monuments, adopted 1931 Covers: international advisory organisation; national legislation; techniques to enhance monuments' settings; permissible modern materials and their use; value of education; need for national inventories
States of the American continent	Treaty on the Protection of Artistic and Scientific Institutions and Historic Monuments (Roerich Pact), Washington, 15 April 1935
UNESCO 1946	Creation of International Council on Museums, successor body to International Museums Office
UNESCO 1948	Creation of ICA: International Council on Archives
UNESCO 1954, The Hague	Convention for the Protection of Cultural Property in the Event of Armed Conflict with Regulations for the Execution of the Convention 1954 (entered into force 1956)
UNESCO 1956	1) Recommendation on International Principles Applicable to Archaeological Excavations, New Delhi, 1956 2) Creation of ICCROM: International Centre for the Study of the Preservation and Restoration of Cultural Property
UNESCO 1964	1) Venice Charter: International Charter for the Conservation and Restoration of Monuments and Sites 2) Creation of ICOMOS: International Council on Monuments and Sites created as non-governmental agency funded by UNESCO
UNESCO 1970	Convention on the Means of Prohibiting and Preventing the Illicit Import, Export and Transfer of Ownership of Cultural Property (entered into force 1972)
UNESCO 1972	Convention Concerning the Protection of the World Cultural and Natural Heritage (entered into force 1975)
UNESCO 1997	Resolution 23 creates the Proclamation of the Masterpieces of Oral and Intangible Heritage of Humanity; 90 examples proclaimed in 2001, 2003 and 2005
UNESCO 2001	Convention on the Protection of the Underwater Cultural Heritage (entered into force 2009)
UNESCO 2003	Convention for the Safeguarding of the Intangible Cultural Heritage (entered into force 2006)
UNESCO 2005	Convention on the Protection and Promotion of the Diversity of Cultural Expressions (entered into force 2007)
UNESCO 2008	Sofia Conference: Convention for the Safeguarding of the Intangible Cultural Heritage becomes operational; first inscriptions due 2009

at which they are ratified. This is the language of diplomacy applied to conservation practices. These international agreements include the Athens Charter for the Restoration of Historic Monuments (1931) and then the International Charter for the Conservation and Restoration of Monuments and Sites (1964) (known as the **Venice Charter**). These two charters set out a philosophy and recommendations for the conservation of historic sites and monuments, and the Venice Charter remains the benchmark for professional standards. Chapter 2 explores the assumptions behind these charters. Similar standards for archaeological excavations were established in the New Delhi Recommendation on International Principles Applicable to Archaeological Excavations (1956). There are also important regional frameworks; for example, the Council of Europe also promulgates heritage charters which are ratified by members, such as the Granada Convention for Architectural Heritage (Council of Europe, 1985).

The Burra Charter and the meanings of places

The great growth of national legislation for natural and **cultural heritage** in the twentieth century and then the expansion of international frameworks have undoubtedly resulted in an intensification of the number and nature of heritage processes. These are devised by professionals largely to be used by other professionals involved with defining, managing and maintaining objects of heritage. All this activity takes place at varying scales, from the international committees assessing proposals for World Heritage status down to a team refurbishing a protected building. Common principles have been developed, however, to assist in the documentation of interventions such as scientific conservation treatments, the results of historical background research or proposals for new visitor facilities. These can all be thought of as projects, and as such they are amenable to being managed in similar ways. The language of project management is highly generic; it is transferable to the creation of heritage processes in which heritage projects can be defined, delivered and evaluated. A unique form of project planning for the heritage sector is the conservation plan, sometimes referred to as a conservation management plan. This has developed in recent decades. As a tool it is unremarkable, but its contents have gradually expanded to include more intangible qualities behind physical heritage.

In 1979 heritage professionals working in Australia adopted their own charter that tailored the international principles for the conservation of sites and monuments in the Venice Charter to an Australian context. The Australia ICOMOS Charter for the Conservation of Places of Cultural Significance, known as the Burra Charter (Australia ICOMOS, 1999), created an international impact on how heritage professionals make decisions about the meanings of heritage sites and places. It did so by renaming the heritage

category 'sites and monuments' as 'places of cultural significance'. This switched the emphasis from 'stones and bones', material culture, towards the meanings of places, the significance that humans attribute to material culture. The Burra Charter definition of significance was 'aesthetic, historic, scientific or social value for past, present or future generations' (Australia ICOMOS, 1999, Article 1.2). The first three values were already integral to judgements about heritage significance that had been made since at least the eighteenth century, as traced earlier in this chapter. Chapter 2 explores the changing understandings of aesthetic value in western heritage practices.

However, **social value** was an innovation, defined in Section 2.5 of the guidelines that support the charter as 'the qualities for which a place has become a focus of spiritual, political, national or other cultural sentiment to a majority *or minority* group [emphasis added]' (Australia ICOMOS, 1988).[2] In the context of Australian settler society, the indigenous peoples had become minorities. The values arising from their cultures, particularly spiritual values, remain very different from western post-Enlightenment understandings. The Burra Charter was the first heritage framework to open up the range of meanings for **tangible heritage** and request that heritage professionals include community understandings of the value of place. Chapter 7 explores social value further and discusses the example of the meanings of place for the Muruwari people of western New South Wales in Australia.

The impact of the Burra Charter's use of values to determine a more holistic approach to significance has gone far beyond Australia as it has been picked up by other official agencies. This occurred because a leading heritage practitioner in Australia, James Semple Kerr, linked the aims of the charter to their application in practice: he created a guide to writing conservation plans for places of European cultural significance (Kerr, 2004). Both the charter and the conservation plan guide have gone through several revisions. In the UK, the methods set out in Kerr's guide were adopted and adapted for use initially by the Heritage Lottery Fund, the distributor of grant aid from the National Lottery, and they have now been formally adopted by government agencies such as English Heritage (English Heritage, 2008). It is the principles behind the plan that carry into practice the Burra Charter's range of values.

Kerr reminds us that methods per se are not the point; he asks that we think of the conservation plan as a 'story that reveals the cultural values and character of the participants and the way these have shaped the fabric and

[2] Note that the Australia ICOMOS guidelines to the Burra Charter 1988 are directly compatible with the previous revision of the charter, adopted in 1988. They are not directly compatible with the 1999 version, a more heavily revised form of the charter, but at the time of writing (2009) new guidelines are not available. Minor revisions to the 1979 charter made in 1981 and 1988 have not altered the main aims or concept of the original text.

function of the place', and he goes on to 'propose how the story should be continued in the future' (Kerr, 1999, p. 19). The Burra Charter has pushed on the heritage debate from finding heritage sites that match up to the established canon of official monuments towards selecting a wider range of places that represent broader social interest. This is often referred to as the **representative** approach, in which material heritage is recognised not because it is 'the best' example but because it has a range of points of interest that represent its type.

World Heritage

The 1972 **World Heritage Convention** (UNESCO, [1972] 2009a) was the first international attempt to create a list of heritage sites, going beyond the national inventory practices that originated in the nineteenth century. This is not of itself particularly innovative, in that the sites selected for World Heritage status emerge from individual national evaluations of their significance which tend to be highly canonical. The reasons for their selection are set out in the World Heritage criteria, which remain within the long-standing western discourse of material, monumental heritage (see UNESCO, 2009b). However, the arrival of World Heritage as a new set of activities for individual nations who subscribe to the convention has created a focal point for further discussion.

For example, the early operation of the convention distinguished between natural and cultural sites, which overlooked the long-standing human presence in outstanding landscapes designated for their natural value. This over-simplification and failure to recognise the relationship between landscape and its inhabitants became particularly apparent in settler societies where indigenous peoples still occupied 'natural sites'. In Australia, a key site for addressing this argument was Uluru-Kata Tjuta National Park. The park was nominated by the Australian government for both natural and cultural criteria, but only the natural criteria were recognised in its World Heritage inscription of 1986. This was corrected in 1994 when the religious and spiritual significance of the landscape (particularly the geological formations Uluru and Kata Tjuta) for the Anangu people and their continuing management practices of the physical site for its spiritual values were firmly re-stated. The park is now inscribed as a dual natural-cultural site or 'mixed property'. However, it is more accurately described as a **cultural landscape**, a concept recognised by the World Heritage Committee in 1992 for landscapes that bear significant cultural meanings (and see West and Ndlovu, 2010; Harrison and Rose, 2010). Chapter 3 explores further the relationship between natural heritage and human activities, from indigenous occupation to deliberate reversion to wilderness.

Intangible heritage

A further innovation came about from an increasing recognition that the material emphasis of the World Heritage convention offered no means of documenting intangible practices. These practices can be broadly defined as heritage that lives through human action, perhaps in song, performance, worship or celebration. Art, craft or language skills are also intangible and very vulnerable to being lost if the next generation does not learn them. The Proclamation of the Masterpieces of Oral and Intangible Heritage of Humanity was a preliminary process, initiated in 2001. The Representative List of the Intangible Cultural Heritage of Humanity derived from the proclamations (2001, 2003, 2005) now stands at ninety examples from around the world (UNESCO, 2009c). Some of these traditions are fascinating hybrids, such as the Maroon heritage of Moore Town, Jamaica. Enslaved people from West and Central Africa who had been taken to Jamaica escaped in the 1600s and successfully established autonomous communities in the mountains of eastern Jamaica. Their cultural backgrounds became fused into a distinctive set of practices and beliefs, communally owned lands and a unique horn used for long-distance communication. Threats to the present culture include economic emigration and Christian missionary interventions. The Masterpieces List has been a test-bed for the viability of a new convention.

The UNESCO Convention for the Safeguarding of the Intangible Cultural Heritage of 2003 is an attempt to document and protect examples of 'living heritage' – social practices that create distinctive cultural communities. It defines domains for grouping intangible heritage, such as **oral traditions** (including languages), performing arts, rituals, craftsmanship and knowledge concerning nature and the universe. The latter is particularly relevant to our earlier example of the significance of Uluru-Kata Tjuta National Park: the Anangu people's cosmology is expressed through their care of the landscape. The purpose of the convention is to devise strategies to minimise threats to living heritage (such as the erosion of associated natural resources) and to enhance the social contexts for these expressions. It is perhaps the most complex international heritage project yet attempted, and it is too early to follow examples in practice (at the time of writing, the first inscriptions to the list have not been made). However, it is a bold attempt to extend the official categories of what heritage is and to see it as living cultural processes rather than as the cold stones of de-populated monuments. It too extends the selection of heritage away from the canonical and towards the representative. These issues are picked up in later chapters, particularly on tourism and performance, where ideas of ownership and change in living traditions such as carnival, are considered. For now, the official recognition of intangible heritage as a major category of global heritage is a key shift of position away from the established discourse around monuments and artworks.

Conclusion

This chapter has ranged widely over the centuries and across the globe to examine how one particular way of thinking about heritage became dominant (the canonical approach) and has been challenged (by the representative approach). We have traced this western discourse (the AHD in Smith's critique) through the evolution of heritage practices. For the first private enthusiasts of the past, and later for the first professionals, collecting, displaying and protecting objects of heritage meant portable or monumental heritage. The bureaucratisation of heritage is a characteristic of its twentieth-century history, as nations enacted a wider range of heritage legislation and the accompanying means to administer it. This has been taken up at international levels, initially by the League of Nations and since the Second World War by the UN.

Ideas about what heritage could be – in official terms – did not change until recent decades. Perhaps the ambitions of the World Heritage programme, to identify places of such importance that they are conceptualised as a common heritage for all, provoked critical reactions and questioning. As we saw, World Heritage criteria have continued to develop and now recognise the concept of cultural landscapes. A more innovative response to official processes of tangible heritage has emerged from Australia in the form of the Burra Charter and the definition for the first time of socially inclusive values. The processes of documenting heritage, such as a site description, have been expanded to include the meanings that different communities attribute to places. The conservation plan, in Kerr's formulation, facilitates community knowledge as well as rendering **official heritage** opinions transparent. The impact of the 'values-led' approach to heritage management is probably most strongly seen in UNESCO's recent interest in intangible heritage. The future of intangible cultural heritage will be a series of huge challenges to sustain distinctive cultures. For the first time, a holistic approach to heritage as something that is meaningful because of what people think and do has received recognition at the highest institutional level. The dominant discourse of official heritage is changing, not least because it now recognises other discourses.

Works cited

Australia ICOMOS (1988) Guidelines to the Burra Charter, Canberra [online], www.icomos.org/australia/ (accessed 4 September 2008).

Australia ICOMOS (1999) The Australia ICOMOS Charter for the Conservation of Places of Cultural Significance [online], www.icomos. org/australia/ (accessed 4 September 2008).

Barnes, J. (2007) 'An inspector calls', *Guardian Review* (7 July) [online], www.guardian.co.uk/books/2007/jul/07/architecture.art (accessed 7 July 2008).

Beddoe, D. (1986) 'Images of Welsh women' in Curtis, T. (ed.) *Wales: The Imagined Nation: Essays in Cultural and National Identity*, Bridgend, Poetry Wales Press, pp. 227–38.

Brown, G.B. (1905) *The Care of Ancient Monuments: An Account of the Legislative and Other Measures Adopted in European Countries for Protecting Ancient Monuments and Objects and Scenes of Natural Beauty, and for Preserving the Aspect of Historical Cities*, Cambridge, Cambridge University Press; also available online at: www.archive.org/details/careofancientmon00browuoft (accessed 11 March 2009).

Byrne, D. (2008) 'Heritage as social action' in Fairclough, G., Harrison, R., Jameson, J.H. Jr and Schofield, J. (eds) *The Heritage Reader*, Abingdon and New York, Routledge, pp. 149–73.

Clarke, E.D. (1793) *Tour through the South of England, Wales and Part of Ireland*, London, Minerva Press.

Council of Europe (1985) *Convention for the Protection of the Architectural Heritage of Europe*, ETS 121, Granada, Council of Europe.

Davies, J. (2007) *A History of Wales* (revised edn), London, Penguin.

Davison, G. ([2000] 2008) 'From patrimony to pastiche' in Fairclough, G., Harrison, R., Jameson, J.H. Jr and Schofield, J. (eds) *The Heritage Reader*, Abingdon and New York, Routledge, pp. 31–41.

Donnachie, I. (2010) 'World heritage' in Harrison, R. (ed.) *Understanding the Politics of Heritage*, Manchester, Manchester University Press/ Milton Keynes, The Open University, pp. 115–53.

English Heritage (2008) *Conservation Principles, Policies and Guidance for the Sustainable Management of the Historic Environment*, London, English Heritage.

Etheridge, K. (1977) *Welsh Costume in the Eighteenth and Nineteenth Centuries*, Swansea, Christopher Davies.

Evans, D. (1997) *A History of Nature Conservation in Britain* (2nd edn), London and New York, Routledge.

Evans, J. (1804) *Letters Written During a Tour through North Wales in the Year 1798*, London, C. and R. Baldwin.

Forder, H. (2004) Lady Llanofer: The Bee of Gwent [online] http://web.ukonline.co.uk/gwenynen.gwent (accessed 11 March 2009).

Geoffrey of Monmouth (1973) *History of the Kings of Britain* (trans. with introduction L. Thorpe), Harmondsworth, Penguin.

Gwent, G. (Mrs Hall of Llanover) (1836) *Gwent and Dyfed Royal Eisteddfod, 1834: The Prize Essay on the Advantages Resulting from the Preservation of the Welsh Language, and National Costumes of Wales*, London, Longman, Rees, Orme, Brown, Green & Longman/Cardiff, William Bird.

Harrison, R. and Rose, D.B. (2010) 'Intangible heritage' in Benton, T. (ed.) *Understanding Heritage and Memory*, Manchester, Manchester University Press/Milton Keynes, The Open University.

Hobsbawn, E. and Ranger, T. (eds) (1983) *The Invention of Tradition*, Cambridge, Cambridge University Press.

Jameson, J.H. (2008) 'Cultural heritage management in the United States: past, present and future' in Fairclough, G., Harrison, R., Jameson, J.H. Jr and Schofield, J. (eds) *The Heritage Reader*, Abingdon and New York, Routledge, pp. 42–61.

Kerr, J.S. (1999) 'Opening address: the conservation plan' in Clark, K. (ed.) *Conservation Plans in Action: Proceedings of the Oxford Conference*, London, English Heritage, pp. 9–19.

Kerr, J.S. (2004) *The Sixth Edition Conservation Plan*, Sydney, National Trust of New South Wales.

Knight, C. (1847–50) *The Land We Live In: A Pictorial and Literary Sketchbook of the British Empire* (4 vols), London, Charles Knight.

Lewis, J. (now Ansell, J.) (1995) 'Passing judgements – Welsh dress and the English tourist', *Folk Life: Journal of Ethnological Studies*, vol. 33, pp. 29–47.

Lord, P. (2000) *The Visual Culture of Wales – Imaging the Nation*, Cardiff, University of Wales Press.

Mason, R. (2004) 'Nation building at the Museum of Welsh Life', *Museum and Society*, vol. 3, no. 1 (March), pp. 18–34.

Nair, S.P. (2006) 'Science and the politics of colonial collecting: the case of Indian meteorites, 1856–70', *British Journal of the History of Science*, vol. 39, no. 1, pp. 97–119.

Newell, R.H. (1821) *Letters on the Scenery of Wales: Including a Series of Subjects for the Pencil*, London, Baldwin, Craddock and Joy.

Payne, F.G. (1964) 'Welsh peasant costume', *Folk Life: Journal of the Society for Folk Life Studies*, vol. 11, pp. 42–57.

Rousseau, J.-J. (1993) *Emile* (trans. B. Foxley, ed. P. Jimack), London and New York, Knopf and Random House.

Royal Society of Arts (2007) *Making History, Antiquaries in Britain 1707–2007*, London, Royal Academy of Arts.

Runte, A. (1997) *National Parks: The American Experience* (3rd edn), Lincoln, NE, University of Nebraska Press.

Said, E. (1979) *Orientalism*, New York, Vintage.

Samuel, R. ([1994] 2008) 'Politics' in Fairclough, G., Harrison, R., Jameson, J.H. Jr and Schofield, J. (eds) *The Heritage Reader*, Abingdon and New York, Routledge, pp. 274–94.

Simond, L. (1817) *Journal of a Tour and Residence in Great Britain during the Years 1810 and 1811*, Edinburgh, A. Constable and Co.

Smith, D. (1984) *Wales? Wales!*, London, George Allen & Unwin.

Smith, L. (2006) *The Uses of Heritage*, Abingdon and New York, Routledge.

Stevens, C. (2002) 'Welsh peasant dress – workwear or national costume?', *Textile History*, vol. 33, no. 1, pp. 63–78.

Stevens, C. (2005) 'Welsh costume: the survival of tradition or national icon?', *Folk Life: Journal of Ethnological Studies*, vol. 43, pp. 56–70.

UNESCO ([1972] 2009a) World Heritage Convention [online], http://whc.unesco.org/en/conventiontext/ (accessed 13 January 2009).

UNESCO (2003) Intangible Cultural Heritage [online], www.unesco.org/culture/ich/index.php?pg=home (accessed 14 June 2009).

UNESCO (2009b) World Heritage: The Criteria for Selection [online], http://whc.unesco.org/en/criteria/ (accessed 6 February 2009).

UNESCO (2009c) The Intangible Heritage Lists [online], www.unesco.org/culture/ich/index.php?pg=00011#list (accessed 11 March 2009).

West, S. and Ndlovu, S. (2010) 'Landscape, memory and heritage' in Benton, T. (ed.) *Understanding Heritage and Memory*, Manchester, Manchester University Press/Milton Keynes, The Open University.

Wightwick, A. (2007) 'Throw out those shawls, hats and miners' outfits', *Western Mail* (24 March), p. 5.

Williams, N. (2006) 'Creating conversations with visitors', *Interpret Wales*, issue 6, pp. 12–13.

Williams, T. (1991) *Salem Y Llun a'r Llan: Painting and Chapel*, Llandybie, Wasg Dinefwr.

Wood, J. (1997) 'Perceptions of the past in Welsh folklore studies', *Folklore*, vol. 108, pp. 93–103.

Young, D. (2004) *Our Islands, Our Selves: A History of Conservation in New Zealand*, Dunedin, University of Otago Press.

Further reading

Barker, G. (ed.) (1999) *Companion Encyclopedia of Archaeology*, London and New York, Routledge.

Choay, F. (2001) *The Invention of the Historic Monument* (trans. L. O'Connell), Cambridge, Cambridge University Press.

Cowell, B. (2008) *The Heritage Obsession: The Battle for England's Past*, Stroud, The History Press.

Delafons, J. (1997) *Politics and Preservation: Policy History of the Built Heritage, 1882–1996*, Studies in History, Planning and the Environment, London, Chapman-Hall.

Harmon, D., McManamon, F.P. and Pitcaithley, D.T. (eds) (2006) *The Antiquities Act: A Century of American Archeology, Historic Preservation, and Nature Conservation*, Tucson, University of Arizona Press.

Harvey, D. (2008) 'The history of heritage' in Graham, P. and Howard, P. (eds) *The Ashgate Research Companion to Heritage and Identity*, Aldershot, Ashgate, pp. 19–36.

Hobson, E. (2004) *Conservation and Planning: Changing Values in Policy and Practice*, London, Taylor & Francis.

Hunter, M. (ed.) (1996) *Preserving the Past: The Rise of Heritage in Modern Britain*, Stroud, Sutton Publishing.

Jokilehto, J. (2002) *A History of Architectural Conservation*, Oxford, Butterworth-Heinemann.

McLeod, J. (2000) *Beginning Postcolonialism*, Manchester, Manchester University Press.

Page, M. and Mason, R. (eds) (2004) *Giving Preservation a History: Histories of Historic Preservation in the United States*, London and New York, Routledge.

Samuel, R. (1994) *Theatres of Memory: Volume 1, Past and Present in Contemporary Culture*, London and New York, Verso.

Chapter 2 Heritage values

Jorge Otero-Pailos, Jason Gaiger and Susie West

Values are embedded in society and vary between societies and across time. Key values for heritage are those concerned with history and beauty, discussed by philosophers as knowledge and aesthetics. The early incorporation of these values into heritage discourses determined the selection of and approach to categories of heritage, only recently expanded by additional values focusing on authenticity and social uses. Formal heritage frameworks have values embedded within them; initially these were implicit and following the Burra Charter they have been made explicit. The first case study in this chapter, by Jason Gaiger, a philosopher and art historian, explores the legacy of European philosophers' understanding of how aesthetic judgements are made. The second case study, by Jorge Otero-Pailos, an architect and conservation theorist, shows how justifications of conservation decisions change with time, through new contexts of politics, aesthetics and scientific possibilities.

Introduction

As we saw in Chapter 1, institutions such as museums have evolved in Europe for over 300 years and heritage legislation has been developing for over 100 years. The rate of expansion of the scope of these formal, 'official' activities to define and present aspects of heritage has been particularly rapid since 1945 (see Harrison, 2010). The politics of why UNESCO needs to keep addressing the way in which heritage is defined and represented through its programmes are broadly similar to those that demand that museums become ever more self-aware of how they select and represent knowledge to the whole spectrum of society. We might think of this as a call to be inclusive, relevant and responsive. This continues to be a big challenge, particularly for complex international institutions like UNESCO.

This chapter traces the values that guide institutions in deciding what is heritage, what they wish to conserve and represent as heritage, and how these values have evolved over time. Some of the challenges to established authorities, whether museum directors, academic archaeologists or chief archivists, have come from voluntary groups concerned that their passions and interests are not being recognised. In this way new themes get added to what Laurajane Smith terms the authorised heritage discourse (AHD); an example in the UK is the industrial heritage that has been recognised through the sustained activities of enthusiasts. Perhaps this thematic expansion has not really challenged official heritage practices; a greater challenge comes from

communities who believe their cultural identities are not being represented by official heritage. The results of the challenge of indigenous peoples and multicultural communities are beginning to be visible in museum displays and thematic programmes that trace 'hidden histories'.

The expansion of 'whose heritage' questions are becoming more visible to people with a passing interest in heritage. But what goes on behind the scenes in terms of the way in which decisions are formally documented and supported by professional processes? The 1972 World Heritage criteria are an important clue, in making public the outline guidance for the arguments that would be acceptable for defining a **World Heritage site**. They offer an insight into the 'world views' of the committee of experts charged with assessing the arguments and making the selection; in other words, the criteria themselves are an official World Heritage discourse. Other heritage frameworks operate in the same way; we use them in this chapter to explore what the 'world views' behind these statements represent as sets of values, and how they might be challenged. So we move from consideration of explicit statements to implicit and underpinning philosophies about the values that objects of heritage carry.

Defining values in conservation

> Cultural heritage should speak through the values that people give it and not the other way round ... the tangible can only be interpreted through the intangible.
>
> (Munjeri, 2004, p. 13)

When we think about heritage values we might express some commonsense opinions about the qualities that are brought to mind when experiencing, for instance, an ancient building, paving stones worn with the tread of generations of feet, or when seeing a vibrant harvest celebration. We might feel that we value the history that we think the heritage represents. By paying to see some official heritage we express an economic value – that the experience is worth the fee. However, this chapter introduces the idea of values as a set of debates first written down by ancient Greek philosophers about, ultimately, the purpose of human existence. Is the highest purpose to achieve knowledge, create beauty or live a good (moral) life? These three divisions have been discussed by philosophers as three different motivators for human action: the search for truth, beauty or goodness. They are powerful and long-standing categories for western intellectual traditions, as we will see in the way they have permeated heritage frameworks. But there are other, less typical examples of heritage that do not easily fit the three values: the difficult heritage of twentieth-century war atrocities; heritage of poverty; heritage of a culture where we cannot find our own understandings of truth,

beauty or goodness. Western discourses around these three values have also been used to rank other world cultures in a hierarchy of the more or the less civilised. This was the case, for example, as encounters occurred with the 'other' (outsiders to these core values) during the spread of colonialism (Chapter 1).

Now although truth, beauty and goodness are quite abstract, there is an equally ancient tradition in the West of applying these values to concrete objects in such a way that they seem to be **inherent** to the objects. This process has blurred the distinction between factual description and judgements. But is it really possible to separate facts from judgements? We always have to make judgements about which facts we wish to bring to others' attention even in everyday speech. As you will see in Chapter 4, museum curators are highly selective in the information they supply on object labels; the most factual labels are often the least comprehensible to the general visitor. However, if we could not select at least some facts out of the mass of all possible facts about an object, for instance, communication would become impossible. So selection usually takes place within the context of general understandings about what it is permissible to leave out. This 'shared understanding' creates a normative framework. 'Objective judgements are widely shared subjective judgements' (Mitchell, 2005, p. 366).

A good example is the way that official heritage designations such as World Heritage sites tend to look like objective judgements in their confident declarations. The Taj Mahal is outstandingly beautiful; Stonehenge is outstandingly ancient; Uluru is outstandingly mysterious. Collective enthusiasm for these monuments is a set of 'widely shared subjective judgements', arising from the sets of values to be found within the processes that bestow official designations.

In heritage terms, these values convert to an interest in history (truth) and beauty (aesthetics); goodness tends to be left unstated. In the field of western art collecting, critics, academics and curators, supported by art dealers and collectors, developed an inward-looking discourse about a particular definition of excellence that was capable of being represented outside this closed circle of commentators as the *only* definition of excellence for this category of object. For art objects, excellence was primarily about aesthetic value. Beauty, as we all know, is a highly subjective concept which shifts over time and between groups. The Welsh dress case study in Chapter 1 drew attention to the processes of imposing English elite aesthetic judgements on Welsh material culture. We will be looking at the relationship between subjective responses to beauty and formal aesthetic judgements shortly in the first case study.

Monumental buildings and works of art were among the earliest heritage categories to be officially collected. They share a common treatment, in that discourses around nationalism and national excellence got attached to them, and they were revered both for their status as historical objects and for their

aesthetic qualities, represented as universally recognisable and valuable. Thus we arrive at the earliest explicit values that have been used to justify why something from the past should be preserved for the future. Put simply, material heritage is identified as the carrier for abstract values in such a way that the values become *inherent* to the object and *universal* in their importance. Once other people began to challenge the thinking behind these processes, history and beauty could stop being used to exclude categories of heritage and the process of understanding heritage as inclusive, relevant and responsive could begin.

The challenges to older discourses about history and beauty, however, might leave us with a problem: do we want to reject the idea of beauty completely? Most of us have instinctive responses to visual and aural experiences that we categorise as beautiful or ugly, and we could probably agree that specialist knowledge leads to a greater appreciation of the experience. Do we throw out an art historian's view of the value of an artwork (indeed, even reject an art historian's claim that a particular object is a work of art)? Is a more inclusive definition of heritage going to leave us in a position where the best we can say is that one person's judgement is as good as another's? In practice, the latter relativist position is not adopted by official frameworks, as will be seen later in the chapter. But we should pause over a fuller account of the processes of aesthetic judgement in the following case study.

Case study: aesthetic judgement

The frequency with which terms such as 'aesthetics', 'aesthetic value' and 'aesthetic judgement' appear in contemporary discussions about heritage belies a lack of clarity about their exact meaning and scope (see, for example, Laurajane Smith (2006, pp. 11, 19, 20, 21, 23, 28, 29, 32, and throughout). The aim of this case study is to introduce some of the key philosophical issues surrounding the topic of aesthetic judgement and to show how reflection on these issues can deepen our understanding of the processes of heritage creation. Aesthetic considerations undoubtedly play an important role in assessing what counts as heritage and in determining how an object or site should be presented and conserved. Nonetheless, there is a widespread suspicion that aesthetic evaluations are unduly subjective and that an appeal to the individual's own affective responses does not provide an adequate basis for collective decision making. It is therefore important to assess the status of judgements of taste and to investigate whether they are amenable to revision in light of greater knowledge and experience.

I begin with a brief account of the origin of the term 'aesthetics', which was first employed in its modern sense in the mid-eighteenth century by the German philosopher A.G. Baumgarten. Although many of Baumgarten's

concerns are remote from our own, his work provides the foundation for much of what follows. In this discussion I shall concentrate on the views of two other eighteenth-century philosophers, David Hume and Immanuel Kant, both of whom were explicitly concerned with the problem of whether it is possible to arrive at a grounded consensus of taste. In the limited space available here it is not possible to do justice to the full complexity of their ideas or to trace the deeper philosophical commitments that underlie their respective positions. Instead, I want to focus on an interrelated set of themes that are directly relevant to current problems and debates.

Kant's 'power of judgement'

The term 'aesthetics' derives from the ancient Greek word *aisthesis*, which means perception or sensation. It was coined by Baumgarten in 1735 to describe the fledgling discipline of 'philosophical poetics', that is to say, the philosophical study of artworks (Baumgarten, 1735, para. 9; Harrison, Wood and Gaiger (eds), 2000, p. 488).[1] However, Baumgarten also used the term more broadly to encompass a projected 'science of sensible knowledge'. In the first part of his unfinished Latin treatise *Aesthetica*, which was published in 1750, he characterised aesthetics as 'the theory of the liberal arts, the lower study of perception, the art of thinking in the fine style, the art of analogical reasoning' (Baumgarten, 1750, para. 1; Harrison, Wood and Gaiger (eds), 2000, p. 489). The originality of Baumgarten's approach lies in his attempt to overcome the profound distrust of sensory perception that had marked the work of rationalist philosophers since the time of Plato. Baumgarten held on to the ancient Greek distinction between things that are perceived through the senses (*aistheta*) and things that are known by the mind (*noeta*), but he rejected the view that sensory knowledge is necessarily inferior. Although logic allows us to analyse thoughts into their constituent elements and to make the relations between them conspicuous, sensory perceptions possess compensating virtues such as plenitude, vividness and complexity, virtues that are revealed in exemplary fashion in works of art. We value art, in part, for its richness and suggestiveness, and this is reflected in the open-ended and exploratory character of our responses. While the affective dimension of experience does not possess the same degree of certainty as, for example, the knowledge provided by mathematics or geometry, it is nonetheless intrinsically valuable and merits closer investigation.

In summary, then, Baumgarten not only coined the term 'aesthetics', he also demarcated its two principal fields of application: the study of artworks and

[1] For the non-English eighteenth-century philosophical texts, references to the paragraph number of the original edition and the page number of the translation are given. This is standard practice, since there are so many different translations available and the reader needs to be able to locate the original passage.

the study of sensory perception as opposed to logical or intellectual cognition. While these two fields are not co-extensive, they do partially overlap. Later thinkers expanded the scope of aesthetics to include, for example, the appreciation of natural beauty, but the identifying feature of an aesthetic judgement remains its reliance on the individual's sensory and affective responses. This recognition forms the starting point for Kant's principal work on aesthetics, the *Critique of the Power of Judgment*, which he published in 1790. He begins the main body of the text with the declaration that

> The judgment of taste is therefore not a cognitive judgment, hence not a logical one, but is rather aesthetic, by which is understood one whose determining ground *cannot* be *other than subjective*.
>
> <div align="right">(Kant, 1790, para. 1; Kant, 2000, p. 89)</div>

When we make an aesthetic judgement we consider how we are affected by the object, that is to say we relate it to the feelings of pleasure or displeasure that it arouses in us. Although an aesthetic judgement raises a claim about the object, its 'determining ground' is to be found in the subject. Despite Kant's technical vocabulary, the basic argument here is quite straightforward and can be elucidated by means of an example.

Consider, first, the cognitive judgement 'This roof is hexagonal'. In order to determine whether or not this is correct, we need to count the number of sides, make sure that they are six in number, of an even length, and that there are no irregular additions and so forth. The judgement 'This roof is hexagonal' is amenable to proof and can be objectively verified. By contrast, the correctness of an aesthetic judgement, such as 'This roof is graceful' cannot be determined through accurate measurement or by identifying a set of distinguishing properties, for there is no single or complete set of determinate properties that all graceful roofs must possess. A low-lying roof may be just as graceful as one that soars upwards, and a composite gable construction can be graceful in a way that differs from that of a simple curved design. The only means to determine whether or not a particular roof is graceful is through reference to the feeling that it produces in the viewer. There is thus an ineliminable element of subjectivity in all aesthetic judgement. As we shall see, however, this does not suffice to provide a complete account of aesthetic judgement, for what Kant terms a judgement of taste possesses a second distinctive feature that is in apparent conflict with the first.

In order to bring out the 'peculiarity' of the judgement of taste, Kant draws attention to a distinction that is operative in our everyday use of language. When we declare our liking for something, such as 'I like the colour violet' or 'I like sweet desert wine', we readily accept that the judgement is based on our own subjective preferences. As Kant observes, 'for one person, the colour violet is gentle and lovely, for another dead and lifeless' (Kant, 1790, para. 7; Kant, 2000, p. 97). It would be absurd to insist that others should respond in

the same way, for what is agreeable to me may be disagreeable to someone else. However, when we make a judgement of taste, which takes the characteristic form 'This object is beautiful' or 'This object is graceful', we go beyond our subjective predilections and purport to say something about the object itself. In doing so, we make a judgement that should also hold true for others, that is to say we raise a claim to *intersubjective* validity. This can be seen by reflecting on the fact that whereas we are willing to concede that other people have their own likes and dislikes that do not necessarily coincide with our own, we are frequently prepared to argue over judgements of taste. Kant puts this in the strongest possible terms by observing that a judgement of taste makes a 'demand' on the responses of others: if someone declares that something is beautiful, 'he expects the same satisfaction of others; he judges not merely for himself, but for everyone, and speaks of beauty as if it were a property of things' (Kant, 1790, para. 7; Kant, 2000, p. 98).[2]

Although Kant correlates the judgement of liking with the claim that something is 'agreeable' and the judgement of taste with the claim that something is 'beautiful', his real concern is to mark the difference between expressing a personal preference and making a normative claim that the speaker is prepared to defend against the judgements of other people. In giving precedence to the concept of beauty Kant conforms to the conventions of the eighteenth century. However, if we look at the actual structure of his argument, we can see that beauty functions as a placeholder for any aesthetic quality that is held to inhere in the object or site and thus to be universally accessible. This recognition allows us to apply his ideas more widely. Consider, for example, the statement on the UNESCO World Heritage website that the Historic Ensemble of the Potala Palace, Lhasa, is characterised by its 'harmonious integration into a striking landscape' (UNESCO, 2009a). This counts as a judgement of taste, since it raises a claim that should hold true for everyone, irrespective of their personal likes and dislikes (Figure 2.1). Nonetheless, if we ask after the grounds on which this judgement is made, it is clear that its ultimate basis is the feeling of harmony or disharmony that the buildings *in situ* produce in the viewer. Whereas the age of the palace, its geographical location, the lay-out of the buildings and so forth can be objectively verified, the question of its integration within the landscape can only be decided by referring to the feeling it arouses.

Kant characterises the strange, dual character of the judgement of taste by observing that it possesses the status of 'subjective universality' (Kant, 1790, para. 6; Kant, 2000, p. 97). Far from providing a solution to the problem of taste, this paradoxical concept serves to identify the core question that needs

[2] For Kant's claim that the judgement of taste makes a 'demand' on the responses of others, see Kant (1790, para. 19; Kant, 2000, p. 121: 'The judgment of taste ascribes assent to everyone, and whoever declares something to be beautiful wishes that everyone *should* approve of the object in question and similarly declare it to be beautiful.'

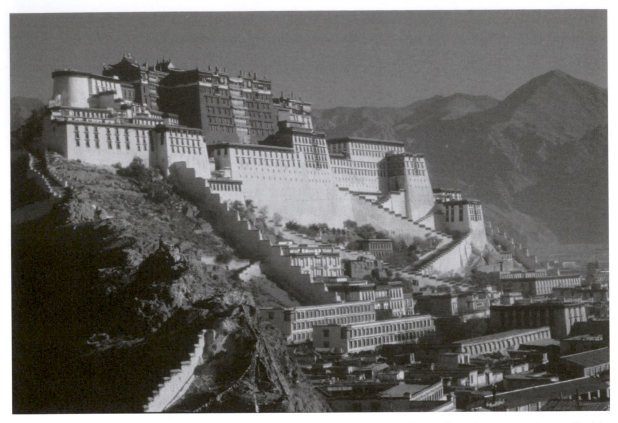

Figure 2.1 Potala Palace, Lhasa, 1985. Photographed by Hubert Ayasse. Photo: © Hubert Ayasse/Sygma/Corbis.

to be answered: what, if anything, entitles us to raise a claim to universal validity on the basis of a *feeling*, something that we normally consider irreducibly subjective? Kant's answer to this question rests on showing that the same mental faculties that are required for ordinary cognition – the faculties of imagination and understanding – are also operative in a judgement of taste and that aesthetic judgement cannot therefore be characterised as a merely physiological response to the object.[3] However, his focus on so-called 'pure aesthetic judgments' leads him to overlook or downplay the processes of deliberation and reflection that characterise our actual disputes about taste. For this reason, I now turn to the work of the Scottish philosopher David Hume and his celebrated essay 'Of the standard of taste', first published in 1757 (Hume, 1985a). In particular, I want to consider Hume's arguments concerning the role of expert knowledge and the potential to revise aesthetic judgement in response to greater knowledge and experience.

[3] Kant's 'transcendental deduction' of the validity of pure aesthetic judgements is to be found at Kant, 1790, para. 38; 2000, p. 170. For discussion of Kant's position, see Allison (2001) and Guyer (1997).

Hume's 'standard of taste'

Hume begins his essay by acknowledging what he terms the 'variety of taste': the sentiments of men vary enormously and what pleases one person may be repellent to another. The age-old maxim *de gustibus non est disputandum* or 'there is no disputing about taste' therefore appears to hold true. However, when it comes to specific judgements of taste we rarely sustain this ecumenical frame of mind. If someone were to assert that the minor eighteenth-century versifier John Ogilby was as great a poet as Milton, we would reject the claim as 'absurd and ridiculous'. Here the principle of the natural equality of taste is 'totally forgot' (Hume, 1985a, p. 231). For Hume, the 'paradox of taste' arises from our commitment to two apparently incompatible positions. On the one hand, we believe that judgements based on sentiment or feeling are necessarily subjective. But, on the other, when it comes to disagreements about taste, we are prepared to argue vigorously for our views. The key to Hume's resolution of the paradox is to be found in his recognition that processes of reasoning and deliberation can operate alongside, and in interaction with, the voice of sentiment or feeling. This idea is elegantly expressed in a passage from his *An Enquiry Concerning the Principles of Morals*, published some six years earlier in 1751.

> Some species of beauty, especially the natural kinds, on their first appearance, command our affection and approbation ... But in many orders of beauty, particularly those of the finer arts, it is requisite to employ much reasoning, in order to feel the proper sentiment; and a false relish may frequently be corrected by argument and reflection.
>
> (Hume, 1985b, p. 173)

Hume develops this argument in 'Of the standard of taste' by identifying five attributes or capacities that are required in order to make a sound judgement. These are, in the order in which he presents them: delicacy of feeling, practice in a particular art, the drawing of comparisons, freedom from prejudice, and good sense or reason. The important thing to note here is that whereas the first item on this list might be described as a natural gift or ability, the others can only be acquired through appropriate experience. Thus, for example, Hume argues that familiarity with a sufficiently broad range of artworks is necessary if we are to learn to discriminate subtle differences: it is by making comparisons that we 'fix the epithets of praise or blame, and learn how to assign the due degree of each' (Hume, 1985a, p. 238). The ability to judge art correctly requires the same 'address and dexterity' as that which enters into its execution. The critic must not only learn to overcome the distorting effects of partisanship, allowing 'nothing to enter into his consideration but the very object which is submitted to his examination' (Hume, 1985a, 239), but he must also use his powers of reason to grasp

both the specific end or purpose for which an artwork has been made and the internal complexity of its individual parts.

The acquisition of expertise therefore plays an important role in judgements of taste. However, if a judgement is to be genuinely aesthetic, it must be based on the subject's own experience of the object, whether at first-hand or in reproduction. It is not enough simply to adduce the opinion of those who possess specialist knowledge in a particular domain, for if I am to make an aesthetic judgement I must submit the object to my own feeling of pleasure or displeasure. Moreover, as we have already seen, the applicability of aesthetic predicates such as 'graceful' and 'beautiful' cannot be determined by identifying a set of determinate properties or by adhering to a set of pre-given procedures. The non-inferential character of the judgement of taste follows directly from its affective basis: we cannot use inductive reasoning to determine whether a roof is graceful or a building is in harmony with its surroundings.

These defining characteristics place important constraints on the judgement of taste: it cannot be grounded in the testimony of others; it is not susceptible to standards of proof; and it cannot be generalised beyond the specific object to which it refers. Nonetheless, if we are to break free from the paradox of taste, we need to avoid setting up a rigid opposition between, on the one hand, the mechanical application of logical rules and principles, and, on the other, the spontaneous and inalterable verdict of sentiment or feeling (Gaiger, 2000). Once we recognise, together with Hume, that our affective responses are amenable to revision through appropriate practices of observation and reflection, the judgement of taste can be opened up to argument and reason-giving. I believe that this approach better characterises our actual dispute about taste. In order to determine whether or not a building (such as the Potala Palace) is graceful or harmonious, we do not simply oppose our subjective responses to the responses of others. Nor do we make unquestioning recourse to the authority of experts. Instead, we try to bring other people to see what it is about the building or site that makes us respond to it in the way we do: we draw attention to features they may have overlooked; we draw meaningful comparisons; and we provide a context in which the significance of these features can be appreciated at their proper value.

Philosophical arguments do not always map neatly on to real-world problems and issues, but they can help us to clarify what is at stake. By discussing the ideas of Kant and Hume I have sought to show that aesthetic judgements possess a distinctive status: they are grounded in the subject's feelings in response to the object and yet raise a claim to universal or intersubjective validity. If this claim is to be substantiated, we cannot retreat into the

immediacy of feeling, but must enter into processes of argument and debate. It is not possible to prove that a particular judgement is correct, but we can seek to bring others to see why we respond in the way we do; at the same time, we must remain open to the possibility of revising our own judgement in response to the views of others. Aesthetic considerations are only one factor in the complex decision-making processes that surround the **designation** and conservation of heritage, and they need to be weighed up against other historical, social and practical concerns. There are also larger questions concerning the role of institutions and the underlying value systems on which such decisions are based. Nonetheless, reflection on the distinctive character of aesthetic judgement enables us to see that it is possible to give due weight to the responses of those who have direct experience of an object or site without jeopardising the requirement of objectivity in disputed claims over heritage.

Reflecting on the case study

Expert opinion is sometimes viewed as part of the problem summed up by the AHD. It is the role of experts to determine official heritage values and so to define objects and places that can become incorporated as official heritage. Experts in this sense are the professionals charged by governments and other institutions with the 'heritage brief', from museum curators to inspectors of ancient monuments. Critical analysis of the role of the AHD suggests that expert opinion is primarily directed towards understanding aesthetic significance. As we saw in Chapter 1, historically this has been the dominant value used in official heritage practices. The case study gives us the critical tools to reflect more carefully on how aesthetic judgements are made and why they remain such an important area for debate. They certainly cannot be dismissed as simply subjective and personal responses; perhaps the 'judgement' element reminds us that they can be justified by using evidence, although of the type discussed within aesthetic discourses. However, an expert working within these discourses can make their specialist approach understandable by non-specialists. The language used in the summaries of World Heritage sites and their significance is one example of relatively accessible expert statements, many of which are aesthetic judgements. The problem that the AHD identifies, the dominance of aesthetic judgement, has been increasingly addressed in recent decades by adding a wider range of values, which the rest of this chapter explores. But it is hard to argue that aesthetic judgement has taken a smaller role. Perhaps it is easier to see that a wider range of aesthetic criteria are being used, including modern and contemporary cultural creations.

Authenticity in objects of heritage

The World Heritage Convention of 1972 slightly expands the historical and aesthetic categories for world excellence in cultural objects of heritage. Monuments and groups of buildings are to be recognised for their 'outstanding universal value from the point of view of history, art or science' (UNESCO, [1972] 2009b, Article 1). Furthermore, the concept of 'sites' appears, which seems to address communities who do not have a tradition of building monumental structures or permanent settlements. Sites can achieve 'outstanding universal value from the historical, aesthetic, ethnological or anthropological point of view'. Briefly, the last two categories cover the western disciplines of ethnography, the investigation of living pre-capitalist societies, and of anthropology, a comparative investigation of societies (usually living pre-capitalist). In other words, history, beauty and science are values to be found in western objects of heritage. Non-western societies, especially those without a tradition of literacy or monument building, are seen to be set apart from those values. A different set of experts needs to find the arguments for placing the material heritage of these communities into a framework that fits the 1972 World Heritage Convention. We saw further expansions of international definitions of heritage, such as cultural landscapes or 'masterpieces' of intangible culture, in Chapter 1.

There is an additional twist to western discourses about heritage, and that is the addition of the concept of authenticity. This sounds as though it might be an additional value, but in fact it is presented in heritage assessments as a quality that really is inherent to the material reality of the object of heritage. We need to ask what a conservation definition of authenticity is, and why it is deemed to be important for the significance of the object in question.

The Nara Document

The Nara Document is designed to set criteria for how the 'test of authenticity' can be applied by the World Heritage Committee to cultural sites proposed for **inscription** on the World Heritage List (ICOMOS, 1994). It is particularly concerned to step away from western definitions of authenticity to acknowledge diversity and to accord 'respect to the social and cultural values of all societies'. The Nara Document does not actually give a definition but refers back to the Venice Charter of 1964, which is concerned to set principles for the conservation of historic monuments. This includes the need for decisions about the original and subsequent states of the physical monument to be based on verifiable evidence. Conservation judgements (how to repair, what materials to use) on this basis should not detract from the monument's historic and aesthetic qualities; the monument is deemed to have its own qualities (inherent) to be preserved and revealed. It is not spelled out, but the Venice Charter is concerned that conservation actions do not compromise

the authentic nature of the monument. This assumes that the monument has survived to the present day, before modern heritage practices, through a series of cultural uses (repairs, perhaps additions, perhaps new uses) that have their own 'authentic' place in the culture that created the monument and any successor cultures. The result is that the monument itself bears the quality of authenticity in relation to its location and culture.

We can see the Venice Charter principles as tending to fossilise the monument, albeit in a state of good repair, at the point at which heritage professionals bring it in to the realm of official heritage practice. In the UK, designated monuments pre-date the Venice Charter by many decades; those defined by law as ancient monuments are protected by strict planning requirements. Consider the example of an ancient monument which comprised a Norman keep (the major building of a castle *c*.1200 CE) and later buildings that were added for prison use: the whole group then became a regional museum from 1894, the Norwich Castle Museum, Norfolk (Figure 2.2). The keep itself had been converted in the nineteenth century from its previous prison function to a vast gallery space, and the stone exterior had also been heavily repaired. Since the UK subscribes to international heritage frameworks, its heritage

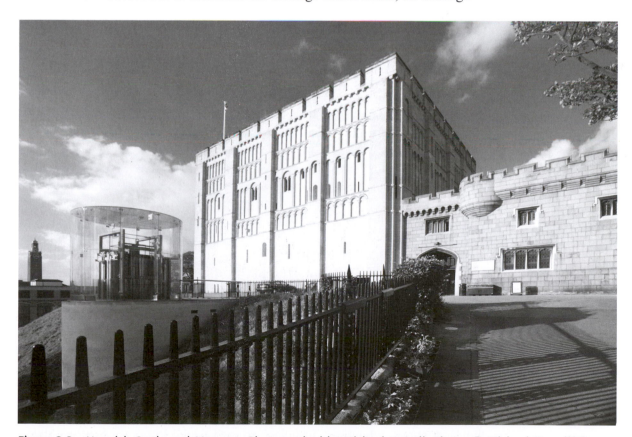

Figure 2.2 Norwich Castle and Museum. Photographed by Michael Howell. Photo: © Michael Howell/Alamy.

professionals would not now consider stripping away the later physical additions to the Norman keep; these tell their own stories and have long-standing social and **community value**. Australian tourists come to visit the medieval keep to see the later prison cells that held their convict ancestors before deportation (a practice operated from 1787 to 1868). The layers of meaning that this monument has acquired over centuries are the result of its adaptation for new uses; were its post-Norman material stripped away it would become an empty ruin. Equally, because it is a living building, it does need to be repaired and periodically upgraded to cope with its public functions; a recent £12 million refurbishment was possible because the heritage professionals agreed that the degree and nature of physical change was in keeping with its history of use. The primary values of history and aesthetics could, it was hoped, be enhanced or further revealed by the proposed works.

Nara is responding to cultural diversity where authentic community uses challenge the heritage professionals' guidelines over defining and limiting physical change. The Nara Document reminds heritage professionals (and their national governments) that heritage is not always to be defined by the dominant cultural group in a given society; nations with multiple or successor cultures must acknowledge the potential for a clash of cultural values around heritage. The language of the document is more overtly political than previous international frameworks; its authors face up to the political uses of heritage and the abuses (either through aggression or suppression) that politically dominant groups can perpetrate against minority group heritage. Even more, they recognise the tensions possible between international heritage practices and local values and meanings: Section 8 calls for local communities to be recognised as the primary carers for their heritage, and for their cultural values to take precedence if the balance between official heritage practices and local heritage values cannot otherwise be agreed (ICOMOS, 1994). The last word can rest with the local 'owners' of heritage so long as all credible evidence can be collected to assess the physical form, uses and range of values that the material heritage has for the local community, for other cultural users and for the international community. Using this process of verification, the authors of the Nara Document hope that diverse, and possibly unpredictable, values can be documented and respected. Authenticity is a quality of the material object of heritage, in Nara terms; values are expressed by humans.

The next case study follows changing western ideas about authenticity in conservation practices by exploring how a group of ancient Greek sculptures has been treated. In the early nineteenth century the sculptures were fully restored with missing elements re-carved to blend invisibly. In the 1970s the restored elements were removed and the statues re-presented in line with new research – controversially, as the nineteenth-century additions could be viewed as part of the objects' history (imagine if they were buildings). Have they lost some authenticity in being stripped back? In contrast to this very

scholarly debate, two very different buildings are used to suggest how more 'open' approaches to authenticity can challenge visitors' imagination. The ghostly appearance of the Franklin House, Philadelphia, and the surprise hidden away in a Chicago office foyer make it clear to visitors that they are seeing something different from the original appearances of these places.

Case study: the subjective element in conservation

This case study sets out two contrasting conservation theories and their historical context in western attitudes to the past. The first is exemplified by **restoration** practices in Europe from the late eighteenth century. This is the period of an aesthetic discourse about classical revival known as neo-classicism ('new' classicism). The guiding philosophy directed that classical antiquities should be restored 'back' to the ancient classical models of art, which were thought to represent the most perfect expression of human achievement; emulation by later societies was therefore a means of perfecting themselves. This gave restoration a social purpose: it was recognised as a public good. The tension between personal artistic expression and the need to remain faithful to ancient forms has remained a subject of debate up to the present day.

By contrast, conservation philosophy in the early twenty-first century has been shaped by some key projects that were executed during the 1970s. The work of the architectural firm Venturi and Rauch is representative of a wider rejection of 'total restoration' in this period, and of the search to strike a new balance between fidelity to a lost original and personal expression. Instead of trying to restore ruins by completing them, some conservation architects attempted to present them as incomplete wholes, expressing the missing parts as absences. The viewer's personal interpretation became a means not only to participate in the contingent completion of historic objects, but also a way for people to edify themselves through contact with historic objects in a critical, rather than a passive, way.

Neo-classical approaches to restoration

In 1811 two architects and archaeologists, the Bavarian Baron Carl Freiherr von Haller and the British Charles Robert Cockerell, led an archaeological expedition to the Greek island of Aegina during which they unearthed fragments of the ancient sculptures that once graced the pediment of the Doric temple of Aphaia (fifth century BCE) (Figure 2.3). Haller convinced his patron (then Prince) Ludwig of Bavaria, an avid collector of ancient Greek art, to purchase the stones. Faced with the difficulty of understanding how the numerous fragments related to one another, Prince Ludwig hired the Danish sculptor Bertel Thorvaldsen to study and restore the fragments (Plon, 1874).

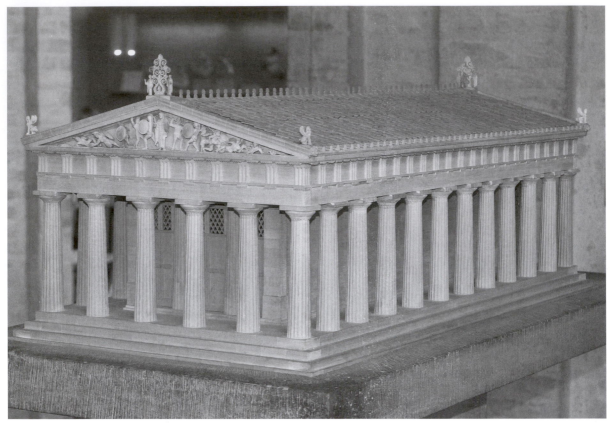

Figure 2.3 Model of the temple of Aphaia, Aegina Island. Glyptothek, Munich. Photograph by Renate Kühling. Photo: Staatliche Antikensammlungen und Glyptothek Museum.

Why did Prince Ludwig hire an artist to carry out this 'scientific' endeavour? A similar job today would be awarded to a team (not an individual) that would include archaeologists, art historians and stone conservators, among many other professionals. Archaeology was at this time a relatively new field of research. One of the forefathers of scientific archaeology is considered to be Johann Joachim Winckelmann, who, in the eighteenth century, developed the first systematic method for observing ancient artefacts, allowing him to distinguish between Greek artefacts and Roman copies. As archaeology progressed, it helped to redefine understanding of ancient art and architecture, showing it to be more regionally inflected than had previously been thought and to have undergone various historical developments. These findings began to put into question Winckelmann's Neoplatonic understanding of art and architecture as something based on a single universal ideal. Nevertheless, his notion that the ancients (especially the Greeks) had come closest to that ideal, and that the only way to achieve great art was to imitate the ancients, continued to hold sway.

Artists and architects had been recognised for their restorations of ancient objects since the Renaissance. Restorations, such as that of the Laocoön sculpture unearthed in 1506 and then restored several times thereafter, were hotly debated and could make or break the career of artists and architects. By the eighteenth century, restoration was considered habitual work for sculptors, and the question of the restorer's competency and creativity came under greater public scrutiny. The basis for judging a restorer's competency continued to follow Winkelmann's theory that the resulting artwork had to measure up to the ancients, conceived as an absolute measure of artistic perfection. Late eighteenth-century restorers therefore believed that it was their responsibility not just to patch up broken statues but to express the aesthetic perfection of the antique ideal. Pitted against the ancients, the late eighteenth-century restorers did not confine themselves to imitation but proceeded to emulate their predecessors, calling attention to and challenging comparisons with the ancients.

As David Lowenthal has noted, late eighteenth- and early nineteenth-century restorers thought that the advancement of restoration knowledge rested on individual genius, not in the collaborative action of a discipline. Antoine-Chrysostôme Quatremère de Quincy, French archaeologist and editor of the *Dictionnaire d'Architecture*, distinguished between the relative perfectibility in the sciences and the fine arts. He thought that whereas in science 'generations transmit the result of these works to the following ones', in art and architecture 'Progress, or what one may call the steps made by predecessors, leaves no traces, no terms that successors could use as a starting point' (Quatremère de Quincy, 1999, 'Antique', pp. 63, 64).

The importance of the individual restorer as an agent in the advancement of artistic knowledge meant that the decision to restore an ancient work or not was subordinate to finding an artist capable of doing the work. Second, it meant that the work of restoration had an educational purpose: the restored artwork had to demonstrate the restorer's superior understanding of it, and thus improve the general public's knowledge of that artwork in particular and of ancient art in general. Once Prince Ludwig became the new owner of the Aegina sculptures he began looking for the only individual who could work like the ancients. Thorvaldsen was considered the logical choice, as one of the greatest sculptors of his time. Quatremère judged that Thorvaldsen had mastered perfectly the Aegina style:

> we will owe to the restoration of the pediments of the Temple of Aegina our better understanding of how they were, of the taste in the composition of pedimental sculpture, and of the style of this ancient school.
>
> (Quatremère de Quincy, 1818, letter 4, p. 82)

Public admiration for Thorvaldsen served in a sense to authorise the restoration.

Some of Thorvaldsen's contemporaries had different views about restoration. When the renowned sculptor Antonio Canova visited London in 1815, he was asked *who* should restore the Elgin marbles. Judging that there was no artist technically capable and sufficiently knowledgeable to match the work of Phidias, who was thought to be the original sculptor, Canova asked that the marbles not be touched (D'Este, 1864, p. 245).

The second half of the nineteenth century was characterised by intense debates in defence of both artistic restoration and minimal approaches to conservation. In England by 1849 John Ruskin had made his case in favour of conservation and against the likes of James Wyatt, discussed below. Later William Morris and his Society for the Preservation of Ancient Buildings would enter the debate on the side of conservation.

Poetic order as mediating aesthetic

Thorvaldsen was seen, along with Antonio Canova, as one of the leaders responsible for instituting a new style of art, which we now call neo-classical. Although we often think of neo-classicism as a change of style – a revisiting of ancient Greek and Roman architecture informed by the new archaeological approaches – it was underpinned by a new way of thinking about art. The terms in which the restorer's competency to restore was explained and understood began to change in the early nineteenth century. Thorvaldsen is interesting precisely because although he was very much practising within the stylistic canon of neo-classicism, the way he and his commentators thought about restoration was already proto-Romantic: they placed a great emphasis on individual genius; and they re-conceptualised restoration as the installation of a 'poetic order', or mediating aesthetic, between the material form of the artefact and its intellectual and aesthetic content, or in other words between practice and theory. Neo-classical restoration practices were a reaction to the division between 'ideal' theory and 'human' practice, motivated in part by the importance that Enlightenment thinkers placed on the power of the individual. Neo-classical restorers invented an entirely new method for relating their art to the past, which purported to be more 'exact' than the simple application of classical theories of composition, such as the rules of proportion. By acquiring a thorough knowledge of the principles of antique art a truly imaginative artist could put themselves into the shoes of the original artist and use their creative powers to 'recreate' the work, including any missing or damaged parts. Thus, theory and knowledge might be combined with creative genius to create a 'poetic order'.

Quatremère offered some of the most insightful writings on the neo-classical understanding of poetic order in his *Dictionnaire*, as well as in his famous letters to Canova regarding the Elgin marbles. For Quatremère, the question of how to restore was intimately bound up in the problem of progress in the arts,

that is, how to remain faithful to the ancient works while allowing for the evolution of contemporary practice. He thought there were two ways of restoring ancient works, and of designing in general:

> The first, improperly called imitation, consists in reproducing only the appearance through copies. The second consists, on the part of the imitator, in appropriating the principles of the antique and consequently its genius or its causes, along with its consequences.
>
> (Quatremère de Quincy, 1999, 'Antique', p. 69)

He strongly favoured the second. The act of restoration was, for Quatremère, at once an act of documenting particulars, of assimilating and learning the universal principles latent within those particulars, and finally, of translating those invariable principles into contemporary particulars by creating something new. Significantly, the act of restoration had to be done by one individual, preferably a genius with great intuition:

> Indeed, it is important, in order to succeed at such *restitutions*, that the same man be at once the translator and the artist. When the double operation of translating and drawing combines within the activity of one intelligence, then, the translation and the drawing exchange reciprocal influences.
>
> (Quatremère de Quincy, 1999, 'Restitution', p. 219)

The choice of the word 'restitution' is important. Quatremère chose it to distinguish his thinking from the old way of understanding 'restoration' as simply copying the old. 'Cold plagiarists' copied, whereas geniuses practised restitution. What the genius restorer was supposed to reinstate to the ancient work was its poetic order, not just its missing parts.

Quatremère proposed that it was in principle possible to free restoration from servile copying. This opened the floodgates of creative personal expression in restoration, something Quatremère was worried about. The notion of poetic order was a way to establish limits on expression. Neo-classical restorers had to find the ordering logic of their aesthetic in the process of making itself. The restorer had to install a poetic order on the work, his chisel had to remake the work so that it showed both the material conditions of its making and the intellectual principles on which it was based. Poetic order was the demonstration of a new synthesis of (variable) practice and (invariable) theory.

Restoration introduced the restorer's creative intentions into the new look of the restored work. Conceptually, the process of restoration was not unlike that of creating an entirely new work of art. Every work of art was seen as evidence of a process, the realisation of intention in material form, the result of a series of lived artistic moments, or self-contained time-frames. With this understanding, neo-classical restoration aimed to *restore the lost time-frame*

that belonged to the artwork. In 1866 French architect Eugène-Emmanuel Viollet-le-Duc expressed his understanding of restoration as 'to reinstate it [the building] in a condition of completeness which could never have existed at any given time' (Viollet-le-Duc, [1866] 1875, p. 9).

In order to be able to look at all the Aegina fragments together, evaluate the relationship of the parts to the whole, and recompose the pediment, Thorvaldsen rented a large studio in Rome. He also purchased marble blocks carefully selected to match the exact colour and grain of the original Parian marble. He wanted the new and the old to be indistinguishable. When visitors to his studio asked him to identify the restored parts he would retort 'I cannot say, I neglected to mark them, and I no longer remember. Find them out for yourself, if you can' (Plon, 1874, p. 58).

As material searches for poetic order, neo-classical restoration practices were inseparable from the specificity of techniques used to work on the material itself. Their scientific authority came from the mastery of ancient techniques by the restorer. It seemed inevitable that the best marble sculptures of the ancient world should be restored by the best marble sculptor of the present.

In like fashion, only the best neo-classical architects appeared to be suited to restore old buildings. Take for instance the British architect James Wyatt, who was noted for his work in the neo-classical style (a little earlier than the now more famous Robert Adam). Wyatt's prestigious appointment, in 1776, as surveyor to the fabric of Westminster Abbey brought him commissions to restore some of Britain's best ancient buildings, medieval Gothic cathedrals such as Lichfield, Hereford, Salisbury and Durham. We need to distinguish neo-classical *restoration* practices from the neo-classical *style* in art and architecture. When Wyatt 'restored' Gothic cathedrals all the new elements he introduced were in the Gothic style, albeit an unabashedly personal interpretation of Gothic. This is how it is possible for us to distinguish easily today between medieval Gothic details and Wyatt's designs: they are not simply copies of existing historic work. I emphasise this only to press the point that restoration did not require exact imitation, but the faithful pursuit of a poetic order which was meant to restore the material and aesthetic integrity of the ancient building. Thus the great creative licence Wyatt took when restoring cathedrals would have appeared to him as a necessity. At Salisbury, for instance, he moved funerary monuments to places between the piers so that they would appear more orderly. Wyatt's 'tidying up' of cathedral surroundings separated them from their urban surroundings, and his landscaped closes made their siting approximate that of Georgian houses on lawns.

Wyatt's neo-classical notion of restoring the poetic order of ancient buildings also anticipated the writings of Viollet-le-Duc, who claimed to be able to 'adopt' the 'means of execution' of ancient master builders on the basis of his knowledge of construction techniques. The 'science' and facts of architectural

restoration were only verifiable by the practical architect who, like him, 'has seen stonework hewn and built by the hand of man, who knows how it is worked, and how it is laid in place' (Viollet-le-Duc, [1877] 1987, pp. 126, 214).

Restorers positioned themselves as returning life to the past. But life can only be here and now. For an architect, to give life to the past meant creating in the manner of the ancients. Neo-classical restoration practices cleared the way for the Romantic identification of art and life. For neo-classical restorers, the life of the ancients was the guide to contemporary life.

Ethics

The task of restoration poetics to bring contemporary life to the past was thought to be meaningless unless there was an objective need guiding the process. Since ancient Greece towered above all other periods, the decision to restore ancient works according to an eighteenth-century model of ancient aesthetics was guided and directed towards the goal of social utility. Restoration aesthetics was for the first time justified on ethical grounds: all citizens would become better people by exposure to the very finest art.

Prince Ludwig claimed the ethical ground of social utility when he commissioned Thorvaldsen to restore the Aegina marbles. The marbles were part of a larger plan by Prince Ludwig to build symbols of Bavarian national identity. He asked architect Leo Ritter von Klenze to design Munich's Königsplatz in the spirit of ancient Greece, a great civic space whose north side was filled by the new museum for classical sculptures, the Glyptothek (Figure 2.4). The buildings were also to be the perfect architectural setting for political rallies. Ludwig, crowned king in 1825, used the Königsplatz to celebrate his dynastic 'incorporation' of Greece through his son Otto, who was crowned first king of Greece in 1832. Klenze's design marked a departure in the history of museums. It was the first building to be devoted entirely to the display of antique sculpture. Thorvaldsen's Aegina marbles became the centrepieces of the display. Klenze wanted to create the perfect architectural setting for neo-classical restorations: the building was supposed to enhance Thorvaldsen's intention to hinder the viewer's ability to tell the old fragments from the new. Klenze decorated the room in the manner of ancient Greek architecture to distract the viewer,

> to make him oblivious of the dreary condition in which they [the ancient sculptures] have come down to us, often after centuries of barbarism and destruction; this is better achieved by providing the walls, against which these antique sculptures are exhibited, with a certain degree of splendour, and even emphasizing it.
>
> (Klenze and Schorn, 1830, p. 1)

Figure 2.4 Unknown engraver, *Glyptothek auf dem Königsplatz*, Munich, *c.*1850, steel plate engraving. Photo: © akg-images.

The history of conservation attests to the fact that modern western society has always invested itself unevenly in the past. That is to say, for every generation one period of the past has seemed to tower above all others as an emblem of wholesomeness and perfection. Sociologist Pierre Bourdieu called this investment the *illusio* or belief that holds fields of cultural production together:

> The smooth running of all social mechanisms, whether in the literary field or in the field of power, depends on the existence of the *illusio*, the interest, the investment, in both economic and psychological sense (this investment is called *Besetzung* in German and 'cathexis' in English).

> (Bourdieu, 1993, p. 159)

The *illusio* of conservation consists primarily in the investment in an aesthetic ideal derived from the past, and in the Romantic belief that its poetics can reconnect contemporary life with a more wholesome former way of life. It is this social investment that has guaranteed the proper functioning of

conservation and determined its changing aesthetics over the past two centuries.

De-restoration politics

I now want to shift gears and look at changing philosophies about how we connect with the past made in the 1970s. The jump is not random. During the 1970s the neo-classical period became the object of great popular and scholarly interest. This was especially the case in Germany in the context of de-Nazification and in the USA where the date of 1776 burned in everyone's minds as preparations were underway for the country's bi-centennial celebration. During the 1970s there was also a return to the neo-classical notion of conservation as a poetic process. This was in reaction to the rise of an increasingly science-based archaeology in the 1960s (the new archaeology). Uncannily, the Aegina marbles were again at the centre of this debate.

Before we return to the marbles, we should also note the rapid formalisation of the processes for conservation after the Second World War (addressed in Chapter 1). In particular, the adoption in 1964 of the International Charter for the Conservation and Restoration of Monuments and Sites (the Venice Charter) represented a key stage in the production of the AHD introduced earlier. The Venice Charter set out general principles for intervening in historic structures and objects, and Article 12 declared:

> Replacements of missing parts must integrate harmoniously with the whole, but at the same time must be distinguishable from the original so that restoration does not falsify the artistic or historic evidence.

> (ICOMOS, [1964] 1996)

In other words, the western nations formally recognised the distinction between the 'archaeological' survival of original features as authentic, and the deliberate reinstatement of features as inauthentic, but acceptable if capable of being understood as such by the viewer (and fake if masquerading as original). For example, decorated pottery fragments might be reassembled and missing pieces might be represented in new clay coloured to tone but must not be made to 'disappear' into the original whole. The conservator would not add their artistic interpretation of the integrity of the original work. So how would curators respond to the many works in their collections that had earlier 'restorations' resulting from very different philosophical understandings?

In 1972, after a decade of work, Dieter Ohly, director of Munich's Glyptothek, unveiled the much anticipated 'de-restoration' of the sculptures from the temple of Aphaia at Aegina. The significance of this event would normally have been restricted to the limited world of museum conservators, but the work involved a major artist's, Thorvaldsen's, previous neo-classical

restoration. This happened to be the time when postmodern architects were rediscovering neo-classicism, and they were quick to come to the defence of neo-classical works. Giulio Carlo Argan, an art historian with a breadth and clarity of vision that earned him a wide readership among architects and conservationists, sounded the alarm and directed attention towards the Glyptothek. What was shocking was what was missing. Ohly had entirely

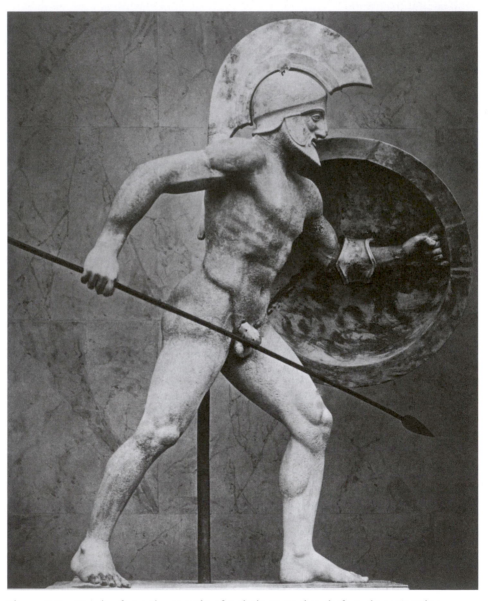

Figure 2.5 Warrior from the temple of Aphaia at Aegina, before de-restoration. Glyptothek, Munich. Unknown photographer. Photo: Staatliche Antikensammlungen und Glyptothek Museum.

destroyed the work of Thorvaldsen. Hiding behind the mask of a 'scientific' restoration method, Ohly had destroyed a great work of neo-classicism with impunity (Figures 2.5 and 2.6).

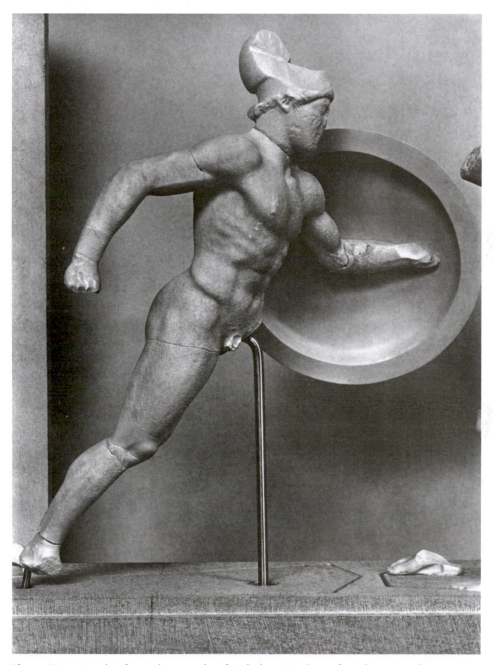

Figure 2.6 Warrior from the temple of Aphaia at Aegina, after de-restoration. Glyptothek, Munich. Unknown photographer. Photo: Staatliche Antikensammlungen und Glyptothek Museum.

Later scholarship has demonstrated what contemporary viewers could only hypothesise: that this eradication of neo-classicism was just as much ideological as scientific. It was part of a particular cultural moment when Germany was attempting to resolve the legacy of its National Socialist era (Diebold, 1995, pp. 60–6). Thorvaldsen's sculptures of ancient warriors had been hailed by Nazis like Hans W. Fisher as models for the new German athlete. As literal fusions of ancient Greek and neo-classical sculpture, they also served as symbolic anchors of the imperialist desire to make Munich what Hitler called the 'Acropolis Germaniae'. Indeed, the Königsplatz was used for Nazi mass rallies and further classical buildings were added to the ensemble.

Ohly's de-restoration seemed justified as a scientific correction. If Thorvaldsen's original restoration was an expression of scientific knowledge about the ancient sculptures combined with creative interpretation, then new scientific discoveries, with their concomitant expansion of existing knowledge, demanded that the restoration be 'improved'. Evidence from new excavations had exposed Thorvaldsen's poetic licence in restoring the sculptures. For instance, he had restored a warrior from the east pediment as lying down when he should have been standing (Figure 2.7). Since Thorvaldsen was not 'just' a conservator but also a famous sculptor, there was the question or whether his restoration should be considered scientific or artistic: was his work evidence of poetic intention or scientific rationality? The answer would determine whether or not it was permissible to 'correct' his work. Ohly viewed Thorvaldsen's restoration as scientific, and therefore flawed, outdated and in need of urgent updating. Ohly's decision was also a

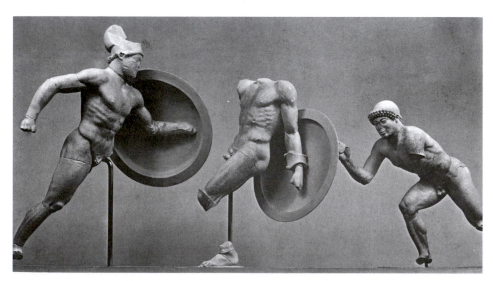

Figure 2.7 Detail of east pediment assemblage from the temple of Aphaia at Aegina. Glyptothek, Munich. Unknown photographer. Photo: Staatliche Antikensammlungen und Glyptothek Museum.

judgement that the discipline of conservation was an 'objective' science which permitted no room for poetic self-expression.

During these same years, postmodern architects entered into the discussion. Their interest in connecting modern architecture with the styles of the past led them to raise theoretical questions which, as they quickly discovered, had already been asked towards the end of the eighteenth century, including how to link tradition and invention, how to express contemporary architecture in a historic style or, as postmodernists liked to say, in the 'language' of the past. They did not wish to make copies of historic styles but to use historic traditions creatively, even playfully. For instance, Philip Johnson designed a skyscraper office block, a key symbol of modernity, with an eighteenth-century-style pediment and other references to classical architecture (the AT&T building, now the Sony Tower, New York, finished 1984). Architects who deliberately re-made historic architectural styles into new, unprecedented combinations in their buildings could be said to be making new meanings out of older traditions – perhaps something that Thorvaldsen would have understood.

Lost time

These conservation and architectural debates about what was the proper 'language' in which to express contemporary work, and about the difference between scientific and artistic approaches to practice, framed the institutionalisation of conservation as an academic discipline. James Marston Fitch, founder of the first historic **preservation** programme in the USA at Columbia University, conceived conservation (or historic preservation as it is termed in the USA) more as an art than as a science. He called it a 'four dimensional' creative practice in his book *Historic Preservation* (Fitch, [1982] 1990). Conservation engaged the first and second dimensions through documentation, which required measuring linear distances, and drawing two-dimensional plans and sections of the existing buildings. It encompassed the third dimension through interventions in the fabric of buildings. Fitch differentiated the three-dimensional work of conservation from that of architecture. Unlike architecture which dealt mostly with the addition of new materials to a site to produce a new three-dimensional building, conservation involved both additive and subtractive processes: in some cases it might require removing walls altogether to achieve the desired historical integrity. Conservation's first three dimensions were relatively straightforward geometric quantities. By contrast, the fourth dimension was less obvious. Fitch made it clear that what he called the fourth dimension was not simply time itself but rather the particular manner in which conservation presented architecture as an object created and shaped through a temporal process.

The question of defining time is as old as philosophy. Modern physics classifies time as a fundamental quantity that defines other quantities (for example, velocity, force, energy), and that therefore cannot be defined by them. Consequently, time can only be defined operationally by the process of measurement and the units chosen. This 'operational' definition of time is close to Fitch's understanding of preservation's fourth dimension as the aesthetic presentation of architecture as a temporal process.

The fourth dimension, as the aesthetic expression of this temporal poetics, was, in Fitch's words, an 'unnatural interface between the viewer and the viewed', visitor and building (Fitch, [1982] 1990, p. 325). The key word was 'unnatural'. The fourth dimension was an aesthetic realm of artificiality, emerging paradoxically from the viewer's confrontation with the genuine building. 'This', underscored Fitch, 'is a totally different relationship from that which normally exists between user and used or owner and owned' (Fitch, [1982] 1990, p. 325). The time dimension of conservation negated the 'normal' way of experiencing buildings as 'useful' three-dimensional objects of daily life. It created an 'abnormal' relationship to buildings through which they appeared as something more than use objects: they appeared as poetic creations.

The 'unnaturalness' of conservation's fourth dimension was also a function of the fact that it did not offer a sequential measure of time (like a clock), or even a narrative measure of it as a linear continuum 'full' of events. Rather, according to Fitch, the fourth dimension was really a measure of 'lost' time: an unbridgeable temporal gap that made the experience of the present object seem totally disconnected from the past. The notion of lost time was central to Fitch's understanding of modernity as the human condition of being alienated from one's own heritage. Conservation's fourth dimension, he wrote, 'responds to the need for alienated peoples to re-establish some experiential contact with the material evidence of their own past' (Fitch, [1982] 1990, p. 325). The wording here is important. The fourth dimension was a 'response', not a solution.

The theme of lost time can be found in the work of other architectural conservation theorists, and became central in North American historic preservation debates during the 1970s and 1980s. Lost time was also a central concept in the European rethinking of architectural conservation, where it was spearheaded by art historians turned conservation theorists like Paul Philippot, who directed UNESCO's International Centre for the Study of the Preservation and Restoration of Cultural Property (ICCROM) during the critical years of 1971–7. Philippot also believed in the 'unbridgeable gap that has formed, after historicism, between us and the past' (Philippot, 1996, p. 225). The missing link of lost time could not simply and naively be filled in without falling prey to the false consciousness of confusing self-projection

with historical fact. If lost time was really 'lost', then by definition one could not know what it was.

For Fitch and Philippot, the most damning condemnation of a conservation project was to say that it was archaeological. That was to say that it had failed to bring life to the past, and instead increased our distance from the past by 'freezing' it. For Philippot, the more alienated the preservationist was from the past, the more they would 'turn to a scientific approach' to preservation and tend to transform the historic building 'into a purely archaeological museum object' (Philippot, 1996, p. 223). These were damning words for his German colleague Ohly, whose reputation never recovered. By physically removing Thorvaldsen's restoration work, Ohly had both destroyed the creative contribution of the sculptor and also fixed the original fragments in a frozen moment of time.

The 'big failure' of archaeological conservation, wrote Philippot, was that it could not 're-establish the continuity of lived history' (Philippot, 1996, p. 224). An example of a large-scale heritage project that attempts to achieve this 'lived history' experience can be seen at Colonial Williamsburg, Virginia. The former capital town of the colony until 1780, it had fallen into quiet decay until its significance as part of the foundation story of modern America attracted physical restoration and investigation projects from the 1920s until today. It claims to be the world's largest living history museum, an eighteenth-century town staffed by costumed interpreters. Fitch attacked Colonial Williamsburg, the darling project of the conservation establishment, as the worst kind of archaeological conservation. The entire town had been returned to 1776 through surgical demolitions and scientific reconstructions, then furnished and perpetually maintained in first-class condition. The archaeological operations to 'purify and telescope historic processes' presented visitors with a 'simultaneity of well-being that would seldom if ever have occurred' (Fitch, [1982] 1990, p. 99). The experience distanced life from the past instead of bringing it closer. Better would have been a more natural mix of old and new, demonstrating the passage of time which separates the eighteenth century from the present day. Fitch's attacks on Colonial Williamsburg undermined the authority of the conventional conservation aesthetic of archaeological reconstruction, which had reigned supreme in the USA since the 1920s.

Fitch proclaimed that conservation poetics had entered a new era in the late 1960s. The practice of total restoration seemed elitist to Fitch because only the person actually performing the restoration could experience conservation as a creative poetic process. The rest of society was reduced to passive spectatorship of the final aesthetic product. In addition, total restoration seemed to replicate an architectural notion of design as a process restricted to professionals. This seemed anachronistic at a time when postmodern

architects were critiquing the lonely figure of the architect-hero and experimenting with more inclusive processes of 'community design'. We would recognise this now as a critique of the AHD. It was time, thought Fitch, to democratise conservation and to engage visitors in the process – to engage them in its poetics. What Fitch meant by democratising conservation poetics was something far more subtle than simply handing over design decisions to the public. The new conservation poetic involved striving towards an aesthetic that made its own making visible.

Venturi and Rauch's 1976–8 reconstruction of Benjamin Franklin's 1780s home in Philadelphia was, for Fitch, the emblematic example of this new conservation poetic: 'a new level of maturity in American preservation' (Fitch, [1982] 1990, p. 303). The US National Park Service originally planned to reconstruct Franklin's home as a traditional house museum complex. Only the foundations of the original structures remained on the site. The street frontage buildings were in fact reconstructed in the 'typical' architectural language of the 1780s (Figure 2.8). Behind this new range of houses with ground-floor shops, they also planned to reconstruct Franklin's print shop and

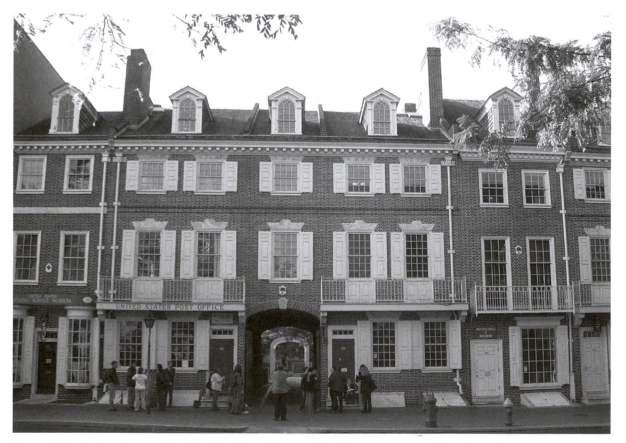

Figure 2.8 Market Street, Philadelphia, 2003. Photographed by Jorge Otero-Pailos. Photo: © Jorge Otero-Pailos.

house, but historians were unable to find sufficient historical documentation to determine the exact aesthetics of the original house. Venturi and Rauch proposed to acknowledge the limits of historical knowledge by reconstructing only those facts about the house and print shop that were archaeologically and historically verifiable, letting visitors imagine the rest. They built a white steel frame that outlined the volume of the two structures as dematerialised 'ghosts'. On the ground, the diagram of the floor plan was drawn on the pavement with walls indicated in white marble against a dark field of bluestone (Figure 2.9). In the absence of the usual artefacts that would have cued visitors about whether they were standing in a kitchen or a bedroom, the three-dimensional diagram of the steel frame was labelled with inscriptions on the bluestone slabs: 'You are now in the first floor area which served as a book bindery.' Other didactic aesthetic devices also served to organise the visitor's attention towards archaeological evidence. Concrete 'periscopes' punctured through the new floor to reveal the archaeological remains of the cellar below the house. Fitch praised Venturi and Rauch for combining the 'cognitive and the sensuously perceptible' and turning the architecture itself into a 'brilliant interpretation of the morphological development of the site' that was more engaging than a simple reconstruction (Fitch, [1982] 1990, p. 304).

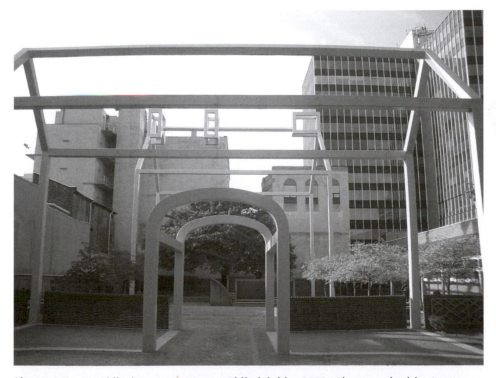

Figure 2.9 Franklin house structures, Philadelphia, 2003. Photographed by Jorge Otero-Pailos. Photo: © Jorge Otero-Pailos.

This was indeed a significant shift in conservation theory. Venturi and Rauch's acceptance that an integral object could not be produced took apart the idea of restoration as the material restitution of the ideal, in direct contrast to some of the total rebuilds that form part of Colonial Williamsburg, for example. To reconstruct the Franklin House in the manner of the 1780s would be to employ an architectural language so general that it would reduce the particularities of what was to be expressed to an idealised stylistic model. Venturi and Rauch thought that a restoration would be a falsehood. Nevertheless, their response maintained the neo-classical notion that a work of conservation (restoration, reconstruction or restitution) should achieve a poetic order, an aesthetic that is expressive of the intellectual and material struggle between the restorer and the object being restored and expressive of the passage of time. Venturi and Rauch tried to express their subjectivity within the material and intellectual limits of the site: the steel frame was at once their subjective interpretation of Franklin's house, and also an objective marker of the limitations of the evidence. They reintroduced subjectivity to conservation poetics as an aesthetic synthesis that knows itself to be inconclusive, and expressed it in forms, like the 'ghost' steel outline of Franklin's house, that are at once whole and incomplete.

This case bears witness to the 1970s moment when subjective expression again appeared legitimate within conservation practice, so long as it remained guided by, or in the service of, a purpose other than itself, namely, the truthful (objective) portrayal of material heritage.

The poetics of incompleteness

Fitch's notion of the 'fourth dimension' characterised a kind of conservation which seeks to prompt the imagination to consider what remains of the past while acknowledging what has been lost. It emphasises the limits of knowledge and the impossibility of ever 'going back' to the past, while simultaneously challenging the viewer to make intellectual sense of the evidence and to form their own creative interpretation of it. The discovery of the difference between conservation poetics and the object preserved paved the way for a more authentic relationship to the aesthetic products of conservation, as opposed to the old idea that any subjective expression in conservation is a form of falsification of the original. Recognising that artificiality is not the same thing as falsification, conservationists began openly to pursue the expression of artificiality.

Take for instance the 1989 restoration of the lobby in Burnam and Root's Rookery Building in Chicago (1884–6). When Gunny Harboe (of McClier Corporation), a student of Fitch, took charge of the restoration team he was confronted with a building that had undergone a number of previous transformations, not least of which was the total redesign of the lobby by

Frank Lloyd Wright, one of America's most celebrated twentieth-century architects. Harboe decided to restore the lobby to Wright's design. Given the poor condition of much of the marble walls, floor mosaics, and plaster ceilings, Harboe had to replace much of the original fabric. The short walk from the street through the double-height stair lobby, through the low and deep corridor of the elevator bank, is an enveloping spatial composition that delivers the visitor to a glorious, light-filled central courtyard (Figure 2.10).

Despite the inauthenticity of the materials, one has the strong impression of being in a work designed by Frank Lloyd Wright. But the immediacy of the experience is negated by one's confrontation with a small patch of authentic tesserae on the floor which reveal the rest as being part of a later restoration. More troubling still, the column sitting on the 'old' mosaic patch seems to be disintegrating, with part of its marble sheathing mysteriously missing. Emerging from the inside is a cast iron column suggesting Burnam and Root's lobby remains encased within (Figure 2.11). The endlessly receding experience of the 'original' and the inversions in our perception of what is

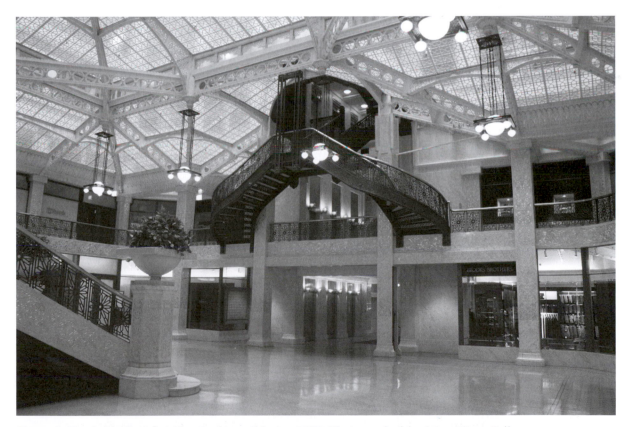

Figure 2.10 Lobby interior, The Rookery, Chicago, 2007. Photographed by Jorge Otero-Pailos. Photo: © Jorge Otero-Pailos.

Figure 2.11 Detail of the lobby interior, The Rookery, Chicago, 2007. Photographed by Jorge Otero-Pailos. Photo: © Jorge Otero-Pailos.

authentic begin to create an aesthetic distance from the environment which makes us grasp its artificiality. It is at this precise moment that the space comes into focus as a work of conservation poetics. Artificiality here emerges as the result of an expressive technique that places one aesthetic synthesis (one period style) next to another without indicating which is subordinate, rendering both inconclusive. The result is a building that, having been touched by conservation, is unlike any other, in the sense that it does not present us with a single moment in history, or even with a sense of the continuity of time, but rather with an impossible, artificial experience of time as something simultaneously discontinuous and co-present. Conservation introduces time as an alien quality in buildings, something to wonder about, not something given as their natural content.

In conclusion, incompleteness

The type of conservation poetics of incompleteness, as I have called them in this case study, that were initiated in the 1970s have by now become the default mode of expression of most western conservationists. The taste for presenting various phases of development alongside contemporary expressions is now dominant and is often associated, rightly or wrongly, with a democratic open society capable of 'accepting' its past and moving on with the present. Witness for instance the retention of Berlin's Reichstag and its restoration into the new German Parliament by Sir Norman Foster and Partners (1992–9). Nazi-era graffiti was uncovered and exposed to the public in one part of the building, while a contemporary glass dome replaced the historic roofing system. Indeed today restorations that have emphasised one period in an object's history at the expense of all the others are seen as elitist, undemocratic and 'top–down'. This is still the objection that many conservationists raise against Ohly's de-restoration of the Aegina marbles. Both cases raise the question of whether one can make a strict correlation between a certain conservation aesthetic and a political programme (democracy, tyranny, and so on). Ohly's and Foster's work were done under the same democratic German government. In thinking about this question, I would suggest that we distinguish between the production and the reception of preservation works. As conservationists, we tend to focus on how objects are received and interpreted by non-conservationists, and we often forget to examine critically our own creative process, and the intellectual histories, the 'boxes' if you will, within which we operate.

Reflecting on the case study

The case study has shown that the values behind conservation decisions come from wider currents in society, and are subject to shifts as different priorities arise over time. This is particularly helpful in thinking about how the values

behind the major international heritage frameworks and national legislation get 'frozen' at the point at which these documents are launched. When Thorvaldsen was 'reimagining' the Aegina marbles, as we saw, he was working with an art history discourse that found truth and beauty in whole objects. The unspoken conservation practice that flowed from that discourse resulted in major interventions. Later in the nineteenth century, 'wholeness' became less desirable. Ruins became celebrated for their disintegration, the aura of damp decay in run-down Venetian palazzos was becoming appreciated for qualities that industrialised modern cities could not supply. The conservation ethic of minimal intervention, stabilising decay but not recreating lost wholeness, began to be discussed. This went on to inform how the first official monuments designated in European countries were treated. Although this conservation practice has variations, it is also apparent in the case of the Franklin House treatment. This is a more nuanced approach to sharing 'truth' between experts and visitors: neither can know exactly what the house looked like from Franklin's time. The experts suggest something that the visitor can look beyond, to see the ruins for themselves.

Beyond beauty

Aesthetic judgement is the activity that creates aesthetic values; it is a difficult one to approach. This is because it embodies a contradiction, from being both a personal response to beauty and wanting to override other people's personal responses. If we find something to be beautiful (or ugly), we usually want other people to see it our way. Most of us do not think about beauty analytically, without the discourse of aesthetics to help us. However, it is possible to explain why we find something to be beautiful if we can access appropriate descriptive terms and comparisons: something that we expect art historians, architects and other people who work with visual culture, for instance, to be able to do. This creates the evidence to substantiate or argue against an aesthetic judgement. Beauty, however we perceive it, is after all an important part of living an enjoyable life, even an experience as simple as a sunny day in a northern winter.

The dominance of aesthetic judgement in heritage decisions has deep roots and inevitably came to be written in to heritage frameworks for making those decisions. International frameworks such as the Venice Charter retain that dominance, but the heritage discourse continues to be shaped by less Eurocentric voices and by questions debated by professionals firmly within western practices, as the last case study demonstrated. The Nara Document on authenticity is one of the more recent statements that tries to make room for communities and their responses to change over time in their objects and places of heritage.

Time and aesthetics are intertwined, not just because aesthetic preferences evolve over time. Time erodes material culture and decisions need to be taken over how to repair damage (loss) or make alterations for changing functions (addition). The problem of addition is a big challenge to aesthetic value. What is more beautiful – the original form in pristine condition or a later appearance with the patina of age and many generations' use? Both conditions may have many aesthetic qualities but only the present-day state is truly authentic.

Conclusion

Values have moved from being an unspoken but fundamental underpinning to the first official heritage practices to an explicit component of how heritage decisions are made. Chapter 1 emphasised the priority given in European intellectual circles from the seventeenth century onwards to the inheritance of classical standards from ancient Greece and Rome. These standards for beauty, the value of history (particularly political history) and the uses of long-lasting monumental architecture to represent these discourses led to a very high appreciation of the intellectual and tangible inheritance from these two ancient cultures. They were used as benchmarks for judging later works and for evaluating other cultures. European cultures also put a great deal of effort into re-using classical cultures to support their own claims for national identity and, usually, superiority. History and beauty became the two dominant values assigned to heritage that measured up to the way these attributes were defined. This chapter has taken beauty, or aesthetic value, as the one that has exercised the greatest hold over heritage decisions and one that is still contentious.

We were introduced to key thinkers who developed aesthetic theory, Baumgarten, Kant and Hume. Again, their historical position as western thinkers reminds us that aesthetic judgements are grounded in cultural contexts and understandings, not globally shared. The case study on historical conservation practices, and their shifting justifications as differing examples of 'best practice' over time, is an important reminder of just how contingent (in the sense of being true only under existing conditions) these heritage practices are.

The emphasis on values is continued in the following two chapters, which explore natural heritage and then museums. Aesthetic value, as you will not now be surprised to learn, has a long-standing role in the ways people value landscapes, particularly those that appear to match other highly valued landscapes. For example, Italian landscapes represented by canonical Renaissance artists were used as visual models for finding beauty in English landscapes. In the eighteenth century the surroundings to the country houses

of the elite were often re-landscaped to match the landforms and planting believed to be the most beautiful (if the least 'natural'). Buildings in the forms of classical temples completed the illusion. These highly designed landscapes are now treated as works of art and given their own status and protection under heritage frameworks. Chapter 3 discusses the succeeding aesthetic discourse of the Picturesque, which valued wilder and awe-inspiring landscapes at a time when new colonial natural environments were becoming better known.

Chapter 4 reminds us of the expansion of values in official heritage, as seen in recent museum practices. The expansion of values from the aesthetic and the historic has been codified in the Australia ICOMOS Charter for the Conservation of Places of Cultural Significance, known as the Burra Charter (first adopted in 1979; Australia ICOMOS, 1999). The Burra Charter was discussed in Chapter 1 for its wide adoption beyond Australia as a model for evaluating significance. Aesthetic, historic, scientific and social value are now routinely considered by heritage experts. Museums have been under critical pressure for several decades to demonstrate their public uses and to show that their experts can share (and receive) knowledge. The circulation of knowledge is, after all, a critical interest to heritage studies, in assessing the question of whose knowledge is taken into account in dealing with 'our' inheritances.

Works cited

Allison, H.E. (2001) *Kant's Theory of Taste*, Cambridge, Cambridge University Press.

Australia ICOMOS (1999) The Australia ICOMOS Charter for the Conservation of Places of Cultural Significance, Canberra (first published in 1979) [online], www.icomos.org/australia/ (accessed 4 September 2008).

Baumgarten, A.G. (1735) *Meditationes philosophicae de nonnullis ad poema petrinentibus* (Philosophical Meditations on Some Matters Pertaining to Poetry), Halle.

Baumgarten, A.G. (1750) *Aesthetica* (Aesthetics), vol. 1, Frankfurt-an-der-Oder.

Bourdieu, P. (1993) 'Is the structure of *sentimental education* an instance of social self-analysis?' in Johnson, R. (ed.) *The Field of Cultural Production: Essays on Art and Literature*, New York, Columbia University Press, pp. 145–60.

D'Este, A. (1864) *Memorie della vita di Antonio Canova*, Florence, Felia le Monnier.

Diebold, W.J. (1995) 'The politics of derestoration: the Aegina pediments and the German confrontation with the past', *Art Journal*, vol. 54, no. 2 (summer), pp. 60–6.

Fitch, J.M. ([1982] 1990) *Historic Preservation: Curatorial Management of the Built World*, Charlottesville and London, University Press of Virginia.

Gaiger, J. (2000) 'The true judge of beauty and the paradox of taste', *European Journal of Philosophy*, vol. 8, no. 1, pp. 3–19.

Guyer, P. (1997) *Kant and the Claims of Taste* (2nd edn), Cambridge, Cambridge University Press.

Harrison, R. (2010) 'What is heritage' in Harrison, R., *Understanding the Politics of Heritage*, Manchester, Manchester University Press/ Milton Keynes, The Open University, pp. 5–42.

Harrison, C., Wood, P. and Gaiger, J. (eds) (2000) *Art in Theory: 1648–1815*, Malden, MA and Oxford, Blackwell Publishing.

Hume, D. (1985a) *Essays Moral, Political, and Literary* (ed. E. Miller), Indianapolis, IN, Liberty Classics.

Hume, D. (1985b) *Enquiries Concerning Human Understanding and Concerning the Principles of Morals* (ed. L.A. Selby-Bigge), Oxford, Clarendon Press.

ICOMOS ([1964] 1996) International Charter for the Conservation and Restoration of Monuments and Sites (Venice Charter) [online], www.icomos.org/docs/venice_charter.html (accessed 8 September 2008).

ICOMOS (1994) The Nara Document on Authenticity [online], www.international.icomos.org/naradoc_eng.htm (accessed 28 March 2009).

Kant, I. (1790) *Kritik der Urtheilskraft*, Berlin and Libau, Lagarde and Friedrich.

Kant, I. (2000) *Critique of the Power of Judgment* (trans. P. Guyer and E. Matthews), Cambridge, Cambridge University Press.

Klenze, L. von and Schorn, L. (1830) *Beschreibung der Glyptothek Sr. Majestät des Königs Ludwig I. von Bayern,* Munich.

Mitchell, W.J.T. (2005) 'Value' in Bennett, T., Grossberg, M. and Morris, M. (eds) (2005) *New Keywords, a Revised Vocabulary of Culture and Society*, Malden, MA and Oxford, Blackwell Publishing, pp. 365–7.

Munjeri, D. (2004) 'Tangible and intangible heritage: from difference to convergence', *Museum International*, vol. 56, nos 1–2, pp. 12–20.

Philippot, P. (1996) 'Restoration from the perspective of the humanities' in Price, N.S., Talley, M.K. and Vaccaro, A.M. (eds) *Historical and Philosophical Issues in the Conservation of Cultural Heritage*, Los Angeles, Getty Conservation Institute, pp. 216–29.

Plon, E. (1874) *Thorvaldsen: His Life and Works* (trans. I.M. Luyster), Boston, MA, Roberts Brothers.

Quatremère de Quincy, A.-C. (1818) *Lettres escrites de Londres à Rome et adressées à M. Canova sur les Marbres d'Elgin à Athènes*, Rome.

Quatremère de Quincy, A.-C. (1999) *The True, the Fictive, and the Real: The Historical Dictionary of Architecture of Quatremère de Quincy*, London, Andreas Papadakis Publisher.

Smith, L. (2006) *Uses of Heritage*, Abingdon and New York, Routledge.

UNESCO (2009a) Historic Ensemble of the Potala Palace, Lhasa [online], whc.unesco.org/en/list/707 (accessed 28 March 2009).

UNESCO ([1972] 2009b) World Heritage Convention [online], whc.unesco. org./en/conventiontext/ (accessed 13 January 2009).

Viollet-le-Duc, E.E. ([1866] 1875) *On Restoration* (trans. C. Wethered), London, Sampson Low, Marston, Low and Searle.

Viollet-le-Duc, E.E. ([1877] 1987) *Lectures on Architecture: Volume 1* (trans. B. Bucknall), New York, Dover Publications.

Further reading

Gregory, J. (2008) 'Reconsidering relocating buildings: ICOMOS, authenticity and mass relocation', *International Journal of Heritage Studies*, vol. 14, no. 2, pp. 112–30.

Hendry, J. (2000) *The Orient Strikes Back: A Global View of Cultural Display*, Oxford, Berg Publishers.

Jokilehto, J. (2006) 'Considerations on authenticity and integrity in world heritage context', *City and Time*, vol. 2, no. 1, pp. 1–16.

Macdonald, S. (2004) 'A people's story: heritage, identity and authenticity' in Corsane, G. (ed.) *Heritage, Museums and Galleries: An Introductory Reader*, London and New York, Routledge, pp. 272–90.

Munoz-Vinas, S. (2004) *Contemporary Theory of Conservation* (2nd edn), Oxford, Butterworth-Heinemann.

Saint, A. and Earl, J. (2003) *Building Conservation Philosophy* (3rd edn), Shaftesbury, Donhead Publishing.

Scott, F. (2008) *On Altering Architecture*, Abingdon and New York, Routledge.

Stanley Price, N.P., Kirby Talley, M. Jr and Melucco Vaccaro, A. (eds) (1996) *Historical and Philosophical Issues in the Conservation of Cultural Heritage*, Los Angeles, Getty Conservation Institute.

Chapter 3 Natural heritage

Rodney Harrison and Donal O'Donnell

A central set of problems for contemporary western heritage management derives from an underlying philosophy that conceptualises nature and culture as separate domains. This chapter considers UNESCO's response to criticism of this philosophy through the introduction of the category of cultural landscapes. It explores the management of natural heritage in the UK and western Europe and juxtaposes this with the problem of understanding 'wilderness' in settler societies. A case study of biodiversity management in the UK by ecologist Donal O'Donnell demonstrates how natural heritage conservation and biodiversity management are carried out at a national level, and examines some of the arguments and values that underpin these activities. Another case study of the history of Yellowstone National Park, by Rodney Harrison, demonstrates the way in which concepts of nationalism have been expressed through the national park system in the USA. The final case study, by Donal O'Donnell, looks at proposals to reconstruct ancient ecosystems in Siberia and the USA, and examines the issues that arise when ideas about reconstructing natural heritage are taken to an extreme.

Introduction

What is natural heritage?

The Australian Natural Heritage Charter defines natural heritage as:

- natural features consisting of physical and biological formations or groups of such formations, which demonstrate natural significance
- geological and physiographical formations and precisely delineated areas that constitute the habitat of indigenous species of animals and plants, which demonstrate natural significance, and/or
- natural sites or precisely delineated natural areas which demonstrate natural significance from the point of view of science, conservation or natural beauty.

(Australian Heritage Commission, 2002, p. 8)

You will see that this definition is dependent on the definition of another concept, 'natural significance'. The charter defines natural significance as

the importance of ecosystems, biodiversity and geodiversity for their existence value or for present or future generations, in terms of their scientific, social, aesthetic and life-support value.

(Australian Heritage Commission, 2002, p. 9)

The term 'ecosystem' describes a series of organisms and the dynamic relationship between them and their local environment. 'Biodiversity' means variability between living organisms (see further discussion later in this chapter), while 'geodiversity' means 'diversity of geological (bedrock), geomorphological (landform) and soil features, assemblages, systems and processes' (Australian Heritage Commission, 2002, p. 9). The value of these elements of natural significance can be measured in so far as they relate to scientific, social, aesthetic or life-giving values (similar to the Burra Charter cultural values discussed in Chapter 1). In practice, the identification and assessment of natural heritage significance is largely the preserve of scientists who determine the conservation values of natural areas and the relative rarity of plant and animal species, and of the tourism industry which determines the aesthetic values of landscapes to humans (see further discussion of tourism in Chapter 6).

As you will see in this chapter, the concept of natural heritage is intimately bound up with discourses in the natural sciences concerning the conceptual relationships between humans and their environment. The relationship between natural heritage and cultural heritage has long been seen to be problematic (see also Harrison and Rose, 2010). This relationship can be explored by looking at the place of natural heritage in the World Heritage List.

Natural heritage and the World Heritage List

The convention adopted by UNESCO in 1972 which established the World Heritage List was called the Convention Concerning the Protection of the World Cultural and Natural Heritage. Within the convention a clear distinction was made between cultural and natural heritage, with the latter defined as

natural features consisting of physical and biological formations or groups of such formations, which are of outstanding universal value from the aesthetic or scientific point of view;

geological and physiographical formations and precisely delineated areas which constitute the habitat of threatened species of animals and plants of outstanding universal value from the point of view of science or conservation;

natural sites or precisely delineated natural areas of outstanding universal value from the point of view of science, conservation or natural beauty.

(UNESCO, [1972] 2009a)

You will recognise this wording, which was adapted by the Australian Natural Heritage Charter with the addition of the concept of natural significance. Fowler (2004, p. 4) points out that even at the time of the 1972 convention many in the global community were already beginning to question the distinction made by the convention between natural and cultural heritage. Indigenous people in Australia and New Zealand, for example, were influential in their criticisms of the separation of natural and cultural heritage in the management of heritage at regional, national and global levels. Typically, natural landscapes are occupied and 'unofficially' managed by human communities. Twenty years later, in December 1992, UNESCO adopted an additional category of 'cultural landscape', intended to recognise the contribution of human communities to landscapes (West and Ndlovu, 2010).

The first place to be listed as a cultural landscape following these recommendations was Tongariro National Park in New Zealand (Figure 3.1). It had initially been nominated to the World Heritage List 1990 as a 'natural' site under criterion (vii), 'to contain superlative natural phenomena or areas of exceptional natural beauty and aesthetic importance', and (viii) 'to be outstanding examples representing major stages of earth's history, including

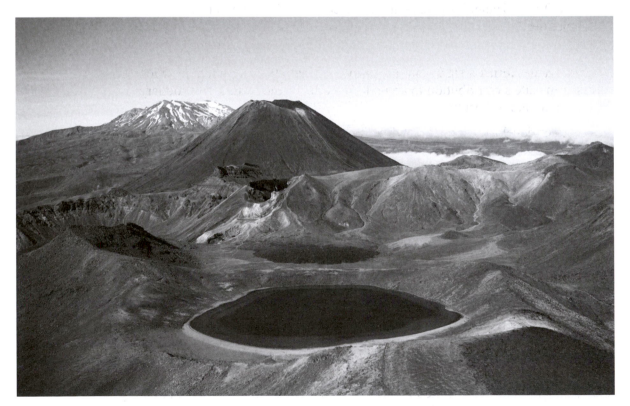

Figure 3.1 Mounts Tongariro, Ruapehu and Ngauruhoe, Tongariro National Park, New Zealand. Photographed by Chris McLennan. Photo: © Chris McLennan/Alamy.

the record of life, significant on-going geological processes in the development of landforms, or significant geomorphic or physiographic features'.

It was subsequently re-nominated in 1993 under cultural criterion (vi), which requires a site 'to be directly or tangibly associated with events or living traditions, with ideas, or with beliefs, with artistic and literary works of outstanding universal significance' (UNESCO, 2009b). The 1993 re-**nomination** referred to 'the power of the unbroken associations of the Ngāti Tūwharetoa *iwi* (Māori tribe) with the mountains', both physical and cultural, the cultural links being

> demonstrated in the oral history which is still a pervasive force for Ngāti Tūwharetoa . The peaks are spoken of with the same reverence and feeling as tribal ancestors, ensuring that the connection is one of spirituality as well as culture.
>
> (UNESCO, 1993)

It went on to note that

> The outstanding natural values have already been recognized by World Heritage listing. The associative cultural values for Ngāti Tūwharetoa and Te Āti Haunui a Paparangi are inseparable from the natural qualities.
>
> (UNESCO, 1993)

Such language forms a stark contrast to the original 1990 nomination which stressed the site's contribution to an understanding of the earth's evolutionary history and natural beauty.

Subsequent developments saw UNESCO host a series of expert panels to develop more detailed criteria for the identification of cultural landscapes. In 2005 it adopted a single list of criteria for World Heritage sites with the revised Operational Guidelines for the Implementation of the World Heritage Convention (UNESCO, 2008). However, the idea of a cultural landscape as a 'special kind' of natural landscape maintains the distinction between the natural and cultural by allowing for the possibility of landscapes that are entirely 'natural' and not somehow 'cultural'. This issue will be discussed in more detail later in this chapter in relation to the idea of wilderness.

Biodiversity

The concept of **biodiversity** is central to natural heritage charters such as the Australian Heritage Charter and to the work of the International Union for Conservation of Nature (IUCN). The IUCN was founded in October 1948 as the International Union for the Protection of Nature and has also been known as the World Conservation Union. It was founded to support scientific research and collaboration between governments and non-governmental

organisations (NGOs) on matters relating to environmental conservation. Biodiversity differs from objects of heritage such as works of art or historical artefacts in that it refers to living organisms that are constantly changing and interacting both with one another and with their environment. We can think of it as a form of **intangible heritage** composed of the interactions between various species and the natural world.

What is biodiversity?

To an ecologist diversity is a specific measurement. It has two components, species richness and relative abundance. Species richness is the number of species in a given area. This is a fairly simple measure; however, since each species counted has equal weighting it is not always an accurate reflection of diversity, as exemplified in Table 3.1.

Table 3.1 Data for two sites where the beetles caught in pitfall traps were identified and counted

	Number of beetles counted	
	Site 1	Site 2
Species A	200	20
Species B	5	0
Species C	1	27
Species D	0	19
Species E	4	21
Species F	0	13
Species G	3	0

While both sites have a species richness score of 5, Site 1 is dominated by one species. All five species recorded in Site 2, on the other hand, are similarly abundant. So Site 2 intuitively would be the more diverse site. This is why the second component of diversity, relative abundance, is taken into account. Ecologists combine the two measures of species richness and relative abundance as a diversity index. It is not the total number of species that is important in determining diversity but the relative proportions of individuals of each species and the number of species.

Biodiversity is a much broader term than any of these more specific measures of diversity. However, an ecologist might use these measures to monitor biodiversity. The United Nations Conference on Environment and

Development in Rio de Janeiro (known as the Earth Summit) in 1992 produced this definition of biodiversity:

> The variability among living organisms from all sources including terrestrial, marine and other aquatic ecosystems and the ecological complexes of which they are part; this includes diversity within species, between species and of ecosystems.

(United Nations, 1992)

Biodiversity is not only about the number of species, or whether a community is dominated by any species, but it is also about *which* species are present.

This enlarges the perspective from just species diversity up to habitat and ecosystem diversity right down to genetic variation within species. Using this definition, species that may be common and widely distributed in one country may be important internationally; for example, the wild flower known as the bluebell (*Hyacinthoides non-scripta*) is distributed across western Europe as far east as western Germany. However, approximately 45 per cent of the world population is in the UK. Any decline in the UK population is thus critical on a global scale. At the genetic level this same species is threatened by hybridisation with the cultivated species, the Spanish bluebell (*Hyacinthoides hispanica*). At the habitat level it is threatened by the decline of its preferred habitat, deciduous woodland.

This definition of biodiversity highlights the importance of the *full range* of ecosystems. The tropical rainforests are considered important because of their high number of species per unit area but equally important is the Arctic, where although there are not many species, some, such as the polar bear (*Ursus maritimus*), occur nowhere else.

Why preserve biodiversity?

Conservationists use five arguments for preserving biodiversity: utilitarian, ecological, aesthetic, stewardship and ethical.

The utilitarian argument is that biodiversity is a resource to be exploited. The diversity of species may form the basis for new foods, chemicals and pharmaceuticals. For example, digitalin, a drug used for treatment of heart conditions, was originally derived from the foxglove (*Digitalis purpurea*).

The ecological argument is that human life depends on basic services provided by ecosystems, for example water cycles through ecosystems, removing wastes via river systems. The wastes are broken down by soil micro-organisms. Plants lift the water from the soil by evapo-transpiration and so provide clean water as rain.

The aesthetic argument is that humans gain pleasure and spiritual well-being from the peace and quiet of a natural environment. Nature has inspired poets and writers through the centuries, an issue discussed in relation to the Romantic movement later in the chapter. This is a powerful argument which is often used by conservation organisations. It is similar to the sort of argument made for the educational values of heritage conserved in museums (see Chapter 4).

The stewardship argument for preserving biodiversity was expressed quite succinctly by Margaret Thatcher (UK prime minister 1979–90) when she said in her 1988 speech to the Conservative Party Conference 'We do not have a freehold on the planet; we have a full repairing lease' (Thatcher Foundation, [1988] 2009). Humans are largely responsible, directly or indirectly, for the main threats to biodiversity, and each generation therefore has a duty of stewardship to pass on the planet to the next generation in as good a condition as possible.

The ethical argument is that humans should make reparation for damage done in the past by restoring the environment to its 'original' wild state before human influence. This is addressed in the final case study of the chapter on Pleistocene re-wilding.

Threats to biodiversity

The main threats to biodiversity are habitat destruction, fragmentation and degradation, over-exploitation, invasive species and climate change. Since humans first evolved around 1 million years ago they have increased in numbers and spread throughout the world. In the last 200 years, the human population has soared from less than half a billion to over 6 billion at the beginning of the twenty-first century. Humans have occupied and influenced practically the whole planet. Kareiva, Watts, McDonald et al. (2007) have mapped the human footprint on earth and concluded that only 17 per cent of the world's land area has escaped influence by humans and approximately 50 per cent of the world's land area has been converted to agriculture. It is the ability of humans to exploit and manage the resources of the earth that has enabled one species to have such a huge and unprecedented influence on all other organisms.

The effects of habitat destruction on biodiversity are fairly self-evident. When habitats such as tropical forest are logged, the organisms that depend on that habitat are lost. Replacement of the forest with oil palm plantations, as is happening in South-East Asia, or with GM-free soy bean, as in Brazil, leaves the area as a monoculture – it is farmed in such a way as to remove 'pests' and so does not sustain other species. Similarly, fragmentation of natural habitat into small areas surrounded by agricultural or urban land makes it difficult for some species to disperse to new areas. This creates

isolated, inbred populations of low genetic diversity which are vulnerable to environmental change.

A major cause of habitat degradation is pollution by nutrient enrichment which often arises as a result of pollution from agricultural fertilisers, and from human and animal waste. It can have quite serious effects on the structure of biological communities. Many habitats of conservation importance, such as chalk grassland and heathland, are nutrient poor. They contain many specialist species adapted to the difficult conditions in these habitats. Nutrient enrichment allows the more ubiquitous and competitive species to establish and displace the specialist species.

The abandonment of traditional fishing methods in favour of modern technology has led to the systematic destruction of local marine populations. In Ireland, crawfish (*Palinurus elephas*) was traditionally fished using pots, but in the late 1960s tangle nets were introduced and within a few years the population declined dramatically. Unfortunately rarity increased prices for crawfish and so fishing effort increased. Although use of tangle nets was regulated, the population has still not recovered.

Most plant and animal species that are introduced to a country where they are not native, either deliberately or accidentally, do not thrive. However, some species such as Japanese knotweed (*Fallopia japonica*) can adapt. Since they are not kept under control by the natural enemies of their native land they become invasive and spread quickly displacing native species. Rhododendron (*Rhododendron ponticum*) is a serious pest of heathland which displaces heather (*Calluna vulgaris*). Not only is it difficult and expensive to eradicate, but there is a conflict of different heritage interests since rhododendron is often a valued component in the landscaping of large country estates.

Conservationists argue that since most threats to biodiversity are caused by humans, it should be possible to reduce or perhaps even reverse these threats. Using the UK as an example, the following case study shows how the two main approaches to conservation – protection and restoration – are applied in a national context, and the extent to which utilitarian and aesthetic/moral arguments are used as justification for their implementation.

Case study: biodiversity in the UK

Protection

Nature reserves

When the writer Daniel Defoe visited the Cambridgeshire Fens in 1722 he described a world that was very different from the one that exists today.

I had a first view of Cambridge from Gogmagog Hills. As we descended westward, we saw the fen country on our right, almost all covered in water like a sea ... for all the water of the middle part of England which does not run into the Thames or the Trent, comes down into these fens. ... In these fens are abundance of those admirable pieces of art called duckoys [a type of trap for ducks]. ... It is incredible what quantities of wildfowl of all sorts, duck, mallard, teal, widgeon, etc. they take in those duckoys every week during the season. ... There is a duckoy not far from Ely, that they generally sent up three thousand couple a week [to London].

(Defoe, [1724–6] 1971, pp. 100–1)

Even in Defoe's time this watery world, teeming with wildfowl, was disappearing as the fens were drained to allow the land to be used for agriculture. Nineteenth-century English naturalists were among the first to recognise the value of these fens as a unique, disappearing, habitat for wildlife (Figure 3.2). Many of them were wealthy enough to set about buying up undrained fenland to preserve it. This land was transferred to the, then embryonic, National Trust between 1899 and 1910 and formed the core of Wicken Fen, one of the first nature **reserves** in England.

In the early days of the nature reserve it was thought that this action alone had saved a piece of the fen forever, but it was soon discovered that preserving biodiversity was not so easy. Within about thirty years of its establishment,

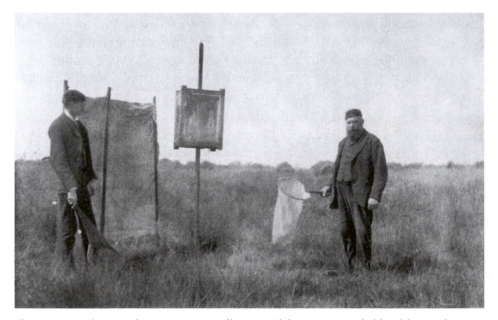

Figure 3.2 Nineteenth-century naturalists on Wicken Fen, Cambridgeshire. Unknown photographer.

the habitat on the reserve was deteriorating badly and populations of many of the bird and insect species were declining. William Farren, one of the early naturalists, summarised the problem:

> When Wicken Fen first came under control of the National Trust, there was a general idea – perhaps a natural one – that it should be allowed to run wild and, to quote an expression often used, to return to its original state. This entirely ignored the question, which is the state most suitable to the economy of the species of insects of all orders for which the Sedge Fen is famous?

> (Friday, 1997, p. 216)

The setting aside of an area of land to protect it from a perceived threat (in this case drainage of the land) is conservation in its crudest form. It does not take into account a basic ecological process called succession. Nor does it consider the reason why the fens around Wicken had not been drained by the late nineteenth century when the naturalists first discovered how rich they were in wildlife.

During succession the structure of a community gradually changes until a stable climax community is attained. In fenland, areas of deep open water become full of submerged water weeds and fringed with reeds. As these plants die, their remains build up and the depth of the water is reduced. This allows reeds to grow closer to the centre until eventually the area of open water is closed over. In time, the area becomes suitable for other plant species to colonise, such as fen sedge (*Cladium mariscus*). Eventually the land becomes drier and woody plant species are able to colonise until shrubs give way to trees and new woodland is formed. This is the climax community. Each community in the succession modifies the environment which permits colonisation by other species more suited to the new conditions and so the original species are displaced.

Traditionally, Wicken Fen was managed in order to produce sedge which was used for thatching. As long as there was a demand for sedge then the fen would not be drained. This is why Wicken Fen had not yet been drained at the end of the nineteenth century. Regular cutting for sedge arrests the process of succession and so the fen is maintained. Once this was understood, a management plan was set up for Wicken Fen which included a systematic cutting regime and regular monitoring of the plants and animals on the reserve.

The lessons to be learned from the early experiences of Wicken Fen are that nature does not stand still. Nature reserves need to be considered as more than places of sanctuary for wildlife. To maintain a habitat for particular species it is necessary to manage the site actively. Since habitat suitable for one species may be unsuitable for another, choices have to be made about

which species will be encouraged. At the time the management plan for Wicken Fen was drawn up a decision could have been made not to maintain the sedge-cutting regime, to let natural succession take its course and permit a woodland to form. This could have been a valid decision since the Cambridgeshire Fens is an area with very little woodland. If this had been done, however, the species that depend on fen habitat (the very ones the nineteenth-century naturalists set out to protect) would have been lost. Similar situations exist in many other habitats of conservation interest, such as chalk grassland, hay meadows and most deciduous woodland. All are the result of human management practices in the past and their maintenance requires continued management. There is an important link between cultural and natural heritage since the preservation of a traditional way of life is crucial to the conservation of the natural heritage (Figure 3.3).

In the UK the flagship reserves are the national nature reserves (NNRs). These were set up after the Second World War to act as a living, national collection of the natural flora and fauna. It was intended that the collection would contain the best examples of every habitat type, both typical and unusual. The experience of the early nature reserves, such as Wicken Fen, highlighted

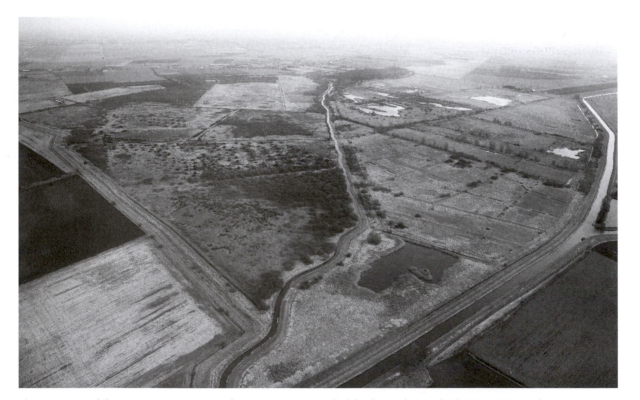

Figure 3.3 Wicken Fen – a sanctuary for nature surrounded by intensive agriculture, 2006. Unknown photographer. Photo ©: National Trust/Wicken Fen.

the need for an understanding of ecological processes to underpin reserve management. The NNRs are places where scientific studies are carried out (some of the larger ones, such as Monks Wood in Cambridgeshire, had research stations within them) and the results of these studies are applied directly in their management. NNRs are the responsibility of government-funded national conservation agencies (at the time of writing these are Natural England (NE), Scottish Natural Heritage (SNH), Countryside Council for Wales (CCW) and Northern Ireland Environment Agency (NEA)). There are 348 NNRs in the UK, of which over 200 are in England.

To complement NNRs, local authorities may designate local nature reserves (LNRs) within their jurisdictions. In contrast to NNRs, LNRs are intended primarily to provide opportunities for the public to see and enjoy nature, so their role is as much recreational and educational as it is for conservation of wildlife. In addition to publicly funded reserves, non-governmental organisations such as the Royal Society for the Protection of Birds (RSPB), the National Trust and the county Wildlife Trusts have their own extensive networks of reserves.

Designations of other habitats

The protection of habitats outside nature reserves is achieved by a series of designations derived from a mixture of UK legislation, directives from the European Community (EC), international treaties and some local designations at county level. Table 3.2 lists some of the more important designations.

The most important scientific designation is site of special scientific interest (SSSI, known as 'triple SI'). It is unlawful to damage SSSIs. Owners and local authorities are obliged to consult with the national agency about site management and planning issues involving the site. The advantage to the owner is that SSSI status can help attract some government grants for site management. The UK government uses the legislation governing SSSIs to fulfil its international and European obligations, so some sites may attract Ramsar and SAC designations (see Table 3.2) as well as SSSI.

The difference between nature reserves and designated areas is that management for nature conservation is not necessarily proactive in designated areas. The advantage of designations is that they can cover a much wider area than nature reserves. In England and Wales NNRs cover 86,000 ha of land (0.6 per cent) whereas SSSIs cover 1,129,000 ha (7.4 per cent). In addition, designations require only discretionary expenditure by the government.

Table 3.2 A summary of some of the more important conservation designations in the UK

Nature conservation	SSSI	Site of special scientific interest	UK legislation	Nationally important sites containing representative examples of major habitat types or geological features or which support rare or threatened species
	SPA	Special protection area	EC directive	Requires government to conserve habitat of rare or threatened or migratory birds
	SAC	Special area of conservation	EC directive	Requires government to conserve habitat of particular conservation importance
	CWS	County wildlife site	Local	Important wildlife areas in county context. Local authorities to protect from adverse development
	Ramsar site		International Treaty following the Ramsar Convention at Ramsar in Iran in 1973	Government committed to designating 'wetlands of international importance' (Ramsar sites) and to using the wetlands within its territory wisely
Natural landscape conservation	AONB	Area of outstanding natural beauty	UK legislation	To protect and enhance areas of beautiful natural landscape. Local authorities obliged to have management plan
	SLA	Special landscape area	Local	Protection for areas outside AONB which are vulnerable to change as identified in county structure plans
Cultural landscape conservation	National park		UK legislation	Areas administered by a park authority to conserve and enhance natural beauty, wildlife and cultural heritage and promote enjoyment by the public
	ESA	Environmentally sensitive area	EC directive	Areas with locally characteristic landscapes, ecology and historical resources that would benefit from agricultural management to conserve and enhance these characteristics

Biodiversity action plans

The Rio de Janeiro Earth Summit in 1992 was a turning point for conservation throughout the world. For the first time biodiversity became a political priority. A commitment to 'develop national strategies, plans or programmes for the conservation and sustainable use of biological diversity'

(the Convention on Biological Diversity) was signed by 150 countries (United Nations, 1992, Article 6).

The UK response was the publication, in 1994, of the UK Biodiversity Action Plan (BAP) (Department of the Environment, 1994) which initiated a series of action plans, known as BAPs, to protect critical habitats and species. At the time of writing (2009), there are 65 priority habitats and 1149 priority species. The criteria for priority habitats are as follows:

- they are habitats for which the UK has international commitments
- they are at risk (that is, they are declining rapidly)
- they provide critical services (for example, breeding areas for a wider ecosystem)
- they contain priority species.

To qualify for priority status species should fulfil one or more of the following criteria:

- they are rare (found in fewer than fifteen sites of 10 km squares)
- they are fast declining (by more than 25 per cent in the past twenty-five years)
- one quarter or more of the world population is located in Britain
- they are legally protected.

Each BAP sets targets for recovery of the species or habitat and lists the actions required.

Priority BAP status differs from conservation designations in that there is no link to a particular place, and no legal protection is conferred. The value of BAPs is that they provide a focus for biodiversity policy throughout the UK. They allow priorities to be set when designations are being agreed, and they inform decisions about how particular sites should be managed. They go beyond mere preservation of existing biodiversity and more towards the idea of restoration.

Custodians of the countryside? Agri-environment schemes

Agriculture has had a major impact on biodiversity. In the UK during and after the Second World War it was government policy to aim towards self-sufficiency in food. This led to a systematic intensification of agriculture through generous subsidies and free scientific advice to farmers. The European Community Common Agricultural Policy reinforced this process in the 1970s and 1980s. Traditional farming methods were abandoned and farming became more industrialised. Hedgerows were removed to accommodate the large machinery, bringing about a huge change in the

landscape: the familiar 'patchwork quilt' of pre-war years gave way to monocultural 'deserts'.

The first indication that this policy was having undesirable side-effects was in the early 1960s when the decline of populations of predatory birds, such as the peregrine falcon (*Falco peregrinus*), was linked to the use of persistent pesticides such as DDT. Farmland birds such as finches and buntings lost out on winter fodder and hedges as nest sites (Stoate, 1996). The increased use of silage as winter animal fodder led to the demise of hay meadows which created problems for ground-nesting birds such as corn crake (*Crex crex*). Since over 70 per cent of the total land area of the UK is used for agriculture, these changes had serious implications for UK biodiversity. It was clear that protecting the best sites through nature reserves and SSSIs was no longer sufficient. As in the case of representative approaches to cultural heritage, schemes that set out to preserve the common and widespread species were now deemed necessary.

It was not until the 1980s, however, when the accumulation of embarrassing surpluses of grain, milk, butter and other products showed up the flaws in this 'productivity at any cost' policy, that politicians began to take action. In 1984 the Environmentally Sensitive Areas (ESA) scheme was introduced. This designated areas of special biological, landscape or historical interest, such as the Norfolk Broads, the Somerset Levels, the South Downs, and the Suffolk River Valleys. The criteria for designation required that they were:

- of national environmental significance
- areas where conservation depended on the adoption, maintenance or extension of a particular form of farming practice
- areas where there had occurred or where there was likely to occur changes in farming practices that posed a major threat to the environment.

In these areas farmers could apply for payments in return for entering into a ten-year agreement to farm less intensively, which included maintaining conservation features such as hedges and traditional barns. What made ESA different from all previous conservation schemes was that it was administered by the Ministry of Agriculture, Fisheries and Food (as it was then called) and not by a recognised nature conservation body.

Although over twenty ESAs were designated this amounted to only a fraction of the agricultural land in the country (10 per cent in England). In 1990, a supplementary scheme was introduced, Countryside Stewardship, which unlike ESAs, was linked to habitats, such as chalk grassland or lowland heath, rather than to geographical areas, which gave it wider coverage. Both schemes were superseded in 2005 by the Environmental Stewardship Scheme. This is intended to simplify administration and improve take-up, but it is based on principles that are similar to its predecessors.

Under these schemes farmers may agree to leave field margins uncultivated or to provide over-wintering sites for predatory beetles (beetle banks). These schemes are not about a return to traditional agricultural practices but are intended to provide space for nature and to reduce the worst effects of intensive agriculture.

Restoration

BAPs and agri-environment schemes go beyond the concept of protection to suggest that it is possible to repair the damage caused by human influence. Restoration is the other main strategy used in biodiversity conservation. It uses the ethical argument that humans have a duty to repair damage caused by their influence and the ecological argument that it is in the best interests of humans to restore any lost ecosystem services.

The aims and effects of restoration are not always obvious. Rackham (2006) points out that a newly planted wood is quite different from an ancient wood. The absence of very old trees means that the specialist insects and fungi associated with them are also absent. Similarly, the effects of the past management of the wood, such as coppicing and pollarding, will be absent and so too will their influence on the flora and fauna. Species such as bluebells (*Hyacinthoides non-scripta*) or wood anemone (*Anemone nemorosa*) do not disperse easily and so do not spread to new woods. Although some restoration projects attempt to plant these species in the new woods, this begs the question of whether this is wildlife gardening or conservation. The creation of new woods is often put forward by developers as mitigation for the destruction of an ancient wood. Rackham (1994) made an interesting comment regarding such a proposal by the developers of Eurotunnel:

> A reconstruction, however well organised, can incorporate only those features that were known about at the time it was begun. It is a pastiche – the equivalent of throwing away a painting by Constable and substituting a painting by Tom Keating [a notorious art forger] in the style of Constable.

(Rackham, 1994, p. 207)

Walker, Warman, Bhogal et al. (2007) have investigated the difficulties of restoring heathland on land that has been used for agriculture. Heathland soil is typically low in nutrients and very acid. To convert heathland soil for agricultural purposes it is necessary to apply large quantities of fertilizer, to increase the nutrients and to add lime, to make the soil less acid. Converting agricultural land back to heathland is not so easy since the residual nutrients are difficult to remove. They have concluded that restoration of arable land back to heathland is too difficult and expensive, and that the end result is not a natural heathland.

They recommend that such land be restored to acid grassland. In this case, restoration is not about restoring the earlier habitat (what we might consider to be the heritage habitat) but it has validity on ecological grounds since it will restore ecosystem services.

Re-introduction

A restoration strategy based on individual species is the re-introduction of species that have become extinct or are almost extinct. The IUCN has devised a set of criteria that is used worldwide to decide which species should be re-introduced:

- there should be good historical evidence of former natural occurrence
- only species lost through human agency and unlikely to re-colonise naturally should be considered
- factors causing extinction should be rectified
- there should be suitable habitat of sufficient extent to which the species can be re-introduced
- re-introduced individuals should be from a population that is as close as possible, genetically, to that of the former native population
- their loss should not prejudice the survival of the donor population.

A successful example is the re-introduction of red kite (*Milvus milvus*) to England and Scotland (Figure 3.4). This bird was once widespread throughout

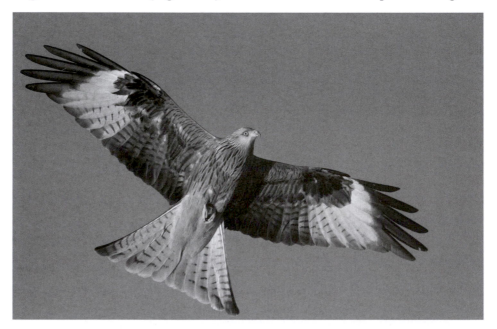

Figure 3.4 Adult red kite in flight, mid-Wales, 2008. Photographed by Andrew Parkinson. Photo: © Andrew Parkinson (rspb-images.com).

the UK. Although it is mainly a scavenger, it was perceived as a threat to gamebirds and was systematically persecuted. By the end of the nineteenth century it was extinct in England and Scotland. A small population survived in Wales, but despite being protected and showing signs of recovery it had failed to spread. A re-introduction programme was started in England and Scotland in 1989, with the first introductions in the Chilterns and northern Scotland. As breeding pairs became established more sites were added to provide an even spread over the whole country. By 2008 there were 1200 breeding pairs recorded. While the UK population has been expanding, the European population has been in decline and the UK population now represents 5 per cent of the world population.

Although this has been a remarkably successful re-introduction programme it should be remembered that it has taken twenty years and a lot of dedicated effort to achieve it. Can all this effort and expense be justified simply on ethical grounds? It could be argued that scarce funding for conservation projects should be targeted at the preservation of habitats where many species will benefit. The proponents of re-introduction projects argue that conservation as a whole benefits from the publicity and awareness raised among the public from such high-profile projects. An example is the Northern Kites project in Gateshead. Education packs were produced for local schools. Each school was encouraged to adopt one of the kites, which the children named. Events were arranged at the release sites so the public could see the birds and learn to appreciate them. The local bus company painted one of their buses as a red kite and ran it on a route which passed near the release sites. The council constructed a Red Kite walking trail. The brewery even produced a Red Kite ale. The local economy benefited from the increase in the number of visitors to the area.

Reflecting on the case study

The UK experience shows how much natural heritage is dependent on human activity. The early experience at Wicken Fen shows that it is not enough just to protect land from human influence. Land must be actively managed to maintain the species that are to be conserved, and decisions have to be made about which species these should be. Many habitats, containing unique species, are the result of human activities such as coppicing and sedge cutting. Therefore these traditional activities need to be maintained as part of site management. Although nature reserves are good for preserving the best sites in the country they can only ever cover a small area of land. There is a need for schemes such as SSSIs and agri-environment schemes to preserve and leave space for nature over a wider area. BAPs are necessary to set priorities nationally and locally.

Attempts to restore arable land to heathland show that it is not always possible to get back to the habitat that existed previously. The recommendation to convert redundant arable land to a habitat that did not exist at that site before shows that restoration is about creating natural habitat rather than trying simply to turn back the clock (Walker, Warman, Bhogal et al., 2007). Although re-introduction schemes set out as mitigation for human persecution of particular species their value is as much in raising awareness among the public as it is about attempting to restore a species to the wild.

There is a direct parallel between the changing approaches to natural heritage management and the changing approaches in cultural heritage management that have taken place over the course of the twentieth century, as discussed in Chapters 1 and 2. Early conservationists, such as those concerned with conserving Wicken Fen, thought that conservation was simply a matter of letting nature look after the land. Many of the areas targeted by early conservationists (such as the early US national parks discussed in the next case study) were chosen as much for their aesthetic value as for their value in preserving plants and animals. However, it is now understood that human management of the land is important for the preservation of many species. With the increased involvement of environmental scientists in natural heritage management, focus has shifted to the active management of 'representative' samples of landscape. The concept of biodiversity measures the conservation values of an area of land in terms of its rarity and **representativeness**. In the same way that in cultural heritage a single 'canon' has given way to the conservation of representative examples of all forms of cultural heritage, so biodiversity conservation assumes that all ecosystems have a right to exist, and that those most threatened on a local, regional, national or worldwide scale should receive appropriate levels of conservation to preserve them.

The problem of wilderness

The chapter so far has largely been concerned with issues arising from western industrialised agricultural practices in densely inhabited regions. The first case study has focused on the ways in which the intensive agricultural practices and occupation patterns in the UK have created particular issues for nature conservation, and how the management of natural heritage in the UK is structured by national and international conventions on biodiversity. The second part of the chapter now shifts to the apparent opposite perspective, the notion of wilderness. The discussion problematises the idea of 'wilderness' within the context of its western philosophical origins and by showing that there are almost no untouched regions. Whose wilderness is it, and who is it being conserved for? In the discussion that follows these issues are examined

in the context of colonial and settler societies, beyond Europe (where there are very few 'wildwood' areas, that is, wood never cleared and re-established by humans), and in particular in terms of the rather problematic relationship between natural heritage conservation and indigenous people in such societies.

The 'nature' of heritage

Are there natural places that exist outside the realm of human cultural significance? When we use the words 'nature' or 'natural' in everyday language we mean things that are not made or influenced by humans. This philosophy of nature has had a fundamental influence on the relationship between natural and cultural heritage management, and on perceptions of natural heritage management in particular.

The idea of a divide between nature and culture has a long history in western thought. With the spread of industrial capitalism in the eighteenth and nineteenth centuries, Romantic artists and writers developed and idealised the notion of spaces that were outside the influence of technology and commercialisation, areas of wilderness or agrarian economies (Figure 3.5). In the late eighteenth and early nineteenth centuries British artists such as John Constable and J.M.W. Turner, and US authors such as Ralph Waldo Emerson and Henry David Thoreau were influential in creating the idea of wilderness beyond the realms of industrial civilisation. The idea of wilderness was strongly influenced by Judaeo-Christian notions of the fall from grace in the Garden of Eden and the idea of a lost, natural golden age of humanity in which humans existed in balance with nature (Olwig, [2001] 2008).

The American author John Muir, whose prolific writings on the relationship between humans and nature brought the concept of wilderness to a wide audience in the late nineteenth century and the years leading up to the First World War, is widely credited as the first modern conservationist (Oelschlaeger, 1991, p. 172). His activism, and that of the conservationist society known as 'the Sierra Club' which he founded in San Francisco in 1892, were significant in the establishment of a number of the first US national parks, including Yosemite National Park (based on the model of Yellowstone National Park, discussed in more detail below). For Muir, wilderness was the manifestation of God. In his work *John of the Mountains* he wrote

> In God's wildness lies the hope of the world – the great fresh unblighted, unredeemed wilderness. The galling harness of civilization drops off, and wounds heal ere we are aware.
>
> (Wolfe (ed.), [1938] 1979, p. 317)

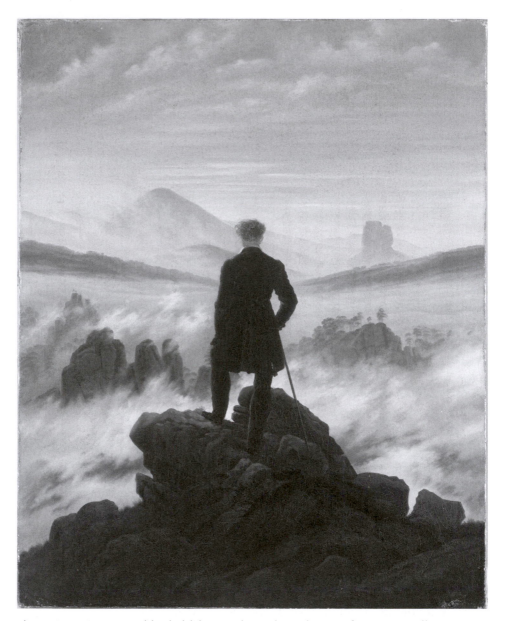

Figure 3.5 Caspar David Friedrich, *Wanderer above the Sea of Fog*, 1817, oil on canvas, 95 × 75 cm. Kunsthalle, Hamburg. Photographed by Elke Walford. Photo: © bpk/ Hamburger Kunsthalle/Elke Walford.

Fundamental to the conception of wilderness was the idea that natural places were good for the human constitution but also fragile and in need of protection from humans and industrial development. This had a profound influence on the scientific study of sustainable forest management in the nineteenth centuries in Europe, British India and the USA (Nash, 1967).

This concept of wilderness has been criticised in a number of ways. We have already seen how an indigenous critique from countries such as Australia and New Zealand with a strong nature conservation tradition influenced UNESCO in the recognition of 'cultural landscapes' as part of the World Heritage List. In Australia for example, interactions between indigenous people and the environment have had a major formative impact on the landscape (see, for example, Rose, 1996). One of the problems with the concept of a 'wilderness' is that it assumes there was a time when nature was 'pristine'. But we know that humans have been modifying their environments for as long as they have existed. We need to recognise wilderness as a conceptual construct based on a set of values regarding the relationship between nature and culture, humans and their landscapes, that may not be shared by all people.

Another criticism of the concept of wilderness concerns its relationship with the picturesque. Wilderness areas are perceived as places that must be beautiful or aesthetically moving, which minimises their usefulness as places for the conservation or preservation of biodiversity: the focus is on particular sublime landscape types, and not on the whole range of biological diversity. The case study that follows explores some of the ways in which these late nineteenth-century ideas about wilderness were manifested in the establishment of the first US national park and the US National Park Service. It also looks at the relationship between natural heritage and its management by the state from a historical perspective.

Case study: Yellowstone and the United States National Park Service

Yellowstone National Park, located in the north-west corner of the State of Wyoming and straddling the States of Montana and Idaho, was one of the earliest areas in the world to be set aside as a national park to conserve wildlife and features of the natural environment. The park contains a number of dramatic landscapes including the Grand Canyon of the Yellowstone, the stony uplands of the Rocky Mountains, and a series of rivers, lakes and thermal hot springs and geysers that are popular visitor attractions. It conserves rare and endangered plants and wildlife, including bears, wolves, bison and elk. Yellowstone was gazetted by an Act of Congress on 1 March 1872, at which time it became the first 'wild' area reserved for recreational purposes under the management of the US federal government. It has an intimate connection to the early nature conservation movement, the history of the US National Park Service, the removal of Indigenous American people and their containment on reserves, and the overall project of heritage and nationalism in the USA.

Creating a wilderness

The area now known as Yellowstone National Park was contained within the traditional lands of the eastern and northern Shoshone people (Spence, 1999, pp. 41–70) but was visited and utilised by their neighbours the Crow and Bannock peoples, among others. Its rich source of fine obsidian for the production of stone tools was traded throughout the central USA, and its geysers were visited by indigenous people who left offerings and incorporated its thermal springs into their spiritual landscape. The equestrian Shoshone communities ranged across a large part of Wyoming, south-western Montana, central and eastern Idaho and northern Utah. They lived a seasonal round: buffalo hunting on the plains and fishing for salmon in the spring; aggregation for inter-tribal gatherings associated with the predation of bighorn sheep, elk and deer, and dangerous forays into adjacent hostile territories to hunt buffalo in the late summer; and dispersal into small bands which ranged through the mountains in the late autumn and winter (Spence, 1999, p. 46).

Although part of the area and its thermal features were described during the expedition of Meriwether Lewis and William Clarke (1804–6), the area was little known to non-indigenous people until explorers began to infiltrate the area in the late 1860s. Influenced by the ideals of Emerson and Thoreau, they suggested that instead of opening the area for settlement it might be considered for reservation. In 1871 the explorer Ferdinand Hayden wrote a comprehensive report on Yellowstone which included large-format photographs made by William Henry Jackson and paintings by Thomas Moran (Haines, 1974) (Figure 3.6). This is significant, as it demonstrates an early link between landscape photography and painting and the creation of wilderness and natural heritage. Hayden's report sought to convince the US Congress to withdraw this region from public auction. On 1 March 1872 President Ulysses S. Grant signed the bill that created Yellowstone National Park.

Early visitation to the park focused on 'monumental' landscape features described by exploration parties of the late 1860s and early 1870s, in particular the geysers and the Grand Canyon (Spence, 1999, p. 55). However, increased visitation during the late 1870s led to a series of conflicts between Indigenous Americans and members of the US Army, who had been charged with the role of administering the park. Groups of Indigenous Americans were discouraged from occupying and using the heavily visited parts of the park, and some people were removed to nearby reservations, although Indigenous Americans continued to occupy and use the park throughout the 1880s and 1890s (Figure 3.7). Spence (1999, p. 60) notes that at this time the park had begun to be perceived as more than a recreational area, and instead as a conservation area, a sort of 'Eden of America'. As its significance became defined in terms of the conservation of plants and

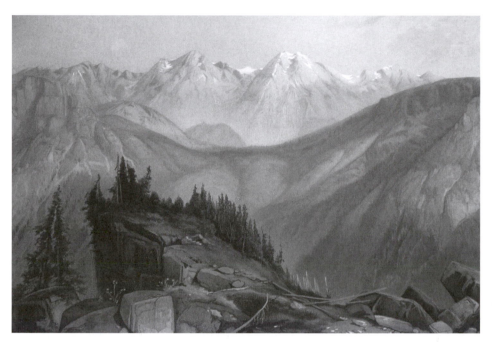

Figure 3.6 Thomas Moran, *Lower Yellowstone Range*, 1874, watercolour, 24 × 36 cm. Smithsonian American Art Museum, Washington DC. Photo: © NPS.

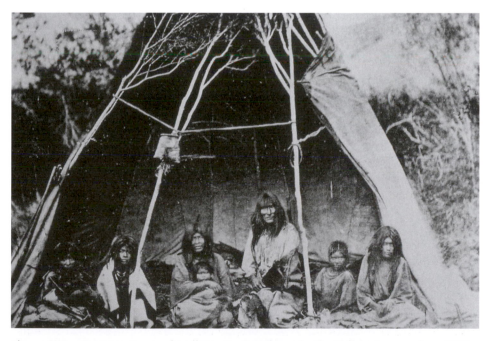

Figure 3.7 Summer Camp of Indigenous Americans in the Yellowstone region, 1871. Photographed by William H. Jackson. Photo: © NPS.

animals, the perceived threat to the park by aboriginal hunters and gatherers became more urgent. Indigenous Americans were forcibly removed from the park, during the early 1890s, culminating in 1895 in the shootings of a large number of Bannock people. Although the rights of aboriginal people to hunt within the Yellowstone area had been recognised by the federal government in a treaty passed in 1868, park officials in 1896 convinced the State of Wyoming and the Bureau of Indian Affairs to bring before the federal judiciary a case against a Bannock man for violating the state's game laws. Although the treaty rights were initially upheld by the judge's decision, they were subsequently reversed in another case, which would have a devastating impact on the rights of indigenous people to occupy and use the park.

The decision to over-ride the treaty rights of the Shoshone (and by implication Bannock and Crow peoples) effectively gave park administrators as well as state and federal agencies the right to prevent Indigenous Americans from entering Yellowstone Park and to enforce their residence on nearby reservations (Spence, 1999, p. 68). As Spence notes,

> Yellowstone ... provides the first example of removing a native population in order to 'preserve' nature. As an empty, seemingly untouched landscape ... Yellowstone represents a perfect Eden, a virtual manifestation of God's original design for America. This conception of wilderness ... proved so powerful that early preservationists either dismissed or ignored any evidence of native use and habitation. And later, when park officials did take notice of Indians, they viewed native hunters as dangerous and unnatural threats to Yellowstone's fragile environment ... these ideas shaped park policy for decades, until Yellowstone had indeed become a place that native people neither used nor visited ... Yellowstone's early history demonstrates that the creation of an uninhabited wilderness required a great deal of effort.

> (Spence, 1999, p. 70)

This pattern of exclusion of indigenous people from US parks and increased insistence on their residence on lands specifically reserved for them was to be repeated across the USA in the years that followed.

Managing Yellowstone for the 'nation'

The removal of indigenous people from the park coincided with a period during which a series of facilities were built to promote and enhance the experience of tourism and recreation in the park, and to house the soldiers who would help 'manage' it. The Corps of Engineers and the US Army began a series of works, constructing roads, bridges, forts and barracks and isolated back-country patrol outposts, as well as hotels, inns, campsites and other

places to accommodate visitors. Many of these structures were built in the area surrounding Mammoth hot springs, and were later converted for use by park administrators in the years following the creation of the National Park Service in 1916. In 1903 an enormous arch was constructed at the new entrance to the park, which was facilitated by the construction of a railway. The arch was named the Roosevelt Arch to commemorate the visit of President Theodore Roosevelt, who would become an important spokesperson for the national park movement (Figure 3.8). In the same way that the removal of indigenous people from the park had been an integral aspect of constructing Yellowstone as a wilderness area, the building of visitors' facilities and commemorative architecture was part of the process of turning this wilderness into a 'national park'.

The Antiquities Act, which was approved by Congress on 8 June 1906, was a key instrument in the development of a US National Park Service. The Act gave the president authority

> to declare by public proclamation historic landmarks, historic and prehistoric structures, and other objects of scientific interest that are situated upon the lands owned or controlled by the Government of the United States to be national monuments.
>
> (Washington, DC, GPO, 1906, Section 431)

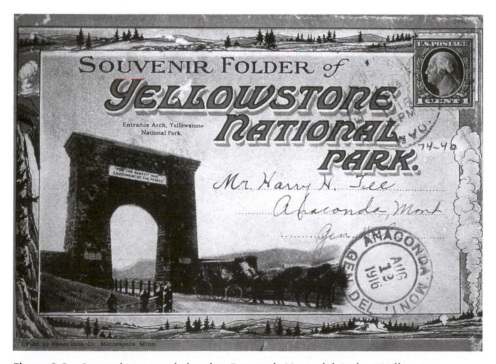

Figure 3.8 Souvenir postcard showing Roosevelt Memorial Arch at Yellowstone National Park, *c.*1916. Photo: © NPS.

Monuments of military significance would be managed by the secretary of war, while those in national forests were managed by the Department of Agriculture. Others remained under the jurisdiction of the Department of the Interior. This fragmented system is said to have been instrumental in President Woodrow Wilson's decision in 1916 to create the National Park Service as a separate bureau of the Department of the Interior (Kieley, 1940). The National Park Service Organic Act 1916 specified the role of the National Park Service as being to

> promote and regulate the use of the Federal areas known as national parks, monuments, and reservations ... which purpose is to conserve the scenery and the natural and historic objects and the wild life therein and to provide for the enjoyment of the same in such manner and by such means as will leave them unimpaired for the enjoyment of future generations.
>
> (National Park Service, US Department of the Interior, 2008a)

The aims of the 1916 Act have been perceived within the history of the National Park Service as contradictory. Commenting on the history of Yellowstone National Park, Rydell and Culpin note

> how can a building intended to inform visitors be compatible with preserving the park's natural conditions, when a building, per se, is not natural? Any history of the administrative facilities built in the park must address these tensions.
>
> (Rydell and Culpin, 2006, p. vi)

This perception of the total separation of humans and nature was less obvious in the early years of the park's operation but has increasingly been seen as a problem within the US National Park Service, with the growing influence of certain environmental philosophies that maintain an essential disjuncture between nature and culture within the conservation movement.

Administration of Yellowstone was passed over to the National Park Service shortly after the 1916 Act was passed. The park became a focus for visitation and tourism, and in the years leading up to the Second World War there was intensive construction of visitor facilities by the Civilian Conservation Corps – part of a work relief programme established by President Franklin Roosevelt to combat unemployment during the Great Depression. After the Second World War visitation increased again as the government sought to promote national parks as places for recreation and public education. Even though much construction work had ceased during the war, the US government saw its national parks as central to establishing a sense of national pride and education regarding citizenship of the nation. In *A Study of the Park*

and Recreation Problem of the United States (1941) the secretary for the interior, Harold L. Ickes wrote:

> The inspiration experienced through visiting the Nation's scenic wonders and historic shrines instills a love of country and maintains morale, and participation in recreational activities is vital to the welfare of the people, both military and civilian.

(Ickes, 1941, p. v)

During the 1950s an ambitious plan was launched to revitalise the visitor facilities associated with all of the US's national parks in time for the fiftieth anniversary of the National Park Service in 1966. 'Mission 66' focused on upgrading roads and other transport connections to and within national parks, and saw a major building programme of visitor centres and accommodation facilities which would act as an educational link between nature and the nation. Within Yellowstone National Park, new visitor centres were constructed at New Canyon Village between 1956 and 1958, and at Grant Village in 1965 (Figure 3.9). Mission 66 has become famous for introducing modernist architecture into the national park system (Allaback, 2000), but it was also a coordinated attempt to develop an educative infrastructure for the more effective communication of the national park ideal to US citizens.

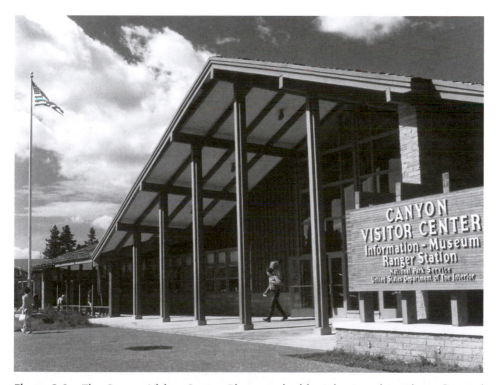

Figure 3.9 The Canyon Visitor Center. Photographed by John Brandow. Photo ©: NPS/ John Brandow.

This educative and nationalistic project of the National Park Service is clear from contemporary statements regarding the mission of the service. At the time of writing, their website notes:

> Most people know that the National Park Service cares for national parks, a network of nearly 400 natural, cultural and recreational sites across the nation. The treasures in this system – the first of its kind in the world – have been set aside by the American people to preserve, protect, and share, the legacies of this land.
>
> (National Park Service, US Department of the Interior, 2008b)

What began with the activism of a few individuals had developed into a nationalistic programme of education by the state that required the 'active' construction of wild places in order to produce a vision of the USA with which its citizens could identify. Through its engagement with UNESCO and the IUCN, the US National Park Service and its national parks became a model for nature conservation and natural heritage management throughout the world.

Reflecting on the case study

One of the striking features of the case study is its demonstration of the 'active' creation of wilderness through the forced removal of Indigenous American people. This illustrates the way in which a perception of wilderness and nature that is at odds with human culture might present a conflict between different systems of value, in this case, indigenous people and the state. Some authors have argued that such forms of natural heritage management proliferate in settler societies that need to provide a moral and historical basis for the occupation and usurpation of land from indigenous people (Harrison, 2008). The 'active' management by humans to create 'natural' areas such as national parks remains a core contradiction of nature conservation and national park management.

Another issue that is woven through the case study is the way in which natural heritage management, like cultural heritage management, contains what we have come to recognise as AHDs associated with the state's educative nationalistic agendas. One of the ways in which natural heritage management obscures such discourses is through an emphasis on the moral correctness, or even the 'natural-ness', of national park management and other forms of conservation. But as we have seen, wilderness is not something that is 'natural', it is something that is created through various discourses and the active management and delineation of land. This process mirrors processes in cultural heritage management, for example the creation of Welsh dress as national heritage, described in Chapter 1.

The final case study in this chapter considers the issues that arise when the ideas of some nature conservationists about the purity of wilderness and the need actively to reconstruct natural landscapes are taken to their logical extreme. The yearning to re-create a natural wilderness (re-wilding) as it was before the arrival of humans is also prevalent among some ecologists. Although humans evolved about 1 million years ago, they first began to make a major impact on the world around them during the late Pleistocene. This is the time about 18,000 years ago when the earth was emerging from the last Ice Age. Some ecologists suggest not only that it is possible to re-create this wilderness but also that it is a human duty to do so, in order to mitigate the harm done by humans in the past.

Case study: Pleistocene Park – the ultimate restoration project

The idea of Pleistocene re-wilding was first suggested by Paul Martin (1970) but was largely ignored until the work of Sergey Zimov some ten years later. Zimov is a Siberian scientist who has studied the historical ecology of Northern Siberia and the surrounding ancient area known as Beringia (Eastern Russia, western Alaska and the intervening continental shelf) since 1980. He is particularly interested in the causes of the extinction of many species of megaherbivores (large plant-eating mammals such as mammoths, bison, horses, reindeer, musk oxen, elk, moose, and woolly rhinoceros), and predators that depended on them, in the late Pleistocene. This extinction coincided with a change in the predominant vegetation from grass to moss.

Zimov's research led him to suggest that a decline in the megaherbivores caused by improved hunting methods and the spread of humans into Beringia was sufficient to cause vegetation change which in turn tipped the balance and led to the extinction of certain megaherbivores. The interesting point about this conclusion is that it suggested the re-introduction of megaherbivores would reverse the late Pleistocene vegetation change and so restore the area to the way it was before the arrival of humans. Zimov actually tried this. In 1988 he introduced twenty-five wild Yakutian horses to an experimental plot in Kolyma, in western Siberia. In areas where the activity of the herd was concentrated, grasses increased in abundance and mosses declined.

The encouraging results of this pilot study led Zimov to start a more ambitious project that he dubbed Pleistocene Park (Zimov, 2005). The first stage of this project is to gather together herds of the surviving megaherbivore species, including Yakutian horses, reindeer and moose, into a restricted area, where they can be protected from hunting. As megaherbivore densities increase and they begin to have an influence on the vegetation, the boundaries will be gradually expanded until they are allowed to roam the full 160 km sq area of

the site. To supplement the surviving species, musk oxen have already been re-introduced and there are plans to introduce bison from Canada. When the megaherbivores are sufficiently abundant it is hoped to introduce populations of Siberian tigers (a seriously endangered species in the area).

The first of Zimov's two main justifications for this project is scientific research, to test his hypothesis that it is possible to recreate the late Pleistocene vegetation communities by re-introducing megaherbivores. His second justification is conservationist, to mitigate damage to the ecosystem caused by humans in the past.

Although, as mentioned above, re-wilding in the USA was first proposed as early as 1970 by Martin, it was not until Zimov showed how it might be done that the cause was taken up by others (Donlon, Greene, Berger et al., 2005; Donlon, Berger, Bock, et al., 2006). The arguments for re-wilding in the land mass of North America are much more ambitious than in Siberia: they take the concept beyond experimentation and into a much wider context.

In North America the accepted restoration benchmark for conservation is the year 1492. This is the date of the arrival of Columbus and marks the beginning of European colonisation which led to major changes in the landscape, due to ranching, farming and urbanisation, and the consequent extinction of many native species. However, Donlon, Berger, Bock, et al. (2006) argue that a less arbitrary benchmark is the earlier arrival of humans in North America during the Pleistocene. Their evidence for this is the archaeological traces of the coincident arrival, from Asia, of humans in North America and the extinction of the megaherbivores during the late Pleistocene. Evidence that these events are linked is the presence of flint spearheads in mammoth remains.

Donlon, Berger, Bock, et al. (2006) propose a programme to try to restore these lost ecological and evolutionary interactions by introducing to the US species that are closely related (possible descendent species) to extinct Pleistocene species. Where these are not available, ecological proxy species that perform a similar ecological function could include Asian and African elephants for mastodons, mammoths and gomphotheres, bactrian camels for the extinct North American camel and Asian asses and Przewalski's horses as proxies for the Pleistocene horse species. Proxy predators are the African cheetah for the North American cheetah and African lions for the extinct North American lion.

Many of these proxy species are endangered in their countries of origin in Africa and Asia. Not only will the re-wilding programme set out to restore lost ecological interactions, therefore, but it will also turn the USA into a Noah's Ark for the rest of the world, providing back-up populations of endangered species.

Donlon, Berger, Bock, et al. (2006) envisage the programme beginning with the release of captive populations of the proxy species from zoos into 'ecological history parks' which would be large ('thousands of square miles') fenced enclosures in economically depressed parts of the Great Plains within the USA. Species would be introduced one by one so that ecological interactions and changes could be studied. The ecotourism generated by these parks would bring economic benefits to the surrounding areas and would raise awareness of conservation issues among the general public.

The arguments for Pleistocene re-wilding in the USA are as follows:

- The ethical argument. Humans were responsible for the late Pleistocene extinctions, so there is a duty to repair the damage by restoring the lost ecological and evolutionary potential.
- The conservation argument. The USA has the financial resources to protect endangered species, so it can act as a Noah's Ark for the world.
- The economic argument. Ecological history parks will encourage ecotourism and bring economic benefits to the surrounding area.
- The awareness argument. A high-profile and controversial project will raise awareness of conservation issues among the general public.

Not surprisingly, such a radical proposal has generated much discussion and some criticism (Smith, 2005; Chapron, 2005; Dinerstein and Irvin, 2005; Shay, 2005; Schlaepfer, 2005; Rubenstein et al., 2006; Caro, 2007). Instead of restoring the Pleistocene ecosystems, the introduction of exotics to the USA is more likely to create new ecological communities which will be quite unlike either modern or Pleistocene communities. Rather than enhancing biodiversity, Pleistocene re-wilding could be detrimental to it (Figure 3.10). There is also the question of restoration benchmarks. Since the functioning of Pleistocene ecosystems is not fully understood it is difficult to use the arrival of humans during the Pleistocene as a reliable benchmark for restoration.

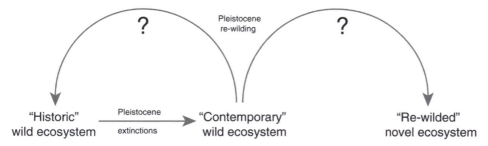

Figure 3.10 Ecosystem Functioning (Figure 1 from Rubenstein et al. (2006)). Re-wilders assume that Pleistocene re-wilding will restore the historic wild ecosystem and original ecosystem functioning. However, it could result in a new re-wilded ecosystem with unique species compositions and new ecosystem functioning.

The introduction of exotics can be unpredictable. Feral camels in Australia are causing problems in desert ecosystems by selectively eating rare plant species. The release of captive bred populations into the wild is often unsuccessful, and the removal of endangered wild species from their countries of origin is undesirable.

Some critics say that a Pleistocene re-wilding project would divert resources from other conservation projects not only in the USA but also in the countries of origin of the proposed proxy species.

Although Pleistocene re-wilding will necessarily have a high profile, it may not create a favourable reaction among the general public. The introduction of organisms that are perceived to be dangerous, such as cheetahs and lions, or damaging to agriculture, such as elephants, is likely to create an anti-environmentalist backlash which could be detrimental to all conservation projects (Shay, 2005).

Reflecting on the case study

The Pleistocene re-wilding case study raises basic heritage issues about the aims of biodiversity conservation and what is being conserved. The question of the most appropriate restoration benchmark suggests that perhaps such benchmarks are arbitrary, and that rather than try to restore to an ill-defined benchmark perhaps the more appropriate action is to preserve the natural world as it is. Restoring the natural world is not as straightforward as restoring a human artefact such as a piece of art, since it is more difficult to decide what was there originally.

Both Zimov and Donlon et al. use the argument that humans are morally bound to mitigate the effects of human action in the past. However, as the Wicken Fen case study showed, the natural world changes and adapts to the actions of humans, and so some organisms are dependent on human actions. Attempts to restore an ecosystem in favour of one organism could be detrimental to others, and intended mitigation could be damaging.

The 'Noah's Ark' argument that endangered species will be safer in the USA than in their country of origin does have a certain arrogance about it. It is not really an argument for wilding at all; rather, it is the argument that is usually deployed in favour of the establishment of a zoo or safari park. We might think of a museum as a parallel for cultural heritage. Many people would argue that cultural 'treasures' should not be held outside their countries of origin, and in the same way the Noah's Ark model of natural heritage conservation seeks to keep a collection of natural 'treasures' outside their context (see Harrison, 2010). Clearly such ideas are controversial and should be considered with caution. More importantly, they force us to

consider the values (see also Chapter 2) that underlie natural heritage conservation and the choices that are made by ecologists who are involved in heritage work.

'Natural' values

Chapter 1 introduced Smith's concept of authorised heritage discourse (AHD). Smith uses the AHD as a sort of shorthand for discussing ways of writing, speaking and managing cultural heritage which authorise particular groups in society to determine what heritage is, who heritage represents and who has access to it. We draw attention to particular forms of AHD, treating them as a range of discourses rather than a single discourse, such as the ones operating in the realm of natural heritage management. As we have seen, a strong notion of the 'natural-ness' and morality of nature conservation underpins natural heritage management. The concept of biodiversity is wrapped up in the language of scientific experts and appears to be beyond question. But underlying nature conservation and biodiversity management is a particular set of values and ideas about nature. We have seen that in some settler societies, the USA for example, such values are not shared but are specific to one dominant group. The same tensions that are a focus for cultural heritage in postcolonial and settler societies also arise in the management of natural heritage.

Similarly, canonical and representative approaches to heritage are discernible here as well as in official cultural heritage designations. Particular forms of values of the natural world are, like their cultural equivalents, considered to be both 'universal' and inherent in their physical character. These issues are also linked to the idea of 'authenticity' in natural heritage management. In Chapter 2 you saw how the notion of 'authenticity' in cultural heritage management came to mean the ways in which the heritage values of a physical 'thing' were reflected in its fabric. Similar ideas relate to natural heritage, in that 'wild' places are always perceived to be more 'authentic' than those that have been managed or recreated by humans. For example, earlier in this chapter you read how Rackham compared the difference between an old forest and a newly planted one to the difference between a painting by Constable and a forgery. The concept of 'wilderness' draws on this powerful notion of authenticity, which in turn derives from western philosophical understandings of the separation between culture and nature.

Another parallel between natural and cultural heritage lies in the economic drivers for investment in protecting and regenerating natural heritage. National parks and nature reserves are major national assets for attracting international tourism and investment. The gazettal of an area of land as a national park commodifies it by making it a site worthy of tourism and

recreation in the same way that listing a building on a **heritage register** immediately makes it seem worthy of visitation and conservation. The relationship between tourism and natural and cultural heritage is explored in more detail in Chapter 6.

Conclusion

In many ways, natural heritage has evolved alongside cultural heritage as a concept that reflects particular values which can be used to create and promote various forms of national and local identities. We have also seen a shift in natural heritage from an early emphasis on aesthetic principles in the conservation of landscapes to the management of representative samples of land based on their biodiversity values, which mirrors the shift in cultural heritage from canonical to representative conservation approaches. Biodiversity has emerged as a key concept with which to measure the significance of species and ecosystems and to justify their management within reserve systems which are controlled by international, national and regional charters and other legal instruments. While many of the moral arguments that underlie the promotion of nature conservation suggest that the management of national parks and other reserves is 'natural' (and hence beyond questioning), we have seen that wilderness and other natural areas are not only the result of a series of historic human interactions with the environment but are also actively 'created' as a result of their management. In the case of Yellowstone National Park, this management regime included the ejection of its indigenous inhabitants to create it as an empty landscape. Although there are many good arguments for the conservation of biodiversity, this chapter has argued the need to treat with caution the moral arguments regarding natural heritage conservation, and to subject them to the same level of critical consideration as those that are put forward in the support of the conservation of cultural heritage. Questions about the ways in which nature is conserved, what is being conserved and for whom, emerge as key areas of concern for a critical study of natural heritage.

The next chapter offers a strong contrast, in considering museums as repositories of cultural heritage. But it is worth bearing in mind the parallel sense of inter-relationships between human practices and the 'heritage collections', whether natural or cultural. Neither category is static over time. Indeed, the discussion of the evolution of Stratford-upon-Avon as the 'Shakespeare heritage town' shows a similar organic relationship between environment and significance that we have been exploring here.

Works cited

Allaback, S. (2000) *Mission 66 Visitor Centers: The History of a Building Type*, Washington, DC, National Park Service, US Department of the Interior, Cultural Resources Stewardship and Partnerships Park Historic Structures and Cultural Landscapes Program.

Australian Heritage Commission (2002) *The Australian Natural Heritage Charter for the Conservation of Places of Natural Heritage Significance* (2nd edn), Canberra, Australian Heritage Commission in association with Australian Committee for the International Union for the Conservation of Nature (ACIUCN).

Caro, T. (2007) 'The Pleistocene re-wilding gambit', *Trends in Ecology and Evolution*, vol. 22, pp. 281–3.

Chapron, G. (2005) 'Re-wilding: other projects help carnivores stay wild', *Nature*, vol. 437, p. 318.

Defoe, D. ([1724–6] 1971) *A Tour through the Whole Island of Great Britain* (ed. P. Rogers), Harmondsworth, Penguin.

Department of the Environment (1994) *Biodiversity: The UK Action Plan*, London, HMSO; also available online at www.ukbap.org.uk/library/Plan_LO.pdf (accessed 12 March 2009).

Dinerstein, E. and Irvin, W.R. (2005) 'Re-wilding: no need for exotics as natives return', *Nature*, vol. 437, p. 476.

Donlon, J., Berger, J., Bock, C.E. et al. (2006) 'Pleistocene rewilding: an optimistic agenda for twenty-first century conservation', *The American Naturalist*, vol. 168, pp. 660–81.

Donlon, J., Greene, H.W., Berger, J. et al. (2005) 'Re-wilding North America', *Nature*, vol. 436, pp. 913–14.

Fowler, P. (2004) *Landscapes for the World: Conserving Global Heritage*, Bollington, Cheshire, Windgather Press.

Friday, L. (1997) *Wicken Fen, The Making of a Wetland Nature Reserve*, Colchester, Harley Books.

Haines, A.L. (1974) *Yellowstone National Park: Its Exploration and Establishment*, Washington DC, National Park Service, US Department of the Interior.

Harrison, R. (2008) 'The politics of the past: conflict in the use of heritage in the modern world' in Fairclough, G., Harrison, R., Jameson, J.H. Jr and Schofield, J. (eds) *The Heritage Reader*, Abingdon and New York, Routledge, pp. 177–90.

Harrison, R. (2010) 'The politics of heritage' in Harrison, R. (ed.) *Understanding the Politics of Heritage*, Manchester, Manchester University Press/Milton Keynes, The Open University, pp. 154–96.

Harrison, R. and Rose, D.B. (2010) 'Intangible heritage' in *Understanding Heritage and Memory*, Manchester, Manchester University Press/Milton Keynes, The Open University.

Ickes, H. (1941) *A Study of the Park and Recreation Problem of the United States*, Washington DC, National Park Service, US Department of the Interior.

Kareiva, P., Watts, S., McDonald, R. and Boucher, T. (2007) 'Domesticated nature: shaping landscapes and ecosystems for human welfare', *Science*, vol. 316, pp. 1866–9.

Kieley, F. (1940) *A Brief History of the National Park Service*, Washington DC, National Park Service, US Department of the Interior.

Martin, P.S. (1970) 'Pleistocene niches for alien animals', *BioScience*, vol. 20, pp. 218–21.

Nash, R. (1967) *Wilderness and the American Mind*, New Haven, CT and London, Yale University Press.

National Park Service, US Department of the Interior (2008a) National Park Service Organic Act 1916 [online], www.nps.gov/history/local-law/FHPL_NPSOrganic1.pdf (accessed 4 November 2008).

National Park Service, US Department of the Interior (2008b) About Us [online], www.nps.gov/aboutus/index.htm (accessed 10 July 2008).

Oelschlaeger, M. (1991) *The Idea of Wilderness*, New Haven, CT and London, Yale University Press.

Olwig, K.R. ([2001] 2008) '"Time out of mind" – "mind out of time": custom versus tradition in environmental heritage research and interpretation' in Fairclough, G., Harrison, R., Jameson, J.H. Jr and Schofield, J. (eds), *The Heritage Reader*, Abingdon and New York, Routledge, pp. 245–55.

Rackham, O. (1994) *The Illustrated History of the Countryside*, London, Weidenfeld & Nicholson.

Rackham, O. (2006) *Woodlands*, New Naturalist Library, London, HarperCollins.

Rose, D.B. (1996) *Nourishing Terrains: Australian Aboriginal Views of Landscape and Wilderness*, Canberra, Australian Heritage Commission.

Rubenstein, R.R. et al. (2006) 'Pleistocene Park: does re-wilding North America represent sound conservation for the 21st century?', *Biological Conservation*, vol. 132, pp. 232–8.

Rydell, K.L. and Culpin, M.S. (2006) *Managing the 'Matchless Wonders': A History of Administrative Development in Yellowstone National Park, 1872–1965*, Yellowstone National Park, Wyoming, Yellowstone Center for Resources.

Schlaepfer, M.A. (2005) 'Re-wilding: a bold plan that needs native megafauna', *Nature*, vol. 437, p. 951.

Shay, S. (2005) 'Re-wilding: don't overlook humans living on the plains', *Nature*, vol. 437, p. 476.

Smith, C.I. (2005) 'Re-wilding: introductions could reduce biodiversity', *Nature*, vol. 437, p. 318.

Spence, M.D. (1999) *Dispossessing the Wilderness: Indian Removal and the Making of the National Parks*, Oxford and New York, Oxford University Press.

Stoate, C. (1996) 'The changing face of lowland farming and wildlife: Part 2, 1945–95', *British Wildlife*, vol. 7, pp. 162–72.

Thatcher Foundation ([1988] 2009) Margaret Thatcher Speech to Conservative Party Conference (14 October 1988, CCOPR 375/88) [online], www.margaretthatcher.org/speeches/displaydocument.asp?docid=107352 (accessed 12 March 2009).

UNESCO (1993) Tongariro World Heritage List Nomination Revision [online], http://whc.unesco.org/archive/advisory_body_evaluation/421rev.pdf (accessed 22 October 2008).

UNESCO (2008) Operational Guidelines for the Implementation of the World Heritage Convention [online], http://whc.unesco.org/archive/opguide08-en.pdf (accessed 12 March 2009).

UNESCO ([1972] 2009a) World Heritage Convention [online], http://whc.unesco.org/en/conventiontext/ (accessed 13 January 2009).

UNESCO (2009b) World Heritage: The Criteria for Selection [online], http://whc.unesco.org/en/criteria (accessed 6 February 2009).

United Nations (1992) Convention on Biological Diversity [online], www.cbd.int/doc/legal/cbd-un-en.pdf (accessed 12 March 2009).

US Department of the Interior (1941) *A Study of the Park and Recreation Problem of the United States*, Washington DC, Government Printing Office.

Walker, K.J., Warman, E.A., Bhogal, A. et al. (2007) 'Recreation of lowland heathland on ex-arable land: assessing the limiting processes on two sites with contrasting soil fertility and pH', *Journal of Applied Ecology*, vol. 44, pp. 573–82.

West, S. and Ndlovu, S. (2010) 'Landscape, memory and heritage' in Benton, T. (ed.) *Understanding Heritage and Memory*, Manchester, Manchester University Press/Milton Keynes, The Open University.

Wolfe, L.M. (ed.) ([1938] 1979) *John of the Mountains: The Unpublished Journals of John Muir*, Madison, University of Wisconsin Press.

Zimov, S.A. (2005) 'Pleistocene Park: return of the mammoth's ecosystem', *Science*, vol. 305, pp. 796–8.

Further reading

Boyle, S.C. (2008) 'Natural and cultural resources: the protection of vernacular landscapes' in Longstreth, R.W. (ed.) *Cultural Landscapes: A Political Ecology of Conservation, Conflict and Control in Northern Madagascar*, Minneapolis, University of Minnesota Press, pp. 150–63.

Chape, S., Harrison, J., Spalding, M. and Lysenko, I. (2005) 'Measuring the extent and effectiveness of protected areas as an indicator for meeting global diversity targets', *Philosophical Transactions of the Royal Society, Series B, Biological Sciences*, vol. 360, pp. 443–55.

International Union for Conservation of Nature (IUCN) (2008) *Natural World Heritage Nominations, A Resource Manual for Practitioners*, IUCN World Heritage Studies 4, Gland, Switzerland; also available online at: http://data.iucn.org/dbtw-wpd/edocs/2008-038.pdf (accessed 5 May 2009).

Olwig, K.R. (ed.) (2005) 'The nature of cultural heritage, and the culture of natural heritage', special issue, *International Journal of Heritage Studies*, vol. 11, no. 1.

Papayannis, T. and Howard, P. (eds) (2007) 'Nature as heritage', special issues, *International Journal of Heritage Studies*, vol. 13, nos 4 and 5.

Spence, M.D. (1999) *Dispossessing the Wilderness: Indian Removal and the Making of the National Parks*, Oxford and New York, Oxford University Press.

World Wide Fund for Nature (WWF) (2009) *Natura 2000, Successful, Flexible, Modern: Facts and Findings*, Frankfurt am Main, WWF Germany; also available online at: http://assets.panda.org/downloads/wwf_natura2000_final_kpl.pdf (accessed 5 May 2009).

Chapter 4 Museum practice and heritage

Tim Benton and Nicola J. Watson

The origins of national museums and their part in the western ordering of knowledge were outlined in Chapter 1. Here we focus on some of the pressing practical problems facing museum professionals in trying to conserve and interpret the collections in their charge while also pleasing the visiting public and their government paymasters. Museum professionals have undergone a radical change in approach in the last thirty years, sometimes referred to as 'the new museology'. We will look at questions of interpretation (the aesthetic and contextual models), issues about value judgements and the changing relation of museums to their publics. The case study by Nicola Watson extends the notion of museum to the scale of an open-air museum, looking at how Stratford-upon-Avon has become a pilgrimage site for Shakespeare lovers. The case study poses in critical form, then, the relationship between tangible and intangible heritage, in a context in which the tangible part of Shakespeare's Stratford had to be constructed over 250 years to acquire its present form.

Introduction

In 1972 the editor of a book provocatively entitled *Museums in Crisis* began his introduction like this:

> The Museum age, which reached its Augustan apogee with the post-World War II boom in art education, in special exhibitions, in collecting, in museum-building, is finally over. Museums, once permanent fixtures by which to negotiate our spiritual journeys, have suddenly revealed infirmities in their foundations that have threatened them with collapse. Like many institutions in the late sixties, they were abruptly thrust from their historical context into the vicissitudes of contemporary life, where the problems of the entire society – many of them irrelevant to art museums – were brought to bear on them.
>
> (O'Doherty, 1972, p. 2)

This might seem an extraordinary statement. Its tone and vehemence is characteristic of a series of books and articles written between 1970 and 1985 when 'crisis' seemed to be afflicting museums, country houses and the whole problem of conservation (Strong, 1974; Wright, 1985; Lowenthal, 1985). By most measures – economic, social or even aesthetic – museums have flourished in the intervening three decades, so was Brian O'Doherty's concern unjustified?

O'Doherty was describing some very important shifts which led to a certain loss of autonomy in the funding and management of museums in Europe and North America. But more importantly, he was describing a change of attitude to museums which drew them into the arena of national politics and challenged the freedom of museum curators to determine their own priorities. These shifts were taking place in different ways throughout the world and they relate directly to the attitudes summarised by Laurajane Smith in *Uses of Heritage* (Smith, 2006). In part, these changes were produced by the intellectual disturbance known as postmodernism, which threw into doubt established beliefs in the validity of aesthetic value (art for art's sake) and the certainty of history (Knell, 2007):

> The museum became what it had rarely been: delightfully contentious. Gone, so it seemed, was any notion of the museum as trusted purveyor of knowledge and learning – 'disinterested' and apolitical; who could now claim anything as neutral?

> (Knell, 2007, p. 3)

In this chapter we look at debates around museums, their curators and the objects they acquire, conserve and display. At issue is the relationship between museum objects, the associations and knowledge they can be thought to embody, and the best means to communicate these to the general public.

What is a museum?

The very definition of what constitutes a museum has changed since 1945. The International Council of Museums (ICOM) was founded in 1946, with responsibility for carrying out UNESCO's policies on museums. It then defined museums in terms of their content:

> The word 'museums' includes all collections open to the public, of artistic, technical, scientific, historical or archaeological material, including zoos and botanical gardens, but excluding libraries, except in so far as they maintain permanent exhibition rooms.

> (ICOM, [1946] 2007a, Article II, section 2)

To museum curators, this meant that their responsibilities were above all to their collections rather than to the potential interest to the general public. The act of preserving 'priceless treasures' and key symbolic repositories of a nation's heritage from decay or destruction and passing them on to future generations was considered to be sufficient justification for the existence of a museum. There appeared to be a continuity between the scientific role of museums – classifying species of animals, plants and geological specimens and collecting representative examples of each – and the artistic and **ethnographic** roles of classifying and evaluating the products of human skill.

Investing in museums meant investing in research into knowledge and understanding of the world (irrespective of whether a single visitor passed through the door). It is also true, however, that most museums also included a brief to 'educate and inform' the general public. The Victoria and Albert Museum (V&A) in London, for example, was first founded as part of the School of Design (opened in 1837 and later to become the Royal College of Art) as a collection of study objects. When the energetic civil servant Henry Cole became director of the School of Design in 1852 he realised that educating artists and designers was not enough:

> Our first and strongest point of faith is, that in order to improve manufactures, the earliest work is to elevate the Art-Education of the whole people, and not merely to teach artisans ...

> (Burton, 1999, p. 29)

The V&A, as it grew into a free-standing museum, always had a mission both to improve the taste of designers, and to interest and educate the general public.

In 1961 the phrase 'for purposes of study, education and enjoyment' was added to the ICOM definition and in 1974 the definition was changed again and remains in force today:

> A museum is a non-profit, permanent institution *in the service of society and its development*, open to the public, which acquires, conserves, researches, communicates and exhibits the tangible and intangible heritage of humanity and its environment *for the purposes of education, study and enjoyment* [emphasis added].

> (ICOM, [1974] 2007b, Article III, section 1)

Museums almost everywhere, whether public or private, are now considered to have essential functions in 'developing' the culture of the local population, promoting a sense of common identity and attracting tourists to the country. Museums are now seen as too important to be left to professional curators and museum managers. For example, in Italy, museums were previously defined in law as '*beni culturali*' (cultural assets), 'organized for the conservation, valorization and interpretation of collections of cultural works' (Cataldo, 2007, p. 43). Recently, however, their legal status has been changed to '*beni di interesse pubblico*' (works of public interest) and their purpose declared as being 'for education and study' (Decreto legislative, n. 42, article 101). This has been defined as a 'Copernican revolution' (Cataldo, 2007, p. 43) because it charges the state with the duty of ensuring that each museum serves the public interest. This has been effectively the approach of government in the UK since the 1980s, with museums being required to demonstrate their effectiveness in satisfying the visiting public rather than simply conserving what they have, acquiring more and carrying out research.

The aesthetic and contextual models

Traditional professional curators saw themselves as the judges of quality and significance. Alfred Barr, the first director of the Museum of Modern Art in New York, is quoted as saying that the job of the curator is 'the conscientious, continuous, resolute distinction of quality from mediocrity' (Oldenburg, quoted in Weil, 2007, p. 101). These curators also understood aesthetic quality as objective:

> Quality resides in the object and it endures as long as its physical existence ... The quality in a work of art is unaffected by the shifting cultural and social conditions that surround it. It may remain unrecognized over long spans of time, but where it lives in a work of art it is forever ready to communicate itself to a beholder who comes to it with unobstructed senses.

> (Eitner, quoted in Weil, 2007, pp. 100–1)

Fundamental to these ideas was the assumption that aesthetic quality in heritage objects is essentially visual and inherent in the object. The idea that the key values of an object are inherent (fixed and immutable), as opposed to being inscribed by the spectator or user, is discussed in Chapter 1 of this book and by Rodney Harrison in *Understanding the Politics of Heritage* (Harrison, 2010). This is a cardinal point in the characterisation of what Laurajane Smith calls the AHD, because these inherent qualities are usually ascribed to objects by those in authority, such as museum curators. It is their taste, their subjective responses to works, as well as their connoisseurship, which seeks to impose judgements of value on society at large. They do this by selecting some objects over others for display, giving them prominence and attaching their comments in the form of captions and gallery texts.

Some curators guard against this by refusing explicitly to endorse or describe the aesthetic qualities of works. According to this view, elaborate **interpretation**, explanation or contextualisation in the form of long captions or texts might interfere with the direct, visual contact between the visitor and the object. We have seen, in Chapter 2, that David Hume believed that any judgement of aesthetic quality must in the end rest on direct experience of the object, but that reason and experience of comparable artworks play important roles in refining judgements of taste. Most art historians and curators feel pulled in both directions; trusting their feelings but also seeking knowledge about the object.

Following Peter Vergo, we might call this approach to conservation and display the 'aesthetic' model, which he contrasts with its polar opposite the 'contextual model' (Vergo, 1989, p. 48). In some ways, this distinction can be likened to the distinction between the 'canonical' and 'representative' criteria of significance, to the extent that 'canonical' works of art are often identified by aesthetic criteria, whereas works with 'representative' significance are

qualified by their historical and social associations. But Vergo's distinction is more about forms of interpretation than criteria of significance. It is possible to interpret 'canonical' works in either an 'aesthetic' or a 'contextual' way, and this is important in discussing museum objects which are predominantly canonical in type.

In the 'contextual' model, the emphasis is not on the inherent aesthetic qualities of objects but on what they can be shown to tell us about the life and times of people. There is much greater emphasis on explanatory texts, reconstructions (if 'authentic' objects are unavailable or insufficiently explanatory) and 'stories' (whether textual, audiovisual or by displays such as **dioramas** or juxtaposition of objects). The danger of the 'aesthetic' model is that it privileges those with the knowledge and training to appreciate objects in a sophisticated way without assistance. As Vergo puts it, 'Left to speak for themselves, they [objects] often say very little; and a sometimes quite considerable effort is required on the part of the historian, the art historian, the critic or the viewer to coax them into eloquence' (Vergo, 1989, p. 49). The dangers of the 'contextual' model are that it could be 'musty with documentation, laden with earnest didacticism, any occasion for private meditation drowned out by the whirr and clatter of the audiovisual programme' (Vergo, 1989, p. 51). Behind this contrast is a sharp distinction between target audiences: a knowledgeable audience of 'art lovers' (generally well educated and relatively well off) or a wider constituency of members of the general public.

The challenge to the aesthetic model

Like certain ritual objects designed to be used once only and then frozen in their use value, museum objects might be said to be decommoditised. That is, unlike commodities which undergo a series of exchanges, in which their social and exchange value is tested and adjusted, objects accessioned into a museum become severely limited in their exposure to social evaluation and exchange. In many cases, museum staff are prohibited by statutes or by the conditions of a gift or loan from de-accessioning (selling) works in the collection. More generally, museum curators have scruples about selling off parts of the collection entrusted to them:

> The word 'deaccession' does not appear in the dictionary ... There are many [curators] who do not accept the practice. They view museums as essentially mausoleums [*sic*] dedicated to preserving, intact, the accumulations of successive generations.
>
> (Malaro, 1985, p. 138)

The legal expert Marie C. Malaro gives a number of reasons for wanting to get rid of objects: selectivity (in order to meet precise goals); costs of

storage; religious or ethical reasons; allowing for growth in new areas; and financial difficulties. A board of trustees may require curators to earn revenue from de-accessioning in order to balance the books, or in order to acquire works more likely to interest the general public. For example, the Corcoran Gallery in Washington sold off over 100 European paintings at auction in 1979, in order to focus on what it saw as the distinctive feature of its collection: American art.

Once de-accessioning is accepted, museum artefacts return to being commodities, subject to market forces. But it can also be argued that the job of the curator is necessarily one of continually seeking to maximise the value of the collection, both by rotating objects on display and by selling and buying objects like any other dealer in the art market. In this view, objects on display in museums, even if not actually up for sale, should be considered as constantly under evaluation. The museum visit would then be considered as part of a continuing social and aesthetic exchange between visitor and curator, with the government – as paymaster on the public's behalf – looking on. The value attributed to the collection is not pecuniary but in the currency of political approval, sometimes measured by increased visitor attendance, sometimes by other more specific criteria. For example, pressure may be placed on a museum to play down its colonial collection and emphasise contemporary work from immigrant or indigenous communities.

Value and authenticity

Every time a curator puts on a special exhibition, or reorganises the display of a group of objects, they hope to add value to the collection and attract visitors. It is important to reflect on the two common meanings of the word 'value'. A dealer who sells a work for more than they have paid for it has added economic value to the work. Typical ways of achieving this are to find out information about it, proving that it is what it claims to be (its authenticity and rarity), associating it with interesting historical information or by giving it exposure to public criticism (by publication or exhibition). By these means, and anticipating trends in public taste, a dealer can buy cheap and sell dear. Museum curators cannot normally realise the economic value of the works in their collections, except by attracting large crowds to special exhibitions or displays. But they can add to the distinction and prestige of the works and this is generally considered to be desirable, if only to persuade large numbers of people to visit and government to maintain generous funding. Nothing detracts more brutally from the prestige of a museum object than to have its authenticity called into question, which is why museum curators are usually obsessed with identifying and documenting works under their care. Supporting claims of authenticity is a complicated business. It is not just a question of making a value judgement – 'Is it good enough to be a

Raphael?' – but rather, 'Does it have the characteristics of other authenticated Raphaels?' And this kind of inquiry quickly enters very arcane territory: microscopic examination of materials, carbon dating, examination of documents proving **provenance** (the chain of ownership) as well as reconstruction of all the changes that may have been made to the object over time.

From an aesthetic point of view, a work which has been faked by a very skilful forger may look better than an original work that has suffered damage and repair, but its value will be much less. We have seen in Chapter 2 how an attempt to strip antique sculptures of all later accretions was also highly controversial. If you believe that the essence of a work of art lies in the original artist's intention, this intention can be rediscovered by skilful restoration of a work. And indeed most paintings and sculptures in public museums have been restored to a greater or lesser extent, to make them attractive for the public. How far you restore a work, how far you strip it back to its original materials (however damaged) and how far you allow later interventions to remain is not only a debate among professionals, but a dialogue between professionals and the public. For example, curatorial scruples about not restoring a work unless the previous condition is precisely known may retain the authenticity of an object but render it less attractive for the viewer.

Museums and their public

Many curators see the need to satisfy the vagaries of public taste and political instruction as an interruption in their work. Putting on major exhibitions, for example, ties up dozens of staff for several years, who might otherwise be researching and conserving the collection. As O'Doherty put it,

> Many feel that there has been an erosion of scholarly responsibilities, and a capitulation to the demands of education, or what its critics call entertainment.

> (O'Doherty, 1972, p. 3)

In an outspoken piece, Bryan Robertson saw a fundamental contradiction between the legitimate purposes of the museum and the needs of democracy:

> The public, conditioned by the strenuous and massively simple slogans of advertising and the super-realistic giantism of cinemascope, now expects to find a commensurate spectacle at the museum and is dismayed not to find some semblance of showbiz glitter in the permanent collections as well as temporary installations. But it is absurd that the *size* of an audience should take precedence over *what happens* to visitors inside a museum. Numbers may relate to democracy but not to art.

> (Robertson, 1972, p. 85)

Robertson, who was an influential art critic for *The Spectator* before becoming director of a new university museum in New York State, did not consider it to be the job of the museum curator to educate the general public. Everything museum curators did to make their collection palatable to the public was, for Robertson, potentially a betrayal of their calling. For example, selecting only the 'best' or most accessible works in a collection night make for a more digestible display, but it deprived scholars (and other individuals) of the opportunity of comparing the quality of a range of objects of the same type. Making the display more attractive was also a danger, for Robertson. He recounted an anecdote about the late Queen Mary visiting the redisplay of the collections of the V&A after the Second World War, when she commented, 'But what a pity everything looks as if it is for sale' (Robertson, 1972, p. 85). And a reviewer in the prestigious art magazine *Apollo* remarked sardonically in 1950, 'The modern museum offers us all the benefits of the modern department store, except of course for the shop assistants, with pastel shades, soft lighting, and culture without tears' (quoted in Burton, 1999, p. 202). What is at stake in these comments is the fear that museum objects will be thought of as commodities.

An example of frontal attack on the 'aesthetic' model is an essay by Philip Wright in which he targets curators as a profession, the privileged status of art as a value, and the structure of museum management as a tool of social and political domination (Wright, 1989). He would place art historian curators at the bottom of the ladder in the museum hierarchy:

> It may mean the downgrading of the curator/art historian to equal status with the researcher/interpretation specialist, the designer/ cognitive psychologist, the educator/communicator and the historian/ anthropologist, in the interest of achieving certain declared objectives for success in the museum's programme and activities. It may also mean the retraining or removal of certain members of the staff or of the governing body, where the museum's more broadly redefined objectives are seen to require new areas of scholarship and new skills for a public service institution.

> (Wright, 1989, p. 146)

Curators must learn to share control with educators and display specialists. Citing Danielle Rice, Wright reaches the heart of the problem:

> If we begin from the premise that art is primarily about ideas and that museums, as institutions devoted to preserving art as property, inadvertently obscure this important concept of art, the moral duty of the educator takes on a special significance.

> (Rice, 1987, p. 214, n. 12)

If, as Rice assumes, art and artefacts are primarily about ideas, there is no reason why these ideas might not be better expressed in words or reconstructions, which most people can understand, rather than in authentic works of art and crafts which many people are not trained to analyse. But art historians reject this notion, claiming that artworks and artefacts have unique formal properties that can never be fully translated into words. Often, they claim, these objects bring you closer to the feelings and imagination of people living in the past than any words could. Explanation or interpretation are always, they argue, subjective and can amount to telling people what to think and feel. The educationalists answer that any display of objects imposes a particular viewpoint on the spectator, through the way the objects are selected and framed. This is one of the imponderable differences of opinion which no amount of management can dissolve. The case of Shakespeare's Stratford-upon-Avon (see case study) shows that there is a hunger for places and things with which to associate the literary imagination.

The democratic role of explanation

The French sociologist Pierre Bourdieu wrote an influential book *L'Amour de l'art* (The Love of Art) in 1969, based on an extensive survey of museum visitors in France, and was one of the first to demonstrate that there is a strong link between museum and gallery attendance and social class (Bourdieu and Darbel, [1969] 1985). A more recent survey, conducted in the UK by MORI for the Museums, Libraries and Archives Council (MLA), included the following conclusions in its executive summary (Figure 4.1):

- The higher an individual's social class, household income and education, the more likely they are to visit museums, art galleries and other types of cultural attractions. The exception to this trend is the visiting of theme parks and zoos or wildlife parks, which appeal equally across all social classes.

- Older people, those in the higher social classes and those without children are the most frequent museum/gallery visitors.

- Almost everyone who has visited a museum or gallery during the last 12 months is extremely likely to visit either the same venue or a similar one again during the next 12 months.

- The majority think it is important for their local town or city to have its own museum or art gallery. This includes a substantial proportion (76 per cent) of those who had not visited one during the past 12 months.

(Museums, Libraries and Archives Council (Great Britain), 2004, p. 6)

The first point confirms Bourdieu's findings and those of subsequent researchers. If just over half of the British population are classed as ABC1s, these groups contribute three-quarters of the museum-visiting public. Furthermore, these groups are most likely to revisit. The last bullet point is intriguing, suggesting that museums are seen by most people as important for local heritage, whether or not they visit them. The main topics listed as reasons for visiting a museum exhibition include 'How people used to live' (62 per cent) and 'The history of the local area' (55 per cent). According to the MORI poll, 37 per cent of those asked said they had visited a museum or gallery in the last twelve months (comparable to visits to a well-known park or garden), fewer than visits to the cinema (59 per cent) or library (51 per cent) but more than visits to a famous cathedral or church (33 per cent), **stately home**, castle or palace (31 per cent) or live sporting event (28 per cent). The social bias in visits to cultural sites affects all of these equally (including football!), with the exception of theme parks and zoos, which are more likely to be visited by those in the DE social classes. As Bourdieu also indicated, educational preparation is even more important than class in determining museum and gallery attendance:

> Those with a household income of £30,000 or more are twice as likely to have visited as those who earn less than £17,500, whilst people with a Masters degree or PhD are three times as likely to have been to a museum/gallery as people with no formal qualifications.
>
> (Museums, Libraries and Archives Council (Great Britain), 2004, p. 5)

These statistics are extremely important when considering the role of interpretation and explanation in museums.

Compared to the significance of these economic, social and educational criteria, ethnicity is relatively unimportant, accounting for only 6 per cent difference in museum attendance. Museums appear to have become 'less boring' than ten years ago. Only 6 per cent of visitors considered museums to be 'boring' (although 15 per cent of those under 25 did think so) and only 1 per cent asserted that they were not made to feel welcome in museums or galleries. These figures differ substantially from a similar survey carried out in 1999, when 15 per cent considered museums to be 'boring'.

Another important finding for museum curators is that over a third of those who have visited a museum or gallery went back for three or more further visits. These repeat visitors expect to see changes when they re-visit, and this requires a continual refreshing of the displays, with temporary exhibitions and events. A special exhibition or event was named as the reason for visiting by 49 per cent of visitors (Museums, Libraries and Archives Council (Great Britain), 2004, p. 11).

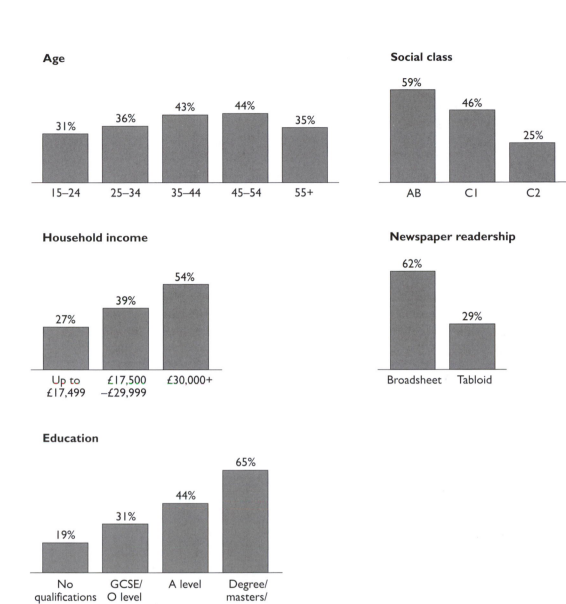

Figure 4.1 Respondents answering 'yes' to the question 'In the last 12 months have you visited a museum or gallery in the UK?'. Of the total sample, 37 per cent responded 'yes' to the question. This analysis shows percentage responses by subdivisions. For example, 31 per cent of 15–24 year olds responded 'yes' to the question. (Museums, Libraries and Archives Council (Great Britain), 2004, p. 5)

Museums as expressions of a ruling class

Curators, in following their search for the best examples, often seem to cut themselves off from the person in the street. Curators have always been aware of this problem. According to Charles Gibbs-Smith, public relations officer at the V&A in the 1950s, it was curious, 'to find how many museum officials

either patronize, resent, despise, dislike or even *hate* the general public ... Our duty as museum officers is to consider as broad a spectrum of the public as possible; ... we should cater for, and seek to attract, every conceivable kind of human being, regardless of intellect, income, colour, creed, age or sex' (quoted in Burton, 1999, p. 202). But being aware of a problem is not to solve it.

Gregory Ashworth and John Tunbridge have argued that heritage objects are inevitably subject to what they call '**dissonance**' (Ashworth and Tunbridge, 1996). Dissonance occurs when heritage objects are competed for between rival stakeholders: the owner of a property and the tourists who visit it; museum curators and visitors.

> The creation of any heritage actively or potentially disinherits or excludes those who do not subscribe to, or are embraced within, the terms of meaning defining that heritage.
>
> (Graham, Ashworth and Tunbridge, 2005, p. 34)

An empirical survey of the most popular and effective museums and exhibition displays suggests that no one approach is the most successful. It depends a great deal on the subject matter and the beliefs and attitudes of people in any particular culture. In debates about accessibility, curators sometimes get ahead of their public. Many museum visitors have a real hunger for certified, world-class quality, and expect to be told where to find it. The most visited exhibition in 2006, in the whole world, consisted of one painting, the *Annunciation* by Leonardo da Vinci, which was displayed at the Tokyo National Museum and was seen by 796,004 people in three months at 10,071 per day. The main explanation for this must be a predisposing fascination with European culture in Japan and the significance of the unique displacement of this work from Florence, which it had only left three times before in its history. An Italian senator chained himself to the gates of the Uffizi Museum in an attempt to stop the loan. Bringing home stolen works of art as the booty of military campaigns is no longer considered legitimate, but something of the same excitement can still be generated through the power of capital.

In Britain, the three most visited art museums – Tate Modern (5.2 million in 2006), the British Museum (4.8 million) and the National Gallery (4.2 million), among the top eight art museums in the world – are those least affected by the new museology. The most visited art museums in the world, the Louvre (8.3 million) and the Pompidou Centre (5.5 million) in Paris, the Metropolitan Museum of Art (4.5 million) in New York and the National Gallery of Art (4.5 million) in Washington, draw their crowds through the fascination of local people and tourists to see original works of art which they believe to be of the highest quality and which they see as defining part of the culture to which they aspire. Following the arguments of Pierre Bourdieu, we visit museums to acquire cultural capital, the knowledge and taste which allows us to claim membership of a higher social standing than we had

previously. The same can be said of reading books and going to university. Is this just cultural snobbery? If the government and its institutions want all citizens to share the same culture, it will have to explain why this is necessary and useful for full citizenship.

For the politicised critic of established museums, none of this goes far enough; museums should focus their attention on revealing the inequalities in society and the workings of power in the cultural sphere, including a critique of the authority of the museum itself and its methods of interpretation and display. It is hard to see why this would not replace one authoritative voice by another and doubtful that it would either increase museum attendance or change many attitudes among the traditional visitors.

The Curator's Egg

A fascinating example of auto-criticism was attempted at the Ashmolean Museum, Oxford in an exhibition entitled 'The ?Exhibition?' (*sic*) or 'The Curator's Egg', between December 1991 and May 1992 (Beard and Henderson, 1994). This display of mostly antique objects from the Ashmolean collection played various games on the techniques of the curator. For example, the question of authenticity was posed by including two life-size plastic Venuses, bought from a garden centre, one with the traditional museum label 'Do not touch' (she still had her £15.95 price tag and a SOLD ticket around her neck) while the other one was ironically labelled 'Replace after use' (Beard and Henderson, 1994, p. 13). Here, neatly compressed, were issues of museum objects as commodities, their financial value and their 'use' value. Being able to touch a displayed object in a museum is breaking a taboo, but a taboo which also works to increase desire for the object. Facing the two very accessible plastic Venuses were two antique stone Venus torsos. This time they were enclosed in a case, but surrounded with other objects and a flurry of labels with questions rather than answers, among which the key one was 'WHOSE STORY IS IT ANYWAY?' The hermetic nature of museum labels, providing information incomprehensible to the general viewer, was also confronted in a number of ways. For example, a made-up label for a Greek vase read:

> Type B non-volute ware
> provenance dub.,
> c. 750–27 BC
> presumed mythological scene
> (post Homeric)
> Satisfied?

(Beard and Henderson, 1994, p. 26)

Recognition from daily life was also included with a cut-out head of Frankie Howerd, whose comic TV series *Up Pompeii!* represented one view of the antique world in popular culture. The exhibition texts included information on the Ashmolean and its staff and awkward questions of value. For example, two very similar Greek vases were placed side by side, one valued at £2,500 and the other at over £100,000. Other texts prompted thought:

> 'Display is about values', 'Display is about glitter', 'Display is about secrets', 'Display is about sincerity'; 'BEAUTY, TREASURE, SNIP, LOOT, UNIQUE INVESTMENT ...'
>
> (Beard and Henderson, 1994, p. 19)

Another label asserted 'YOU SEE, YOU HAVE TO TRUST US', while several labels attempted a more direct form of address to the visitor. For example, a group of objects relating to Roman women's cosmetics was given

> a chatty paragraph about Roman women's make-up equipment, comparing ancient mirrors with 'today's "compact"' (and next to that, the closest thing we could find to a 'compact' at the local chemists)
>
> (Beard and Henderson, 1994, p. 27)

This exhibition was part of the self-questioning prompted by the new museology and raised several interesting questions. The main beneficiaries of this kind of reflection are museum professionals who are becoming much more aware of the 'voice' of the label and the nature of the information provided, from a viewer's perspective.

Place, space and museums

It has been argued that museums will cease to maintain their clear sense of difference from other social institutions:

> The museum's relationship to its collections and to the ownership and care thereof will change, and in some instances have already changed. The distinct edges of differing functions among libraries, memorials, social services centers, schools, shopping malls, zoos, performance halls, archives, theatres, public parks, cafes and museums will (and in many cases have already begun to) blur.
>
> (Gurian, 2005, p. 71)

Two successful museums which, in very different ways, provide some evidence of this trend are within a few hundred metres of each other on the Washington Mall, USA. The National Air and Space Museum is the most visited museum in the world, with an annual attendance of over 9 million. Its form is that of a Barnum and Bailey three-ring circus or a very large shopping mall. Three vast halls, full of airplanes and rockets, are surrounded by a

bewildering array of display techniques: conventional galleries setting machines into their historical and social context, special exhibitions, spectacular films and multimedia presentations, and machines on which you can try your hand at flying a fighter or landing on the moon. The machines themselves, mute and unexplicated, are the star of the show, rather like a car sales lot. In many ways, the museum meets the needs of the new museology perfectly, mixing display techniques for different kinds of visitor and responding to public desires. The visitor is free to pick and choose his, or occasionally her, route, to suit his technical expertise and attention span. But the museum is far from sharing the social emancipatory aims of the new museology. There is an overtly national and military mood, which makes it a sensitive place for discursive historical analysis. A very well-attended exhibition about Enola Gay (the bomber from which the atom bomb was dropped on Hiroshima) was completely altered during its design as a result of pressure from US airforce veterans (Dubin, 1999; Luke, 2007). The exhibition designers had intended to use the exhibition to ask questions about the moral authority of bombing defenceless civilian targets, to reflect the experience of the victims and to question the effectiveness of area bombing in general during the Second World War. Instead, the exhibition focused on the technical aspects of the operation, parts of the restored bomber and the experience of the crew. The sensitivities of families who had lost bomber crew in action and the political muscle of the veterans' organisations could not be ignored. And there is a general lesson here. The stronger the level of public admiration for something, whether it be military airplanes or Renaissance paintings, the more difficult it becomes to question these values.

The United States Holocaust Memorial Museum, a few hundred yards away, like the National Air and Space Museum, benefits from a broad consensus in public attitudes to its content. But the display could not be more different. Instead of a free choice of routes, the visit is programmed along a single path. Instead of a reliance on aesthetic objects, the main emphasis is on text and reconstruction. Instead of a relative openness of interpretation, the emotions of the visitor are put through the wringer. The ticket for admission consists of an identity card for a child murdered in the Holocaust. The galleries are dark and narrow. Harrowing photographs and very personal details make it impossible to escape the horror of what took place. Elaine Gurian sees this museum as typical of a new kind of 'institution of memory', in which information gathering is linked to generating specific emotions and attitudes, rather like a novel or play. The Holocaust Memorial Museum works because most Americans accept the premises on which it is based and are sensitised to the message. David Horne has warned of the dangers of a 'tourism of horror' which would place the Holocaust too safely in the past (Horne, 1984, p. 244). By contrast, the Beit Hashoah Museum of Tolerance in Los Angeles tries to generalise the lessons of genocide by including atrocities in Cambodia,

Rwanda and elsewhere. 'The very unexceptional quality of hate groups throughout the world attempts to send home the message that intolerance is a virus to which no society is immune' (Richter, 2005, p. 267). Instead of focusing on the horror of the Holocaust, attention is drawn to the terrible and dangerous normality of genocide.

Museums are big business, in their annual turnover of private and state funding and in their stimulation of tourism. Museums and galleries are tied, to a greater or lesser extent, by their collections, the expertise of their staff and the changing fashions of government policy. They are necessarily object led in a user-centred world. Many museum professionals feel threatened by the new obligations to meet the needs of politicians, sponsors and the visiting public. As James Cuno, director and president of the Art Institute of Chicago, put it, 'The problem is really one of authority and power. Who has authority and power over museums?' (Cuno, 2007)

National heritage is not necessarily 'object centred'. Some parts of the heritage are so important for a sense of national, and in this case linguistic, identity that some tangible presence needs to be created to satisfy demand. We saw in Chapter 1 how an aspect of Welsh identity was fixed around a particular image of dress, and how a range of factors contributed to this over several centuries. In the following case study an intangible heritage (that of Shakespeare's plays and poems) has been slowly turned into tangible places to visit during a process that has lasted 250 years. Turning parts of a town into a museum is dependent on the sometimes conflicting interests of several different groups: lovers of Shakespeare, the theatrical profession, Anglophones seeking roots for their linguistic culture and, not least, the tourist industry. Although Stratford-upon-Avon, Warwickshire, might seem rather different from a conventional museum, there are comparable issues (authenticity, the tensions between users and professionals, the relationship between tangible and intangible heritage). What follows is an edited extract from a longer essay in which Nicola Watson also traces the 'placing' of Shakespeare in the streets of London and indeed in buildings around the world (Watson, 2007).

Case study: Shakespeare on the tourist trail

One side-effect of the increasing veneration of Shakespeare over the course of the eighteenth century – a period that turned Shakespeare from a rough untutored playwright of incidental 'beauties' into the National Poet – was the first stirrings of the Stratford tourist industry. To visit Stratford-upon-Avon today is to visit Shakespeare's town, set in the heart of Shakespeare Country (Figure 4.2). Indeed, Stratford has been Shakespeare's town for the better part of two centuries, even though the euphoric road signs announcing this are of

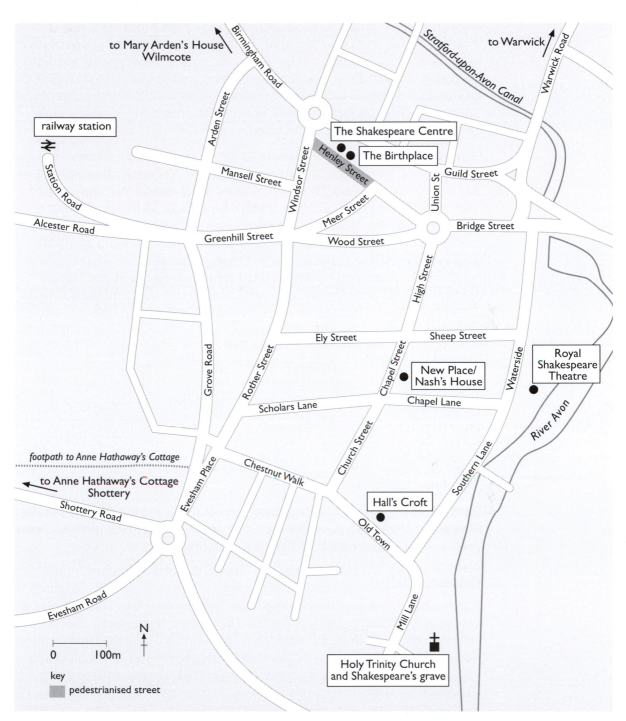

Figure 4.2 Map of Stratford-upon-Avon, showing the places associated with Shakespeare: the Birthplace; New Place; Nash's House; Hall's Croft; Anne Hathaway's Cottage; Holy Trinity Church and Shakespeare's grave.

relatively recent date. The sheer extravagance of the tourist industry in Stratford would seem, to a sceptical glance, to have developed in defiance of likelihood: on the evidence of his plays and poems, Shakespeare had little interest in real locations realistically portrayed, and certainly none at all in the area around Stratford – the chief exception being Sly's offhand reference to 'Marian Hacket, the fat alewife of Wincot' (Wincot being a village in the environs of Stratford) in the induction to *The Taming of the Shrew.*

One obvious explanation for Stratford's development into a literary shrine is simply that it was where Shakespeare, the greatest dramatic poet of his time and since, was born and buried. (Nor, to be briefly pragmatic, did it hurt that over the course of the eighteenth century the growth of Birmingham resulted in the improvement of the road up from London.) Yet the obvious explanation begs as many questions as it appears to answer. Why should it be of the slightest interest where a dramatist is buried? And still less, where he was born? The conventional answer to this conundrum has been that literary pilgrimage is modelled on religious pilgrimage, and that with the supposed decline of religious sensibility came the secularisation of pilgrimage and the replacement of the saint and his or her holy and healing places with the author and his or her native haunts. It is certainly true that the literary pilgrimage takes over much of the language, protocols, and emotional structures of the religious pilgrimage, as Péter Davidházi has shown (Davidházi, 1998, pp. 66–88). Yet this observation does not in itself explain the desire to visit the physical remains of a writer as a substitute for those of a saint. This desire is typically taken for granted by modern travellers, with literary pilgrims commonly speaking of their wish to 'get closer' to the writer, as though assuming that by visiting the grave and the birthplace of Shakespeare they will access the 'real' Shakespeare.

'Doing' Stratford today, the neophyte is most likely to start at the Birthplace (Hodgdon, 1998). The street has been pedestrianised, to allow plenty of room for the tourist groups fresh off the coach (Figure 4.3).

Entry at present is through a cunningly designed portal exhibition, housed in a large modern red-brick building, through which the visitor is acclimatised to a provincial Tudor past which supposedly infuses the plays and provides a backdrop for what biographical detail we have about Shakespeare. Seduced by a discreet and ever-changing soundscape accompanying large visual displays, we are inducted into a locality peopled by constables just like the ones in *Much Ado About Nothing*, by many different tradespeople such as those featured in *A Midsummer Night's Dream*, and by travelling players who 'probably' provided the young Shakespeare with his first contact with the theatrical world. The whole dramatises Stratford as both epitomising and embosomed in Shakespeare's Countryside, and as energising the plays in general and in particular: 'his plays and poems abound with references to rural

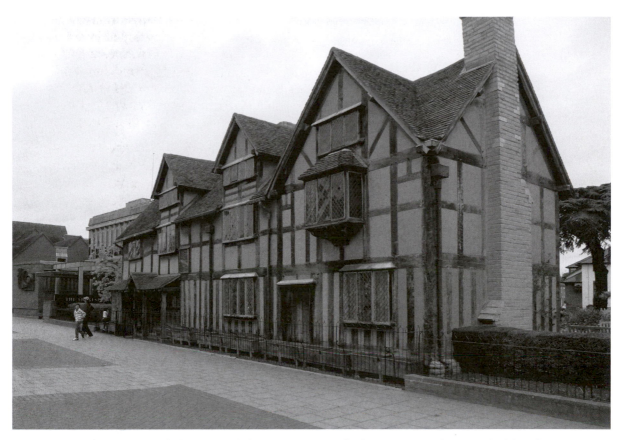

Figure 4.3 Shakespeare's Birthplace and visitor centre, Stratford-upon-Avon. Photographed by Tim Benton. Photo: © Tim Benton.

characters, country customs, wild flowers, animals and birds'. The display mixes artists' impressions of Renaissance Stratford with some original artefacts of the period. A few authentic objects, such as a copy of the first edition of the plays, reinforce the authority of the exhibition. To bring the Bard to life, his study has been re-constructed, with Shakespeare at his desk (Figure 4.4). To authenticate the details of the reconstruction Hans Holbein's portrait *A German Merchant*, 1532, is illustrated alongside (seen reflected, back to front, in the photograph).

In keeping with this pastoral aesthetic, the visitor then enters the Birthplace proper through a garden, planted up with flowers and herbs mentioned in the works (Figure 4.5).

The Birthplace itself is displayed principally as a house rather than as a museum. Visits are by tour only, with each room introduced by an actor dressed in Tudor costume, who animates the house as it might have been when Shakespeare was 11. Shakespeare's father is shown in his glove-making workshop, where, using the first person, he introduces visitors to his daily

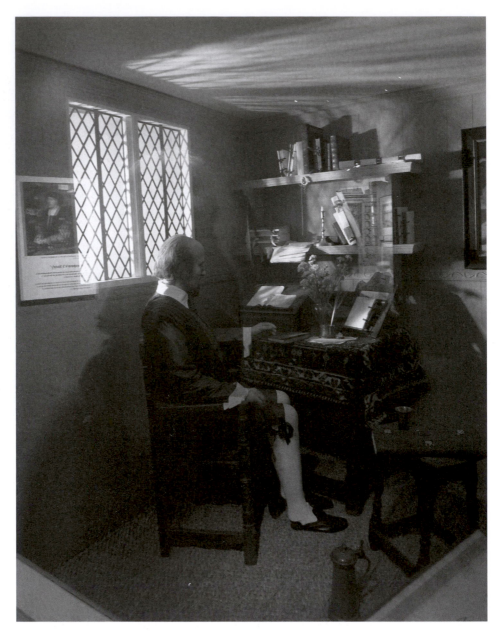

Figure 4.4 Reconstruction of Shakespeare's study, Shakespeare's Birthplace and visitor centre, Stratford-upon-Avon. Photographed by Tim Benton. Photo: © Tim Benton.

routine and remarks on their anachronistic accoutrements (wrist watches, denim jeans). Most areas are conspicuously free of print information, which is instead confined to a room containing displays that tell the history of the Birthplace itself. Items include: details of the visit of John Adams and Thomas Jefferson in 1786; the first visitors' book from 1812; the collection of *Extemporary Verses, written at the Birthplace of Shakespeare at*

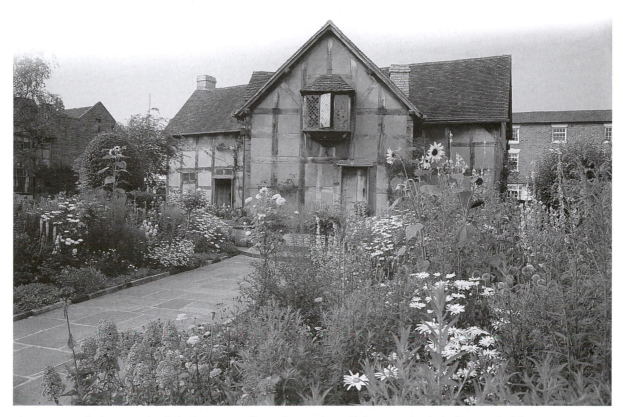

Figure 4.5 Shakespeare's Birthplace, seen from the garden, Shakespeare's Birthplace and visitor centre, Stratford-upon-Avon. Unknown photographer. Photo: © Shakespeare's Birthplace Trust.

Stratford-upon-Avon by People of Genius (1818), made up by the then owner of the Birthplace, Mary Hornby; visitor statistics then and now; and the famous window from the 'birthroom' (so-called from the early nineteenth century, though the term is more redolent of obstetrics than of belles-lettres), which preserves what remains of the sanctioned practice of graffiti indulged in by some of the earliest visitors, including Sir Walter Scott. Even this room is principally designed not so much as a museum as a warm-up act, demonstrating the importance past celebrities have accorded to their visits. Depictions of the birthroom also emphasise this, though apparently in contradictory ways: a photograph taken in 1882 is included largely to illustrate the practice of earlier visitors in scrawling their signatures on the whitewashed walls. The room itself ('Please turn off your mobile phones!') is consciously empty and blandly domestic (Figure 4.6).

To visit the Birthplace nowadays is thus explicitly to recapitulate two and a half centuries of previous pilgrimage and yet to come to an empty silent space, potential, secretive and blank, signifying the space or time before 'Shakespeare', before there was anything to remember. To visit the next stop

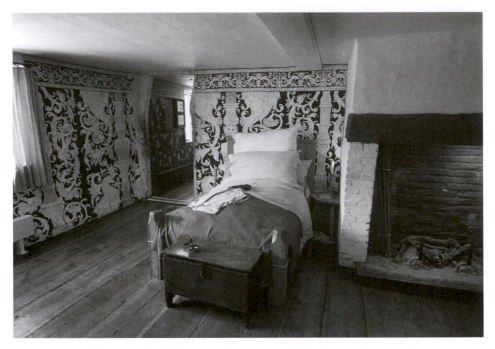

Figure 4.6 Shakespeare's birthroom, Shakespeare's Birthplace visitor centre, Stratford-upon-Avon. Unknown photographer. Photo: © Shakespeare's Birthplace Trust.

on a conventional, biographically organised pilgrimage around the Shakespeare Properties, Anne Hathaway's Cottage, out in the village of Shottery, is also to visit context prior to text, but in a yet more domestic, privatised and feminised mode, as befits a place which has traditionally been associated with young love. Anne Hathaway's Cottage exemplifies airbrushed English rural charm, and is emphatically feminine in **presentation**. Guides in the first room sing paeans to its cunning domestic conveniences; it is enviably housekept down to the last sprig of rosemary laid out in blazing pewter. Shining with beeswax, the artefacts on display all speak of women's work: butter pats, pattens, milking stools, an iron, lace-making equipment, a linen-press, a nursing-chair and samplers. The annexed exhibition also chronicles the history of delight in Shakespearean domesticity by means of a case of antique souvenirs which include a nineteenth-century biscuit-ware model of the cottage, a late nineteenth-century trinket chest with a painting of the cottage on the lid, and an early twentieth-century souvenir bust of Anne. In keeping with this ethos visitors are then solicited to buy pretty views of the cottage variously stamped on birthday cards, jigsaws, trays, mats, coasters, a tea-cosy, china boxes, and tea-towels, and, less obviously branded but part of a more general romance of housekeeping, aprons, lavender, lace, pewter plates, and most seductive and impractical of all, 'beeswax furniture polish as used in the Shakespeare Houses'.

The indefatigable tourist, with or without souvenir beeswax polish pushed into bag for future use, would now return to Stratford to see Nash's House (next-door to the site of the now vanished New Place, Shakespeare's own house), Hall's Croft (home of the more respectable of Shakespeare's sons-in-law), and then perhaps foray out to Wilmcote to see Mary Arden's House (the former home of Shakespeare's mother, only identified as such in 2001), and perhaps also the house formerly known as Mary Arden's House, which still serves as The Shakespeare Countryside Museum. They might then take tea to recruit their strength for the evening's performance of Shakespeare by the Royal Shakespeare Company playing at the Memorial Theatre or its satellites (though many more tourists visit Stratford than its theatres). But I suggest instead a pause for breath at this juncture. We have taken a look at the two properties that, with the exception of Shakespeare's tomb itself, have had the longest history as Stratford tourist sites. The history of the development of these three sites into the core of the present-day tourist experience of Stratford through their representation and reproduction is the subject of my next section.

The construction of Shakespeare's Stratford

The site that originally attracted visitors was Shakespeare's tomb and monument, and it was the first to be illustrated, in 1656 in Sir William Dugdale's *Antiquities of Warwickshire* (see Figure 4.7 for later image). In 1737 the artist and antiquary George Vertue made a visit during which, in addition to sketching the monument, he commissioned a local sculptor to make him a cast to display at home, the first ever souvenir reproduction (Deelman, 1964, p. 35). Vertue was by no means alone in his desire to appropriate the piece, for by that time the monument was in a poor state of repair, thanks to the vandalism of a growing number of relic hunters. Monies were therefore raised to restore it in 1748, a first restoration that would be overtaken in 1793 when Edmond Malone, the age's most influential Shakespeare editor, notoriously persuaded the vicar to paint the coloured bust stone-colour, so as to render it, as he thought, more as it must have been originally (Deelman, 1964).

What evidence survives of eighteenth-century visiting practices indicates that in addition to a swift though punctilious visit to the tomb there was, as early as the 1740s, a further informal tourist itinerary developing. In 1742 the young David Garrick, accompanied by his friend the actor Macklin, came to Stratford specifically to view, indeed to sit under, the mulberry tree growing in the garden of New Place, which according to Shakespeare's biographer and editor Nicholas Rowe was supposedly planted by the hand of its former owner, Shakespeare himself (Shakespeare, 1709). By 1756, the next owner, Reverend Francis Gastrell, was already complaining of

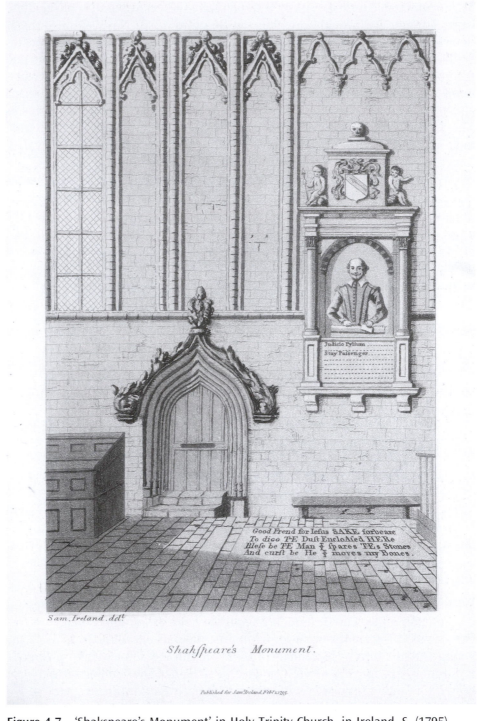

Figure 4.7 'Shakspeare's Monument' in Holy Trinity Church, in Ireland, S. (1795) *Picturesque Views on the Upper, or Warwickshire Avon*, London. British Library, London, 789.b.4. Photo: © British Library Board. All Rights Reserved.

the tiresomeness of the growing number of visiting enthusiasts to his summer home, all eager to view, touch and take their own twigs from the mulberry tree that was becoming ever more famous with every reprint of Rowe's edition (Deelman, 1964, pp. 35, 46). The infuriated Gastrell first felled the mulberry tree, in 1756, and subsequently, in an effort to avoid tax, demolished the house entirely in 1759.

Deprived of a prime tourist lure, Stratford's cannier residents set about promoting other locations in its stead. In 1762, for example, the correspondent of the *British Magazine* stayed at the White Lion in Henley Street and reported that the landlord had shown him Shakespeare's birthplace, and further, had taken him over to Bidford to show him a crab-apple tree nicknamed 'Shakespeare's canopy' (Fogg, 1986, p. 86). This crab-apple tree was the one under which Shakespeare was supposed by tradition to have slept off a drinking binge, and through the multiplication of accounts such as that of the *British Magazine* it became so celebrated that it was steadily destroyed by further plundering relic hunters, finally collapsing in 1824 (Schoenbaum, 1970, p. 114).

The Shakespeare tourist

But it was undoubtedly the success of the leading actor of the day, David Garrick, in staging the first major public celebration of Shakespeare, the Jubilee in 1769, that put Stratford on the national map for the generality of tourists. This event accelerated the process of making it a must-see location in itself, rather than merely a coaching town in which the traveller might idle away the hours waiting for his dinner by visiting places of local interest, including Shakespeare's tomb. In August 1769 Garrick's publicity machine brought a large crowd drawn from high society out from London to Stratford, to celebrate Shakespeare's two-hundredth birthday five years and four months late with a heady cocktail of miscellaneous entertainments – a breakfast, an oratorio, a concert, a ball, a horse race, a procession of 170 Shakespearean characters, a set of songs sung round the streets, an ambitious 'Ode' celebrating Shakespeare's achievements composed and recited by Garrick himself (Figure 4.8), a masquerade, an Assembly and Fireworks. These many and various entertainments included no performance of Shakespeare's actual works – contemporaries were so unsurprised by this that no comment was passed at all. Garrick was unlucky in the weather (a persistent downpour meant that the procession had to be cancelled, and the performance of the 'Ode' was almost flooded by the rising Avon), and many and various acid comments were passed about the nature of the entertainments; most eyewitness accounts felt that the event was an expensive fiasco.

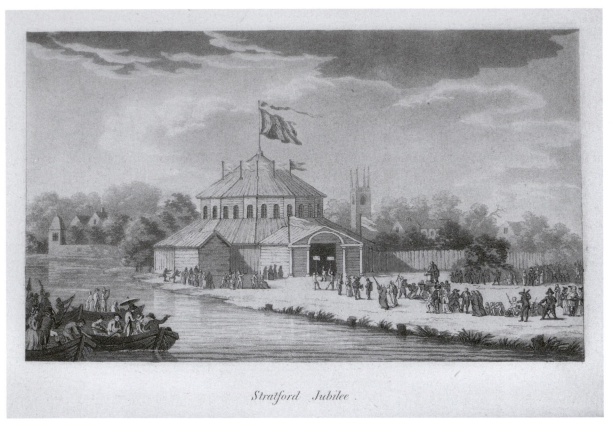

Stratford Jubilee

Figure 4.8 'Stratford Jubilee', in Ireland, S. (1795) *Picturesque Views on the Upper, or Warwickshire Avon*, London. British Library, London, 789.b.4. Photo: © British Library Board. All Rights Reserved. The temporary rotunda in which the 'Ode' was performed.

The persons who attended the Jubilee at Stratford in 1769 were not exactly tourists as we would understand the term, and nor was the Jubilee exactly a tourist event in that it was essentially occasional. Yet Garrick's extravaganza contributed notable elements to the developing Stratford tourist industry. In the most general terms the Jubilee codified, expanded, and boosted a small-scale provincial industry by successfully linking different Shakespeares – the Shakespeare of the London stage, the Shakespeare of the printed page, the rural Shakespeare of Stratford, the increasingly mythic 'Shakespeare' praised by critics and nationalists – within a multimedia spectacular staged in a single location (Lanier, 2002, p. 146). Reports of the Jubilee were illustrated by the first public print of the Birthplace in the *Gentleman's Magazine* (July 1769, plate following p. 344) (Figure 4.9).

The rained-off procession of Shakespeare characters was planned to stop at the Birthplace, hung with an allegorical banner representing the sun bursting out from behind clouds to enlighten the world, which was draped from the window of the room that Garrick had decided (arbitrarily, and without any

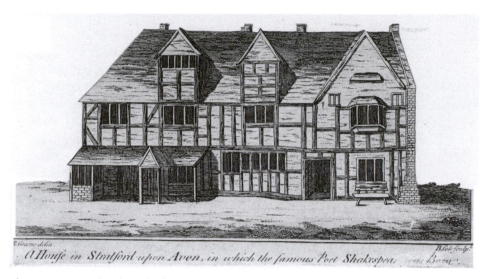

Figure 4.9 Benjamin Cole (engraver) after drawing by Richard Greene, 'A House in Stratford upon Avon, in which the famous Poet Shakespeare was Born', engraving in *The Gentleman's Magazine* (1769). Furness Image Collection, M/St850.10b ML, University of Pennsylvania Library. This shows the Birthplace as a detached building although in fact it was terraced. The Birthplace was restored by the Victorians to match this engraving.

actual scholarly evidence, though the attribution has stuck) had been the Birthroom. Here they were to sing:

> Here Nature nurs'd her darling boy, ...
> Now, now, we tread inchanted ground,
> Here Shakespeare walked and sung!

<div align="right">(quoted in Brown and Fearon, 1939, p. 81)</div>

Individually dramatised locations were linked into a narrative by the moving of the procession from spot to numinous spot – from the Birthplace to the monument in the church, where Shakespeare's tomb was ritually heaped with flowers. So fundamental did this narrative of location become to the cult of Shakespeare that it remains the underlying itinerary of the Shakespeare Birthday Procession to this day, a procession that takes place annually on 23 April and culminates in the ceremonial laying of flowers on the writer's tomb.

The Jubilee did more than invent a prototype tourist itinerary; it invented a prototype tourist sensibility and protocols to match. The lines above, for example, suggest an essentially touristic audience for the Birthplace. Rather than viewing the house as an interesting 'antiquity', the audience is solicited to a theatrical experience lived in the moment, and fundamentally sentimental in its effort to put the tourist into the same place and thus, by an effort of time-defying imagination, almost into the presence of the Poet. To serve as a memento and mark of this charged moment, the Jubilee also invented the

literary souvenir, as opposed to the relic. Relics, in the shape of bits of the felled mulberry tree, had already made the fortune of a local craftsman, William Sharp, who bought up much of the timber and proceeded to turn out an implausibly large number of expensive knick-knacks which he sold for good prices from 1756 onwards to all comers, including David Garrick himself. These objects operated within the Shakespeare cult with something of the power of the shards of the True Cross, although the wood itself, carved, polished and often inlaid, served as its own reliquary. The Jubilee, however, introduced the first mass-produced souvenirs – manufactured objects designed to be taken away as a memento of the occasion, and as certification of having been there. In addition to the sale of 'Shakespeare favours' (specially woven coloured ribbons made into sashes and rosettes, attached to badges and medals with a likeness of Shakespeare on one side and an inscription on the other that devotees were to wear as a sort of uniform), cotton handkerchiefs printed in red with eight characters from the plays were on sale to the less well-heeled. The Jubilee committee also sponsored an 'Official Jubilee Bookseller' who purveyed copies of Garrick's Ode, the collection of Jubilee songs entitled *Shakespeare's Garland*, and other assorted opportunistic occasional publications, from a stall set up in the Birthroom (Deelman, 1964, p. 259).

That glimpse of the bookseller, swathed in the glorious coloured light falling through the Birthroom window from the allegorical silk banner hung across it, exemplifies the way in which the Jubilee succeeded in securing print culture to a physical origin. Yet the need to hang an allegorical painting from the Birthplace window also illustrates how this particular place had yet to become recognisable, let alone iconic, and let alone a locus promising a supremely authentic tourist experience. That authenticity and uniqueness, paradoxically, was only achieved through the reproduction and dissemination of its likeness. In this sense the engraving in the *Gentleman's Magazine* did what ecstatically pausing the procession outside the Birthplace could not do fully; it linked the Birthplace and the Shakespeare you might read at home together within print culture. The massive publicisation of the Jubilee across Europe was reinforced by the smash-hit part-satirical depiction of its aspirations and discomforts which Garrick himself staged at Drury Lane in order to recoup his costs, his afterpiece *The Jubilee* (Dobson, 1992, pp. 214–7). The play was provided with painted backdrops of Stratford in such realistic perspective that, on visiting Stratford for the first time in 1785, John Byng recognised the White Lion hotel 'because it had been so well painted at Drury Lane theatre' (Deelman, 1964, p. 282). The scenery included a depiction of the parish church as well, suggesting that Stratford would have been increasingly recognisable to travellers before they had ever laid eyes on the place. Stratford from henceforth was the privileged location for Shakespeare pilgrims, and Stratford residents profited accordingly.

Shakespeare's Stratford in print

Though Shakespeare's earlier biographers, notably John Aubrey and Rowe, had connected the Bard with Stratford and its environs, the man who first elaborated Shakespearean biography with visually realised locations by way of illustration, and who modelled appropriate tourist sentiment in a romantically enthusiastic first-person narrative of his pilgrimage, was Samuel Ireland. He is now best remembered as the father of the forger of Shakespeare's letters, William Henry Ireland. *Picturesque Views on the Upper, or Warwickshire Avon* (1795) successfully joined up long-familiar Shakespearean oral traditions into an itinerary for an extended excursion into the country, which could then be readily repeated by readers fired with the sort of enthusiasm that one traveller was already expressing in 1793:

> STRATFORD! All hail to thee! When I tread thy hallowed walks; when I pass over the same mould that has been pressed by the feet of SHAKESPEARE, I feel inclined to kiss the earth itself.

<div align="right">(Clarke, 1793, p. 379)</div>

Ireland's *Picturesque Views* is lavishly illustrated with detailed engravings of locales associated with Shakespeare: the Birthplace, Charlecote House (where Shakespeare was alleged to have been caught stealing deer by Sir Thomas Lucy), Fulbrook Lodge (the alternative scene of the deer-stealing episode, according to John Jordan), 'the kitchen of Shakespeare's House' (including 'Shakespeare's Chair'), the monument in the church, Anne Hathaway's Cottage (the first ever representation), and an artist's impression of the temporary rotunda in which Garrick had recited his Ode at the Jubilee nearly thirty years earlier (see Figure 4.8). Of especial interest is a marvellously implausible reconstruction of New Place complete with Tudor figures (Figure 4.10).

This looks nothing like what we know New Place to have looked like in Tudor times, but it does look like what contemporaries felt a Tudor house should have looked like. Here, Ireland previews the Victorian desire to make Stratford adequately Tudor and so 'Shakespearean', going to the length of putting Shakespeare's crest above the Adam-style neo-classical doorway. Ireland models for his reader a must-do itinerary, a useful guide to appropriate sentiments, and appropriate activities, including the acquisition of relics and souvenirs. Though Ireland's publication is not what we would understand as a guidebook, being more a cross between travel narrative, coffee-table book and antiquarian notes, it brings together for the first time biography, pictures and a first-person account of visiting the place, describing a visit that readers are effectively urged to repeat for themselves.

If Shakespeare's monument is recognisably the product of a seventeenth-century aesthetic and the Birthplace the product of an essentially romantic cult

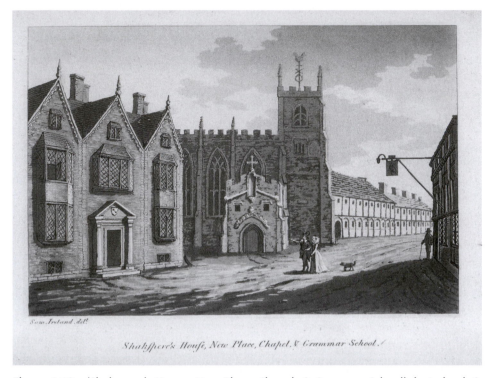

Shakspere's House, New Place, Chapel, & Grammar School.

Figure 4.10 'Shakspere's House, New Place, Chapel, & Grammar School', in Ireland, S. (1795) *Picturesque Views on the Upper, or Warwickshire Avon*, London. British Library, London, 789.b.4. Photo: © British Library Board. All Rights Reserved.

of the origins of genius, Anne Hathaway's Cottage as it is presented today is clearly derived from the way in which the Victorians visualised and understood it. Victorian interest in the Cottage grows in large part out of a desire to have a sober and domestic Bard, in the teeth of the troubling facts of Shakespeare's marriage at eighteen to a woman some eight years his senior, and already heavily pregnant, the provision in his will pointedly leaving only the 'second-best bed' to his wife, and the general embarrassment of the Sonnets, which, whether addressed to man or woman, were clearly not addressed to his wife. When William Howitt, author of the influential *Visits to Remarkable Places* (1840) and *Homes and Haunts of the Most Eminent British Poets* (1847), made his visit to Stratford in 1839, he consciously diverted his footsteps away from the Birthplace towards neglected Shottery, 'authentic and unchanged', testimony to a newly domestic, marital and retired Bard. By the 1880s the Cottage was firmly fixed as a locus for an idealised pastoral love of the sort that is conspicuously absent from the comedies but was nonetheless felt to be authentically Elizabethan (one anonymous hack-writer burbled of the stream across the lane, 'no doubt many a flower has been dropped in its limpid current by the happy lovers') (Shakespeare's Country, 1886, vol. 1, p. 17).

To Americans especially it summed up all that was English: a guide of the 1890s wrote it up as a 'perfectly representative and thoroughly characteristic bit of genuine English rustic scenery' (Guide to Stratford-upon-Avon, 1890s, p. 22). In 1886 William Winter, perhaps the most influential American writer on Stratford after his countrymen Washington Irving and Nathaniel Hawthorne, was much taken with this 'rustic retreat' as 'the shrine of Shakespeare's love' (Winter, 1886, p. 83). Typically for his time, he traced Shakespeare's supposed love of flowers and of pastoral landscape to his happy memories of the scenes of his wooing, and reverently carried away a 'farewell gift of woodbine and roses from the porch' (Winter, 1886, p. 84). Though this portrait of the poet in love is more than faintly comic, it demonstrates the way in which by the 1880s Shottery had evolved into a satisfactory location for the heady mix of rustic chivalry, merrie Englandism, fairies, botany and romantic domesticity that 'Shakespeare's England' was supposed to have been. By 1901, courtesy of this enthusiasm, the whole set-up had become a good deal less 'rustic' than advertised; Christian Tearle in his *Rambles with an American* noted rather sourly that 'The meadow paths are not nearly as sylvan as the guide-books would lead one to expect. The endless stream of excursionists, which has flowed along them throughout spring, summer and autumn for so many years, has left its mark' (Tearle, 1910, p. 81).

By the middle of the nineteenth century, then, Stratford was the centre of a thriving and well-codified tourist industry. The Birthplace had fallen out of the hands of its private owner and had been rescued in 1847 for the nation from a rumoured American plan to ship it to the USA, there to exhibit it at fairs around the country. The Birthplace Trust was formed to preserve the site, and the house was aggressively restored to Tudor picturesqueness for the 1864 tercentenary. The garden was planted up with 'Shakespearean' plants, a museum established next door, and a set entry charge levied. The Trust subsequently acquired both Nash House and the site of New Place in 1864, Anne Hathaway's Cottage in 1892 and the house then believed to be Mary Arden's House in 1930. The town would become increasingly monumentalised with statues and plaques, including the Jubilee fountain in the marketplace (given by an American with strong temperance leanings and a desire to lay to rest the local folklore about Shakespeare's boozing), and, after many false starts such as the proposal around 1868 to put a theatre on the site of New Place, the Memorial Theatre eventually opened in 1879. Tourist numbers climbed steadily: in 1806, when records began to be kept, there were about 1000 visitors a year; 2200 came in 1851, but, after the opening of the railway line from Warwick in 1860, 6000 came in 1862; in the tercentenary year of 1864 some 2800 visitors came in the festival fortnight alone; by 1900 there were some 30,000 visitors a year; in 1937, it is thought that there were 85,222 visitors; and by the 1980s well over a million visits were being paid annually to the Trust's five properties together (Fogg, 1986, p. 147; Brown,

1979, p. 60; Ousby, 1990, p. 551–2; for numbers of American visitors, see Smith, C.R., 1868–9, p. 1). Figures quoted by authorities vary widely, possibly because of variation in the use of sources: early figures are based on records kept by the Birthplace and visitors' books at the inns.

The story of the invention of Stratford as Shakespeare's town is as much a story about textuality as it is a story about preserving the ancient fabric of the town. The dissemination of publications about Stratford, combined with the dissemination of visual representations ranging from prints to pop-up models to ceramics, meant that Stratford increasingly became familiar to many who had never, and might never, set foot there.

To avoid creating disappointment, Stratford increasingly strove to become more like the Stratford of the imagination, stripping off its modern facades to become more 'Tudor'. Indeed, Nathaniel Hawthorne complained that the Birthplace was 'a smaller and humbler house than any description can prepare the visitor to expect', that indeed, there had been too much description: the visitor had 'heard, read, thought, and dreamed' too much about the place for it to live up to expectations (Hawthorne, 1863, pp. 112, 115). Yet Tearle's American tourist Mr Fairchild complained in 1901 both that the tidied-up Birthplace was 'offensively modern' and that it was still too archaic: 'so mean and so dark that you can't think of any civilised person living in it, without a sort of pity'. The sense of Shakespeare as 'some great natural wonder' forces the discerning Mr Fairchild out into Shakespeare's countryside to bathe 'in Shakespeare's river', and, having disgustedly flung away his souvenir plaque into the Avon because it was adorned with an inaccurate transcription of Shakespeare's lines, he plucks instead a few leaves of ivy from the Birthhouse (Tearle, 1910, pp. 77, 78, 80, 94). In this he is entirely in the spirit of modern literary pilgrimage; though brought to Stratford by the power of print culture, he tries to discard print culture in favour of something non-commercial and natural, an immediate physical or organic experience rather than a representation or reproduction.

Stratford represented, and still largely represents, a Victorian dream of Englishness, an energetic dreaming that arguably turned Stratford into the world's first theme park. The development of the Shakespeare tourist trail in Stratford met (and still meets) an urgent cultural need to place the author within some kind of physical and natural context.

Reflecting on the case study

One of the themes of the case study is the search, by literary tourists, for some kind of authentic and tangible experience of Shakespeare's imaginative world. Being guided through the house where he was born by actors in period dress, sitting by the Avon, or buying more or less authentic relics of the writer's life

are all ways of stirring the imagination. One of the features of the Stratford experience is immersion in 'Englishness', represented by more or less genuine sixteenth- or seventeenth-century houses. This search for authentic, unspoiled Tudor 'Englishness' helps to explain the popularity of Anne Hathaway's cottage. The emphasis on the supposed authenticity of this context sits uncomfortably with the appeal to the authority of Shakespeare's literary output. Nicola Watson has shown that from the origins of the construction of Shakespeare's Stratford, the substitution of context for art – trying to share what Shakespeare saw and felt rather than what he wrote – was a key attraction, even for those closest to the literary productions (actors, authors and critics). Similar processes exist even in museums full of authentic canonical artworks, when curators add contextual information to their interpretation of the works. Another feature of this story that can be compared with any heritage management is the importance of media output. Nicola Watson shows that from the early days of the development of Shakespeare's Stratford, images and text published in magazines, brochures and books were essential not only for publicising the venue but for fixing its authority. The website of the Shakespeare Birthplace Trust (2009) as well as the various maps and guidebooks to Stratford continue this tradition.

Gains and losses from the new museology

Museums necessarily demonstrate many of the features of the AHD in their clearest form. In many museums, curators are required by law to conserve and display the objects in the collection, and the curatorial profession relies on a set of skills and principles which may not be available to or shared by the general public. The impact of the new museology movement and changes in government funding in the last thirty years have fundamentally changed practice in most museums, placing a much higher degree of emphasis on viewer satisfaction. Symptoms of this shift are the proliferation of 'blockbuster' exhibitions, didactic display styles which sometimes replace authentic objects with multi-media or graphic displays, and the ever-present potential for brand tie-ins and shopping. But museum curators are also responsible to their sponsors (including government) to enhance the value of cultural assets by research, specialised exhibitions and publications. The tensions between these roles have typically resulted in a mixed economy of expertise, with educationalists, marketing advisors and curators sitting side by side on executive committees and exhibition groups. From one point of view, the new museology is working – attendance is up, participation has become slightly wider. From another point of view, the nurturing of specialist expertise has suffered, and museums have slipped towards the 'dumbing down' which many see as symptomatic of western societies in the twenty-first century but which may be the necessary corollary of increased attendance.

Conclusion

Museums since 1945 have shifted considerably in their perceived purpose. We saw this in the revisions to the original ICOM definition that merely required the holding of collections open to the public (1946). By 1961 'study, education and enjoyment' were recognised, and by 1974 a more outward-looking function of being 'in the service of society and its development' was added. This reconsideration of the purpose of museums coincided with a period in the West when established academic disciplines began to embrace new world views, often referred to as postmodernism, and cultural critics considered the relationship between industrial societies in decline and the rise of the 'heritage industry'. One of the outcomes has been a shift in professional practice in museums, seeking new ways of getting the visitor to engage with the collections; the new museology. However, curators differ widely in their approach. There is a distinct difference, for example, between 'aesthetic' and 'contextual' approaches. The museum world also has to be understood in an economic context, particularly for objects that acquire additional financial value because of their perceived recognition by museum professionals ('genuine' and 'authentic' artworks). Some museum visitors still want to use a museum as a point of reference, to 'look up' authentic examples of art or craft work or to improve their knowledge and understanding. Research has proved that the reasons for visiting are closely linked to wider social distinctions of class, income and education. A paradox for museum managers is that the blockbuster exhibitions that attract the highest number of visitors are often the most conventional in presentation and offer the most highly esteemed works of art. Some museums have gone on to re-invent themselves as close to other consumer experiences, such as shopping malls and theme parks: this option is limited by the nature of the collections. The case study of the emergence of the Stratford-upon-Avon tourist industry has traced the origins of the 'contextual approach' currently deployed, and the cumulative effects behind visiting the historic sites of 'Shakespeare's world'. It has also demonstrated the importance of the needs of visitors: Shakespeare's Stratford came about because of a real hunger, among Shakespeare readers, to locate the Bard in a physical setting.

This chapter closes the first part of this book, which has emphasised the processes that have emerged in an increasingly professionalised international heritage sector. It is also an important point of reference for the next four chapters, which can be seen as taking single strands from the complex totality that the museum experience offers, highlighting the need to communicate and create rather than to curate and conserve. Interpretation and tourism is discussed beyond the confines of formal museums; social action is discussed as a contrasting 'street museum' experience; and performance is considered as an act of social communication in formal and grassroots heritage contexts.

Works cited

Ashworth, G. and Tunbridge, I. (1996) *Dissonant Heritage: The Management of the Past as a Resource in Conflict*, Chichester, Wiley.

Beard, M. and Henderson, J. (1994) '"Please don't touch the ceiling': the culture of appropriation' in Pearce, S. (ed.) *Museums and the Appropriation of Culture*, London, Athlone Press, pp. 5–42.

Bourdieu, P. and Darbel, A. ([1969] 1985) *L'Amour de l'art*, Paris, Les Editions de Minuit.

Brown, D. (1979) *Avon Heritage: The North: The Vale and the Forest*, Bristol, Dorothy Brown/Bristol Visual and Environmental Group.

Brown, I. and Fearon, G. (1939) *Amazing Monument: A Short History of the Shakespeare Industry*, London, William Heinemann.

Burton, A. (1999) *Vision and Accident: The Story of the Victoria and Albert Museum London*, London, V&A Publications.

Cataldo, L.P.M. (2007) *Il museo oggi: linee guida per una museologia contemporanea*, Milan, Hoepli.

Clarke, E.D. (1793) *A Tour through the South of England, Wales and Part of Ireland, Made during the Summer of 1791*, London, printed at the Minerva Press for R. Edwards.

Cuno, J. (2007) 'Money, power and the history of art: whose money? whose power? whose art?' in Watson, S. (ed.) *Museums and their Communities*, Abingdon and New York, Routledge, pp. 510–18.

Davidházi, P. (1998) *The Romantic Cult of Shakespeare: Literary Reception in Anthropological Perspective*, Houndmills, Macmillan.

Deelman, C. (1964) *The Great Shakespeare Jubilee*, London, Michael Joseph.

Dobson, M. (1992) *The Making of the National Poet: Shakespeare, Adaptation and Authorship, 1660–1769*, Oxford, Oxford University Press.

Dubin, S.C. (1999) *Displays of Power: Memory and Amnesia in the American Museum New York*, New York, New York University Press.

Dugdale, W. (1656) *The Antiquities of Warwickshire Illustrated from Records, Leiger-Books, Manuscripts, Charters, Evidences, Tombes, and Armes: Beautified with Maps, Prospects and Portraictures*, London, Thomas Warren.

Fogg, N. (1986) *Stratford-upon-Avon, Portrait of a Town*, Chichester, Phillimore.

Graham, B., Ashworth, G.J. and Tunbridge, J.E. (2005) 'The uses and abuses of heritage' in Corsane, G. (ed.) *Heritage, Museums and Galleries*, London and New York, Routledge, pp. 26–37.

Guide to Stratford-upon-Avon (1890s) *A Guide to Stratford-upon-Avon ... with a Description of the Historic Memorials and Relics of Shakspeare*, Manchester, Abel Heywood.

Gurian, E.H. (2005) 'A blurring of the boundaries' in Corsane, G. (ed.) *Heritage, Museums and Galleries*, London and New York, Routledge, pp. 71–7.

Harrison, R. (2010) 'What is heritage?' in Harrison, R. (ed.) *Understanding the Politics of Heritage*, Manchester, Manchester University Press/Milton Keynes, The Open University, pp. 5–42.

Hawthorne, N. (1863) *Our Old Home: A Series of English Sketches*, Boston, MA, Ticknor and Fields.

Hodgdon, B. (1998) 'Stratford's empire of Shakespeare; or, fantasies of origin, authorship, and authenticity: the museum and the souvenir' in Hodgdon, B. (ed.) *The Shakespeare Trade: Performances and Appropriations*, Philadelphia, University of Pennsylvania Press, pp. 191–240.

Horne, D. (1984) *The Great Museum: The Re-Presentation of History*, London, Pluto Press.

Howitt, W. (1840) *Visits to Remarkable Places: Old Halls, Battle Fields and Scenes Illustrative of Striking Passages in English History and Poetry*, London, Longman.

Howitt, W. (1847) *Homes and Haunts of the Most Eminent British Poets* (2 vols), London, Richard Bentley.

ICOM ([1946] 2007a) Development of the Museum Definition According to ICOM Statutes (2007–1946) [online], http://icom.museum/hist_def_eng.html (accessed 25 February 2009).

ICOM ([1974] 2007b) ICOM Statutes [online], http://icom.museum/statutes.html#3 (accessed 25 February 2009).

Ireland, S. (1795) *Picturesque Views on the Upper, or Warwickshire Avon: from its Source at Naseby to its Junction with the Severn at Tewkesbury: with Observations on the Public Buildings, and Other Works of Art in its Vicinity*, London, R. Faulder and T. Egerton.

Knell, S.J. (2007) 'Museums, reality and the material world' in Knell, S.J. (ed.) *Museums in the Material World*, Abingdon and New York, Routledge, pp. 1–28.

Lanier, D. (2002) *Shakespeare and Modern Popular Culture*, Oxford, Oxford University Press.

Lowenthal, D. (1985) *The Past is a Foreign Country*, Cambridge, Cambridge University Press.

Luke, T.W. (2007) 'Nuclear reactions: the (re)presentation of Hiroshima at the National Air and Space Museum' in Watson, S. (ed.) *Museums and their Communities*, Abingdon and New York, Routledge, pp. 197–212.

Malaro, M.C. (1985) *A Legal Primer on Managing Museum Collections*, Washington DC, Smithsonian Institution Press.

Museums, Libraries and Archives Council (Great Britain) (2004) *Visitors to Museums and Galleries*, London, Museums, Libraries and Archives Council.

O'Doherty, B. (1972) 'Introduction' in O'Doherty, B. (ed.) *Museums in Crisis*, New York, G. Braziller, pp. 2–5.

Ousby, I. (1990) *The Englishman's England: Taste, Travel, and the Rise of Tourism*, Cambridge, Cambridge University Press.

Rice, D. (1987) 'On the ethics of museum education', *Museum News*, vol. 65, no. 5 (June), pp. 13–19.

Richter, L.K. (2005) 'The politics of heritage tourism development' in Corsane, G. (ed.) *Heritage, Museums and Galleries: An Introductory Reader*, London and New York, Routledge, pp. 257–71.

Robertson, B. (1972) 'The museum and the democratic fallacy' in O'Doherty, B. (ed.) *Museums in Crisis*, New York, G. Braziller, pp. 75–86.

Schoenbaum, S. (1970) *Shakespeare's Lives*, Oxford, Clarendon Press.

Shakespeare, W., Rowe, N., Gildon, C. and Curll, E. (1709) *The Works of William Shakespear; in Six [i.e. Seven] Volumes. Adorn'd with Cuts*, London, Jacob Tonson within Grays-Inn Gate next Grays-Inn Lane.

Shakespeare Birthplace Trust (2009) [online], www.shakespeare.org.uk/ (accessed 25 February 2009).

Shakespeare's Country (1886) *Shakespeare's Country: A Short Description of the Route of the East and West Junction Railway* (2 vols), London.

Smith, C.R. (1868–9) *Remarks on Shakespeare, His Birthplace etc. Suggested by a Visit to Stratford-upon-Avon, in the Autumn of 1868*, London, privately printed.

Smith, L. (2006) *Uses of Heritage*, Abingdon and New York, Routledge.

Strong, R.C. (1974) *The Destruction of the Country House, 1875–1975*, London, Thames & Hudson.

Tearle, C. (1910) *Rambles with an American*, London, Mills & Boon.

Vergo, P. (1989) 'The reticent object' in Vergo, P. (ed.) *The New Museology*, London, Reaktion Books, pp. 41–59.

Watson, N.J. (2007) 'Shakespeare on the tourist trail' in Shaughnessy, R. (ed.) *The Cambridge Companion to Shakespeare and Popular Culture*, Cambridge, Cambridge University Press, pp. 199–226.

Weil, S.E. (2007) 'On a new foundation: the American art museum reconceived' in Knell, S.J. (ed.) *Museums in the Material World*, Abingdon and New York, Routledge, pp. 100–9.

Winter, W. (1886) *Shakespeare's England*, Edinburgh, David Douglas.

Wright, P. (1985) *On Living in an Old Country: The National Past in Contemporary Britain*, London and New York, Verso.

Wright, P. (1989) 'The quality of visitors' experience in art museums' in Vergo, P. (ed.) *The New Museology*, London, Reaktion Books, pp. 119–48.

Further reading

Bennett, T. (1995) *The Birth of the Museum: History, Theory, Politics*, London and New York, Routledge.

Bennett, T. (2004) *Pasts Beyond Memory: Evolution, Museums, Colonialism*, London and New York, Routledge.

Bennett, T. (2005) 'Civic laboratories: museums, cultural objecthood and the governance of the social', *Cultural Studies*, vol. 19, no. 5, pp. 521–47.

Boswell, D. and Evans, J. (eds) (1999) *Representing the Nation: A Reader. Histories, Heritage and Museums*, London and New York, Routledge/ Milton Keynes, The Open University.

Corsane, G. (ed.) (2005) *Heritage, Museums and Galleries: An Introductory Reader*, London and New York, Routledge.

Fyfe, G. (2004), 'Reproductions, cultural capital and museums: aspects of the culture of copies', *Museums and Society*, vol. 2, no. 1, pp. 47–67.

MacDonald, S. (ed.) (2006) *A Companion to Museum Studies*, Blackwell Companions in Cultural Studies, Malden, MA and Oxford, Blackwell Publishing.

Merriman, N. (1991) *Beyond the Glass Case: The Past, the Heritage and the Public in Britain*, London, Leicester University Press.

Pearce, S. (1995) *On Collecting: An Investigation into Collecting in the European Tradition*, London and New York, Routledge.

Walsh, K. (1992) *The Representation of the Past: Museums and Heritage in the Post Modern World*, London and New York, Routledge.

Chapter 5 Interpretation of heritage

Susie West and Elizabeth McKellar

Professional heritage interpretation aims to engage and challenge the heritage visitor through all their senses to create a connection with the object of heritage in question. It is a western discourse that exists only in relation to official heritage; postcolonial or indigenous peoples are positioned as maintaining understandings of their own heritage which can be added to official heritage interpretations. The origins of heritage interpretation are in the US National Park Service, reconnecting settlers to wilderness. Heritage interpretation has come of age, being recognised in a global framework of standards for practitioners, the Ename Charter. Problems in the scope of this framework are explored but it is an important addition to the existing body of international heritage documentation. The case study by Elizabeth McKellar, an architectural historian, explores the interpretation scheme in Blenheim Palace, an English aristocratic residence and a World Heritage site. The recent scheme has moved away from the high art criteria of the World Heritage designation to a personality-led experience of the palace as a home, particularly with regard to female owners and servants. The chapter concludes with a brief consideration of a small-scale public archaeology project that deals with difficult heritage in ways that seek to empower multiple voices in the local community.

Introduction

The meaning of the term interpretation within the heritage sector is best thought of as a set of professional practices intended to convey meanings about objects or places of heritage to visitors or users, although its wider sense of translation, to render something intelligible, is a good place to start. Translators are, after all, human beings who are able to move between different world views that languages express. This is not a task that computers can yet achieve, however well programmed to select appropriate idiomatic phrases. For example, we can think about the role of the translator who rendered into English the acclaimed Turkish writer Orhan Pamuk's novel *The Black Book* (2006). In this edition at the end of the novel there is a lengthy note by the translator Maureen Freely. This is a thoughtful reflection on the qualities of expression in Turkish writing which are not so characteristic of English prose. Of course, reading it in English, we actually read the translator's interpretation of the Turkish text. She has rendered a set of intangible concepts, assumptions and meanings that lie behind the text into a new language that does not necessarily support the original mentality.

The other historic role of a translator is to act as a guide in person, perhaps escorting tourists around a site or on a tour. This is a more active mediation between the visitor and what they have come to see; it is an intervention in the visitor experience. There is a triangular relationship between the visitor, the tour guide's representation and the possible meanings of the thing they have come to see. A bad tour guide can ruin the experience: nobody wants a deluge of facts or to be rushed through a crowded itinerary. Heritage interpretation aims to be the equivalent of skilled translator and discrete tour guide; it is visitor focused, and however it is delivered it should find a way of engaging the visitor to relate their own experiences to the heritage experience. We will look at common principles that have emerged since the 1950s shortly.

Heritage interpretation is not the defining factor in everything that the visitor can experience at a heritage place. The total impact of the site is the result of its presentation, an over-arching term for the overall organisation of the visitor experience. Signage, parking, physical access, the cleanliness of the washrooms and the excellence of the café are all elements that facilitate a good site presentation. Even the design and location of litter bins are considered for their relationship both to the visitors (are there enough bins in the right places?) and to the site (are they ugly?). Heritage organisations with a strong image, or brand identity, such as the National Trust in England, have a very uniform approach to presentation across their diverse properties, sometimes to the extent that dark green paint and shops smelling of lavender may erode the distinctive qualities of individual sites (Figure 5.1). This

Figure 5.1 National Trust gift shop, Newton House, Dinefwr Park, Llandeilo, Carmarthenshire. Photographed by Paul Harris. Photo: © NTPL/Paul Harris.

chapter is not going to explore the presentation of sites but you might like to think more about the contribution these presentation elements make when you next assess an interpretation scheme.

The emergence of natural heritage interpretation

As we saw in Chapter 1 when thinking about the history of official heritage practices, the USA pioneered natural heritage protection in the late nineteenth century with the creation of national parks. The US National Park Service that was formed in 1916 to manage the parks employed staff to guide visitors as well as to manage their natural resources (see also Chapter 3 discussion). Introducing a diverse natural heritage to the USA's settler population has arguably been an important nation-building project. It was also a logical response to the challenges of conveying natural history information in authentic settings. How much more interesting to have a knowledgeable guide show you beetles under stones or edible mushrooms, and keep you safely on a trail. The use of human guides does at least two other things: it draws on our willingness to tell, or to be told, a good story; and it creates a relationship between the guide and the visitor. The guides inevitably build up a body of experience about what visitors find interesting and ways of conveying just enough information, as part of the two-way interaction between the parties. This is a reflexive relationship, and we will return to this and more qualities to be found in participatory heritage activities in Chapter 8, on performance.

As a field of activity, heritage interpretation became formalised from the 1950s onwards, as practitioners began to publish works on the methods and philosophy of their work. Freeman Tilden, who published *Interpreting Our Heritage* in 1957, is now regarded as the founder of modern heritage interpretation. He began his working life as a journalist and creative writer before joining the US National Park Service in 1941 as a literary consultant. His experience of communicating through the written word expanded to a distillation of the principles of how parks guides could communicate with their visitors. He offered six principles:

1 Any interpretation that does not somehow relate what is being displayed or described to something within the personality or experience of the visitor will be sterile.

2 Information, as such, is not interpretation. Interpretation is revelation based upon information. But they are entirely different things. However, all interpretation includes information.

3 Interpretation is an art, which combines many arts, whether the materials presented are scientific, historic or architectural. Any art is in some degree teachable.

4 The chief aim of interpretation is not instruction, but provocation.

5 Interpretation should aim to present a whole rather than a part, and address itself to the whole man rather than any phase.

6 Interpretation addressed to children (say up to the age of 12) should not be a dilution of the presentation to adults, but should follow a fundamentally different approach. To be at its best, it will require a separate program.

(Tilden, 1977, p. 9)

Here, the visitor is defined as bringing something with them to the heritage visit, their personality and personal experiences, which will enable them to find their own responses (to the 'provocation'). They are not to be thought of as passive recipients but, perhaps like Tilden's earlier newspaper readers, likely to respond to the questions and challenges laid out in front-page news. An important phrase picked up by subsequent interpretation practitioners is 'interpretation is revelation'. The guide or interpreter clears the way for the visitor to experience something about the heritage in question that helps them make sense of the whole experience. Interpretation is supposed to be thought provoking, often by prompting the visitor to compare their experience to something that is revealed to them about the heritage site. It is more about getting the idea than about coming away with a list of facts. If you come away from a heritage visit that has been well interpreted, you will probably find it easy to sum it up to friends by talking about the impact it has had on you, before you tell them about any new facts you have acquired (Figure 5.2).

Tilden's principles have continued to be discussed and refined by subsequent interpreters working in environmental and cultural heritage. Making the heritage visit a stimulating experience for all the senses continues to be the main challenge. A strong means to achieve this has been developed through the use of themes to structure the content. For example, the main points of interest about a site might be a unique geological form or a distinctive ecology; a historic site might have a particularly well-preserved type of building or a strong historic personality. These topics can all be presented as themes for the visitor to follow, asking questions about how and why these topics are relevant. The chapters of this book are thematic, of course, as one solution to the problem of how to organise our understanding of a wide field. For interpreters, the use of themes reminds them not to list all possible facts about a site for visitors but to select the information to support the wider themes. We will return to the usefulness of thematic interpretation shortly but should pause to consider heritage places that do not have this sort of interpretation available. Although the ideas behind Tilden's dynamic sense of interpretation have been discussed for at least half a century, their application has been patchy as different owners of public heritage have developed their own traditions of interpretation (and responded to budgetary constraints).

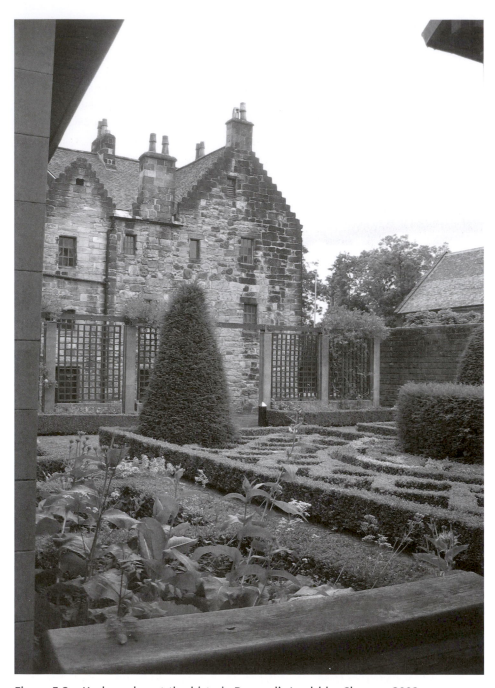

Figure 5.2 Herb garden at the historic Provand's Lordship, Glasgow, 2008. Photographed by Susie West. Photo: © Susie West. The medicinal herb garden at the only medieval house surviving in Glasgow is intended to help visitors reflect on the original purpose of the building as a medieval hospital.

The scholarly tradition

Tilden developed his principles in the context of a professionalised parks service, where the official owner of natural heritage was the federal institution and the official keepers of access and information were the institutional employees. Ownership of knowledge and control of access to knowledge is an important theme in critical heritage studies, of course, and public interpretation is not in itself a direct bridge between professional experts, the general public and special knowledge groups. It is, to continue the road-building metaphor, more of a one-way street in which professional expert knowledge is presented in a highly edited form. In a settler society like the USA, indigenous people's land rights had already been severely limited, and their understandings of natural heritage were not incorporated into the National Park Service discourse (see Chapter 3 on natural heritage issues, particularly Yellowstone Park). The institution was the expert.

In Europe, as we saw in Chapter 1 with the rise of state heritage organisations in the nineteenth century, tangible cultural heritage was the main focus. The uses of the dominant cultural form, monumental buildings, were taken to be two-fold: representing national history and giving a guide to national moral character, and upholding high artistic achievement. Heritage as truth, history and beauty was discussed in more detail in Chapter 2, exploring aesthetics and authenticity. Both chapters necessarily focus on the roles of experts nominated by official processes (as opposed to local communities) in constructing definitions of official heritage.

Heritage interpretation was also, in its early forms as much as now, in the hands of official keepers outside of the communities local to the place or objects of heritage. Tilden's principles were positive suggestions but they also reflect the absences to be found on many sites: an absence of provocation, revelation and interaction with visitors. In England, the government department that was responsible for a portfolio of officially defined ancient monuments from their designation in the 1880s onwards was the Office and then the Ministry of Works. The officials who regulated the conservation of ancient monuments – ancient monument inspectors – also worked in the ministry. They combined scholarly research, including archaeological excavation, with regulation of the conservation and presentation of the monuments in direct state care. In this way an institutional set of practices emerged that created a distinctive mode of presentation still observable at some English Heritage sites (the current successor body to the Ministry of Works). We might call this the scholarly tradition, as it was led by a concern to develop an academic understanding of these sites. You could also think of this as the 'canonical tradition', introduced in Chapter 1, in which experts select and justify the canonical places or objects of heritage. One result of this activity was the prioritising of a particular community, composed of heritage

professionals and academics, in which to develop and disseminate research results. The language used by the scholarly community included shared understandings of technical terms, historical narratives and current research questions. None of these was necessarily available to or shared by most members of the public.

The presentation decisions made by ancient monument inspectors up to the later twentieth century were largely concerned with revelation, but not the ideational revelation that Tilden meant. Working as they did with built heritage, the inspectors prioritised an accurate understanding of the form of the monuments, which were often ruined and partially concealed by debris and earth. Medieval monuments in particular were often excavated in order to find buried walls, which were then conserved in order to keep them visible and clear of earth. Finding all the walls meant that the plan of the monument could be understood and compared with other examples. If you ever visit an English medieval monastery in state care you might notice that the ruins are usually cleanly presented rising out of mown turf. Where the foundations of lost walls were too fragmentary to display in this way they might be represented as concrete outlines in the turf (see Glastonbury Abbey in Chapter 8). Different architectural spaces could then be identified for visitors, by the use of cast metal plaques simply stating the architectural term: keep, reredorter, kitchen. The plan of the monument had been revealed, but not many of its meanings.

The main interpretive device for these sites was the guidebook, often written by the inspector who had conducted the research and presentation of the site. The style and tone usually assumed a reader with a degree of insider knowledge, particularly of English medieval political history and architectural history. They had a formula for introducing the reader to the site, conducting them around a tour of the features before going on to discuss the site in its wider historical context. The ministry guidebooks were packed with information, but not shaped by themes, adhering to strict chronological order and often finishing the historical discussion at the close of the monument's last period of active use. A medieval monastery that was closed down in the 1530s might have had an interesting later life as a private house or a picturesque landscape feature for a great estate, but these later centuries were often ignored.

The meanings of the monument were very narrow in these narratives, focusing on named owners, architects, important visitors, and stylistic influences or innovations. There was little discussion of social history, daily life activities, or the uses of the monument as an object of heritage. In other words, the knowledge communities that operated within the scholarly tradition were able to investigate some basic questions about classifying sites and relating them back to national history which were highly relevant to historical disciplines. These questions and answers have tended to be presented to a wider public as

(without question) relevant to everybody. Silences over other social questions, such as the presence of other groups (women, children and servants!) or meanings, usually indicate that the questions have not been asked. This is the AHD in action (Smith, 2006). These silences have recently been strongly challenged, for instance in the national response to the bicentenary of the abolition of the British Atlantic slave trade in 2007. This prompted many heritage professionals to reconsider how questions could be asked about recovering and representing the history of the black presence in Britain.

International standards for interpretation

The World Heritage Convention of 1972 does not use the word interpretation; instead it calls on states parties 'by all appropriate means, and in particular by educational and information programmes, to strengthen appreciation and respect by their peoples of the cultural and natural heritage' (UNESCO, [1972] 2009a, Article 27). So it is not prescriptive as to how World Heritage sites should be interpreted, but it is keen that the values identified in World Heritage criteria should be explained to visitors. The operational guidelines, which interpret the convention and are periodically revised, still have little say about interpretation, subsuming it under presentation and management activities (UNESCO, 2009b). 'Education and information programmes' sound as though they belong in the scholarly tradition rather than in Tilden's vision of a revelatory interpretation.

The Ename Charter

This understated World Heritage interest in interpretation has been taken up by the International Council on Monuments and Sites (ICOMOS), the international professional body for the conservation of cultural heritage that advises the World Heritage Committee. It effectively sponsored the first international charter for standards in public interpretation of cultural heritage sites which was drafted by the staff at the Belgian headquarters of a long-running public archaeology project based at the medieval town of Ename. The Ename draft was discussed by a conference organised by the US National Park Service in 2002, which confirmed that this was a useful document for international discussion through ICOMOS. There is now a specially created ICOMOS international committee on Interpretation and Presentation of Cultural Heritage Sites (ICIP). The ICOMOS Charter for the Interpretation and Presentation of Cultural Heritage Sites (the Ename Charter) was ratified in September 2008 as a new benchmark for international professional standards (ICOMOS ICIP, 2008).

There are several professional associations of heritage interpreters, such as the Association for Heritage Interpretation (UK), the National Association for

Interpretation (USA) and regional networks like Interpret Europe, but as you can see these are not international networks. While heritage interpreters are very interested in establishing best practice and continuing to develop their understandings of visitor responses, this is not the same as an over-arching framework for international standards. Interpretation is becoming formalised in the same manner as technical conservation of monuments (see Chapter 1 for the Venice Charter) or the identification of intangible heritage (through the Convention for the Safeguarding of the Intangible Cultural Heritage). As such, it is subject to the same mechanisms for getting international agreements, which should result in a range of differing experiences being brought into the document. The Ename Charter represents agreement on what Tilden suggested was an art, not a definable science. How useful is a high-level consensus?

The Ename Charter defines interpretation as:

> The full range of potential activities intended to heighten public awareness and enhance understanding of cultural heritage sites. These can include print and electronic publications, public lectures, on-site and directly related off-site installations, educational programmes, community activities and on-going research, training and evaluation of the interpretation process itself.

> (ICOMOS ICIP, 2008)

It defines presentation more narrowly than it has been used earlier in this chapter (for site presentation), taking it to be the 'carefully planned communication of content', or how people access interpretation content. Like Tilden's work, it goes on to offer principles to organise this work, in this case seven objectives:

1 Access and understanding
2 Information sources
3 Attention to setting and context
4 Preservation of authenticity
5 Planning for sustainability
6 Concern for inclusiveness
7 Importance of research, training and evaluation.

(ICOMOS ICIP, 2008)

These principles are then fleshed out and we should pick out some meanings from them. Specifically, Principle 2 calls for information sources to include living cultural traditions as well as standard scientific and scholarly methods of creating data. Principle 3 includes tangible and intangible values to be preserved as part of the physical setting and social contexts of the place. Principle 6 notes that stakeholders and associated communities should be involved in developing an interpretation programme, that is, beyond inclusive

content. Sustainability in these principles is used in the sense that all interpretation activities need to be designed to be long term and maintained, made possible by social, financial and ecological sustainability. The aspirations of the interpretation principles then, as you might guess, relate closely to the language found in other recent international heritage frameworks. Only two sections – those that expand on the meaning of Principle 1 'access and interpretation' – gesture towards Tilden's dynamic sense of the two-way process of interpretation. They are as follows:

1.1 Effective interpretation and presentation should enhance personal experience, increase public respect and understanding [of the site], and communicate the importance of cultural heritage sites.

1.2 Interpretation and communication should encourage individuals and communities to reflect on their own perceptions of a site and assist them in establishing a meaningful connection to it. The aim should be to stimulate further interest, learning, experience and exploration.

(ICOMOS ICIP, 2008)

This is very focused on the heritage site as the object of appreciation, which some interpretation professionals might feel to be rather narrow. After all, most visitors respond to survey questions asking about their reasons for visiting a site with the reply that relaxation and sociability are important. However, visitors are also taxpayers and most state heritage agencies are interested in following the World Heritage Committee's example of self-promotion. The more that visitors appreciate the 'heritage product' on offer, the greater the likelihood they will offer support, visit more sites and reinforce the experience.

So the Ename Charter offers a high-level check-list of everything a heritage interpreter should consider and incorporate into planning a cultural heritage site interpretation scheme. It recognises the possibilities of presenting more than one discourse about the significance of a site, particularly for sites in settler societies or where local communities maintain traditions in tandem with the conditions of modernity, perhaps in postcolonial contexts. Although it has only recently been ratified as a global charter, it has emerged out of an evolving consensus from heritage interpretation bodies and is a product of its time.

Questioning the Ename Charter

As part of the consultative process undertaken through ICOMOS, an international conference held in 2005 at Charleston, USA, produced a short commentary on the state of the draft Ename Charter at that time. This commentary has come to be known as the Charleston Declaration (US/

ICOMOS, 2005). It is worth comparing the proposals made for wider definitions with the reduced formulas that made it through to the final version of the charter. For example, Charleston suggested that:

> 'Presentation' denotes the carefully planned arrangement of information and physical access to a cultural heritage site, usually by scholars, design firms, and heritage professionals. As such, it is largely a one-way mode of communication. 'Interpretation,' on the other hand, denotes the totality of activity, reflection, research, and creativity stimulated by a cultural heritage site. The input and involvement of visitors, local and associated community groups, and other stakeholders of various ages and educational backgrounds is essential to interpretation and the transformation of cultural heritage sites from static monuments into places and sources of learning and reflection about the past, as well as valuable resources for sustainable community development and intercultural and intergenerational dialogue.

(US/ICOMOS, 2005)

This is a useful reminder of the distinction between the 'behind-the-scenes' activity of heritage professionals and the 'real-time' activities of all site users. The Charleston emphasis on the other uses of heritage, for identity making and understanding between diverse groups, also got diluted in the final Ename Charter version. Perhaps this suggests that the critical understanding that sees heritage as part of this cultural work, as we've been exploring in this book, is not acceptable as a global understanding of the uses of heritage.

We should think further about identity and diversity as factors that are often implicit in official interpretation. It would be a crude response to dismiss the scholarly tradition as boring to most visitors, but this is undeniably a problem that Tilden was aware of in the 1950s. Visitors are not, after all, scholars. As the content of the Ename Charter makes clear, heritage interpreters by no means reject the need for good scholarship; indeed the range of sources that a wide-ranging research project can produce is a valuable addition to any cultural heritage site. Modern interpretation practice that uses a thematic approach needs to be on target with the choice of themes for the site and how these are nuanced: thinking back to the example of an English medieval monastery, there are limits to how many times a visitor wants to read the same 'day in the life of a monk' story, and yet a first-time visitor may need this approach. Scholars should be involved to draw out the specificities of the site but they are not necessarily the best communicators, however enthusiastic they may be about their specialism. Heritage interpreters since Tilden have found the use of themes to be a good way of bridging the gap between scholarly detail and a good story.

However interesting the choice of thematic stories, the conversion of scholarly detail into more engaging approaches does not solve the problem of who the user of the interpretation is likely to be. There is no single visitor 'type'. We all bring differing states of knowledge and experience with us, inflected by our identities: age, gender, class, ethnicity, language and nationality. Tilden recognised some of this in his call for interpretation for children to be an entirely different approach from that offered to adults. A simple tool aimed at children, such as a quiz asking them to look for things as they go round a heritage site, perhaps animals in artworks and decoration, is often offered to families.

It is only recently, however, that official heritage interpretation has begun to question whether the interpreters' own identities produce narratives that implicitly exclude other visitor identities. The Ename Charter tackles this to an extent, insisting on the need to find ways of facilitating visitor connections to the site. It refers to the need to include local communities, perhaps the original producers and keepers of the heritage, by involving them in determining the information used in the interpretation. However, it does not offer a response to how other groups with no direct connection can be drawn in to reflect on the heritage.

Interpreters in a multicultural society like the UK are increasingly interested in this problem, particularly for tangible culture sites that have relatively narrow visitor profiles (white, middle class, middle aged) despite being close to highly diverse centres of population. Economic means, aspirations and leisure habits all play a part in who becomes a heritage visitor (West, 2010). However, once the visitor arrives on site or in the museum, more sophisticated interpretation schemes may be able to offer targeted means of getting a visitor to compare, for example, their food choices or use of decorative motifs to what they find (what is revealed) at the heritage site. This is an extension of the use of themes, not just to narrate stories about heritage but to point up differences and similarities between the culture under scrutiny and the diversity of visitors' cultural understandings. The leading body in the UK for challenging official heritage interpreters to think more creatively about engaging ethnic minorities in their work is the Black Environment Network. Their mission statement calls for them to work in two directions: 'On the one hand we reach out to ethnic communities in order to stimulate participation. On the other hand we work to support mainstream organisations so that they may gain the necessary awareness and skills to work effectively with ethnic communities in a socially and culturally relevant way' (Black Environment Network, 2008).

The Charleston Declaration is brief. It concludes with suggestions for more discussion:

- Incorporating stakeholder perceptions and values in interpretation programs remains a challenge.

- The interpretation of religious and sacred sites, places of contested significance, and sites of conscience or 'painful memory' needs further analysis in terms of establishing acceptable boundaries and better guidance as to their interpretation.

- In spite of years of expert discussion, the concept of 'authenticity' continues to be elusive. Additional research and discussion is needed to define its nature and role in heritage interpretation.

- Certain cultures and communities oppose or prefer alternative methods for the public interpretation of their cultural heritage sites. This requires a continuing dialogue and analysis of how heritage site categories and the circumstances that surround them should influence the decision to interpret as well as the level of interpretation.

(US/ICOMOS, 2005)

These comments share an interest in the underlying philosophy of heritage interpretation: who is in control and in whose name is this produced? The Ename Charter itself offers no direct answers. John Jameson offers a useful discussion of some of the issues behind the Charleston Declaration, reminding us that as a document intended to function as a global reference, the Ename Charter sits well within the UNESCO position of asserting that heritage 'is an *inclusive possession of all humanity* belonging to no one individual' but that these concepts of heritage 'developed within Western philosophical traditions' (Jameson, 2008, p. 438). The Charleston Declaration is a reminder that this is an imported tradition for many communities, some of whom may actively reject the proposition. What would the Ename Charter recommend for a stakeholder who refuses to join in?

The uses of heritage for supporting national identities, often through highly selective representations of history, is another problem touched on by the Charleston Declaration in the final discussion point above. Countries with 'fragile or questionable human rights histories' may have no interest in producing official interpretations that are historically verifiable and inclusive (Jameson, 2008, p. 435). The presence or contribution of ethnic minorities might be too challenging for the group currently in power to acknowledge, for example. This point is closely related to the Charleston Declaration's interest in how to interpret religious or **sacred sites**, contested sites and sites of conscience, in itself an unusual grouping. They have in common a particular exercise of power that may have no interest in recognising other world views; some sites are the result of a clash of such world views. The designation of

armed resistance to a dominant power as freedom fighting or terrorism, depending on your point of view, remains a conundrum for good reason. The Ename Charter, in its insistence on the use of interpretation to strengthen the visitor's appreciation of and bond with a cultural heritage site, certainly leaves little room for our relationship with difficult heritage associated with violence, atrocity or repression.

Interpretation master planning

We turn now to consider how heritage interpreters begin to put interpretation in place at a site. Modern professional practice uses formal planning practices to work through the stages of developing a scheme; indeed, the documentation to demonstrate that the considerations summed up in the Ename Charter have been dealt with is often a requirement of grant-giving bodies. In this sense, interpretation practice draws on common principles of project management, planning and delivery found across commercial and public-sector operations.

The World Heritage Convention and its operational guidelines require the parties responsible for World Heritage sites to demonstrate that 'effective and active measures' are being taken to ensure the 'identification, protection, conservation, presentation and transmission to future generations' of the World Heritage site (UNESCO, 2009b, Articles 4 and 5). All this information is most conveniently gathered up in a site management plan, which summarises the background research, policies and the delivery of objectives. Most sites have a range of management issues: conservation, visitor and interpretation are the most common ones to be defined by separate plans (conservation plans were discussed in Chapter 1). We are concentrating on interpretation plans here as the tool for defining the how and why of a site's interpretation content and delivery. Of course, the interpretation plan should support and enhance the conservation needs of the site, as defined in any associated conservation management plan. The process of documenting an interpretation project means that, as with any text, it can be interrogated for silences and omissions, as well as circulated beyond the official interpretation team. It may be used as a tool for transparent and accountable practice.

The interpretation plan contains the answers to a series of questions that the people responsible for devising the interpretation have been asking of themselves and of their site (or other object of heritage such as a museum or single gallery). Put yourself in the position of leading an interpretation team: where would you start? The advice collated over years of practical experience by leading practitioners such as Sam Ham (1992) can be summarised as this list of prompts:

1 *Why* do you want to interpret something?
2 *Who* should be involved in the interpretive process?

3 *What* are you interpreting?

4 Who you are interpreting *for*?

5 What *messages* do you want to communicate?

6 What are your *specific objectives*?

(Scottish Natural Heritage, n.d.)

The most fruitful answers should be an exploration of the range of possibilities seen in the Ename Charter. For example, who are the stakeholders for your site? This may include people living, or owning property, on the boundaries of the heritage site; special interest groups for a part of the site's history; local groups who already use the site or who you hope to include in the future. A better understanding of the range of visitors (local or international, one-off or repeat visits, interests, identities) is also important for ensuring the social and financial sustainability the Ename Charter calls for. Answers to who is involved and who are the likely audiences will shape the answers to the remaining questions.

The process of writing and then acting on an interpretation plan may be time consuming, depending on the number of stakeholders to be consulted and the way this is managed, or new research may need to be commissioned. It will be more or less as complex as the heritage it is discussing, from a single object to a refurbishment of a museum gallery to the overview of a large building in a historic landscape. This chapter's case study on the re-interpretation of Blenheim Palace, a historic **English country house**, deals with a monumental building. The decision taken by the owners and professional interpretation team about which stories to promote to visitors reflects recent interest in discussing social history. This is a grand house packed with fine art and antiques, but the new interpretation themes prioritise distinctive personalities and their daily lives, particularly women at the house.

Case study: reading 'The Duke of Marlborough in story' at Blenheim Palace

Blenheim Palace in Oxfordshire, a World Heritage site, is one of the most spectacular buildings in Britain (Figure 5.3). Its monumental size, vast grounds and fantastical architecture make a powerful impression on visitors as they approach it up one of several long drives. It is marketed as 'Britain's Greatest Palace' yet is not a royal residence. It was built for John, 1st Duke of Marlborough, as a present from Queen Anne to celebrate his victory over the French in 1704 at the Battle of Blenheim, or Blindheim, in Bavaria, Germany. The battle was a decisive turning point in the War of Spanish Succession (1701–13) and saw Louis XIV's army suffer its first major defeat in forty years, to an Anglo-Dutch alliance commanded by Marlborough.

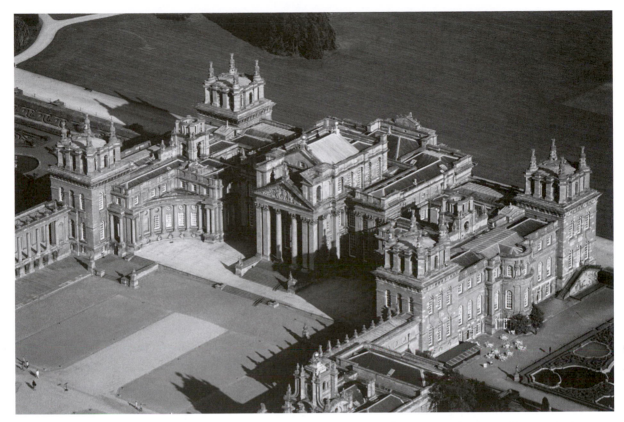

Figure 5.3 Blenheim Palace, Oxfordshire. Photographed by Yann Arthus-Bertrand. Photo: © Yann Arthus-Bertrand/Corbis.

From the beginning the palace was intended to be both a monument to Marlborough himself and to royal and national glory. Sir John Vanbrugh, the architect of the palace, wrote (with some false modesty) of how he hoped Blenheim would be perceived by future generations:

> As I believe it cannot be doubted, but if Travellers many Ages hence, shall be shewn The Very House in which so great a Man Dwelt, as they will then read the Duke of Marlborough in story; And that they Shall be told, it was not only his Favourite Habitation, but was Erected for him by the Bounty of the Queen And with the Approbation of the People, As a Monument of the Greatest Services and Honours that any Subject had ever done his Country. I believe, tho' they may not find Art enough in the Builder, to make them Admire the Beauty of the Fabrick they will find Wonder enough in the Story, to make 'em pleas'd with the Sight of it.
>
> (Webb, 1928, vol. 4, p. 29)

Blenheim is perhaps better known today as the birthplace of another great British war hero, Winston Churchill, who figures prominently in the building's presentation. From its very inception this unique phenomenon, a non-royal palace built by the state for a private individual, has been the site of conflicting interpretations arising from its dual private–public nature. The palace raises interesting issues, including notions of: public and private, conceptions of family in the presentation of aristocratic houses, issues of gender, the construction of national stories of heroism and militarism, and display practices in country houses.

'The monument of ingratitude': the building and its history

The manor of Woodstock, totalling some 2269 acres, was granted to Marlborough in 1705 as the site for this display of magnificence. The estate today is as famous for its naturalistic landscape park by Capability Brown of *c*.1764–74 as for the palace itself. George III on visiting in 1786 remarked 'We have nothing to equal this' (Sherwood and Pevsner, 2002, p. 460). In this case study the focus is on the architecture rather than the park, but both have been attracting visitors for as long as Blenheim has been in existence. Daniel Defoe in his *Tour ... of Great Britain* of 1724–6 eloquently conveyed the enormous scale of the estate and presciently foresaw what was to become a major problem in the future:

> The magnificent work then is a national building, and must for ever be called so. Nothing else can justify the vast design ... Gardens of near 100 acres of ground. Offices fit for 300 in family. Out-houses fit for the lodging of a regiment of guards, rather than of livery servants. Also the extent of the fabric, the avenues, salons, galleries, and royal apartments, nothing below royalty and a prince, can support an equipage suitable to the living in such a house.
>
> (Defoe, 1986, p. 355)

The lack of clarity about the palace's purpose and status can be traced right back to its building history which commenced in 1705. It reached partial completion in 1719, the year the Marlboroughs moved into their private apartments, but works continued on the state rooms and the grounds for a long time thereafter. To begin the complications there were two architects involved, John Vanbrugh, who had the major responsibility, and Nicholas Hawksmoor. As with their previous collaboration at Castle Howard (1700–26), no one is sure to this day precisely to whom the building should be credited. Second, it was not the duke but rather his formidable duchess, Sarah, who took the more active part throughout the building process, constantly intervening to the exasperation of the architects and contractors (see Figure 5.9). She came to call the place, echoing a phrase originally coined by Vanbrugh, the nation's 'monument of ingratitude' (Green, 1951, p. 109). For Sarah the enterprise they

were engaged in was one of constructing a private home whereas for the builders, who were paid from royal funds, this was a public building project running in parallel with other state works at Greenwich Hospital for Seamen, St Paul's Cathedral and Hampton Court Palace, all in and around London. The palace was, then, a royal monument as much as a ducal residence, and it is its combined public–private nature that has shaped interpretations of the site ever since. This duality was neatly exposed in a contemporary poem satirising the palace's impracticability as a domestic dwelling.

> 'See, Sir, see here's the grand approach,
> This way is for his Grace's coach;
> There lies the bridge, and here's the clock,
> Observe the lion and the cock,
> The spacious court, the colonnade,
> And mark how wide the hall is made!
> The chimneys are so well design'd,
> They never smoke in any wind.
> This gallery's contriv'd for walking,
> The windows to retire and talk in;
> The council-chamber for debate,
> And all the rest are rooms of state!'

> 'Thanks, Sir,' cry'd I, 'tis very fine.
> But where d'ye sleep, or where d'ye dine?
> I find by all you have been telling
> That 'tis a house, but not a dwelling.'

> (Dr Abel Evans, 'Upon the Duke of Marlborough's house at
> Woodstock', quoted in Montgomery-Massingberd, 1985, p. 54)

The ambiguity surrounding Blenheim's purpose extends to the architecture of the palace. Vanbrugh and Hawksmoor designed in what is generally termed the English Baroque style, a native version of the flamboyant type of classicism then fashionable throughout Europe. At Blenheim they combined historical English elements, principally in the dramatic skyline which created what Vanbrugh termed 'a castle air' with the monumental European Baroque palace-type. The overall plan and conception of Blenheim is based on the grandest Baroque palace of all, that of Marlborough's defeated opponent Louis XIV, at Versailles (Figure 5.4). The architectural historian Kerry Downes writes, 'The language of Versailles ... Nowhere was it more appropriate, nowhere stronger, than at Blenheim' (Downes, 1966, p. 81). Blenheim follows the French plan of a dramatic staggered outline set around a formal courtyard, known as a *cour d'honneur*. This central courtyard introduces the martial theme of the building. Its corners are marked out by cannon balls, and more recently two cannons have been introduced flanking the entrance to the house.

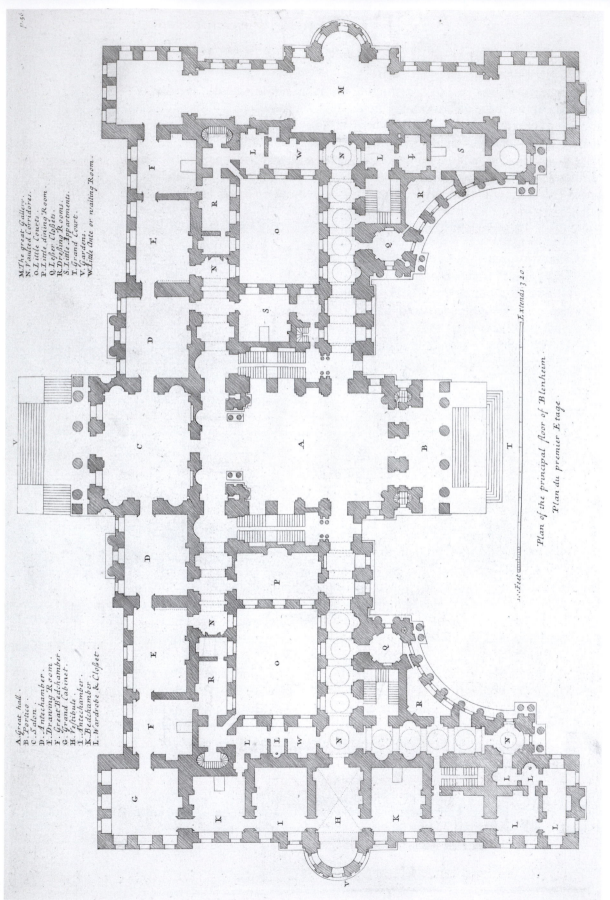

A. Great hall.
B. Portico.
C. Salon.
D. Antechamber.
E. Drawing Room.
F. Great Bedchamber.
G. Grand Cabinet.
H. Vestibule.
I. Antechamber.
K. Bedchamber.
L. Wardrobe & Closet.

M. The great Gallery.
N. Vaulted Corridores.
O. Little Courts.
P. Little dining Room.
Q. Lesser Closets.
R. Dressing Rooms.
S. Little Apartments.
T. Grand Court.
V. Gardens.
W. Little Ante or waiting Room.

Plan of the principal floor of Blenheim.
Plan du premier Etage.

Extends 320.

Figure 5.4 'Plan of principal floor of Blenheim', from Campbell, C. (2007 reprint), *Vitruvius Britannicus*, vol. 1, plate 56 (Mineola, NY, Dover). British Library, London, fm08/.1318 DSC. Photo: © British Library Board. All Rights reserved.

The military triumphalism is continued with the statues and trophies which dominate the skyline, and most explicitly in the sculptures of the English lions mauling the cockerels of France which sit on the Clock Tower Archway (Figure 5.5). On the south front a bust of Louis XIV that Marlborough had captured at Tournai was placed like 'a head on a stake' (Downes, 1966, p. 81). This great monument to English victory, then, despite incorporating explicitly anti-French imagery, is ultimately derived from French prototypes, a paradoxical combination that has inevitably led to some simplification of its architectural complexity in order to establish its significance for an AHD.

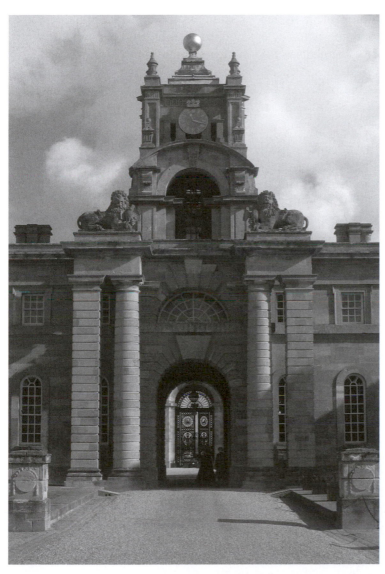

Figure 5.5 Clocktower archway, Blenheim Palace. Photographed by Elizabeth McKellar. Photo: © Elizabeth McKellar.

Blenheim became a World Heritage site in 1987. It was included on the World Heritage List on the basis of criteria ii and iv – for ii as an innovative and influential piece of architecture and for iv as 'a perfect example of an eighteenth-century princely dwelling' (UNESCO, 2009c). The listing refers to Blenheim as an exemplification of British values and a 'refusal of French models of classicism'. The need to present a discourse of authentic artistic expression in order to satisfy criterion ii has led to the demotion of certain key aspects of the building and the elevation of other arguably less central concerns. Thus its dependence on the Versailles model, although acknowledged, is played down while the non-Baroque English elements in its planning and design, principally the romantic castle air, are highlighted. Blenheim, as the citation notes, is eclectic, but the balance within that of European and native elements is still contested among architectural historians. The ICOMOS statement attached to the listing acknowledges this by saying that the palace is 'unclassifiable' and talks about the difficulty art historians have in defining the term 'English Baroque' (ICOMOS, 1987, p. 2).

The discrepancy between Downes's view of the palace and the ICOMOS view arises from the fact that interpretations of architecture and artworks are not fixed and stable but will vary over time and between individuals or groups of scholars. It is not surprising that in a case like Blenheim, where the official definitions are highly contentious and there is no agreed expert definition of its style, the task of explaining the architecture to the public is hugely problematic. In this instance the AHD surrounding the palace's architecture is highly unstable, resulting in a much greater emphasis in its presentation on the less difficult criterion iv than on the more contentious criterion ii. The architectural impact of the palace has been negated or minimised through a strategy of presenting it as more private than public, more the home of the Dukes of Marlborough than as an iconic piece of monumental architecture.

The public presentation of the palace

Blenheim, as we have noted, has had a long history as a visitor attraction. From the moment the foundation stone was laid onlookers flocked to the site. Vanbrugh in 1709 wrote of 'the multitude of People who come daily to View what is raising to the Memory of the Great Battle of Blenheim' (Green, 1951, p. 303). This is an interesting comment which highlights the palace's dual interest both as a piece of architecture and as a monument to military victory. William Mavor in his guidebook to the palace of 1793 stated that 'Blenheim may be seen every afternoon from three to five o'clock except on Sundays and public holidays' (Mavor, 1793, p. 10). Visitors prior to the twentieth century would have been restricted to the genteel only, although

Mrs Arbuthnot in 1824 was shocked to discover on her visit with the Duke of Wellington that 'People may shoot and fish at so much per hour!' (Montgomery-Massingberd, 1985, p. 12). In the period following the Second World War profound social and economic changes combined with pressure from the Labour government of Clement Atlee (UK prime minister 1945–51) forced a re-evaluation in the role of country houses. The government offered tax breaks if a property was opened to the public for a minimum of thirty-six days a year. Blenheim was accordingly opened to the public on a previously unprecedented scale when the palace began charging half-a-crown per person from 1950 (Bapasola, 2007, pp. 62–3). Already by 1951 it was the most visited stately home just ahead of Longleat, another pioneer in opening privately owned large-scale country houses. Special events and functions were also introduced early on and these remain one of the mainstays of Blenheim's programme and income today, indeed to the extent that they form one of the main sources of friction with the local community who dislike the traffic jams that build up when such activities are taking place in the park (Blenheim Palace, 2006a, section 4.2.1, p. 41).

The 11th Duke succeeded to the title in 1972 and the following year he was one of the founders of the Historic Houses Association. He has substantially increased the commercial activities and revenue of the estate, turning it into the multimillion pound operation it is today. As the palace remains a private residence it receives no public subsidy and therefore must generate all its own revenue for expenditure on the conservation and presentation of the palace and park. Diversification, of course, has been the key to the estate's activities, involving a substantial expansion of the farming, forestry and shooting and fishing operations, the setting up of a bottled mineral water business, as well as the opening of new attractions. These have included displays devoted to the two main characters with whom the house is now associated, Marlborough and Winston Churchill, as well as the creation of a family area in the Pleasure Gardens. There is also a great emphasis on the award-winning education programme which has been established since 1979 and which accounts for 5 per cent of visitor numbers.[1] The site currently attracts in the region of 400,000 visitors each year. Of these, 80 per cent are British and 20 per cent are foreigners. Americans are the largest overseas group followed by Australasian and Japanese tourists. The central attractions are the palace and the park and gardens, with entry being available either for all three or for the latter two alone. In 2007/8 a ticket for all three was bought by 69 per cent of visitors, and 31 per cent of visitors bought a ticket for the park and gardens alone.

[1] These and the following figures are for 2007/8, provided by Blenheim Palace. (The education figures are only for children up to age 16.)

For those who do enter the palace the initial choice is between the new display, *Blenheim Palace: The Untold Story*, discussed below, and the state rooms which incorporate an exhibition on Winston Churchill, including the room where he was born. The route encourages one to visit the Churchill display first (rooms W–S on the right-hand side of the plan in Figure 5.4) and for many visitors their introduction to this Baroque palace is accompanied by the sonorous tones of the nation's war-time leader. Churchill is thus placed literally at the heart of the house to represent its core values, although strictly speaking he was only a relation and not an occupant. His grandfather was the 7th Duke and his father, Randolph Churchill, the second son. The militaristic theme is continued in the state rooms which are dominated by a series of tapestries commissioned by Marlborough to commemorate his major victories (Figure 5.6). As with the exterior, images of the vanquished are prominent, not just in the battle scenes depicted in the tapestries but also through spoils such as a captured French royal standard, and a portrait and a bust of Louis XIV. The latter has recently been placed opposite a similar bronze of Marlborough, thus underlining not just the theme of triumphalism but also – as with the entire house – placing Marlborough almost on a par with royalty, an association that was criticised by

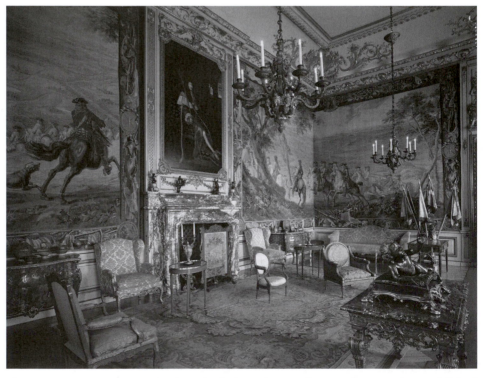

Figure 5.6 State rooms tapestries, Blenheim Palace. Unknown photographer. Published with the kind permission of His Grace, the Duke of Marlborough.

contemporary satirists (Hart, 2002, pp. 252–4). In the complex interweaving of public and private the quasi-royal presentation of Marlborough in his 'palace' presents another level of ambiguity. This is also true of the incorporation of explicitly French motifs and imagery both on the exterior and in the interior. The prominent display of images of Louis XIV depicts both the power of the Sun King and simultaneously Marlborough's even greater triumph in overcoming so powerful an enemy. In modern terms the palace re-appropriates the iconography of its enemies or 'the other' and subverts it by re-utilising it in a foreign context. A similar process can be seen at work a century later at Apsley House in London (now run by English Heritage), where the Duke of Wellington proudly displayed an 11-foot-high nude statue of his defeated enemy Napoleon Bonaparte holding, ironically, a statuette of Victory.

The state rooms were rooms of display, intended particularly for the reception of the monarch, while the private apartments of the family were, and still are, in the east wing. At the heart of the public rooms are the hall and salon, or saloon, with their dramatic illusionistic paintings by James Thornhill and Louis Laguerre respectively. It was quite common to employ foreign artists and decorators in Britain at this date as there were few native practitioners with their level of skill; indeed, Thornhill was one of the first home-grown artists of stature. From the centrally placed hall and salon fan out the series of state rooms arranged as a dramatic linked sequence – called an enfilade – along the south front. These were originally laid out as two sets, male and female, of interlinked rooms (ante-room, drawing room and bedchamber) either side of the salon, an arrangement which ultimately derives from the king's and queen's suites at Versailles. Unfortunately the inter-relationship between the hall and salon are invisible to the public due to the necessity for a one-way flow system which disrupts the architectural hierarchies of the room sequence (see Figure 5.4). Neither is there a plan in the current guidebook (Blenheim Palace, 2006b) to help make sense of the spaces through which visitors pass, as would be standard, for example, in a National Trust guidebook.

Throughout the inside of the palace the main emphasis is on the family rather than on the architecture or the building's contents. This is in line with a widespread trend in country houses, particularly occupied ones, to resist museum-type displays and instead celebrate their roles as places of residence and the seats of great dynasties. There is very little labelling throughout the state rooms and most of what there is relates to memorabilia connected with Marlborough's victories. The primary means of imparting information is via the guides and most visitors take the recommended guided tour, although it is not obligatory. Karen Wiseman, the palace's education officer, stated in an interview that personal testament is favoured over explicitly didactic material which it is believed would detract from the period feel and sense of

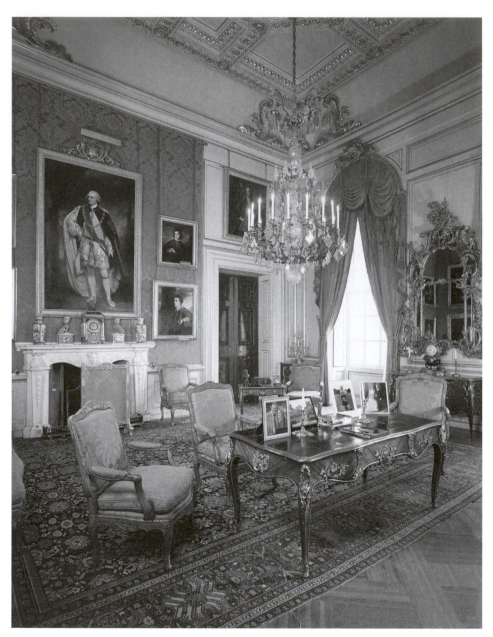

Figure 5.7 The green drawing room, Blenheim Palace. Unknown photographer. Published with the kind permission of His Grace, the Duke of Marlborough.

continuity that the state rooms offer.[2] The rooms and their functions have, of course, been altered over the centuries but current policy is to present them as near to their original appearance as possible in terms of the style of decoration and furnishings. The placement of the furniture face-out towards the visitor

[2] Interview with Karen Wiseman, Education Officer, Blenheim Palace, 6 June 2008.

route derives from the 1950s when it was re-organised for public display (Figure 5.7). Most visitors, according to Karen Wiseman, are interested in the history of the family rather than the palace as an artistic ensemble, although there are specialist groups who visit specifically to view the architecture or the furniture or tapestries.

In line with visitors' interests the guided tour singles out only the most noteworthy examples of family portraiture (such as Figure 5.10) despite housing some truly outstanding examples of British art. Almost as much attention is given to Winston Churchill's amateur paintings, in a display sponsored by Hallmark cards, as to some of the Old Masters in the state rooms. The values celebrated here are certainly not those of high art. The focus is on the familial and its memorialisation as a repository of national glory. There is little attempt made to present the palace as an innovative piece of architecture, although this is central to its World Heritage listing, or as a collection of exceptional artistic value. Far from Smith's 'banality of grandiloquence', one might instead suggest that something rather different is operating at Blenheim; intangible heritage takes precedence here over material and built heritage (Smith, 2006, p. 126; see also West, 2010).

The acknowledgement of the public interest in the family extends beyond the usual display of family photos as far as the opening of the present duke's private apartments to the public in the summer when he is not in residence. The focus on the inhabitants rather than the art or architecture, although long-established, might perhaps have been given added impetus by today's celebrity-obsessed and personality-dominated culture. A similar trend was visible in the BBC's *Restoration* programmes and associated publications of the early 2000s (Wilkinson and Rhys Jones, 2003). These provided a peculiar type of reverse beauty-parade whereby crumbling historic properties at risk throughout Britain were put forward to the public to vote for the building they felt most worthy of protection. Consistently it was buildings with a personal narrative which did well and those which were put forward solely on aesthetic grounds that failed. Country houses and palaces have generally shied away from explaining to visitors how such buildings were originally used by their owners. The next section discusses an attempt to address this issue in an innovative new display that looks at life at Blenheim for both owners and servants.

New narratives: *Blenheim Palace: The Untold Story*

In 2006 the palace's management team decided that a new attraction was needed to broaden Blenheim's appeal in an increasingly crowded and competitive market. The aim was to attract both new and repeat visitors in the 45-plus age bracket. Sinclair Design Partnership, who had previously worked on the exhibition on Marlborough and Winston Churchill in the palace's

stables, were engaged to conceive and project manage the new display with a £1 million budget. Patricia Sinclair in an interview explained that her brief was to provide 'the wow factor' which would draw visitors to Blenheim rather than to other regional rival attractions. The palace also wanted something that would run itself and not need guided intervention, unlike the state rooms. After extensive market testing and research two 'storylines' emerged as being the most popular with the public: the family and servants theme, and the women of Blenheim.[3]

Blenheim Palace: The Untold Story opened – astonishingly to those used to public-sector exhibition planning schedules – only one year later, in May 2007. It presents dramatic events and stories in the history of the family and their servants through the eyes of Grace Ridley, maid to Sarah, 1st Duchess of Marlborough. Grace, a ghostly figure, is the guide who leads visitors from room to room. She is the product of an old illusionary stage trick, called a Pepper's ghost, combined with new projection and filming techniques. This was inspired, according to Patricia Sinclair, by the Wimbledon Lawn Tennis Museum where a Pepper's ghost of John McEnroe takes visitors on a tour of the behind-the-scenes areas. Extensive use is made of new technology to provide interactive exhibits and a non-static display. The exhibitions are housed on the upper floor, previously disused, and the enclosed (indeed slightly claustrophobic) nature of the display helps to create the sense of a private realm separate from the state rooms below. The public–private separation works on a number of levels therefore: inside and outside the park walls, inside and outside the palace and within the building itself.

The exhibition had to be capable of being constructed in sympathy with the Grade I listed building. The display sits like a box independently within the existing structure supported by metalwork, which could be removed if required, leaving the original architecture intact. The exhibition is organised as a one-way procession through a series of nine rooms housing tableaux featuring models animated by photographs and audio recordings. Although the movements of the models are relatively restricted, generally confined to their heads, there is a clever use made of devices such as mirrors and portraits in which projections of moving faces appear to tell their stories (Figure 5.8). Extensive research was carried out to ensure the correct period feel in terms of costume, furnishing and speech in each of the rooms. The dialogue was written by professional scriptwriters and based on contemporary sources where relevant, in order to create as 'authentic' an atmosphere as possible. Due to strict health and safety rules concerning the maximum number of people allowed through the exhibition at any one time, only 4 minutes is allocated for each room, at the end of which visitors are encouraged by

[3] Telephone interview with Patricia Sinclair of Sinclair Design Partnership, 8 July 2008.

Figure 5.8 *Blenheim Palace: The Untold Story* display. Unknown photographer. Published with the kind permission of His Grace, the Duke of Marlborough.

audio directions to move on. This will create undue pressure for some visitors; however, even at this pace the exhibition takes 45 minutes or so to pass through.

Unlike in the state rooms below, the focus is on the domestic, and on relationships within the family and between them and their servants. Relationships between servants are not generally explored, although this is largely due to a lack of surviving documentary evidence. Sarah is the dominant figure in the opening rooms which depict her engaged in the building of the palace and reminiscing at the end of her life as she sits at her boudoir (Figure 5.9). In contrast to the state rooms which are dominated by their military tapestries, the political and military stage on which the Marlboroughs operated is alluded to only as background within this domestic context. Marlborough is represented, although his most memorable scene is in the room where he is shown hiding in a wardrobe to escape the wrath of Charles II. Marlborough had an affair as a young man with the king's mistress, Barbara Villiers, before he married Sarah and became the 1st Duke. Scandal is not avoided therefore, indeed it plays a strong role in the publicity for the display, although all those represented are safely in the distant past. Later rooms deal with the lavish expenditure of the 4th Duke in the eighteenth century, including the employment of Capability Brown, and the subsequent strain this placed on Blenheim's finances. The narrative is presented mainly through the eyes of servants, such as the 4th Duke's groom of the chamber

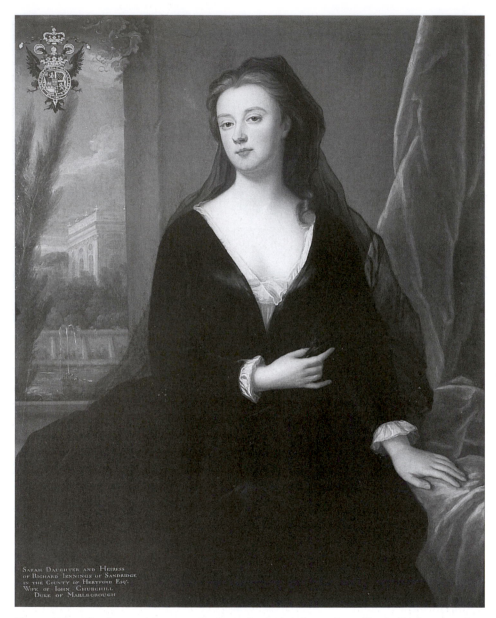

SARAH DAUGHTER AND HEIRESS
OF RICHARD JENNINGS OF SANDRIDGE
IN THE COUNTY OF HERTFORD ESQ.
WIFE OF JOHN CHURCHILL
DUKE OF MARLBOROUGH

Figure 5.9 Charles Jervas, *Portrait of Sarah, 1st Duchess of Marlborough, in Mourning,* *c.*1722, oil on canvas, 124 × 99 cm. Blenheim Palace. Published with the kind permission of His Grace, the Duke of Marlborough.

Jem Hitchens. Another significant female figure in Blenheim's history, the American heiress Consuelo Vanderbilt, wife of the 9th Duke, acts as Grace's interpreter for the twentieth century and is used to introduce the themes of modernity, transatlantic influences and, most significantly in the Blenheim context, the Second World War (Figure 5.10).

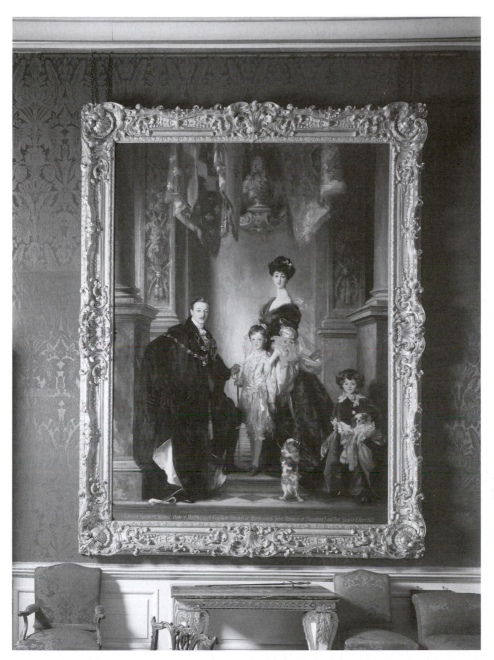

Figure 5.10 John Singer Sargent, *9th Duke of Marlborough, Consuelo his Wife and their Children, John Marquess of Blandford and Lord Ivor Spencer-Churchill with their Dogs*, 1905, oil on canvas, 338 × 241 cm. Blenheim Palace. Published with the kind permission of His Grace, the Duke of Marlborough.

Interspersed between these themed rooms are three 'infozones' which present information through panels and interactive touchscreen monitors. These cover a wealth of information ranging from the building of the palace, to the Battle of Blenheim and technological innovations. These rooms contain layered information suitable for the three broad categories of visitor that the interpretation industry identifies as 'skimmers, dippers and divers', reflecting the amount of text that visitors are prepared to read. The displays are based on a considerable amount of research from original documents and provide an in-depth and compelling view of servant life. Grace Ridley herself, for example, began life as a housemaid but rose through the ranks to become Sarah's head chambermaid during nearly forty years of service. She was clearly a highly valued member of the household as the duchess left her £16,000 in her will, a vast amount for the time, and entrusted her with burning her letters after her death (Bapasola, 2007, pp. 6–7).

The Untold Story seriously engages with the idea of 'history from below', an approach which acknowledges the power of the everyday and the excluded, as pioneered in the heritage studies area by Raphael Samuel in his *Theatres of Memory* of 1994 (see Chapter 7 and further discussion in Harrison, 2010). It goes far beyond the now slightly hackneyed format of opening up service areas such as kitchens, laundries and dairies. The latter approach has been seen as providing a way in which modern visitors can engage more directly with country houses through an identification with the labouring rather than the leisured members of the household. The Blenheim display differs substantially in several respects. First of all, it is situated not in the outlying areas of the house but at its centre in the upstairs bedrooms. Second, the subject matter is not restricted to domestic labour but also embraces family and sexual relationships. The servants here are portrayed as active participants in the life of the family through their access to the most private rooms in the house and their role as confidants.

The choice of Grace to act as a guide is also indicative of the importance of women in Blenheim's story. We have already seen that it was the duchess, rather than the duke, who took the most active role in the building of the palace and who oversaw its completion (albeit reluctantly), and it was another duchess, Consuelo Vanderbilt, whose American money saved the house in the early twentieth century (Figures 5.9 and 5.10). These powerful female figures act as a counterpoint to the two military heroes who dominate the state rooms and exhibitions at ground level. While the females might still be considered to be spatially subordinate, in that they occupy the upper not the main ground floors, nevertheless the prominence which they are accorded in this exhibition represents a new dimension in the public display of the country house. The 'family' here is no longer presented as predominantly male. This would be particularly inappropriate in the case of the Marlboroughs because the title, following a special Act of Parliament in 1706, passed through the

female line as all the 1st Duke's surviving children were girls. The redressing of the gender balance in this exhibition reflects an increased awareness among historians of the political and social patronage wielded by elite women such as Sarah, who for a long time was the favourite of Queen Anne. Public and private are mixed up once more here and notions of family are nicely nuanced.

Life stories at historic houses

The more explicit addressing of the issue of gender, just as with the emphasis on servants, is a trend that is likely to become more pronounced in country house displays in the immediate future. To take just one example, Kew Palace in Kew Gardens, London, otherwise known as the Dutch House, has recently been re-displayed with a concentration on gender and its private domestic function as a home for the large families of the Hanoverian monarchy in the eighteenth century. The more dynamic display techniques and people-centred narration of *Blenheim Palace: The Untold Story* may yet also be embraced by the National Trust who have recently commissioned a similar approach to Upton House in Warwickshire. The quotation from Vanbrugh given at the start of this case study showed that he always saw the site as having a dual purpose both as a monument to a national victory and as the embodied history of a man. In a refreshing departure the new display shifts the emphasis away from Blenheim as a national military monument to a history of people of all types. The AHD of the victory monument, one might say, has itself been vanquished by the contemporary interest in a more people-centred and inclusive approach.

Reflecting on the case study

The case study shows how the current interpretation scheme for Blenheim Palace has made the move from high art to the human – from, in the words of the eighteenth-century commentator Dr Abel Evans, 'house' to 'dwelling'. It is a rich example of how a monumental site, imposing in scale, bulk and complexity, can be made intelligible through the use of strong, clear themes. However, we should also reflect on whether there are any other significant sacrifices that this approach may cost. One of the risks for interpretation is that it does not give the visitor a clear chronological framework: personalities, the site and events become detached from each other. In a multi-period site, as most heritage sites are, some phases of the life of the site become downplayed in the interpretation scheme. This is often remedied, as at the Blenheim *Untold Story* exhibition, by additional information resources that visitors with the interest and time can use. Although the state rooms tour begins with a relatively recent personage, Winston Churchill, the guided tour is an opportunity for the guides to establish a basic chronology in their scripts for visitors. This is not just to convey accurate information; it can be a way of

enhancing visitors' sense of authenticity: they are confronting 'the real thing' resulting from the contribution of many generations. The visitor's relationship with a sense of time comes to the fore of many heritage experiences, ranging from a conscious connection with aspects of the past to the pleasure of doing something 'out of routine' as a leisure experience.

Expanding interpretation discourses

By definition, interpretation as a heritage practice is a western discourse that has become necessary because official heritage has become disconnected from everyday understandings. This is why influential practitioners such as Freeman Tilden have insisted that the role of the interpreter is to find ways of reconnecting the visitor (defined as being 'outside' the heritage) with the heritage experience. The notion of who 'the visitor' is has increasingly been problematised as critical perspectives break it down into identity and interest groups. Heritage interpreters have responded by thinking about who they wish to engage and the most appropriate techniques to use. Their professional practice has 'come of age' by the creation of a global framework for heritage interpretation standards, the Ename Charter sponsored by ICOMOS.

Although we have looked at professional philosophy and practices, interpretation is the creation of a discourse, or multiple discourses if possible, about heritage and history. These world views, as the chapter's opening comparison with literary translation suggested, are as much about knowledge as they are about activities. The Ename Charter calls for communities who maintain knowledge that sits outside western discourses to be consulted. Their understandings could be represented as part of the meanings of the heritage. Of course this statement constructs non-western discourses as being outside the practices of heritage interpretation and thus needing to be brought in. It may not really change the dominance of western conservation philosophies in global heritage discussions. This relationship between types of knowledge is particularly relevant in postcolonial or settler societies, and indeed it is the relationships between indigenous peoples and settlers that have pushed a more inclusive interpretation agenda. A former slave estate in the USA is an example of a genuinely two-way interaction between official heritage experts and a diverse community of interests, meeting over an example of difficult heritage.

The Levi Jordan Plantation web interpretation project

An archaeological research project began in 1986 at a former nineteenth-century sugar plantation in Texas, USA. The site was the *c*.2000-acre estate purchased in 1848 by Levi Jordan in Brazoria County, Texas. His first farm workers were twelve enslaved African-Americans. The plantation developed into a major sugar and cotton producer including a sugar factory (mill) for

processing the sugar canes of this and neighbouring plantations. Slaves were also treated as products, their numbers increasing through children born on the plantation and by additional imported slaves. By 1862, according to tax records, 150 slaves lived there. When the Civil War ended in 1865 ownership of slaves was made illegal. Newly emancipated workers re-established their lives as waged labourers resident on the plantation or as tenant farmers. Labour-intensive sugar production was reduced in favour of cattle and cotton. Family ownership of the estate became divided, and by 1892 the tenants resident in the former slave quarters abandoned their homes and many of their possessions. These quarters were left, padlocked, to decay until 1913 when the brick walls were demolished. Only a portion of the main house (built of wood) and the brick-built sugar house survive as standing buildings (Brown, 1995).

The research excavation was initiated by Dr Kenneth L. Brown of the University of Houston and focuses on detailed recovery of the evidence from the former slave quarters. Using painstaking excavation techniques, the interiors of the cabins, or single-room residences arranged in barracks, reveal patterns of use and the abandoned possessions of the last residents. This project belongs in the tradition of historical archaeology projects, pioneered in the USA. Historical archaeology uses archaeological techniques to investigate sites from the colonial period. In Europe the most recent centuries of archaeological remains have until recent decades often been ignored and their potential data destroyed without record in favour of medieval or earlier layers beneath them. In the USA, colonialism introduced a written culture but this was not available to all. Historical archaeology has the potential to integrate many types of source. It also facilitates the recovery of 'hidden histories', of generations and communities who did not create many, or any, surviving written records. The conditions of living as enslaved peoples and the lifestyle transition to a state of freedom, albeit in marginal economic and social contexts, can be investigated through archaeology to recover material culture never previously regarded as official heritage.

As a university project, this began as an expert-defined and controlled investigation. Archaeologists as an academic and professional community have become more self-conscious about their control over how data is created and disseminated. The process of excavation, although frequently conducted over a number of years at research sites, is ultimately ephemeral: once finished, only monumental sites can survive continued exposure. Fragile sites based on timber and shallow layers can only be covered over (even if by replica buildings, as at Colonial Williamsburg, Virginia) and the artefacts displayed in a museum. Public archaeology developed as a response to the need to engage public support and enthusiasm for the practices of archaeology; in some ways it parallels the principles of heritage interpretation, tailored to the particular form of revelation that is the stripping away of archaeological layers.

In 1992 anthropologist Carol McDavid joined the project to develop a public collaborative strand. This tackled the difficult heritage of enslaved people, the relationship of the local community to this history (including continuing racial tensions) and specifically the presence of descendants of the nineteenth-century African-Americans. McDavid realised that the process of collecting information about the site from community members would be most successful if the newly created public organisation for the project accurately represented all stakeholders. African-American descendants joined the Levi Jordan Historical Society Board, a contrast to some previous plantation projects that had clearly marginalised slave descendants' interests and concerns (Levi Jordan Historical Society, 2008a). McDavid led the creation of an interactive website as the primary means of interpreting the experts' questions, activities and conclusions. The website invited responses and interventions, and displayed contributions from stakeholders such as plantations descendants, in the form of **oral history**, visual and documentary sources. McDavid describes this as the making of a conversation about public archaeology, a collaborative act. This project embraces difficult heritage, 'acts which are acknowledged and dealt with in different ways by different groups of site descendants' (owners, white workers, black workers) (McDavid, [2002] 2008, p. 516). The website was developed to facilitate multiple voices arising from the different understandings of the past, rather than to present a unified expert narrative or a homogenous popular consensus about meanings. One section is devoted to words, as an ongoing discussion about contested meanings and associations, for example the use of 'slave' instead of 'enslaved person' and the term 'magician/healer' for African practices outside of western medicine. It has a direct and friendly editorial voice, frequently appealing for readers' responses.

At the time of writing, the website is being updated and management of the plantation site has been taken over by the Texas Parks and Wildlife Service, although the Levi Jordan Historical Society continues to operate as a community group whose mission is 'to preserve and interpret the archaeologies and histories of all of the people who lived and worked on this plantation' (Levi Jordan Historical Society, 2008b). It will be interesting to see if the Parks Service also uses the web for online interpretation of the physical site and how this is presented as an official heritage site.

Conclusion

A brief introduction to professional interpretation practices originating from the pioneering work of Freeman Tilden in the US National Park Service can only hint at the variety of approaches. Part of the diversity comes from the relationship of interpretation to conservation: mounting a highly designed exhibition inside a purpose-built space is very different from the conservation

needs of a delicate historic interior or the beauty and ecology of a natural site. This is why this chapter closes with a discussion of conservation management planning and the place of interpretation plans as one component of many in professional practice.

The chapter has inevitably focused on the professional activities of trained heritage interpreters. The case study for the interpretation schemes inside Blenheim Palace have exemplified one such expert-led and high-investment scheme at an aristocratic house with particular claims to a place in national memory. Interestingly, it has demonstrated that the official heritage designation of World Heritage status for the high art qualities of the architecture does not dictate the content of the current scheme, which is driven by historical personages and nuanced by gender and class identities. The final example of the Levi Jordan Interpretation Project has demonstrated how an archaeological research project developed a public presence using a website to represent multiple expert and community interests around a site of difficult heritage. The content was supported by a properly representative project board, considered to be essential to engaging African-American trust in the uses of private understandings in a public domain. Distributed knowledge may well facilitate a re-distribution of power and the emergence of socially accountable heritage practices.

The central tension for interpretation remains the relationship between the experts and the public. Passive consumers of information selected by unknown experts are the opposite of what a stimulating interpretation scheme hopes to achieve. Yet Tilden's definition of good interpretation as revelatory and provocative can only meet the heritage consumers halfway, some of whom may reasonably just want a nice day out. The following chapters, discussing tourism, social action and performance, all offer some wider perspectives on how understandings of heritage are conveyed, shared and re-made.

Works cited

Bapasola, J. (2007) *Household Matters: Domestic Service at Blenheim Palace*, Woodstock, Blenheim Palace.

Black Environment Network (2008) What We Are Doing [online], www.ben-network.org.uk/doing/intro.html (accessed 3 September 2008).

Blenheim Palace (2006a) Blenheim Palace World Heritage Site Management Plan (unpublished report).

Blenheim Palace (2006b) *Blenheim Palace Guide Book*, Norwich, Jarrold Publishing.

Brown, K.L. (1995) 'Material culture and community structure: the slave and tenant community at Levi Jordan's Plantation, 1848–1892' in Hudson, L.E. (ed.) *Working Toward Freedom: Slave Society and Domestic Economy in the American South*, Rochester, NY, University of Rochester Press, pp. 95–118.

Defoe, D. ([1724–6] 1986) *A Tour through the Whole Island of Great Britain* (ed. P. Rogers), Harmondsworth, Penguin.

Downes, K. (1966) *English Baroque Architecture*, London, A. Zwemmer.

Green, D. (1951) *Blenheim Palace*, London, Country Life.

Ham, S. (1992) *Environmental Interpretation: A Practical Guide for People with Big Ideas and Small Budgets*, Golden, CO, North American Press.

Harrison, R. (2010) 'What is heritage?' in Harrison, R. (ed.) *Understanding the Politics of Heritage*, Manchester, Manchester University Press/Milton Keynes, The Open University, pp. 5–42.

Hart, V. (2002) *Nicholas Hawksmoor: Rebuilding Ancient Wonders*, New Haven, CT and London, Yale University Press.

ICOMOS (1987) *Advisory Body Evaluation no. 425*, Paris, ICOMOS; also available online at http://whc.unesco.org./archive/ advisory_body_evaluation/425.pdf (accessed 30 March 2009).

ICOMOS ICIP (2008) The ICOMOS Charter for the Interpretation and Presentation of Cultural Heritage Sites (Ename Charter) [online], http://icip.icomos.org/downloads/ICOMOS_Interpretation Charter_ENG_04_10_08.pdf (accessed 30 March 2008).

Jameson, J. (2008) 'Presenting archaeology to the public, then and now: an introduction' in Fairclough, G., Harrison, R., Jameson, J.H. Jr and Schofield, J. (eds) *The Heritage Reader*, Abingdon and New York, Routledge, pp. 427–56.

Levi Jordan Historical Society (2008a) About ... [online], www. webarchaeology.com/html/about.htm (accessed 3 September 2008).

Levi Jordan Historical Society (2008b) Mission Statement [online], www.webarchaeology.com/html/mission.htm (accessed 3 September 2008).

Mavor, W. (1793) *New Description of Blenheim*, London, T. Cadell.

McDavid, C. ([2002] 2008) 'Archaeologies that hurt; descendants that matter: a pragmatic approach to collaboration in the public interpretation of African-American archaeology' in Fairclough, G., Harrison, R., Jameson, J.H. Jr and Schofield, J. (eds) *The Heritage Reader*, Abingdon and New York, Routledge, pp. 514–23.

Montgomery-Massingberd, H. (1985) *Blenheim Revisited: The Spencer-Churchills and their Palace*, London, Bodley Head.

Pamuk, O. (2006) *The Black Book* (trans. M. Freely), London, Faber and Faber.

Samuel, R. (1994) *Theatres of Memory: Past and Present in Popular Culture*, London and New York, Verso.

Scottish Natural Heritage (n.d.) Interpretative Planning, Inverness [online], www.snh.org.uk/wwo/Interpretation/pdf/planning.pdf (accessed 30 March 2009).

Sherwood, J. and Pevsner, N. (2002) *The Buildings of England: Oxfordshire*, New Haven, CT and London, Yale University Press.

Smith, L. (2006) *Uses of Heritage*, Abingdon and New York, Routledge.

Tilden, F. (1977) *Interpreting Our Heritage* (3rd edn), Chapel Hill, NC, University of North Carolina Press.

UNESCO ([1972] 2009a) World Heritage Convention [online], whc.unesco. org./en/conventiontext/ (accessed 13 January 2009).

UNESCO (2009b) The Operational Guidelines for the Implementation of the World Heritage Convention [online], http://whc.unesco.org/pg.cfm? cid=57 (accessed 3 March 2009).

UNESCO (2009c) Blenheim Palace [online], http://whc.unesco.org/en/list/ 425/ (accessed 3 March 2009).

US/ICOMOS (2005) The Charleston Declaration on Heritage Interpretation [online], www.edfitz.com/icoms/archived/ (accessed 5 May 2009).

Webb, G. (1928) *Complete Works of Sir John Vanbrugh*, vol. 4, *The Letters*, London, Nonesuch Press.

West, S. (2010) 'Heritage and class' in Harrison, R. (ed.) *Understanding the Politics of Heritage*, Manchester, Manchester University Press/Milton Keynes, The Open University, pp. 270–304

Wilkinson, R. and Rhys Jones, G. (2003) *Restoration: Discovering Britain's Hidden Architectural Treasures*, London, Headline Publishing.

Further reading

Carter, J. (2001) *A Sense of Place: An Interpretive Planning Handbook*, [Scotland], Scottish Interpretation Network.

Corbishley, M., Henson, D. and Stone, P. (eds) (2004) *Education and the Historic Environment*, London and New York, Routledge.

Girouard, M. (1978) *Life in the English Country House: A Social and Architectural History*, New Haven, CT and London, Yale University Press.

Hems, A. and Blockley, M. (eds) (2005) *Heritage Interpretation*, London and New York, Routledge.

Howard, P. (2003) *Heritage: Management, Interpretation, Identity*, London and New York, Continuum.

Jameson, J.H. (ed.) (2004) *The Reconstructed Past: Reconstructions in the Public Interpretation of Archaeology and History*, Walnut Creek, CA, Alta Mira Press.

MacKenzie, R. and Stone, P. (eds) (1994) *The Excluded Past: Archaeology in Education*, London and New York, Routledge.

McManamon, F.P. and Hatton, A. (eds) (2000) *Cultural Resource Management in Contemporary Society: Perspectives on Managing and Presenting the Past*, London and New York, Routledge.

Merriman, T. and Broche, L. (eds) (2006) *The History of Heritage Interpretation in the United States*, Fort Collins, CO, National Association for Interpretation.

Veverka, J.A. (1994) *Interpretive Master Planning*, Helena, MT, Falcon Press.

Yorke, R. and Baram, U. (eds) (2004) *Marketing Heritage: Archaeology and the Consumption of the Past*, Walnut Creek, CA, Alta Mira Press.

Chapter 6 Heritage and tourism

Matthew Kurtz

This chapter examines the relationships between heritage and tourism with an emphasis on economies of tourism. Specifically, it explores the constraints faced by tourism entrepreneurs in controlling representations of heritage. The chapter begins with a discussion of tourism and World Heritage and then reviews how studies of tourism informed early work in heritage studies. The first case study explores how tourists shape their own experience of the North Cape on the northern edge of Europe. The case interrogates the assumption that tourists are relatively passive consumers of authorised heritage discourses. How influential are officials and business entrepreneurs, then, in controlling the representation of heritage? The following section teases out four different manners through which that discourse can be shaped. The subsequent case study draws from the author's work in Arctic Alaska as an economic and historical geographer. Since 1947, business firms have presented narratives of Eskimo heritage to tourists. This case considers the business strategies that an indigenous community has used to change the representation of their heritage in Alaska. The difficulties they have faced bring the chapter back to questions about the complex relationship between heritage and the economy.

Introduction

Any endeavour to understand the practice of heritage will, sooner or later, need to investigate the relationship between heritage and the economy. But just as heritage varies from place to place, so too does the economy, and that geographical variation makes the relationship difficult to summarise. Some like to point out how economic conditions and profitable topics shape the practice of heritage – how they influence which particular heritage (there are always others) gets written up and advertised in a locale, for instance. Others argue the reverse, that interpretations of heritage shape the economy in significant ways. This is true for cities like Stratford-upon-Avon, which was the early home of Shakespeare and which now has an unusually prominent theatre sector, as we saw in Chapter 4. So interpretations of heritage influence the economy, just as the economy offers opportunities and constraints for the practice of heritage. We can understand this as a reflexive relationship, a quality found in many other heritage activities discussed in this book.

Economic development, tourism and heritage

Tourism is a substantial industry. When measured in terms of gross national product (GNP), tourism is thought to account for about 12 per cent of all global economic activity. Its suffusion, intensity and reach give tourism immense power in shaping popular perceptions about places around the world. That means the economy – in the form of interest from the 'right' (or most profitable?) kinds of tourists – may substantially affect which histories, and which interpretations, of a particular site become the official canon of its heritage.

Conversely, consider the World Heritage site designation. That status often serves to brand a site as a top international attraction, which leads many to believe the site's heritage will drive local economic development. For instance, soon after China's Lijiang Ancient Town was named a World Heritage site in 1997 the local government started to promote tourism development (Figure 6.1). In their enthusiasm for potential prosperity, some residents recommended that local religious artefacts be turned into tourist souvenirs. Outside entrepreneurs converted residential homes along the main street in Lijiang's Ancient Town into stores. Within five years there were 877 souvenir shops and service outlets along that central street. Expectations of economic gain also seem to have been met. By 2005 the expenditure of international tourists in the city amounted to almost US $50 million per year. That was five times the expenditure before the area was awarded its World Heritage site status.

However, Graham, Ashworth and Tunbridge (2000) suggest that the effectiveness of heritage as an instrument for economic development is often exaggerated. In many cases, local financial resources and entrepreneurial skills are insufficient to revitalise business around a heritage site, leading to more ownership by outside investors and to the immigration of entrepreneurs. Communities often witness the outsourcing of heritage expertise, transnational arrangements for marketing and sales, and the influx of labour for new service-related jobs in the area. Even UNESCO's World Heritage programme suggests caution about the economic benefits of heritage tourism. Its consultant (Pederson, 2002) points to widespread economic leakages, since most of the money tourists spend – on airfares, hotels and booking agents – benefits large foreign companies. Developers and local elites also tend to monopolise the smaller-scale components such as tour-guide operations and area transport services. And tourism often adds to burdens on some segments of the community without producing many benefits for them. These effects can start to snowball once it appears that profits can be made from additional demands for what is, otherwise, considered just a free (or public) attraction: local heritage.

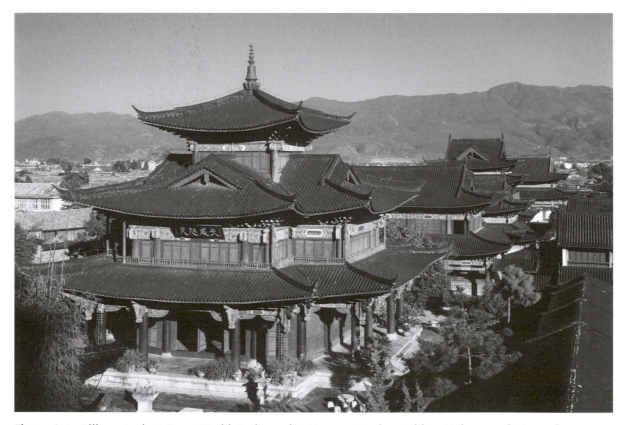

Figure 6.1 Lijiang Ancient Town World Heritage site, Yunnan Province, China. Unknown photographer. Photo: © JTB Photo Communications, Inc./Alamy.

The nature of these complex effects and processes has been explored at length. In what has become an intellectual benchmark for such studies, Stephen Britton (1991) argued that tourism is an elaborate global production system that packages and sells places. The system is comprised of three major components: first, the social groups, physical elements and intangible cultural features that are incorporated into tourism as attractions; second, the activities and organisations, often transnational in scope, that are geared to selling travel and tourism packages; and third, the agencies that regulate those activities. Britton offered a systematic account of a global industry – mass tourism – that had grown in the wake of de-industrialisation and economic restructuring, including the upstream and downstream dependencies in its integrated supply networks, its fragmentations and tensions, and its tendency to set places in competition with one another, in order to attract both tourists and the investments of the tourism industry.

In recent years scholars have used Britton's work to explore the internal dynamics and external effects of what they call the 'new tourism' – that is, ecotourists, backpackers and independent travellers. An industry for this kind of tourism has developed, involving smaller-scale producers (guest-houses instead of international chain hotels; craft artefacts rather than mass-produced souvenirs) and niche marketing in speciality publications like *Wanderlust*, the *New Internationalist* or *Green Magazine*. Yet it is not clear that the impacts of the new tourism phenomenon on local communities are much better than those of the mass tourism industry. On the one hand, Hampton (2005) suggests that there is less leakage of profits from the local community and more use of local material and labour in the 'new tourism' around Indonesia's heritage industry, for example, than in its mass tourism resort industry. On the other hand, Mowforth and Munt (2003) caution that the effects of the new industry may not be as beneficial as many assume. Using backpacker tourism in Nepal as an example, they suggest that when compared with conventional tourism less money is usually spent and fewer jobs are created in the destination area. Moreover, the environmental and cultural impacts may be just as severe due to the dispersal of individual tourists. Thus the links between heritage tourism and community economic development may be very different from place to place.

A history of tourism studies

So far, this chapter has explored the relationship between heritage and the economy by focusing on the impacts of tourism on local communities. This concern has deep roots in the field of tourism studies, which emerged as a distinct body of research in the 1970s. Its appearance followed rapid postwar expansions of recreation and travel in industrialised nations (Rojek, 2005). Its first two scholarly journals serve as signposts for this emergence: the *Journal of Travel Research* initiated in 1962, and the *Annals of Tourism Research* founded in 1973. Both journals were initially supported by business associations and both featured quantitative, applied research. In 1975, however, the *Annals* began to solicit more critical and theoretically oriented articles on tourism. Major investments in tourism destinations in the developing world, the environmental movement and post-Vietnam critiques of American culture were part of the context in which the *Annals* changed its course. Its founding editor accordingly asked a set of provocative questions:

> Should all developing countries engage in the tourist trade? ... Is the influx of tourists, tourism products and the influence of foreign ways of life healthy for their social and economic development? ... Can the negative impacts of tourism be reduced or overcome?

> (Jafari, 1975, p. 233)

He argued that there was 'a definite need to improve not only the tourism "know-how"' (which had been the subject of the journal's applied research articles) 'but also the tourism "know-why"' (p. 233). Thus the *Annals of Tourism Research* began to provide a forum in which academics could explore the nature of tourism through a more critical dimension.

The *Annals* also offered a place where new books, from a range of disciplines, could be discussed as part of this new academic field. In other words, it helped create a category of 'classic work' in tourism studies, reviewing books that are now regularly cited in literature reviews, such as *The Golden Hordes*, *The Tourist*, and *Hosts and Guests*. The first of these, which opened with the claim that tourists were 'the barbarians of our Age of Leisure' (Turner and Ash, 1975), was described in the journal as the first significant attempt at a sweeping social history of tourism. Its authors posited a shift from the individual traveller to the mass tourist. A year later, the journal hailed *The Tourist* (MacCannell, 1976) as a major contribution to the field. A sociologist by training, Dean MacCannell argued that prototypical tourists were the religious pilgrims of the modern world, on a quest to understand society and their place within it by looking at the lives and work of others. He suggested the 'staged authenticity' of real life on display was one of the consequences of mass consumption: the moment that tourists identify a traditional community or an authentic site, the place must be kept in artificial stasis to maintain the image that other tourists will expect (much as Stratford-upon-Avon has been, as discussed in Chapter 4). Yet scholars learned little in the pages of this book about how tourists might actually read the narratives on display in different ways. The same was also true for the last major contribution to tourist studies in the 1970s, *Hosts and Guests* (Smith, V. (ed.), 1977). As anthropologists, its contributors were far more concerned with culture and context than MacCannell had been. Yet their emphasis was on the 'hosts' – on the impacts of tourism on local residents and workers in various parts of the world. Again, readers learned little specifically about the tourists or 'guests' who took in the sights.

Robert Hewison's book *The Heritage Industry: Britain in a Climate of Decline*, fell comfortably into this trend in tourism studies. Its publication in 1987 may have helped to mark the emergence of critical heritage studies but, like others in the main current of tourist studies at the time, Hewison was concerned with those who produced material for tourism. He focused on the tourist trade in post-industrial Britain and assumed that tourists themselves did not warrant close consideration. They were just passive consumers of the 'culture' that the heritage industry was producing (see Harrison, 2010).

John Urry (1992) soon challenged that assumption. In *The Tourist Gaze*, he observed that

> Hewison presumes a rather simple model by which certain meanings, such as nostalgia for times past, are unambiguously transferred to the visitor. There is no sense of the complexity by which different visitors can gaze upon the same set of objects and read them in a quite different way.

(Urry, 1992, p. 111)

To the contrary, Urry argued that tourists were different from one another in their patterns of consumption.

The differences that he highlighted, however, had less to do with the variegated perspectives of tourists, and rather more to do with structured class differences among them. These were differences that the changing tourist industry had come to accommodate, and his history is very much that of accommodation in the UK. Urry's chapter on the history of seaside resorts (primarily English), for instance, is about their emergence when railroads facilitated cheap transportation out of growing industrial cities for nineteenth-century working-class families. The process was not inevitable. Legislation had to force the railways to provide seats for a low-income market, and differences in property markets forced Blackpool to become an affordable resort town for the working class while entrepreneurs in nearby Southport constructed gardens and wide promenades to attract more affluent tourists. Thus Urry's narrative-based analysis concentrated on the perspectives of tourism promoters, more so than tourists themselves. Yet it opened a gate through which the varied perspectives and desires of tourists could be analysed as an active, shaping force in tourism, as a group of people who bring their own experiences and interests to the interpretation of heritage.

The focus on tourists themselves resonated with Freeman Tilden's notion of interpretation as a two-way process involving provocation (see Chapter 5). But other theoretical trends also encouraged a move, among academics, from tourism studies to tourist studies in the 1990s. Some began to argue forcefully that culture industries, like fashion, film and tourism, all had an active audience on their hands, and that this audience rarely took what was offered as it was intended. Indeed by 2001 a new quarterly journal had been launched, called *Tourist Studies*, to offer theoretically informed explorations of how consumers actually engaged with tourist destinations. Among its goals was the analysis of 'the socio-cultural nature of tourism and tourist practices' in order to foster 'critical debate on the nature of tourist experience' (Franklin and Crang, 2001, p. 19). More recently, Laurajane Smith (2006) has also argued that 'heritage' tends to be defined in a way that overlooks the importance of the participation and memory work of various communities for whom it is significant – communities that include tourists as well. Her work in addressing

that oversight represents a trend, one that is putting tourists' diverse perspectives higher on the agenda in tourism studies.

In keeping with these new directions in tourism studies, Inger Birkeland (2005) chose to interview a number of tourists on their way to the North Cape, in northern Norway, to learn about their life histories and how they themselves found the North Cape meaningful. Her study takes us to the Arctic. This may seem like an odd choice for case-study material on heritage tourism. Many see it as a peripheral region with little history or global significance. Yet its indigenous communities are attracting the curiosity of more tourists as well as attention from researchers keen on documenting a heritage of traditional knowledge in the Arctic. UNESCO's World Heritage List already identifies four sites north of the Arctic Circle, and its list of currently proposed sites (if accepted) will more than double that number. Increasingly, the Arctic is becoming the object of heritage. Birkeland's study, then, asks how tourists find an Arctic heritage personally meaningful.

Case study: visitors at North Cape, Norway

On 3 July 1956 the 715-foot passenger ship *RMS Caronia* set sail for its fifth annual North Cape Cruise (Figure 6.2). Leaving the Port of New York at 11 p.m., it arrived in Iceland seven days later. It then went on to the North Cape, arriving on 13 July, and south along the Norwegian coast, ending at Southampton in the UK on 3 August. The ship's 500 passengers were served by over 600 crew. A windowed cabin for two on the main deck would have cost its occupants almost ten times as much as the same room on the ship's standard eight-day transatlantic voyage. But tourists paid this mark-up regularly, filling the cabins from 1951 to 1967 for the ship's annual thirty-day North Cape Cruise, in part for a chance to see the midnight sun and in part to do so from the north of Europe, from a place on the shores of the Arctic Ocean that was billed as 'the edge of the world'. And in 1956, the passengers of the *RMS Caronia* were to be met not only by the sun at midnight but also by a new road that enabled people to drive a car, or take a coach, to the North Cape from other parts of Europe.

A history of the North Cape

That road would open a new phase in the history of the North Cape. Before 1956 the site was accessible only by sea, and this had added to its mystique. At 307 metres above the Arctic Ocean the spectacular promontory had been a site of interest for writers and explorers since 1553, when the English Willoughby Expedition sailed past the headland. In the Enlightenment (described in Chapter 1), new maps and atlases had identified the North Cape as Europe's most northerly point. Fascination spread as new book markets

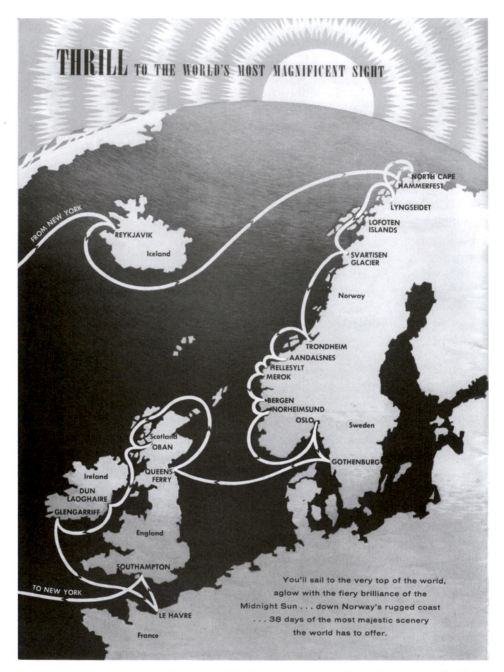

Figure 6.2 North Cape Cruise map, 1956. Image courtesy of http://www.caronia2.info/

enabled travel writers to finance and narrate their adventures to this Arctic headland. Early visitors included Louis-Philippe of Orleans, the future king of France, who travelled to the site in disguise after the French Revolution. In 1873 Norway's King Oscar II commemorated his visit, made shortly after his

coronation and amidst considerable media fanfare, with the construction of the first permanent monument at the headland. By 1875 the North Cape had sufficient notoriety for Thomas Cook (pioneer English founder of the synonymous international travel company) to organise a trip. By 1877 a steamship line was running summer cruises to the headland, and 1893 marked the start of a new phase in North Cape tourism development as a regular coastal ferry line, the *Hurtigruta*, began to serve communities along Norway's coast all the way north to the promontory. In 1934 the ferry service started to advertise to tourists as well, suggesting they abandon the 'floating hotels' that were being offered by the cruise lines and instead mix with locals on the large, comfortable ferries (Jacobsen, 1997).

A popular postcard from 1927 (Figure 6.3) suggests that those who visited the North Cape and purchased souvenirs at the small pavilion were not concerned that the site might appear to their friends back home to be a little too overcrowded. Indeed, in contrast to many iconic images of a more recent vintage (see, for example, Figure 6.4), the postcard's suggestion that this site at Europe's northern edge was both trendy and comfortably accessible to able-bodied world travellers may have broadened its appeal in the 1920s.

All this started to change in the 1950s as the number of cruise ships increased and the new road was opened. A steel globe sculpture (visible in Figure 6.4) was built to mark the exact latitude of the site, providing visitors with a photogenic new symbol of the North Cape. That latitude – 71°10′21″ North – was significant: it measured how close to the North Pole one stood, or 'how far up' one had gone on the maps of Europe. The globe sculpture soon replaced the dramatic images of the headland from the sea as the iconic image of the North Cape. A visitor centre was finished by 1989. By the 1990s the site was receiving 250,000 tourists annually. Birkeland reports that the Norwegian media now

> depicts the North Cape as an example of mass-tourism, which is so often despised. When the summer season starts in late June, newspaper journalists come with reports from the North Cape. We can read about Norwegians traveling with their camper vans to see the midnight sun or we can peruse snapshot images of German bus tourists toasting in champagne on the cliffs.
>
> (Birkeland, 2005, p. 5)

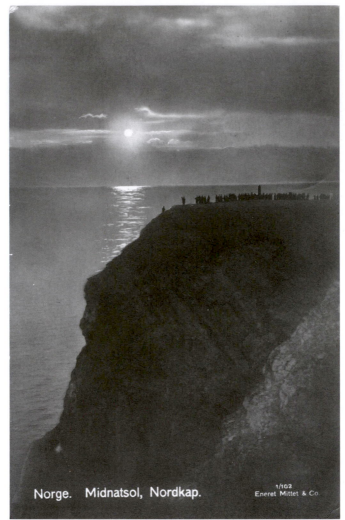

Norge. Midnatsol, Nordkap.

1/102
Eneret Mittet & Co.

Figure 6.3 Postcard of the North Cape and the midnight sun, 1927. Unknown photographer.

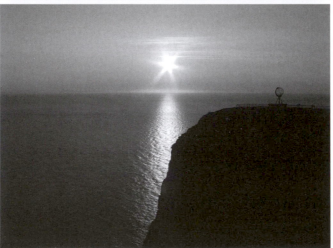

Figure 6.4 Photograph of the North Cape and the midnight sun, 2003. Photographed by Yan Zhang, accessed from Wikipedia, 2 February 2009. Photo: © Yan Zhang.

Three authorised narratives of the site

How do the authorised heritage discourses situate the North Cape? Such discourses can be found in the official narratives of the Norwegian government and in the local museums that cater to the site's international (mostly European) visitors. There, three major narratives are at work. The first suggests that the North Cape is one of the wonders of the world, a place where the sublime experience of sighting the sun over the Arctic Ocean enthralls and invigorates the people who see it during what would otherwise be 'night time'. Many institutions and guides tell tourists, accordingly, that this is the reason the site is significant. It offers a chance to experience an intense sense of awe in the face of the extraordinary. Moreover, because it is considered 'at the northern tip of a continent' and 'at the edge of the world', the site itself belongs to no one and thus, by the same reasoning, belongs to everyone around the world. It is common property as part of the Arctic and, in this narrative, the experience of awe at the site is therefore the global heritage of humanity.

This can be a persuasive discourse, but it is important to put it in the context in which the narrative emerged. The site only became important at a time when nationalism in Europe necessitated the identification of national icons. Against a backdrop of industrialisation and nineteenth-century urbanisation, Romanticism had become the prevalent perspective with which to view natural landscapes; it was through the viewpoint of Romanticism, in other words, that natural landscapes became powerfully moving in a particular way (see Chapter 3). After the Norwegian–Swedish War for Norwegian independence in 1814, nationalism tapped into the Romanticist movement to cultivate an iconography of Norwegian landscapes. This is the context in which Norway's coastal fjords and the North Cape itself came to symbolise exotic majesty and the sublime. Hence, the appeal of the headland as a stirring natural wonder, within this discourse, draws on visual references and emotional triggers that are not equally effective across cultures. At the same time, the suggestion that the experience of awe at the site belongs to everyone (as the purportedly global heritage of humanity) overlooks any possible indigenous claims to the Arctic headland area.

If the narrative of exotic natural wonder is one of the authorised heritage discourses for the North Cape, a second narrative spells out a continuous tradition of pilgrimage. Advertising brochures, for instance, often quote the words of early adventurers at the promontory. This does not just make good copy: the visitor centre also has a tableau of historic visitors to the headland, and 22 miles south, a port-side museum has a permanent exhibit on the history of 'North Cape Tourism' from the seventeenth century onwards. With such narratives, visitors are reminded that they are experiencing a journey

that others have undertaken before; that they will see the same landscape at the North Cape that other adventurers have seen for centuries; and that they are the latest participants in a long tradition of North Cape tourism. This is a major element of the official discourse about the promontory: its passing tourists, it suggests, are the essence of the legacy commemorated at the North Cape, a place whose heritage has been to draw like-minded travellers in search of the awesome sights at the northern edge of Europe. To announce the new road in 1956, for instance, the Norwegian Travel Office issued a 550-word press release that told of five travellers between 880 CE and 1873, one thousand years of tourism. More than fifty years later the North Cape Municipality still states that the 'North Cape is and always has been a goal for adventurers. The Italian priest Francesco Negri who visited us in 1664 was the first one that we know of' (North Cape Municipality, 2009). Officially, North Cape tourism is meant to celebrate a long heritage of tourism at the North Cape.

A third narrative makes 'progress' stories out of changes in the site's amenities. In contrast to the first narrative of majestic natural wonder, this discourse suggests that nature is an obstacle that should be overcome through the provision of comfortable facilities and better transportation. And in contrast to the second narrative about a long tradition of pilgrimage to the site, this one favours change over continuity. Of course, this narrative rarely appears in isolation from the other two, so tensions tend to reverberate between them. Yet through this alternative position the official narratives open up some discursive space in which new facilities, attractions and travel arrangements around the North Cape can be advertised. However, the third narrative may obscure one of the official reasons for visiting the North Cape – to experience, first-hand, a sense of immersion and awe in nature's majesty at the edge of the world where civilisation ends.

Interpretations of the North Cape among tourists

These three narratives potentially help to structure the North Cape's significance for many individual visitors. As a cultural geographer, Birkeland (2005) collected the stories that nine tourists shared with her about the North Cape's significance for each of them. None rehearsed the discourse about the long legacy of tourism to the headland. For Birkeland, the many different opportunities, projects and experiences among these visitors around the North Cape would have been poorly encapsulated as simply a celebration of a continuous tradition of travellers.

At the same time, her goal was not to capture true tourist perspectives about the site. In the selections that follow, the purpose (like hers) is to better understand how one particular site can generate all sorts of different

meanings when it intersects with the life histories of a wide range of visitors. The purpose is not to select the best or most meaningful interpretation of the site. Rather, it is to understand the conditions and processes through which tourists generate their own interpretations. Four such stories are considered.

Hans was a European banker, 50 years old, and recently divorced. On the voyage north, he claimed to like watching other tourists. He thought himself a close observer of human nature. He was not really interested in the North Cape itself. Fairly well educated, he thought the site would be too crowded – he recalled newspaper stories about busloads of tourists – and he did not like that. The claim that the site was the northern-most point was also trivial and wrong: there was a lowland peninsula near the headland that, in fact, reached slightly further north, but no one cared to visit it. Hans was more interested in the sights he could see from the ferry. For him, the north of Europe was quiet, slow and peaceful. He compared it to the south of Europe, which he found to be too noisy and rushed. He thought the north was more restful, and he had fond childhood memories of learning to fish on the North Sea. He felt at home aboard the ship as he immersed himself in the smells and sights of nature and the sea. After his divorce he had decided to slow down and spend less time at work. It was the north in general, not the North Cape, that interested him. 'The north has become more important to Hans in his adult years', Birkeland observed, 'and it is as if he wants to develop the northern parts of himself' (2005, p. 70). Thus, Hans had synthesised his own memories and desires with the official narratives that tell of a sense of awe in northern landscapes. Yet for Hans, the result was less a sense of awe than that of slowness, and that could not be found at the North Cape itself among all the people and activity.

Similar translations took place with what Lavina had to say about the North Cape. She was in her 30s, single, and worked as an editor at a publishing firm in central Europe. Her family had repeatedly moved when she was young, so she often preferred to stay in one place when on vacation. She claimed to be a practical and outgoing person, but she liked to have time to think when on holiday. Her travel agent had suggested the *Hurtigruta*. Lavina had associated the north with pristine nature, much as the authorised heritage discourse about the North Cape suggests, but she actually found the unusual light more interesting. She would come up to the deck in the middle of the night to see it. It reminded her of a childhood book she had read about the north. She wrote letters to her sisters about it, but even as an editor she could not find the language to describe the light.

According to Birkeland, some tourists were indifferent to the sights and scenes aboard the *Hurtigruta*. Bob, for example, was from a small town in North America. He lived with his mother, and he had made his living for the last

thirty-seven years as an accountant at a steel plant. Bob had decided to see Norway years ago. He thought the scenery from the ferry was beautiful and he took lots of pictures. But he did not care much about nature or the outdoors. The North Cape did not mean anything special to him. He just loved to travel. While his friends back home got married and started raising kids, he started to travel around the world at every opportunity, but he still thought of himself as a small-town guy. For him, the North Cape Cruise was yet another trip. The official discourse about their destination, the Arctic headland, made little difference beyond what the 'progress' narratives said about the comfort of the contemporary travel arrangements along the way.

Other tourists were dubious of people who go to the North Cape simply because it is another famous sight to see. Sophia, for example, wondered why people went when they were not committed to engaging with the journey. She had not used the ferry. A computer technician in her 30s, she had set out for Scandinavia after deciding that something was missing from her pleasant life in Spain. Her mother told her that she had 'lost her north', her orientation in life, so Sophia left for Norway. There she took up volunteer work in a small town for several months, then decided to walk the remaining distance to the North Cape. The walk took six months, and the rhythm of walking helped her develop a philosophy. It involved a commitment to engage with the things around her – touching, listening, smelling, observing the landscape – and the natural process of walking enabled Sophia (as Birkeland put it) 'to walk inside herself'. By the time she reached the Cape, she had found her north. She had since learned about others who had made that journey, some centuries before her. But Sophia had authored her own narrative of pilgrimage. Other narratives about the site's long history of visitors simply helped Sophia anchor her own story after it was complete.

Reflecting on the case study

The stories that these four tourists shared with Birkeland demonstrate how visitors to a heritage site are often much more than 'passive consumers'. While others may reject the official narratives entirely or, perhaps, rehearse them all with little critical reflection, these four tourists were each very selective in their appropriations, letting some of the authorised discourses influence their own interpretation yet rejecting other parts of the official narratives. Hans (the banker) and Lavina (the editor) both believed that places of natural heritage were good for the soul. Writers had popularised this idea in the nineteenth century (see Chapter 3), and it continues to exert its influence today. Yet Hans and Lavina both disliked the official progress narrative. Like other skilled professionals, they worried that the attraction had become a mass tourism machine. On the other hand, Bob (the accountant) was drawn to the

site precisely by promises of comfort on an exotic journey. And for Sophia (the computer technician) these narratives were all insufficient. For her, the point of the journey was self-discovery through a more direct engagement with the world.

The diversity among these four tourists demonstrates how the authorised discourses intersect with personal life histories to generate a multiplicity of interpretations regarding the significance of the site. In part, this diversity is facilitated by the autonomy afforded by the ferry's social spaces, and by the emphasis on action (walking, looking, wandering) at the natural heritage site itself. The North Cape is relatively free from formal exhibitions and structured interpretations, and its visitors may be more willing to take up the challenge of producing their own interpretations and meanings (as discussed in Chapter 5). Yet these conditions should not obscure the vitality of what tourists actually do, a vitality that overruns the three standard discourses on offer for tourists' consumption.

Controlling the interpretation of heritage?

When official narratives invoke the North Cape as a heritage site, whose heritage is said to be on display? The question is not an idle one. The site has been a destination for visitors from other parts of Europe for several centuries. It has also been used over that period as part of a large grazing area for the reindeer herds of Saami people: a different heritage, another sense of identity called forth in the same place. So the site has certain meanings for international travellers, for whom it is thought to be a place of continental significance, and a rather different significance for indigenous people, for whom it was once (among other things perhaps) part of an ancestral range land.

This is not an isolated example. As Smith notes, a number of events in the 1960s and 1970s 'made "heritage" one of the important focal issues' for indigenous peoples (Smith, L., 2006, p. 277). Combined with civil rights and environmental politics, these indigenous movements gained substantial attention in the settler societies of the US, Canada, Australia and New Zealand during these decades. These movements challenged the absence of indigenous people in many popular and professional arenas. Central to that challenge was an effort by indigenous peoples to define their heritage in their own terms. Smith succinctly summarises the issue with a phrase borrowed from the Tasmanian Aboriginal activist Ros Langford: 'The issue is control' (Smith, L., 2006, p. 281). Who, then, should control the official interpretation for the North Cape: the professional class of historians and interpreters, regional business promoters or local indigenous communities?

Yet, perhaps this question assumes that someone *does* in fact control how that heritage is understood. Framing the issue wholly in terms of competing groups obscures a question about how (and how much) control is exercised. The tourists that Birkeland interviewed seem to suggest that the official discourses were not that effective, that those who authored these narratives did not exercise that much control over the tourists. Each of Birkeland's travellers seemed to take pieces of an official narrative while jettisoning others, so as to translate the professionally authored narratives into something noticeably different. However, none of them mentioned the potential significance of the North Cape as part of Saami heritage. This suggests that the official narratives (which located sites of Saami significance elsewhere in the region) hold some power or influence in setting the terms for which the North Cape was understood by this group of tourists: as an unpopulated, natural site (perhaps better understood as a cultural landscape – see Chapter 3). And this in turn points back to the importance of *who* authors the official narratives, much as Langford and Smith suggest, as well as the question of what control looks like.

The next case study teases out some different manifestations of control in regard to the presentation of cultural heritage. It takes you to the opposite side of the Arctic. There, an Iñupiat Eskimo community has been a tourist destination for the last half-century. Their experience offers a chance to distinguish between four different manners of control (or 'modes of power' – see Allen (2003)) that have been used to exercise influence in the presentation and interpretation of heritage in that part of the world. One of these modes was manipulation, which involved deceit on some level. Another was authority, which was based on the recognition granted to a person according to perceived qualities and qualifications. A third was seduction: where authority must be continuously secured, seduction involves exercising some power over another. In general, one seduces someone else by tantalising their desires while letting them choose to play along or opt out. A fourth tactic was persuasion, involving the assumption that all parties (interpreters and visitors alike) were prepared to listen and communicate as equals. These four distinctions can help us see how control can work. Otherwise it quickly becomes a black-box concept (where the purpose of control is clear but its internal operations are not). Distinguishing between some different forms of control, accordingly, provides a better critical understanding of the relationships of power that are inherent in the representation of heritage.

Questions about how power is exercised should be considered alongside the issue of who exercises it. In recent years, local, indigenous and under-represented communities have achieved more visibility, if not more control, in the production of heritage. The following case study exemplifies this trend,

in so far as it documents the growing role of the indigenous community in the localised business of heritage tourism. More than that, it explores how one particularly under-represented group – Iñupiat teenagers – moved to centre-stage in authoring their heritage.

Case study: a heritage of Eskimo dance on display

For almost a decade most of my field-based research has taken me to Kotzebue, an Iñupiat Eskimo community on the north-west coast of Alaska. In the census of April 2000 (the most recent at the time of writing) its population was tallied at just over 3000 residents, of whom 75 per cent claim Iñupiat Eskimo (or indigenous) heritage. Alaskan convention for naming indigenous peoples collectively is the term Native, as will be seen later in the discussion of contemporary Native entrepreneurs. The community is the administrative centre for a region of Alaska. With just over 7200 people in the whole region, few parts of Alaska are less populated. The state's largest city, Anchorage, is over 500 miles away. There are no roads to Kotzebue, and one travels to any of the ten smaller villages in the region by small plane, boat or snowmobile. Since paid jobs are not abundant, hunting and fishing often puts food on the table. Fuel and heavy goods are barged in during three summer months when the sea is ice-free. Kotzebue's airport at the south end of town is therefore a busy one. It accommodates cargo planes that bring groceries and lighter goods to the region throughout the year, as well as the Boeing 737 passenger jets whose daily landings and take-offs mark the rhythms of life.

Every summer day from June to August, those Boeing 737 jets carry several dozen tourists to the Arctic community. There, a company owned by the indigenous people takes them on a packaged tour of Kotzebue, where the tourists are promised a chance to see

> a world steeped in Alaska Native culture, history and tradition. You will see Native life unfold in its simple daily rhythm. ... We invite you to our home on the edge of the world – north of the Arctic Circle, in the Land of the Midnight Sun.
>
> (Tour Arctic, 2003)

Arctic Alaska Travel Service, 1947–51

The summer tours of Kotzebue started more than half a century ago. In the spring of 1947 an enterprising pilot from California started a new business, the Arctic Alaska Travel Service. He had been stationed in Alaska during the war, a period of massive expansion in the region's population around its military bases. There he had learned that many of

Alaska's new immigrants wanted to visit small villages in the remote parts of the territory. New aviation technologies, a growing air-taxi industry and the construction of airstrips were all beginning to make such places more accessible for day-trips. The entrepreneur hired two young pilots to help with the business. The two women had been stranded in Kotzebue during a February blizzard. There were about 600 people living in the village, and these two pilots attended an Iñupiaq dance festival while grounded by the storm. Their enthusiasm to share that experience convinced their new boss that he should charter a plane for a summer weekend trip to Kotzebue for paying passengers. Using a new Boeing 247D 'airship', the entrepreneur left for the Arctic coast in June with a full load of ten passengers. In Kotzebue, he recalled,

> our small band walked through the village and down the beach. We saw fish drying on the racks, admired sled dogs tied to their primitive kennels, studied a Beluga whale dragged up on shore. For visitors from interior Alaska who had never seen how the coastal peoples lived, it was a fascinating experience.

(West, 1985, p. 33)

Arctic Alaska Travel Service conducted three more tours that summer. By August 1947 the programme had developed into an overnight stay. Iñupiaq dances were part of the attraction (Figure 6.5). A staff member from the Governor's Office had informally advised the entrepreneur that selling the opportunity to see these performances might be culturally inappropriate in the village, but the young businessman pressed ahead anyway: rather than offering direct payment to the elders for their performance, he promised a rare treat of ice cream for everyone in attendance. Unaware of the power that was exercised over them, children in Kotzebue became part of the spectacle. Yet the entrepreneur's motive was clear to the elders – he stood to be paid well by his passengers – and they consented to the manipulation. The elders staged the first performance, and he was soon paying them directly for what soon became yet another job.

In the summer of 1948 the small company offered the tour on a weekly basis and started distributing a brochure (Figure 6.6) that described the attractions of the trip. They included crossing the Arctic Circle, 'Eskimo dances' and a reindeer dinner. The tourists would stay overnight at the 'Eskimo Village of Kotzebue, where visitor has opportunity to enjoy real Alaskan atmosphere, witness whaling, sealing, salmon fishing and other native pursuits' (Arctic Alaska Travel Service, 1948, p. 1).

By 1950 the weekly newspaper in Kotzebue was reporting that residents had 'never seen so much Eskimo dancing as they have this summer'. To draw more tourists, the entrepreneur linked the Arctic air trip to his rail-bus tours of Alaska. He distributed flyers to other tour agencies, pushing the Kotzebue tour

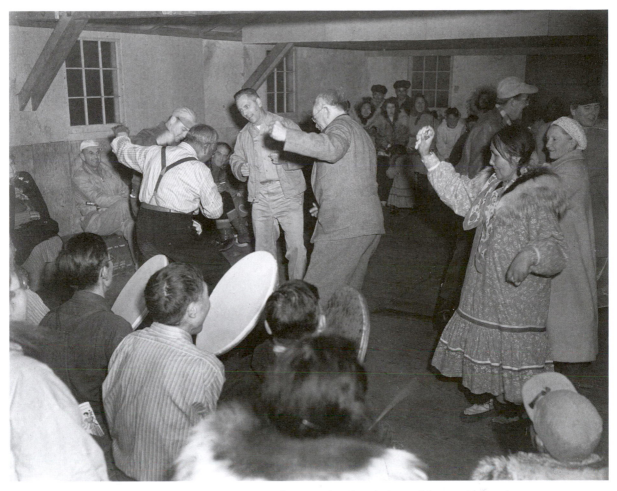

Figure 6.5 Tourists join an Eskimo dance, 1949. Photographed by Gladys Knight Harris. Southwest Museum, Los Angeles, Gladys Knight Harris Collection, No. 26866. The man wearing a white shirt and braces (left) and the woman wearing a *kuspuk* (right) are Iñupiaq Eskimo dancers.

for cruise ship companies and nationwide airlines, and the number of customers for the village tour grew. With help from the territorial government, he also set up an Alaska Visitors Association, a lobby for Alaska's new tourism industry. The group soon brought photo-journalists and travel writers to Alaska, who then described the trips around 'The Last Frontier'. By 1951 his company had tied local developments in Kotzebue into wider networks of circulation, and his personnel were no longer needed to run the ground tour on the Arctic coast. Wien Airlines, a carrier in Fairbanks, Alaska, opened a small hotel in the community, and they took over the ground operations. Arctic Alaska Travel Service simply promoted the tour and sold tickets.

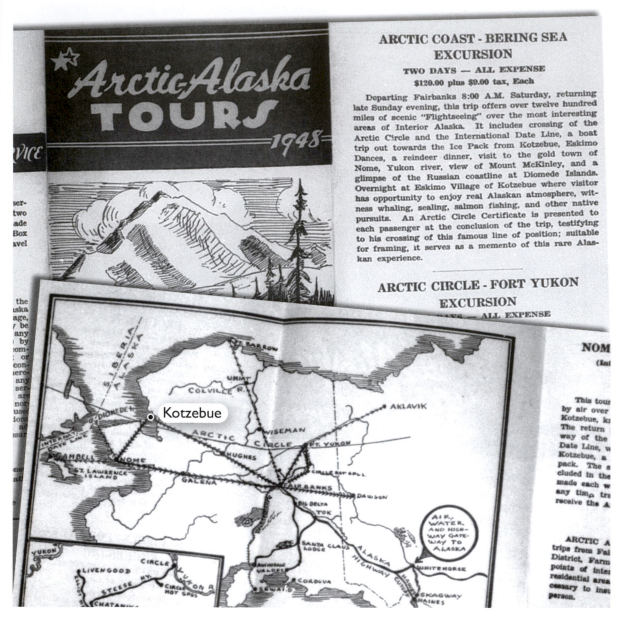

Figure 6.6 Pages from the Arctic Alaska Travel Service tour brochure, 1948.

Wien Airlines, 1951–72

When Wien Airlines took over, the Kotzebue tour had already taken a form that would last for the next fifty years. It included regularly scheduled transit, a standardised menu of food, a guided tour around the village and a nightly Eskimo dance. In an age of mass production, the unpredictable experience of Arctic travel became the packaged tour, a journey designed to be efficient and

reproducible. Reporters praised the destination for its predictability and its comforts: the regularity of air travel, accommodation and services; 'a pitcher and a wash basin' in every hotel room; the planned entertainment; and so on. And the tour was matched against what they had elsewhere learned to expect – 'no igloos', one reporter noted, 'but almost everything else jibed: kayaks, oomiaks, fur-trimmed parkas' (Spring, 1953, p. 1).

The Kotzebue tour tapped a large reserve of curiosity and expectation about Eskimos among Americans. They had seen Eskimo people in magazines and world fairs prior to the First World War. The interwar years saw the first depiction of Eskimos on film with *Nanook of the North* (1922), a groundbreaking documentary, and *Eskimo* (1933), a major Hollywood film. The movies set the stereotype: the happy-go-lucky man, highly adaptive, solitary yet dedicated to his family. The negative stereotype of Indians as aggressive savages began to play against a new American hero in interwar films: the Eskimo who, like an idealised American, was a resourceful individualist, one who faced up to the challenges of nature, a peaceful innocent who could only be corrupted by civilisation. Alaska's colonial government adopted such depictions, frequently using adjectives like 'resourceful' and 'peaceful' to describe Eskimo people in their tourism promotions. They only added the attraction of authenticity to these narratives: visitors were offered the 'rare' opportunity to see an actual Eskimo village or 'a real Eskimo dance', rather than a facsimile or an image on the screen.

The authorised discourses also started to concentrate on Eskimo dancing. The performances made for striking imagery of course, with dynamic poses and elaborate clothing. Usually they involved just one or two dancers on stage, and the small number of dancers accorded well with the image of Eskimos as solitary individualists or as a hetero-normative couple. Writers also began to offer up the meaning of these dances. A government press release in 1949, for instance, stated that one highlight of the Kotzebue visit was 'the Eskimo dances, which depict stories of Eskimo life' (Browne, 1949, p. 2). The next year the author was more specific about the stories in these performances: 'Eskimos perform dances of the hunt and Native legends' (Browne, 1950, p. 4). Elsewhere, journalists were even more emphatic in the need to interpret the performances. Writing about Kotzebue for *Travel* magazine in 1954, for instance, one journalist reported

> One of the most fascinating aspects of the trip is the exhibition of native dancing. This exotic ritual is performed to the saturnine beat of skin tom toms. ... Each motion is representative of an event and the dances portray experiences from the life in the villages or of the family. Some are triumphant demonstrations of a successful hunt, while others somberly depict a great tragedy.
>
> (Barrer, 1954, p. 42)

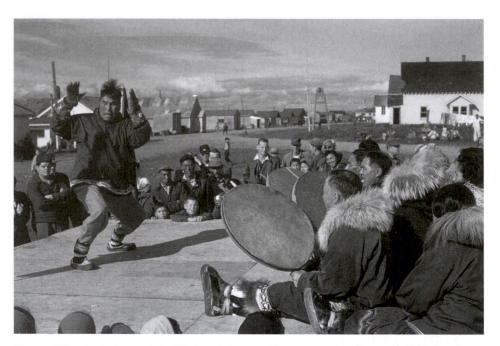

Figure 6.7 A photograph in *National Geographic*, June 1956. Photographed by W. Robert Moore. Photo: © W. Robert Moore/National Geographic Image Collection. The caption in the magazine read 'Dancing to Drum Rhythm, an Eskimo Tells the Story of a Whale Hunt'.

In yet another example, *National Geographic* captioned a photograph from the community (Figure 6.7) with the explanation 'Dancing to drum rhythm, an Eskimo tells the story of a whale hunt' (Grosvenor, 1956, p. 772). In other words, the meaning of each dance was its reference to earlier events elsewhere. According to this interpretation, the dances were just dramatic representations or artful reproductions of something else – the real world beyond the stage – like pictures in a historical museum or an exhibit at the world fair.

After these readings started to circulate, Wien Airlines persuaded Chester and Tillie Seveck, an Iñupiat Eskimo couple from a village to the north, to work for them year-round on salary. In 1954 the two began to greet the tourists as they first disembarked from the plane in Kotzebue. The couple posed for pictures and led the daily performances during the summer (Figure 6.8). They went on tour in the wintertime, promoting Alaska tourism at travel fairs around the world. They spoke English with competence, and Chester had spent forty years working as a herder in the Government Reindeer Service. That, he noted, made him a good candidate for 'herding tourists' (Seveck, 1973, p. 32). The couple appeared on national television shows with Steve Allen, Art Linkletter and Groucho Marx. When Tillie Seveck passed away Chester married Helen Tazroyluke, a widow from another small village further

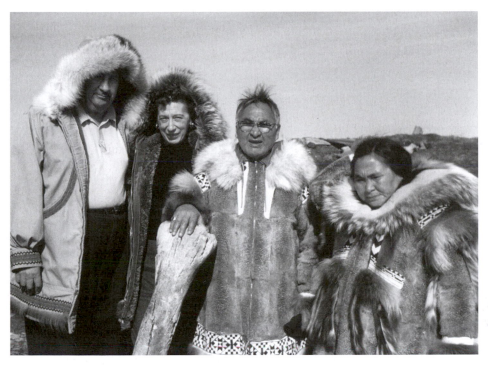

Figure 6.8 Helen and Chester Seveck (right) pose with two tourists in Kotzebue, Alaska, June 1963. Unknown photographer.

north. Like many recent indigenous immigrants to the rapidly growing hub community in north-west Alaska, they both spoke the Iñupiaq language fluently. And since the missionaries in Kotzebue had banned all traditional dances the couple had more knowledge of these dances than most of Kotzebue's long-term residents. From the margins of Kotzebue's social network, the Sevecks became the ideal representatives of what was offered as local tradition.

Recruiting the Sevecks meant that Wien Airlines had a powerful instrument with which to promote a discourse of heritage. The salaried arrangement not only gave their relatively new package greater continuity and face-recognition among would-be visitors, but it also situated the narrative of Kotzebue and its indigenous customs with authority. The Sevecks' authority, however, was not the same as control. Its influence was carried by the recognition of knowledge and expertise. Yet authority is conceded, not imposed, and it must be continually justified by those who claim it. That claim meant the Sevecks always had to be on performance. Attire and bodily cues were not sufficient beyond the first impressions they made when greeting each group of tourists. Embodied proximity was also crucial to the exercise of influence, and the impact of their authority was most intense when the Sevecks themselves were directly present and

active, demanding continual recognition from the visitors simply by their distinctive presence, their presentations and their expectation to be photographed.

The Sevecks and the intangible heritage at Kotzebue were fast becoming one of Alaska's most notable attractions. By 1961 the number of tourists had grown to several thousand, coming from all over the USA. Among the 2544 people who completed the airline's survey in 1960, forty-six hailed from Canada, twenty from Italy and five from the UK. Another carrier began to fly tourists to the Arctic community. By 1970 Kotzebue had grown into a town of almost 1700 people. Many had moved from camps and small villages elsewhere in the region. In Kotzebue, they found themselves the hosts for over 5000 visitors annually.

Alaska Tour and Marketing Service, 1973–88

The next tour operator would see the number of tourists reach its peak. Nonetheless, from 1951 to 1972 Wien Airlines had parented the operation through its boom. The same period saw some remarkable changes in Alaska. A movement had gathered pace for the settlement of indigenous **land claims**. While the livelihood of Alaska's indigenous people was under increasing threat, the US government had never recognised their rights to the land. In 1966 Native groups filed formal claims all over the state. Then a small company discovered oil on the north coast of Alaska in December 1967, and the construction of an 800-mile pipeline necessitated a quick settlement of these land claims. An agreement was signed in 1971. The solution was uniquely American. The claimants were to become shareholders of numerous business companies in Alaska, called 'Native regional corporations'. Among them was NANA, a Native corporation based in Kotzebue with almost 5000 Iñupiat shareholders. Over 25 per cent of the shareholders lived in Kotzebue alone. With the passage of the Alaska Native Land Claims Settlement Act in 1971, NANA was allocated US $59 million in capital and gained title to 9 per cent of the land in the north-west part of Alaska. With its sights set on creating profits and jobs for its shareholders over the next two decades, NANA would make most of its money by providing field services to the oil companies in Alaska.

Before NANA was incorporated, however, a former airline executive started his own company, Alaska Tour and Marketing Service (ATMS). Based almost 2000 miles away in Seattle, the new company consolidated the airline ground operations for the Kotzebue tour. ATMS bought airline seats, booked hotel rooms and meals, recruited Seattle college students to serve as tour guides in Kotzebue, and then marketed and sold the packaged tour.

Yet NANA was also active in Kotzebue's tourism industry. With considerably more capital than ATMS, the Native corporation invested in the construction of a state-of-the-art hotel for tourists in Kotzebue, making arrangements with

ATMS to provide all the accommodation needed by the tourists. Location was an important concern. Wien Airlines had built its hotel on cheaper land at the north end of the town. As visitor numbers increased in the 1960s, large groups of tourists would walk along the shoreline to the shops, restaurants and businesses in the centre of the community, which was a half-mile away. As they did so, they regularly disturbed the fish racks and the beachside harvest activities of indigenous hunters – the same sights that were being advertised as part of the tour. Considering the concerns of its Iñupiat shareholders, the Native corporation built the larger new hotel, the *Nullagvik*, in the business district itself. That reduced the amount of visitor foot-traffic up and down the shoreline. Thus the move was not just a way to capture the leakage of economic revenues through local ownership of the hotel facilities, thereby keeping more capital in the community. It was also a way to help sustain the cultural heritage of the community in the face of frequent disturbances from tourists.

Around the same time, NANA began construction of the Museum of the Arctic. Opened in 1976, this featured an auditorium seating 120 visitors. Along the walls was a diorama of the animal life in the region, and it was in this space that the dances came to be performed for visitors. But at the centre of the museum experience was a professionally produced, multimedia slide show. Using still-images that faded from one to the next, the programme spoke of the spirit of the land, of a resilient and spiritual people under a shimmering aurora, and of their negotiations between the modern and traditional world. The signature moment in the programme occurred when the recorded voice-over addressed the importance of the seal oil lamp. At that point, an Iñupiaq performer regularly moved from the shadows onto the stage below, usually to the surprise of the audience, to light an actual seal oil lamp as the voice-over and projection of images continued overhead.

Next to the authority of the Sevecks' performance, the museum's new audio-visual programme was less a moment of control over interpretation, more a work of seduction: the possibility was always open for its viewers to opt out of its story, yet the programme strove to intensify any existing desire to believe its narrative. It used darkness and shadows to excite curiosity and focus attention, and its still-frames, while evoking nostalgia, also allowed one to pause and reflect. Nonetheless, the show was effective only in so far as it offered each audience member the opportunity to choose. Viewers could let themselves be carried by its discourse about a culture of adaptation, spirituality and respect for the land. But among the standing images of the Arctic landscape, in the dimmed lights of the auditorium, the possibility of rejection, or even indifference to its invitations and seductive appeals, was always available. There was no hiding of the show's purpose or strategy. Travel writers called it 'an impressive program'.

With the Sevecks as authoritative cultural ambassadors, an appealing programme, Native-owned facilities, and a site that was genuinely in the Arctic, the Seattle-based ATMS had an attractive package of cultural heritage. All of these elements contributed to the claim of authenticity, and in America in the 1970s, that itself was a powerful discourse. The number of tourists who visited Kotzebue continued to climb, peaking around 12,000 visitors annually near the end of the decade. Then in the 1980s the novelty waned and the numbers started to decline. By 1988 Chester Seveck had passed away, Helen Seveck had retired and the number of tourists had dropped dramatically. ATMS filed for bankruptcy. NANA picked up the ground operation in Kotzebue and formed a new subsidiary, Tour Arctic.

NANA's 'Tour Arctic', 1989 – ongoing

When the Native corporation acquired the ground tour the overall package remained much the same as forty years earlier. It still included a guided tour of the community, an Eskimo dance, dinner, lodging and an 'Arctic Circle Certificate' verifying that the visitor had been to the Land of the Midnight Sun. The significance of NANA's purchase, however, was that the last remaining elements of the tour package – the guided ground tour, marketing and sales – operated under their direction. Yet the company still did not control the interpretation of heritage. There are several reasons for this. First, NANA's representations were somewhat constrained by the stereotypes of Eskimo life that visitors expected to see in Kotzebue. Second, NANA had inevitably limited resources with which to operate. Third, the different manners of influence (persuasion, seduction, authority, manipulation) they deployed to achieve what they wanted all fell short of control. Yet it was significant that NANA now had a strong place in the chain of decisions that informed the presentation of the ground tour and advertisements.

Consider the ground tour first. There were few obvious changes when NANA bought the operation from ATMS. The 48-page manual from 1984 (given to tour guides working for ATMS) and the 50-page manual from 1990 (for tour guides working for NANA) show close similarities, but the Native corporation chose to add a major paragraph in their instructions about the greeting of visitors at the airport. That paragraph began:

> Remind your guests that the culture they are going to learn about is quite different. The people of Kotzebue welcome visitors but request that they ask permission before taking photographs of people and keep negative comments regarding subsistence [wildlife harvest] activities to themselves.

> (Tour Arctic, 1990, pp. 7–8)

The paragraph then recommended some phrasing that the guides could use: 'You might say something like ... "you may see things that don't appeal to you, such as seals being harvested ... Please be respectful of our lifestyle and keep negative comments or feelings to yourself if possible".' The material drove this point home by putting it in context:

> In the past, some visitors have actually gone up and looked inside residents' homes. This is really discouraged, and although [as a guide, you can be] quite sure this group will be sensitive to residents, you are required to mention it.
>
> (Tour Arctic, 1990, p. 8)

Those instructions underscore the pressures that some tourists had placed on an Arctic community that had been identified as a site of cultural heritage. The pressures were already reflected in NANA's decision to build its hotel in a place where the disturbance of shoreline harvest activities would be minimised. By inserting local shareholder concerns into tour-guide policies as well, NANA's executives hoped to address the extreme cases of intrusion that tourism had introduced.

Second, there were changes in hiring practices. ATMS usually recruited college students in Seattle to serve as their tour guides in Kotzebue. This was partly because many Kotzebue residents preferred to be out on the land rather than working in the community all summer. After 1989 NANA tended to fill the tour-guide positions with younger shareholders, those who had received shares in the company in the years following the Alaska Native Claims Settlement Act. The interpretation of heritage that visitors encountered in Kotzebue was thus embodied in a very different way. After 1989 tourists more often listened to someone of Iñupiaq ancestry, someone who spoke of 'our lifestyle' (as the instructions quoted above suggest) rather than about 'their' culture. This turned what had been a distant 'exhibit' that tourists were to observe into an engagement in which visitors were immediately immersed.

For tourists, however, the most notable change was brought about with the passing of Chester and Helen Seveck. In their absence, NANA moved the focus of the package tour away from the feature dance performance by Iñupiaq elders and toward younger generations instead. Facing the low profit margins endemic to tourism, NANA turned the operation into a training opportunity for Kotzebue teenagers, who otherwise found formal jobs to be relatively scarce in the area. Within ten years NANA's tourism division started to feature the youth in their advertisements as well: 'Lessons of the old ways are relished by the young Iñupiat ... Come and meet these energetic youth. Let them share the ancient ways with you' (Tour Arctic, 1998, p. 1).

NANA's skills-training approach also resonated with the way Iñupiaq dance was understood in the area. Official interpretations, recounted by journalists and elders alike, described most dances as a depiction of Iñupiat heritage, a story about an event in their life or in that of their predecessors: 'an Eskimo tells the story of a whale hunt'. But other interpretations in Iñupiaq culture saw the dancer as more than just a storyteller. In this view, dance was thought to be a performative tradition, one that demonstrated the dancer's ability to adapt and change. It was a measure of their talent for looking, moving and acting like something else: a curious bear, an angry reindeer or a flippant seal. That, in turn, played on the long-standing importance of adaptation and personal transformation in Iñupiaq culture.

Adaptation was not just a survival skill in a harsh, Arctic environment. It was also part of a world view. Where Euro-American dispositions tend to see things for what they are (a tent, a saw-blade or a child), an Iñupiaq view more often looks for what the same things can be turned into: a tent that could be rebuilt as a sled, a saw-blade that could be turned into a knife, or (through adoption) a child out of whom a daughter could be made. This tendency to look for what people potentially could be appears in the work of Aknik, an Iñupiaq elder who told his readers – regardless of their ethnicity – 'I could make you good Eskimo dancer [*sic*] any time, if you just wanted to learn' (Green, 1959, p. 60). The tendency informed NANA's decision to highlight Iñupiat youth in its tour programme, helping teenaged shareholders turn themselves into tour-guides and dancers. And it shaped the very purpose of the performance, since the dancers had to become (that is, evocatively to imitate) a mouse or a polar bear, for instance, as they moved through a story for tourists.

The problem is that these motivations are not obvious. Tourists seem to expect to see or meet an elder. Indeed, some explain the absence of an elder in culturally familiar terms, suggesting in hushed tones that the corporation is exploiting the youth for profit. In truth this was not the case. The peak in numbers after NANA took over occurred around 1994, with a little over 8000 tourists. By the end of the decade it had dropped to less than 5000 annually, and NANA continued to run its tour business at a loss. This was sustainable because the Native corporation made its profits elsewhere. And it was acceptable, because tourism was considered a good way to maintain the community's cultural resources and to develop valuable human resources in the region.

Coda: the author goes to Kotzebue, September 1998

When I go to Kotzebue my role is usually that of a researcher and academic, a geographer by training. However, when I first landed in Kotzebue one September afternoon in 1998, I was just a tourist, arriving on a Boeing 737 as

tourists do. I remember exiting out of the rear of the plane and walking the short distance to the building. There, a young woman in fur-lined Eskimo tunic greeted me. She pointed to a bus, where I joined twelve other tourists. With a younger pair from Austria and older folks from other parts of the USA, I was the only one from Alaska. Our guide mentioned that a dozen was a good number for September. We were driven a short distance to a large white tent near the beach. Inside, three teenagers told us about the items that sat on the table in front of them – rope made of seal skin, masks from whalebone, and furs. Kids were playing outside. It sounded like they were having fun. The two young women, wearing *kuspuks* (hooded dresses), said that they learned some Iñupiaq in elementary school. Each of them pronounced their Iñupiaq name, and the young man told us his English name which, in order to preserve his anonymity in this case study, I will substitute with the pseudonym Charlie. He joked about mosquitoes in the area, and then watched us with a smile when he said that his favourite food was just normal stuff: hamburgers, pizza, seal and whale fat. I think we all laughed at that. We recognised part of his inventory as typical American teenager food. Otherwise, it seemed to be a playful parody of 'normal' food on our own grocery lists. The day was getting late, and I suspect we tourists were beginning to think about our dinner.

When Charlie listed his favourite foods – whale fat, seal, hamburgers and pizza – I now wonder if he was not playing with us. He offered a list of seemingly commensurable items, something all too familiar. It included two foods that his audience would likely associate with Iñupiat people, and two with Euro-American teenagers living elsewhere. But these associations may mark a Euro-American understanding of identity, one that assumes that its own categories are unambiguous and that the things described by those categories – like 'Iñupiaq' and 'Euro-American' – do not change or transform themselves very fast. Faced with these terms, Charlie was letting *us* choose which category we thought he should belong to: an Iñupiaq person, or a classic American kid. Yet for me, Charlie's list was paradoxical. Clearly it was a parody of the categories of culture and ethnicity that Euro-Americans often use. And it was a playful comment to get me to think. But from all the time I have since spent in Kotzebue, that kind of comment also strikes me, now, as a rather Iñupiaq one to make.

Despite what our watches were telling us, our dinner did not come next. Instead, we tourists were taken to NANA's Museum of the Arctic. As I walked in I saw the display whose image I had seen in Tour Arctic's promotions. Two full-size Iñupiat wax figures stood in an oomiak boat, near taxidermy and sculptures of the sea-life from the Kotzebue Sound. As I walked past the exhibits and the diorama in the museum, I overheard another tourist chatting with the younger kids who had greeted us at the door. She asked whether they were getting paid for their work, to which they answered no. That answer

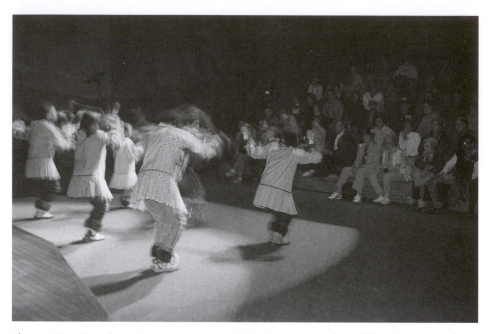

Figure 6.9 Kotzebue, Alaska, postcard, 1998. Photographed by Cliff Hollenbeck. Photo: © Cliff Hollenbeck/NANA. The caption on the back reads: '"Sayuq," or Motion Dances, are performed in Kotzebue as they have been for generations past. Traditional dances are a form of entertainment that tell stories of life experiences.'

raised an eyebrow, but then, they own the Native corporation they were working for, and the market economy is not as extensive in this community as it is elsewhere. Our young hosts were gaining valuable experience as they worked with corporate managers at the museum as well as with elders at the culture camps. The younger kids directed us to the auditorium seats for a slide presentation and dance (Figure 6.9). While my fellow tourists took pictures of their performance, the sparkle and enthusiasm that the teenagers shared with us that evening are not easily reproduced on film. Charlie asked us to join them in the last dance, an invitation that unsettled the categories that define who are the performers, and who is the audience.

Reflecting on the case study

Why do very talented young people appear not to meet the hopes of some tourists? Observations suggest that some tourists expect the authority of elders when learning first-hand about Alaska Native heritage. But this raises questions that are worth reflection. Did that authority account for a substantial part of the tour's earlier success? If so, how influential are those discourses that associate the intangible heritage of North American indigenous peoples principally with Native elders, associating it much less with other age groups?

In Kotzebue, it may have been difficult to persuade many visitors that the presence of younger dancers on stage might itself reflect a long-standing heritage of individual transformation and cultural adaptation. The popular discourse about North American indigenous heritage also tends to ignore change and assume fixed forms of tradition and culture. Among tourists then, what is the relationship between their individual life histories, their prior constructions of 'indigenous people' and their openness to be taken (quickly) by surprise with the very terms of their engagement?

The balance of power in tourist economies

This chapter has explored the relations of power in the practice of heritage. This has partly involved laying out some of the different manners with which power is exercised in the presentation of heritage. By necessity, it has also entailed paying attention to the issue of who exercises that power, and here the implications of the tourism industry on the practice of heritage are prominent. In critical heritage studies, there is a considerable literature about the context of larger institutions that produce the official narratives in question (though the next chapter, on social action, moves away from an institutional focus). These institutions are often public agencies or non-profit organisations. However, the tourism industry's privately owned, for-profit institutions play a large part in the practice of heritage too. Its interpreters are often advertising consultants, employees of large cruise-ship companies, or owners of small bed-and-breakfasts. Economic development programmes often highlight the advantages of their investment and their entrepreneurial activity in local tourism, though the entrepreneurs who run the smaller businesses, at least, are often more interested in lifestyle issues than in making profits (Shaw, 2004). These entrepreneurs may author a good part of the discourse of heritage but they do so, accordingly, with relatively few resources at their disposal.

The second case study shows a different kind of entrepreneurialism. The Native corporation in Kotzebue, Alaska, has financial resources comparable to a larger institution, but like many smaller organisations it is also closely bound to certain concerns in the community. This unusual conjuncture takes us back to questions about the relationship between heritage and the economy that started this chapter. There it was argued that heritage often helps to shape the economy. Tourism can exemplify this in a straightforward way: a substantial part of the economy in northern Norway, for example, is based on the flows of money that international tourists bring to towns around the North Cape. But a more complex argument takes form with NANA's business strategy in Alaska. There, the indigenous community tends to highlight the significance of resourcefulness and adaptation in Iñupiaq Eskimo culture. This heritage is evident in the dances themselves, which put individual adaptations on display, and the heritage has informed NANA's

holistic approach to regional economic development, where its executives have deliberately used the local tourism business as an opportunity to develop the human resources of teenagers in the area – even when it has meant incurring a loss on the Native corporation's financial statements. Heritage helps shape the economy.

Different economies also offer opportunities and constraints for the practice of heritage, and tourism exemplifies one way that this process can play out. It is often thought to be a critical component of a community or regional development strategy, one that both circulates outside money into the area (thereby creating jobs) and creates a distinctive identity for the region (thereby attracting talent and capital investment). That logic sometimes builds support for projects involving the practice and interpretation of heritage. Yet the case study in Kotzebue shows that the economy also places constraints on the practice of heritage. Cultural tourism is, at best, a marginally profitable endeavour, and in many cases it operates with accounts in the red. This limits how innovative or challenging the practice of heritage can be. Open up a programme that may be too challenging at first for the anticipated audience, and a free-market economy based solely on profits may soon close it down. In other words, the particular economic context helps shape the practice of heritage.

Conclusion

The start of this chapter charted a move in tourism studies from business-orientated analyses, to research on the impacts of tourism, to studies of actual tourists. The early analyses worked well to bolster the authorised heritage discourse of canonical sites and monuments (discussed in Chapter 1), but the later focus has pushed more attention on to how tourists negotiate the canons of heritage around specific sites. The North Cape study explored one such site, where four tourists translated, challenged, and personalised the authorised narratives in a variety of ways. Yet there were limits to their challenges: in the absence of an indigenous canon, for instance, none seemed to imagine the potential significance of the North Cape in Saami culture. This suggests that authorised heritage discourses are influential, though the ways in which the representation of heritage can be controlled is limited. The Kotzebue case study has touched on four different manners of influence as it has traced the changing relationship between the tourists and representatives of the indigenous community with the performance of Iñupiaq Eskimo dance. The chapter has picked up several issues discussed in Chapter 5, particularly in regard to interpretation as a provocation of the visitor's personal experience, and who is in 'control' of that process. We will explore the increasing role of local community perspectives further in Chapters 7 and 8, first approaching the role of **unofficial heritage** and then the importance of performance in social communication.

Works cited

Allen, J. (2003) *Lost Geographies of Power*, Malden, MA and Oxford, Blackwell Publishing.

Arctic Alaska Travel Service (1948) *Arctic Alaska Tours*, Fairbanks, AK.

Barrer, M. (1954) 'Visiting the top of the world', *Travel,* vol. 102, no. 1 (July), pp. 41–3.

Birkeland, I. (2005) *Making Place, Making Self: Travel, Subjectivity and Sexual Difference*, Aldershot, Ashgate.

Britton, S. (1991) 'Tourism, capital and place: towards a critical geography of tourism', *Environment and Planning D: Society and Space*, vol. 9, no. 4, pp. 451–78.

Browne, R. (1949) 'For *Travel Agent* magazine', Alaska Development Board press release, in the collection of Alaska State Archives, Record Group 315, Series 53, Box 863, File 'Articles', Juneau, AK.

Browne, R. (1950) 'For *Flair* magazine', Alaska Development Board press release, in the collection of Alaska State Archives, Record Group 315, Series 53, Box 865, File 'Promotion and Publicity, April to June 1950', Juneau, AK.

Franklin, A. and Crang, M. (2001) 'The trouble with tourism and travel theory?', *Tourist Studies*, vol. 1, no. 1, pp. 5–22.

Graham, B., Ashworth, G.J. and Tunbridge, J.E. (2000) *A Geography of Heritage: Power, Culture and Economy*, London, Arnold.

Green, P.A. (1959) *I am Eskimo, Aknik My Name*, Juneau, AK, Alaska-Northwest Publishing.

Grosvenor, E.M.B. (1956) 'Alaska's warmer side', *National Geographic*, vol. CIX, no. 9 (June), pp. 737–75.

Hampton, M. (2005) 'Heritage, local communities and economic development', *Annals of Tourism Research*, vol. 32, no. 3, pp. 735–59.

Harrison, R. (2010) 'What is heritage?' in Harrison, R. (ed.) *Understanding the Politics of Heritage*, Manchester, Manchester University Press/Milton Keynes, The Open University, pp. 5–42.

Hewison, R. (1987) *The Heritage Industry: Britain in a Climate of Decline*, London, Methuen.

Jacobsen, J.K.S. (1997) 'The making of an attraction: the case of North Cape', *Annals of Tourism Research*, vol. 24, no. 2, pp. 341–56.

Jafari, J. (1975) '*Annals of Tourism Research* – at the end of its second year of publication', *Annals of Tourism Research*, vol. 2, no. 5, pp. 232–4.

MacCannell, D. (1976) *The Tourist: A New Theory of the Leisure Class*, New York, Schocken Books.

Mowforth, M. and Munt, I. (2003) *Tourism and Sustainability: New Tourism in the Third World* (2nd edn), London and New York, Routledge.

North Cape Municipality (2009) [online], www.nordkapp.no/north-cape.51216.en.html (accessed 17 March 2009).

Norwegian Travel Office (1956) The North Cape – Top of Europe: From a Norwegian Travel Office Press Release 24 April 1956 (P. Stevens) [online], www.caronia2.info/m195607.php (accessed 10 March 2008).

Pederson, A. (2002) *World Heritage Series no. 1 – Managing Tourism at World Heritage Sites: A Practical Manual for World Heritage Site Managers*, Paris, UNESCO.

Rojek, C. (2005) 'Leisure and tourism' in Calhoun, C., Rojek, C. and Turner, B. (eds) *Sage Handbook of Sociology*, London, Sage Publications, pp. 302–13.

Seveck, C. (1973) *Longest Reindeer Herder*, Anchorage, Arctic Circle Enterprises.

Shaw, G. (2004) 'Entrepreneurial cultures and small business enterprise in tourism' in Lew, A., Hall, C.M. and Williams, A. (eds) *A Companion to Tourism*, Malden, MA and Oxford, Blackwell Publishing, pp. 122–34.

Smith, L. (2006) *Uses of Heritage*, Abingdon and New York, Routledge.

Smith, V. (ed.) (1977) *Hosts and Guests: The Anthropology of Tourism*, Philadelphia, University of Pennsylvania Press.

Spring, N. (1953) 'The kids of Kotzebue', *Seattle Times*, pictorial section (23 November), pp. 2–7.

Tour Arctic (1990) *Tour Manual*, Kotzebue, Alaska, NANA (author's collection).

Tour Arctic (1998) Tour Arctic [online], www.tour-arctic.com (accessed 23 July 1998).

Tour Arctic (2003) Welcome to the Arctic [online], www.tour-arctic.com/main.html (accessed 17 June 2008).

Turner, L. and Ash, J. (1975) *The Golden Hordes: International Tourism and the Pleasure Periphery*, London, Constable.

Urry, J. (1992) *The Tourist Gaze: Leisure and Travel in Contemporary Societies*, London, Sage Publications.

West, C. (1985) *Mr Alaska: Forty Years of Alaska Tourism, 1945–1985*, Seattle, Weslee Publishing.

Further reading

Beck, W. (2006) 'Narratives of world heritage in travel guidebooks', *International Journal of Heritage Studies*, vol. 12, no. 6, pp. 521–35.

Berno, T. (2007) 'Doing it the "Pacific Way": indigenous education and training in the South Pacific' in Butler, R. and Hinch, T. (eds) *Tourism and Indigenous Peoples: Issues and Implications*, Oxford, Elsevier, pp. 28–39.

Cole, T. and Scherle, N. (2007) 'Prosecuting power: tourism, inter-cultural communications and the tactics of empowerment' in Church, A. and Coles, T. (eds) *Tourism, Power and Space*, Abingdon and New York, Routledge, pp. 217–46.

Hall, S. and Bombardella, P. (2005) 'Las Vegas in Africa', *Journal of Social Archaeology*, vol. 5, no. 1, pp. 5–24.

Harrison, D. and Hitchcock, M. (2005) *The Politics of World Heritage: Negotiating Heritage and Conservation*, Clevedon, Channel View Publications.

Jones, C. and Munday, M. (2001) 'Blaenavon and United Nations World Heritage site status: is conservation of industrial heritage a road to local economic development?', *Regional Studies*, vol. 35, no. 6, pp. 585–90.

Porter, B. and Salazar, N. (eds) (2002) 'Resolving conflicts in heritage tourism: a public interest anthropology approach', special issue, *International Journal of Heritage Studies*, vol. 11, no. 5.

Sharpley, R. and Telfer, D.J. (eds) (2002) *Tourism and Development: Concepts and Issues*, Clevedon, Channel View Publications.

Shaw, G. and Williams, A.M. (2002) *Critical Issues in Tourism: A Geographical Perspective* (2nd edn), Malden, MA and Oxford, Blackwell Publishing.

Smith, M.K. (2003) *Issues in Cultural Tourism Studies*, London and New York, Routledge.

Timothy, D.J. and Boyd, S.W. (2003) *Heritage Tourism*, New York, Pearson Education/Harlow, Prentice Hall.

Chapter 7 Heritage as social action

Rodney Harrison

This chapter considers the ways in which 'unofficial' objects, places and practices of heritage might be used at the local level to build a sense of community and identity, and the ways in which these local practices might run counter to the ways in which heritage is employed by the state. The first case study looks at how a group of Indigenous Australians from western New South Wales use the physical remains of the former Dennawan Reserve in an active way to create connections between individuals in a community and their past. The second case study explores Jay Brown's Walking Tour of Brixton in south London as an intervention intended to subvert the traditional accounts of London's heritage given to tourists. The tour does this through emphasising the multicultural heritage of Brixton, a south London borough with a history of racial conflict and historically associated with the settlement of migrants from the Caribbean after the 1950s. This chapter complements the book's focus on official practices of heritage through a consideration of the unofficial processes of heritage which largely operate at the local level.

Introduction

This book has concerned itself almost entirely with institutional or official practices of heritage. Now this chapter considers some of the ways in which practices of heritage might be understood to function as a form of social action, both as interventions in official heritage practices and through local, community-building aspects of unofficial heritage practices. The term official heritage practices is used to mean the processes of heritage identification, management and conservation that are embedded in legislation and government. Unofficial objects, places and practices of heritage may not be recognised by governments or be listed on official heritage registers but they are considered to be significant or culturally meaningful by communities and collectives in the ways in which they constitute themselves and operate in the present, drawing on aspects of the past. The case studies that follow explore some of these unofficial objects, places and practices of heritage, as well as the ways in which they engage with and cut across official processes of heritage.

Heritage from below

The historian Raphael Samuel suggested that we must consider the *social* role of heritage. He argued that the popular appeal of heritage implied that heritage was not simply imposed on people from above but could be used for positive social change. He is famously associated with the term 'history from below', which refers to a form of social history that focuses on the lives of people such as women, children and the working classes who were previously thought of as less important and who were therefore neglected by historians. Samuel himself promoted the importance of non-institutional or community-based history. He thought that 'people's history' or 'history from below' had the potential not only to benefit local communities but also to influence the academic discipline of history. Writing about Britain and the increased interest in history and heritage that occurred during the 1980s, he argued that significant new ways of understanding the national past were emerging. He suggested these new approaches had the potential to challenge and revolutionise society's understanding of the past and the present, and to point to a more pluralistic future:

> history as a mass activity – or at any rate as a pastime – has possibly never had more followers than it does today, when the spectacle of the past excites the kind of attention which earlier epochs attached to the new. Conservation ... is one of the major aesthetic and social movements of our time. Family history societies fill the record offices with their searchers. We live ... in an expanding historical culture, in which the work of inquiry and retrieval is being progressively extended into all kinds of spheres that would have been thought unworthy in the past, that whole new orders of documentation are coming into play.
>
> (Samuel, 1994, p. 25)

The sociologist Stuart Hall extended some of these arguments to suggest that multiculturalism has the potential to revolutionise the ways in which countries perceive their heritage, and in doing so to effect social change in the present. Discussing the challenge of multiculturalism in relation to an understanding of the nature of heritage in the UK, he notes:

> the majority, mainstream versions of the Heritage should revise their own self-conceptions and rewrite the margins into the centre, the outside into the inside. This is not so much a matter of representing 'us' as of representing more adequately the degree to which 'their' history entails and has always implicated 'us', across the centuries, and vice versa. The African presence in Britain since the sixteenth century, the Asian since the seventeenth and the Chinese, Jewish and Irish in the nineteenth have long required to be made the subjects of their own dedicated heritage spaces as well as integrated into a much

more 'global' version of 'our island story'. Across the great cities and ports, in the making of fortunes, in the construction of great houses and estates, across the lineages of families, across the plunder and display of the wealth of the world as an adjunct to the imperial enterprise, across the hidden histories of statued heroes, in the secrecy of private diaries, even at the centre of the great master-narratives of 'Englishness' like the Two World Wars, falls the unscripted shadow of the forgotten 'Other'.

(Hall, [1999] 2008, p. 225)

We will return to consider the implications of **diasporas** for heritage in more detail later in the chapter. For the time being it is important to think about what Hall is suggesting here in terms of excavating new narratives about the past. There are hidden, neglected aspects of history which relate to the long tradition of interactions between cultural groups that lie buried in the memories and mementoes of ordinary communities. Heritage, through its focus on the relationship between humans and material things from the past in the present, can reveal and celebrate these hidden narratives. Hall continues:

The first task, then, is re-defining the nation, re-imagining 'Britishness' or 'Englishness' itself in a more profoundly inclusive manner. The Brits owe this, not to only us, but to themselves: for to prepare their own people for success in a global and decentred world by continuing to misrepresent Britain as a closed, embattled, self-sufficient, defensive, 'tight little island' would be fatally to disable them.

(Hall, [1999] 2008, p. 225)

These inclusive representations of the present that Hall calls for could be achieved, in part, by emphasising certain aspects of tangible and intangible heritage. But we should not see these comments as specific to the UK. In writing this, Hall points to the significant potential for heritage to change the way in which nations view themselves and their relationships with their minorities and the rest of the world. The idea of transforming heritage 'from below' is a powerful example of the social role that heritage can play in society.

Making a sense of place

A more recent articulation of the social role of heritage and the part it plays in individual and collective identity owes its roots to the work of political scientist Benedict Anderson ([1983] 2006) and anthropologist Arjun Appadurai (1996, [2001] 2008). Their ideas, in so far as they relate to heritage, are perhaps best summarised by archaeologist Denis Byrne (2008). Byrne

suggests we should think of heritage as a form of social and cultural *action*. Most anthropologists now agree that cultures are not simply an accumulation of things and people but are better understood in terms of a series of processes by which new and old practices are adapted and adopted within a cultural system. These processes can be thought of as forms of 'work' which help to produce culture. In Chapter 1 you saw how UNESCO recognises the social practices that help to create distinctive communities as intangible heritage or living heritage. Intangible heritage consists of cultural practices such as language, performing arts, rituals, crafts and knowledge of the natural world which help individuals to build relationships with their communities and with the world in which they live.

Drawing on the work of Appadurai (1996, [2001] 2008), Byrne discusses the ways in which communities use both intangible heritage practices and the social practices relating to tangible forms of heritage as a part of the 'work' that maintains their connection to particular places and to each other. A community's campaign to conserve a building, for example, requires the community to form together as a collective, to acknowledge certain shared values, and to emphasise their connections both with each other and with a particular place. Appadurai calls this work the 'production of locality'. For Appadurai, **locality** is a relational rather than a spatial concept – 'the local' is not so much the place where you live but a space to which you feel connected and through which you feel connected to others. Appadurai's radical contention is that the local is not inherent, that societies must do cultural work to create it and make it real. We establish a sense of belonging to a community and to a place through cultural practices that create this sense of locality. Humans use heritage to produce the local by rooting particular practices – which they use to help link them to a particular community and/or to a particular place – in the past. The linking of these places to the past gives them greater legitimacy in the present. In the same way that we come to associate the landmark events of our individual lifetimes –the births, deaths and marriages – with particular places where they took place, at a group level, community-validated events gain their significance from an association with particular places and from a shared understanding that is rehearsed as part of the **collective memory** of a community.

An example of this form of cultural work undertaken by communities to produce the social relations inherent in a locality (or place) is festivals. During festivals people affirm their relationships with each other through a series of activities, or rituals, that celebrate particular historic events and their relationship to a particular place. An example is the Notting Hill Carnival which was established in 1959 in the west London suburb of Notting Hill in the wake of a series of race riots (Figure 7.1). It was initiated as a way for the British African Caribbean community to assert a sense of pride and kinship, as well as to promote unity with white Londoners. This annual festival, which is held over

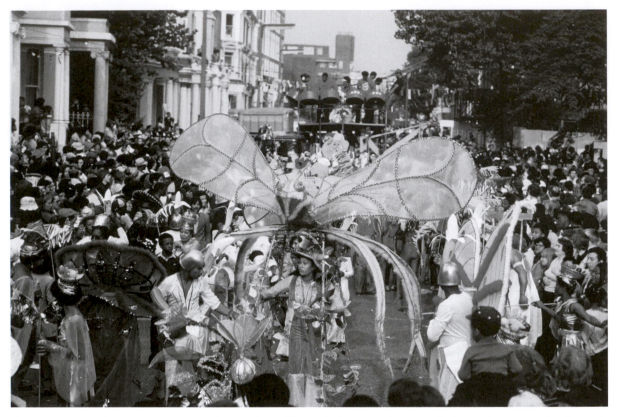

Figure 7.1 Flamboyant costumes at the Notting Hill Carnival, 2006. Photographed by John Sturrock. Photo: © John Sturrock/Alamy.

a long weekend in the summer and involves two days of parades, music, dancing and food, is one of the largest outside Brazil. It does significant social 'work' in promoting racial harmony. It asserts a sense of community for British African Caribbeans through an emphasis on shared black Caribbean cultural experiences – in particular dance, music and cuisine. The Notting Hill Carnival is integrally linked both to the specific histories of British African Caribbeans in Notting Hill itself and to their heritage in the Caribbean.

The Notting Hill Carnival is an invention of heritage designed to deal with a particular cultural problem – racial tension between British African Caribbean people and white indigenes – and draws on older traditions of festivals and carnival from Britain and the Caribbean. Within the British tradition, carnival was historically rooted in seasonal celebrations that involved the temporary inversion of social order. In the Caribbean, carnival also had its roots in the upending of social order, and its symbolism evoked the escape of African slaves once a year to play music, dance and dress in flamboyant costumes. Bringing these two traditions together in a way that emphasised some of the positive aspects of cultural diversity in Britain in terms of music, dance and

cuisine was an ingenious way of attempting to bring together a community that was divided. The Notting Hill Carnival and further examples of the intangible practices of festivals are also discussed in Chapter 8.

These intangible heritage practices such as carnival, which bring people together and help to produce 'the local', can be considered as ways in which individuals and communities are engaged with producing culture. This active engagement in the production of culture is important as it allows the individual to build up cultural capital. Sociologist Pierre Bourdieu's concept of cultural capital (1986; see Robbins, 1991) describes the skills and knowledge that people accumulate within the course of their lives and how these skills can be employed culturally in a way that resembles the use of economic capital. Cultural capital might be understood in a similar way to prestige or 'know-how': the ability to 'get along' and acquire more influence and status. Being able to connect oneself to the past, and to the collective past of others via the recollection or recreation of specific memories and histories, is a form of cultural capital that relates to heritage. Heritage is not always something imposed from above but can be something that people create and use actively to maintain the connections between themselves and other places and things. This model of heritage as a form of social action accommodates the intangible aspects of heritage such as song, language and tradition, those forms of heritage that we might think of as heritage *practices*.

The production of the local becomes even more marked when we consider the example of the many groups of people in the contemporary world, linked by common ethnic or historical relationships, who have experienced forced or voluntary movement from their place of origin. This experience, referred to as being in *diaspora*, creates a very real need for communities to develop practices of heritage with which to bind themselves both to their homeland and to the new places in which they settle. In diasporic communities the tangible and intangible aspects of the past have a particularly strong appeal in helping to establish a sense of connection between dispersed communities in the present. The connection between the local and the global emerges as important here, as the experience of the local is increasingly influenced by developments at the global level. For migrant, dislocated or diasporic communities, heritage provides a powerful language of place and community around which individuals and groups can mobilise a series of technologies for producing 'the local', even if that locality is not based in real space but exists only via an email list or a virtual discussion group.

If heritage can be a form of cultural capital and a way of connecting people with each other and with the environment that surrounds them, the promotion of heritage or involvement in heritage can be considered to be a form of social action. By drawing on the past and creating a new significance for its traces and memories, people can transform and refigure the ways in which their

societies operate. This is the sort of agenda that Stuart Hall has envisaged for heritage, as discussed earlier in the chapter.

What is a community?

In the first part of this chapter the word 'community' is used rather freely. It is worth pausing to think in a bit more detail about what a community is. Although we might feel we know inherently what the word means, it has a specific meaning within the fields of anthropology and sociology that informs our understanding of this aspect of heritage studies.

The *Concise Oxford English Dictionary* defines a community as 'a group of people living together in one place', 'a place considered together with its inhabitants' and 'the condition of having certain attitudes and interests in common'. Anthropologists tend to define communities as much by what they *are not* as by what they *are*. Many anthropologists would draw attention to the way in which community is defined in contrast with an 'other'. For example, Gupta and Ferguson (1997, p. 13) note that 'Community is never simply the recognition of cultural similarity or social contiguity but a categorical identity that is premised on various forms of exclusion and construction of otherness'. There are all sorts of different ways in which community may be developed, whether primarily with reference to those things that are held in common by its members or, in contrast, in terms of those things that define one group in opposition to its outsiders. Shared participation can be used to constitute a sense of community ('us') in the same way that notions of difference can be used to construct a collective sense of otherness ('them').

Benedict Anderson (1983) developed the concept of the 'imagined community' to attempt to account for the power and spread of nationalism in the West at the same time that the links between community and locality were becoming increasingly broken. For example, it is now common to hear the term 'online community' used to describe an interest group that holds in common various ideals and goals but communicates using the internet and is geographically dispersed. Anthony P. Cohen (1985) and Arjun Appadurai (1996) have argued that the dissolution of the spatial boundaries of a localised community in the modern world has led to the increased importance of symbolic and imagined forms of community. Recent work on community has sought to explore the alternative forms of community that have arisen in response to the separation of community and locality. Some of these forms of community are best thought of as imagined, such as online communities where there is no physical contact between members. Other forms which manifest themselves through a combination of long-distance and face-to-face social relationships that may or may not be centred on a particular place are increasingly developing in response to the new circumstances of modern life.

As discussed earlier, it is now possible to think about diasporic communities who have a relationship to a homeland and its culture without having ever visited it. Drawing on shared experience, interest, histories and common experiences, these new articulations of community 'arise ... out of an interaction between the imagination of solidarity and its realization through social relations' (Amit, 2002, p. 18).

While the term 'community' has a warm and fuzzy feel, we should think critically about what community means as a way of identifying with one group *in opposition to* another. Many issues of conflict arise within multicultural or plural societies around the issue of heritage. In the same way that heritage can be used as a way of including particular people within an imagined or created community, it can simultaneously be used to exclude others (Ashworth, Graham and Tunbridge, 2007). Such issues are complicated in heritage because of heritage's economic imperative and the fundamentally commercial nature of heritage in the modern world (discussed in more detail in Chapters 5 and 6). We should be suspicious of forms of heritage that appear explicitly to exclude particular people or groups within society; at the same time we must remain mindful of the need for communities to express and emphasise those cultural and social aspects of a shared past which allow them to maintain connections in the present.

We should also see the emphasis on cultural diversity within multicultural societies as a fundamentally important function of heritage in plural societies (Ashworth, Graham and Tunbridge, 2007; see further discussion in Harrison, 2010). As Appadurai (2006) points out, it is the fear of minorities that has led to most contemporary widespread outbreaks of violence and terror by majorities; and such outbreaks have tended to occur where minorities are smallest, not in instances where they might appear to be powerful or a threat. Where heritage can be employed to normalise cultural diversity and establish the place of minority cultural groups within society, it has the potential to have a powerful influence on civil harmony. Clearly there is a potential discord here between an emphasis at the level of the state on the heritage of cultural majorities and the need to include cultural minorities within the state's official heritage practices. In both of the case studies that follow, the forms of heritage as social action are established at a grassroots level and operate in direct opposition to state-led heritage management practices.

The two case studies explore some of the ways in which unofficial practices of heritage might be considered to be forms of social action. The first case study looks at the ways in which a group of indigenous people from Australia are engaged actively in producing a connection between themselves and their past, developing their connections to a place from which they have been historically excluded but which they claim as an intimate aspect of their past. In doing so, they emphasise the links between themselves and their ancestors,

as well as with this particular place. Their activities at the site draw creatively on both aspects of contemporary heritage and national park management, as well as on traditional notions of the land and its cultural power.

Case study: 'lost places', heritage and community building

Dennawan is a former Aboriginal reserve near Weilmoringle, in western New South Wales, south-eastern Australia, that acted as a labour pool for surrounding pastoral (sheep-ranching) stations over the period *c*.1860–1941. These pastoral stations are now managed by the New South Wales (NSW) National Parks and Wildlife Service as part of Culgoa National Park. My interest in Dennawan was piqued by two of my colleagues, Tony English and Sharon Veale, who undertook a project in Culgoa National Park shortly after its gazettal on a pilot cultural heritage assessment for new park acquisitions. Their work identified Dennawan as one of the most important places to the local Muruwari community. They explained how they had been taken to the site and shown around by some of the people who remembered living there as children, and the dynamic relationship that former residents, their relatives and other members of the local community had formed with the material remains on the site. This presented an opportunity to spend a period of time studying in detail the relationship between the archaeology of this former reserve site and people's attachments to it as one of a series of places from which a particular group of Indigenous Australians had been removed in the recent past. (This account is an edited version of Harrison (2003). A more detailed account of the former Dennawan mission can be found in Harrison (2004).)

Dennawan is a place to which many older Muruwari people have a close spiritual and emotional attachment, remembering their experience there as a time when 'traditional knowledge and cultural life was sustained and integrated with participation in the local pastoral economy and the development of distinct skills, experiences, and interactions' (Veale, 1997, p. 102). Betty Waites, a Muruwari woman who lived at Dennawan during the 1930s and who was interviewed in the mid-1990s by historian Sharon Veale, recalled that

> There were a lot of children at Dennawan. There was the West family, and they had children, they had a girl. The Cubby's, I played with them and Mrs Grimes and there was a woman called Granny Suzie, Donald Byno's sister, we used to call her, this is the nickname now, Granny Doonie. But she had girls and we used to play together. We had this big rounders ground and we all had to play there, at the rounders ground. It was all families living together, but you know they used to share what they got. If one went out and got the wild meat, the others they'd share.

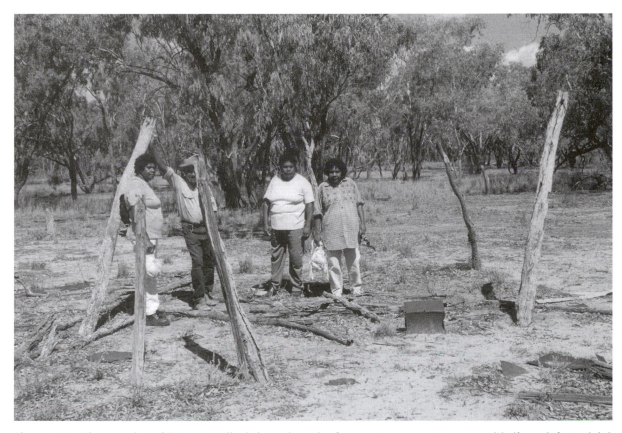

Figure 7.2 The remains of 'Granny Bailey's house' on the former Dennawan Reserve, with (from left to right) Muruwari project collaborators Josey Byno, Arthur Hooper, Dorothy Kelly and Vera Nixon, 2002. Photographed by Rodney Harrison. Photo: © Rodney Harrison.

Essie Coffie, another Muruwari woman who lived at Dennawan, described the experience of returning to Dennawan in the 1990s, when visiting the site with relatives, as 'coming home'. These intensely emotional responses to returning to the site of the former Aboriginal reserve help describe the significant role that Dennawan plays as a heritage site for this local community. This case study explores some of the ways in which a younger generation of Muruwari people with no direct living experience of the site are using its remains to develop connections with each other, and to reconnect themselves with a place from which they were historically excluded (Figure 7.2).

Aboriginal reserves and the heritage of diaspora

Most Australian schoolchildren would be able to tell you that Australia was 'discovered' by the Englishman Captain Cook and settled by white invaders in 1788 at the small settlement of Port Jackson, later to become the metropolis of Sydney. Australian government policies have subsequently had a profound

impact on both indigenous people and colonial relations in Australia. From the middle of the nineteenth century, Christian missions, state and later federal governments played a major role in the relocation and segregation of Indigenous Australians both from members of their own language groups and from the white population. Indigenous Australians were subject to controls and legislation that isolated them and controlled their lives in a variety of ways including their ability to be involved in the traditional social and religious lives of their ancestors, which had centred on the relationship between people and the land. Under later policies, individuals were intended to be assimilated into white society through processes of removal. The widespread nature of these removals, which occurred over the period 1930–70, stimulated a government report (Commonwealth of Australia, 1997) and the coining of the term 'stolen generations' to describe the children who were removed from their families to be placed in the care of non-indigenous Australians.

Although it has much deeper roots, the modern **Land Rights** movement emerged as a force during the 1970s. Drawing on the rhetoric of 'Black Power', it drew attention to the failure of assimilation in Australia while asserting the rights of indigenous people to exist as a distinct cultural group within settler society. The Native Title Act, which was passed by the Australian federal government in 1993, provides for the determination of cases in which Indigenous Australians might be found to hold **native title**, defined as a series of common law rights (such as the right to occupy, hunt, fish and forage, as well as to fulfil ceremonial obligations) over particular parts of the landscape. Although widely heralded at the time as an important gesture of land justice for Indigenous Australians, in practice many long and drawn-out legal battles have ensued, and for the majority the Act has had little obvious benefit in terms of rights over land due to the fact that many other land uses are considered to extinguish native title. In cases where conflicts exist between indigenous customary law and non-indigenous law, native title is often found to be extinguished. In 2008, in recognition of the mistreatment of the stolen generations of Australia, the Australian federal government issued a formal apology for the forced removals of Indigenous Australians from their families and their country in the past.

Many of the Indigenous Australians who live in the more densely settled south-eastern states of Australia experienced profound dislocation and forced removal from their traditional country. In a society where all connections between people were mediated by way of strict laws based on a relationship with a particular landscape, even small restrictions on movement to important sacred sites would have had a major effect on indigenous communities and their relationships with one another. Because many Indigenous Australians experienced a forced removal from their traditional lands and families, they

feel they are in a certain sense in diaspora in their own country. The term 'diaspora' is most often associated with the Jewish and Chinese diasporas. My object here is to emphasise the comparative potential of a study of the ways in which the experience of dislocation from a homeland encourages a particular way of relating to associated heritage sites. However, it is important to point out that where the Jewish and Chinese diasporas describe the movement of very large numbers of people across the globe, the usage I employ in this study describes a much more local, although certainly no less significant, spatial shift. The term 'diaspora' is used here to cover a range of different processes that dislocated Indigenous Australians from their country, from official 'concentration' policies and forced removals to less obvious but equally important processes of alienation of land which restricted people's access to parts of the landscape. The important point of similarity resides in the way in which Indigenous Australians understand their 'country' and collective identity in quite specific geographic terms: removal from one's traditional country, even if it is simply to a reserve in an adjacent area, encourages a relationship with the homeland that renders the removal similar to the large-scale geographic movement of ethnic groups more often associated with the term.

Dennawan

Dennawan's history goes back to the early 1880s, when a small white settlement began to take shape at Bourbah (as Dennawan was then known), centred on a local pub and post office located at the convergence of two travelling stock routes. Of course, local Muruwari people had occupied this area for thousands of years prior to this first white settlement, but it is only from this period that we see the first historical records associated with the settlement at Bourbah. Aboriginal people had been camping on local pastoral stations before this time, including on nearby Tatala, where in 1901 a census collector recorded twenty (adult) Muruwari people camped.

With the growth of other pastoral stations in the area and the declaration of a mail route along the Culgoa River, the hotel at Bourbah became the Diemunga (postal) receiving office in 1889. A fire at the turn of the century destroyed the hotel, and a new hotel was built approximately 2 km to the south, near an area where Muruwari people were camped alongside a small lagoon. At this time Diemunga receiving office came to be known as Dennawan post office. This name was probably based on the Murawari word for emu, *dinawan*.

In 1912 about twenty Muruwari people were recorded as remaining camped at Tatala on part of the travelling stock route, not far from the Bourbah Hotel. It was argued that if an area was reserved exclusively for Aboriginal people and fenced, the constable could 'compel them to camp on it and prevent

objectionable people trespassing on the reserve'. The reserve at Dennawan was gazetted shortly after this, and soon grew to the size of a village, with as many as 100 people at a time camping there. The settlement was serviced by the hotel and Dennawan post office and store, but was abandoned with the closure of these services in the early 1940s. Today Dennawan is a ghost town. It consists of little more than the occasional scatter of tin cans, broken glass and house frames distributed over several longitudinal sand dunes around a water tank and soak. In its heyday it was a bustling village, home to a community of hundreds of Indigenous Australians who worked on surrounding pastoral properties, but today only scattered fragments pay testament to the settlement that once existed there.

Why did people leave?

One of the important aspects of the history of Dennawan concerns the reasons for its abandonment. In the context of a longing to return to Dennawan, people cite many different reasons for an (unofficially) forced abandonment. In 1936 increased powers given to the state government's Aborigines Protection Board through amendments to the Aboriginal Protection Act 1909 had considerable impact on Indigenous Australian communities in the north-west of New South Wales. In 1938, as part of a 'concentration' strategy the board proposed to relocate Muruwari people from Dennawan to Brewarrina Mission, approximately 150 km to the south. Ration support, which the reserve had traditionally received from the Aborigines Protection Board, became uncertain and sporadic. A national economic depression and a decline in the availability of local pastoral work due to widespread withdrawals of land from larger leaseholders (to be made available as additional areas for smaller leaseholders) also contributed to this move. The closure of the post office and store at Dennawan meant an effective closure of all services to the remote settlement. This, coupled with what anthropologist Howard Creamer recorded as an extremely bad drought occurring c.1940–1, probably forced Muruwari people into larger nearby centres such as Goodooga, Brewarrina and Weilmoringle. Despite their earlier resistance to the forced removal that had been attempted just two years before, Muruwari people were finally faced with the necessity of abandoning the settlement on the reserve.

Returning to nothing: Dennawan becomes a heritage site

The formal, almost ritual ways in which Muruwari people move about and interact with the remains of the former settlement when they visit it is an integral part of the cultural and social significance of Dennawan. Indeed, almost as soon as the settlement was abandoned people began returning to the ruins, taking other people with them to tell them about the history and their memories of the place. The post office was dismantled soon after its closure and re-used as

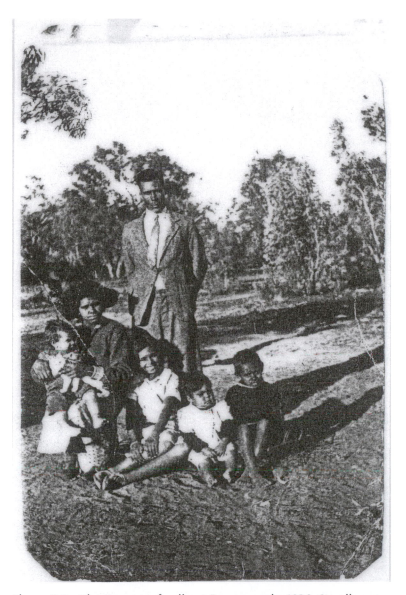

Figure 7.3 The Ferguson family at Dennawan in 1936. Standing at rear, Duncan, seated is his wife Blanche holding baby Cheeko, with children Gloria, June and Fred, 1936. Unknown photographer. Photo: reproduced with kind permission of June Barker.

building material on a nearby pastoral station. In 1943 the Aborigines Inland Mission (AIM) 'native worker' Duncan Ferguson drove past Dennawan and noted his sadness to see all the abandoned homes falling into decay (Figure 7.3). In 1953 the mission house was removed. In the late 1950s Duncan Ferguson and his wife Blanche had their photos taken near the remains of their first house, built in 1936, its flattened kerosene tin walls and rough timber

bush pole frames already fallen into ruin. I recorded interviews with a number of people who were taken to Dennawan by people who had lived there, or by descendants of those who had lived there, and mapped and recorded the way in which they were shown the site during these returns (Figure 7.4).

Today Dennawan is an important and frequent site of pilgrimage. The frequency of visits back to Dennawan increased dramatically from the time that the NSW National Parks and Wildlife Service began working in Culgoa National Park in 1996. In the light of a widespread feeling of loss, often articulated by Muruwari people as a loss of culture associated with the loss of language skills and the death of knowledgeable elders, Dennawan has become a heritage site that is subject to increased visitation and scrutiny. The ruin of the site and the decay of the buildings are together seen as a metaphor for perceived cultural decline, but interrogation of what is left behind is considered to be of great importance as a way of salvaging information and connections with the past. People often express the sentiment that if they could only arrest the decay of the site, they might be able to regain control of their cultural lives. Nostalgia for the way of life at Dennawan is articulated as a desire to regain control of cultural and spiritual life in the context of the increased development of and reliance on manufactured goods and modern material cultures. The decay of the settlement is considered to be symbolic of the erosion of traditional indigenous economic skills and technologies.

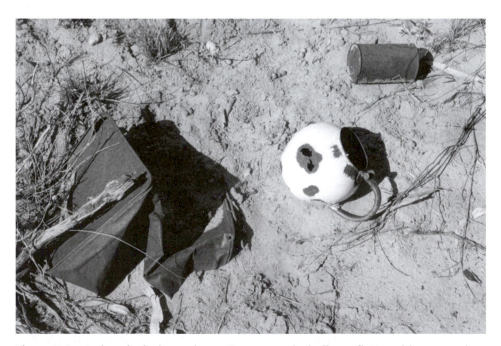

Figure 7.4 Archaeological remains at Dennawan, including a flattened kerosene tin, enamelled milk jug and tin can, 2002. Photographed by Rodney Harrison. Photo: © Rodney Harrison.

Understanding the significance of Dennawan to Muruwari people

For descendants of the Muruwari people who used to live on the Dennawan Reserve, the dead often visit the living in dreams. Contemporary Muruwari people have a number of beliefs about relics and their relationship with ancestors that have contributed to the development of Dennawan as a place of pilgrimage. Physical contact of the body or skin with artefacts is considered a way of making a connection with the ancestral past. During visits to archaeological sites Muruwari people like to rub artefacts such as flaked stone against their skin. Vera Nixon explained in an interview in 2001,

> When you're rubbing the stones over your skin you can get the feel of – you sort of get the feeling of the spirits coming into your skin somehow or another. I dunno, it's a strange feeling, but it's a good feeling.

The belief that ancestors' spirits are associated with objects they used during their lifetimes structures people's interactions with the remains of the former settlement. A trip to Dennawan, then, is much more than just an opportunity to learn about the past; it is an opportunity to make direct and intimate contact with it. Josie Byno said

> When we go and visit the place and see the artefacts that they used to use and the fire there, the oven, we get very emotional. Not only that, there is a special feeling in the air that surrounds us. We can feel that spiritual feeling wherever we go, and we know that they are with us.

While it is important for people to be able to touch and interact with the artefacts on site, it is considered dangerous to remove them. People who do this are tormented with bad dreams or sickness. In contrast, just being at the site is considered to make Muruwari people feel physically healthy. Arthur Hooper, at the time in his seventies, noted

> Ever since I've been coming out here, doing a little bit of work for people, I've been feeling really great. I'm really happy to see the old place again. And my feelings – inside me it's a very glad feeling, I have no worries about anything else. No aches and pains, I just walk around the place for hours and hours without getting tired.

The ability of the place to effect change on the body of Muruwari people is an important facet of the spirituality and significance of the former Dennawan Reserve. These bodily influences are intimately tied to various spiritual associations with the former settlement, in particular the slippage between post-1930 associations with Aborigines Inland Mission Christian missionaries who lived on the site and older, deeper associations with *wiyrigan* (medicine

men) and *miraaku* and *miraga* (spirits) who were traditionally held to inhabit the area. This slippage creates a certain denseness of shared experience that is felt by Muruwari people in the present when visiting the archaeological site, which they have increasingly done on a regular basis, especially over the past ten to twenty years.

During field trips with National Parks and Wildlife Service staff, certain unexplained incidents that have occurred at Dennawan have been considered to be consistent with the presence of spirits or ghosts at the site. A man who accidentally knocked over one of the standing frame posts of one of the buildings at Dennawan feared that he would be tormented with lack of sleep. The relics and ruins at Dennawan act as the focal points for interactions between the present and the past as well as between the living and spirit worlds.

Objects and ruins on the site are personified. They act as focal points for creatively imagining the actions of ancestors. The following observation made by Dorothy Kelly while we were at Dennawan illustrates this important part of Muruwari people's experience of this place.

> Mum brought us out here to this special spot; there are a few remains still standing. Lots on the ground and lots of tins, kerosene tins that they made their houses with, and this is so special, very special. This is our Granny's house. In your mind, you can see Mumma walking around, playing around, and Grandmother here in the family.
> Everyone was one big family, and I think she played a lot with Musso, our cousin Arthur Hooper, and even the swing ... he made her a swing over here, and it means so much ... but in our mind, you can see it all, right in front of you, everything. The house standing, Mum as she is, you can see our grandparents. Although we didn't see them, in our mind it's so clear.

The archaeology of the former Dennawan Reserve has much information to contribute regarding the relatively hidden histories of Indigenous Australian pastoral labour camps in the nineteenth and twentieth centuries. However, the ruins of the former reserve are much more than a source of information to local Muruwari people; they represent the focus for a programme of shared, collective memorialisation of the past. The artefacts that remain on the former reserve are invested with intense emotional and spiritual power. They form the conduit for controlled interactions between the spirit and human worlds, and between past and present. Instead of ceasing to exist after its abandonment, Dennawan continues to hold power and fascination for Muruwari people as a place where local traces and memories persist, challenging and actively assisting in the creation of the past and the present. It does this as much through the mutual involvement of people and objects, which both evoke and create collective memories, as

through their absence or decay. For Muruwari people, Dennawan is past and future. Each trip to Dennawan represents an opportunity to excavate a place of buried memory.

Heritage and community building at Dennawan

Contemporary historical geographers have shown us the ways in which aspects of performance help to create a space. By moving in and around particular spaces in particular ways, human action creates a 'place' from a 'space'. The formal route by which people move around the former settlement is one of the important ways in which Muruwari people 'create' Dennawan as a heritage site. The routes on this journey – composed of the places and sites shown by former residents to other Muruwari people – have been invested with special significance and creative power, and are considered to be authentic links to a distant ancestral past. These places have the power to speak to contemporary Muruwari people in very intimate and personal ways. They are the places that document the past in the way those ancestors wished to have it represented, rather than in the way a third party might represent it. Because of this it forms a very genuine link to the past, an authentic memorial with which creatively to construct new collective memory.

This is evident in discussions with the Byno sisters about where their mother used to take them when she came out to the settlement. These places, in combination with the places shown to them by their cousin Arthur Hooper, are now shown to their children. This process documents the active creation of a collective memorialisation of the past at Dennawan:

ARTHUR HOOPER: She [Tottie Byno, the sisters' mother] used to bring you out when you were small eh?

VERA NIXON: Yeah, well, she used to bring us out here when she was alive, and she used to tell us where people used to live but we can't remember much ... where they used to live now.

DOROTHY KELLY: A special place she used to take us was the corroboree ground, and where she used ... where her mum was living, where she used to live, you know, the main places.

Josie Byno continues:

> I think Dennawan is very special to us and it's got significant value ... a spiritual value, and we love coming back up here because our mum brought us up here when she was alive and she showed us around here. A lot of people don't do that because they don't like memories ... but my mum, she liked memories and she would get us up here as often as she could and we would spend a whole day here. And she

was very emotional about the place, and now coming back it's just repeated – we get very emotional about it too. So it's really of value to us.

(Interviews, 18 November 2001)

With time, the physical traces of the site become more important as a source for the creation of collective memory, as people's lived memories of the place become less clear. Access to the site and an ability to people it with anecdote and incident become a form of cultural capital, and the primary way of re-creating memory in the abandoned space. Each new return to the site provides opportunities for discovery as well as for re-populating the place with newly created memories. On many trips out to the place with local Aboriginal people frequent reference was made to occurrences during previous trips, both in terms of the significance of individual events, and in order to orient and map the absent spaces of the site as a peopled place.

The humble archaeological remains at Dennawan belie the intensity of local people's emotional attachments to the site and its relics. Dorothy Kelly reflected on this when she said

Well Rodney, sometimes it's very hard to describe the feelings within, deep within the heart, and sometimes there's no words to describe it. Even for an old tin, or any object that's just lying on Dennawan itself, it means so much, and words can't describe the feelings inside me.

The act of returning to Dennawan could be thought of as a sort of pilgrimage and a form of performance. By frequently returning to the heritage site with members of the community, and taking part in an unofficial heritage process of collective imagination and memorialisation, Dennawan has become a part of the social glue that holds the local Muruwari community together. The connection between heritage and performance is explored in more detail in Chapter 8.

Dennawan as an 'official' heritage site

Dennawan was first drawn to the attention of the NSW state government in 1977, at which time local Muruwari people commented on the need to stabilise and conserve the fragile remains of the houses on the reserve, and to protect it as an archaeological site from the impact of sheep grazing. Although it was registered on the NSW Aboriginal Sites Register at this time, none of the recommendations for works on site to stabilise or conserve it were followed through. When Culgoa National Park was gazetted in 1996, these issues were once again raised by local indigenous people who were concerned about the deterioration of the site. When I was working there over the period 2000–3 discussions between local Muruwari people and park managers about how best to conserve Dennawan were ongoing. At the same time, the local

Muruwari native title representative body was also attempting to have Dennawan excised from the national park and purchased under the Aboriginal Lands Strategy. These continuing negotiations over the management of the site reflect the ways in which the unofficial heritage significance to the local Muruwari community is not reflected in the style of its management as an official heritage site.

Some people might see the ways in which Muruwari people have engaged creatively with their heritage at Dennawan as 'untraditional'. In the context of the Native Title Act in Australia, it behoves Indigenous Australians to demonstrate their continued and ongoing traditional association with the land under question, and as such an acknowledgement of dislocation or removal from a place can be problematic. However, it is wrong to suggest that this creative engagement with heritage is not related to more traditional relationships between Indigenous Australians and their landscapes. As anthropologist Anthony Redmond explains,

> Space and place have meaning and existence only in relation to the positioned, mobile, and intentional human body ... Far from being 'frozen over' or 'outside time', human experience continues to draw lifeblood from, add clarifying detail to, and animate the mythic structures of country. Human emotional investment makes the country ... grow.

> (Redmond, 2001, pp. 136–7)

Muruwari people's interactions with the physical traces of the past at Dennawan both reproduce and create anew relationships with country and the ancestral past. It is the dynamic between memory, landscapes, objects and the performative qualities of interactions with them that allows people actively to create a sense of community and locality in this 'abandoned' place. I hope that you have been able to comprehend the way that Muruwari people relate to the site as a sort of cultural 'work' and as an unofficial heritage practice that is centred on creating a sense of community and relationship with a landscape from which people have been historically excluded.

Reflecting on the case study

In the case study we can see that a process has developed whereby what was originally simply a village or pastoral labour camp has been memorialised by the process of the passage of time and the historical significance of the abandonment of the settlement to contemporary Muruwari people. The case study provides an example of the way in which a particular community who feel they have been physically and culturally excluded use heritage to build a sense of shared identity in the present. Perhaps more importantly, Dennawan

emerges as a symbol of restitution, a place where people can undertake cultural 'work' to connect themselves with each other and with a place they thought they had lost.

One of the interesting aspects of the case study is the way in which the material remains on the site become prompts for memory. Appadurai's ideas about the production of locality were discussed earlier in the chapter. Here we can see physical artefacts used quite literally as technologies to produce the local, and connections between the local and the community.

The case study also provides a poignant example of the sort of approach to 'heritage from below' in which Raphael Samuel was most interested. The perceptions of local people and their recollections based on oral accounts by their ancestors have been used not only to produce innovative new accounts of this particular place but also to interpret broader indigenous work histories and the heritage of the sheep-ranching industry in Australia (Harrison, 2004). The case study similarly highlights diaspora as a distinct problem of the contemporary world which uses of heritage may seek to address. The desire that migrant communities have for reconnecting themselves with their fellow diasporic and source communities across time and space is much broader than Australia, and links the heritage needs of people across the globe. Whatever the location and circumstances, these unofficial practices of heritage that we see developing at a local level require detailed investigation to uncover their connection with broader cultural and social issues such as the ones discussed in the case study.

It is not only the unofficial practices of heritage that could be thought of as doing social 'work' or having social agency. The next case study considers the ways in which individuals and communities can use official heritage practices to challenge, or intervene, in mainstream heritage systems, and in doing so change the ways people think about themselves and their heritage. Here the focus shifts from the Australian outback to the urban setting of Brixton in south London in the UK. The case study in Chapter 1 demonstrated how dominant discourses shape heritage in their own image. Heritage can become a form of social action when individuals and groups attempt to subvert this process and create counter-cultural heritages. As we saw in Chapter 2, these unofficial challenges to official heritage practices and the values and discourses that underpin them can be powerful, and have the potential to make official definitions of heritage more inclusive.

Earlier in this chapter Stuart Hall's comments about the ways in which multiculturalism is challenging what we perceive to be heritage were discussed. London is a city with a large proportion of African Caribbean migrants, but until recently there has been little recognition of associated objects, places and practices in mainstream heritage practice.

However, a series of individuals and communities are changing our view of the heritage of London through an emphasis on black heritage and tourism there. The next case study features an interview with one of these people, Jay Brown, about her walking tour of Brixton in south London, and the ways in which it is changing how people view London's past and, by extension, its present.

Case study: an African Caribbean heritage walking tour in Brixton, UK

The term African Caribbean is used to describe communities whose members share a West Indian background and whose ancestors were originally Indigenous Africans. Today, over 350,000 people of African Caribbean descent live in Greater London (this section draws on information from the website of the Museum of London, n.d.). This is approximately 7 per cent of the total population, making African Caribbean people and their descendants one of London's most numerous ethnic minority groups. While the bulk of the ancestors of these people emigrated to London after the Second World War, London has much earlier connections with the black Caribbean, when Africans from the region were brought to London as part of the slave trade from the late sixteenth until the early nineteenth centuries. African Caribbeans continued to come to London, but the introduction of the British Nationality Act 1948 brought about changes in response to the postwar skilled labour shortage by giving British citizenship to all people living in Commonwealth countries, along with rights of settlement and entry in Britain. Among the first to enter under this legislation was a group of 500 Jamaicans who arrived in London on the ship the *Empire Windrush* and who settled predominately in Brixton as well as in other areas of London (Figure 7.5). Their voyage is celebrated in the name of the square in central Brixton known as Windrush Square, which was renamed in 1998 as part of the fiftieth anniversary celebrations of the journey.

Active recruitment by the UK National Health Service and British Rail in the West Indian islands in the 1950s led to a wave of migration from the Caribbean, and another African Caribbean settlement, particularly popular with people from Barbados and Trinidad, was established in Notting Hill Gate in west London. This was to be the site of early racial unrest, and in 1958 riots occurred there as a result of serious attacks on West Indian residents by white youths. The annual Notting Hill Carnival (discussed earlier in this chapter) was hosted for the first time in the following year in response to these riots as a way for the African Caribbean community to assert a sense of pride and kinship, as well as to promote unity between British African Caribbeans and other Londoners.

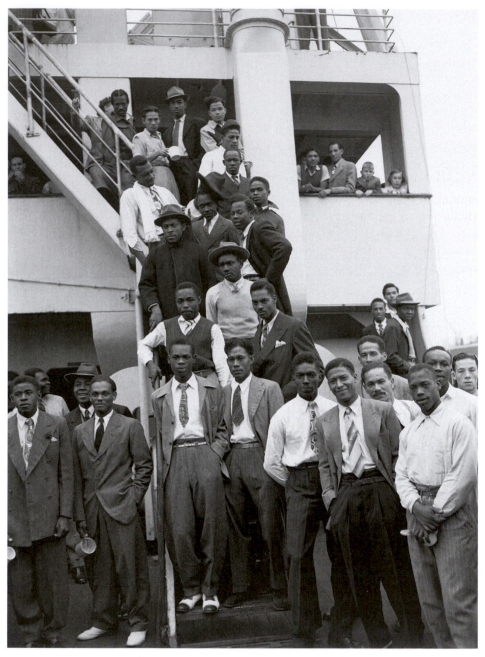

Figure 7.5 Jamaican men aboard SS *Empire Windrush* at Tilbury Docks, 22 June 1948. Photographed by Eddie Worth. Photo: © Eddie Worth/AP/PA.

The 1981 Brixton riots

During the 1960s and 1970s Reggae music and Rastafarian culture became symbols around which London's West Indian community's newly emergent sense of identity and pride, which derived in part from the American civil rights movement, was centred. Yet at the same time that British African Caribbeans were developing a newfound political and cultural visibility, they were increasingly the target of both structural and casual racism in Britain. High levels of unemployment in black British communities and the much greater levels of imprisonment of African Caribbeans when compared to white Britons left some black Britons feeling that they were the victims of a racist campaign of government and police oppression. Comments made by the British leader of the Conservative Party Margaret Thatcher in a television interview in January 1978 reflected the uneasy race relations that had developed in Britain in the late 1970s and set the scene for a series of riots that broke out across Britain over the spring and summer of 1981. She noted:

> People are really rather afraid that this country might be rather swamped by people with a different culture ... The British character has done so much for democracy, for law, and done so much throughout the world, that if there is any fear that it might be swamped, people are going to react and be rather hostile to those coming in.

> (Thatcher Foundation, [1978] 2009)

These riots, later centred on Toxteth in Liverpool, are now considered to have been important in heralding a new self-confidence among black British communities and the development of inclusive multicultural policies by the British government. Brixton is famous in the context of this story for having been the first place where rioting occurred. During the riots in Brixton petrol bombs were used against police for the first time in Britain. These were turbulent and violent times that have an important place in the history of contemporary British race relations. The tensions that were developing in Brixton in the late 1970s were highlighted in the Clash song 'Guns of Brixton', released on the album *London Calling* in 1979. Written and sung by bassist Paul Simonon, who grew up in Brixton, the song reflects on the growing sense of unease in Brixton and the difficult relationships that had developed between the local community and the police.

In early April 1981 police had begun a plain clothes operation called Operation Swamp 81 (which took its name from Prime Minister Thatcher's speech), during which nearly 1000 people were stopped and searched in the south London borough of Lambeth over the course of six days (this account of the riots draws on Waddington, 1992). These searches – made under the controversial stop and search or 'sus' laws, which allowed police to stop and search anyone if an officer thought they were committing a crime – were a

source of resentment among the local black community who felt that police discriminated against them by focusing their operation on young, black men (Figure 7.6).

A series of events beginning on Friday 10 April moved tensions on to a new level. A group of people observed the police investigating the stabbing of a young black man and questioning a mini-cab driver accused of hiding drugs (he had in fact simply put away a wad of money for safekeeping). A crowd of 150 people gathered to accuse the police of having planted evidence on the driver and an altercation between a black youth and the police broke out. When the youth was put into the back of a police van, it was set upon by the crowd. The situation escalated and as more police gathered to disperse the crowd they stood their ground, arguing that there was a long history of police harassment in the area. The van was hit by missiles thrown from within the crowd, and was subsequently turned on its side and set alight. Violence escalated as the crowd set about damaging and looting property, and Molotov cocktails were thrown at police.

By Saturday, many buildings and cars had been damaged by the fires which had broken out in the Brixton town centre. The rioters retreated to the 'Frontline' on Railton Road, so named because it was the area away from the surveillance of police where it was possible to buy and sell drugs and escape the detection of authorities. A makeshift barricade was erected across Railton Road, while further looting occurred in shops and buildings. A stand-off ensued, after which rioters were eventually dispersed by police using fire hoses. Further isolated attacks were made on the police and businesses on Sunday and Monday, after which the rioting was assuaged. By the time the rioting had finished, 279 policemen and some 450 people overall had been injured, while 28 buildings had been damaged or destroyed by fire, 207 cars had been damaged or destroyed, 354 arrests had been made, and some 7300 officers had been called in to quell the riots.

One of the factors that made Brixton a flashpoint for rioting was the very stark cultural and economic mix of people resident in the area. Following the riots, an inquiry was conducted. The report, prepared by Lord Scarman (1981), highlighted the social and political deprivation of black Britons. It noted the extremely high levels of unemployment in Brixton, where 25 per cent of black people were unemployed at the time, with over 55 per cent of young black men under 19 unemployed. The report pointed to the sense of poor political representation as a factor that fed the riots, and the misplaced moral panic at muggings and street crime in Lambeth which had led to the development of Operation Swamp 81 in the first place. Most importantly, it challenged the practice of 'stop and search', which was dropped as a result of the inquiry.

Although Brixton was the scene of the first riot of 1981, further racially motivated riots broke out in a number of places across Britain in the following months. Today the riots are seen as having had positive outcomes: they

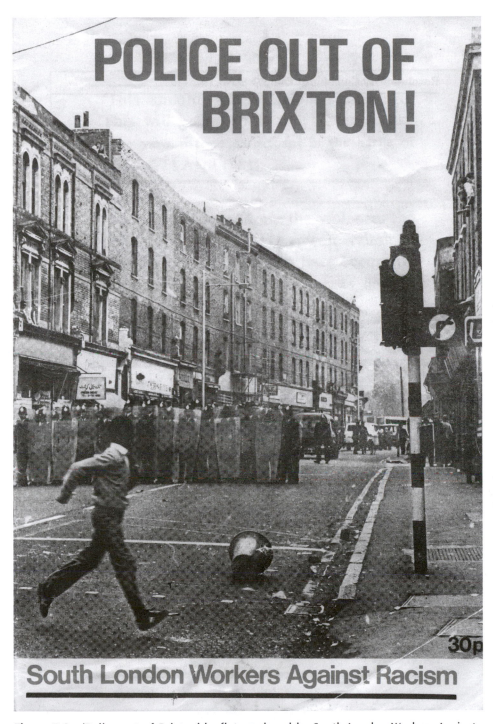

Figure 7.6 'Police out of Brixton' leaflet produced by South London Workers Against Racism, 1981, mixed media. Photo: © Museum of London. The front cover image shows a photograph of police holding riot shields during the 1981 Brixton Riots. The leaflet refers to the 'criminalisation' of the people of Brixton.

highlighted lack of political representation, police racial profiling and unemployment as contributory factors. As a result, a whole series of political and structural mechanisms were put in place to deal with these issues. Despite these, subsequent riots broke out in Brixton in 1985 in response to the shooting of an unarmed woman during a police house search. Nonetheless, Brixton has experienced a period of stability in the intervening years, and there has been greater political emphasis on developing multicultural policies which are more inclusive of both black Britons and people of many other cultural backgrounds.

Brixton Walking Tours

Jay Brown, a former Brixton resident with long-term connections to the area and a member of the British African Caribbean community, has been running Brixton Walking Tours since 2002 (Figure 7.7). She was inspired by community-based tourist ventures in Harlem, USA and South America that are run by locals and allow tourists a safe way of accessing an alternative view of a different culture. She is one of a number of people currently involved in promoting black British heritage in London. I was lucky enough to interview her and to accompany her on one of her tours in March 2008 (Figure 7.8).

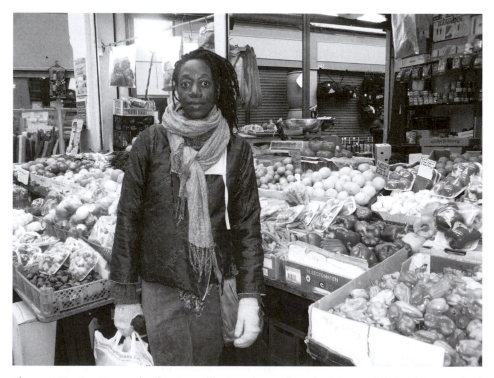

Figure 7.7 Jay Brown in the Granville Arcade markets in Brixton, 2008. Photographed by Rodney Harrison. Photo: © Rodney Harrison.

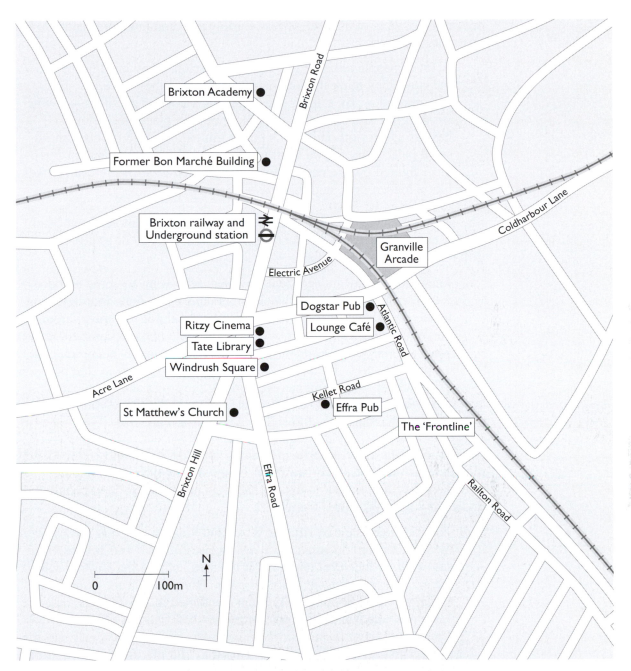

Figure 7.8 Street map of the Brixton area showing sites on the tour and places discussed in the text.

Jay advertises her business on the internet, via postcards which she leaves for distribution with local businesses, and through word of mouth. Although Brixton is not a traditional destination for tourists or visitors to London, the

area and the 'vibe' of its local African Caribbean community are central to her business. Jay notes:

> A lot of people are afraid to come to Brixton. They have heard about the riots, they think it could happen again and they have a misconception. By starting the tours, it's a key for people to see what Brixton has to offer ... If you think about the places they [tourists] have to go to [in London] it's pretty limited. It's fine if you want to see a palace, fine if you want to go on the Wheel [the London Eye], but I figured people needed something which was off the beaten track, like a hidden gem, and that's what Brixton is.

She sees her tour as targeted at those who wish to learn more about black British culture and at independent travellers who want to be exposed to a different side of London life:

> There are a lot of independent travellers who want to come and do their own thing ... Lots of black Americans come here and they want to see how [black] people live in London, and not just travel around the West End ... This is a place I think people need to come to, to see what is going on in London. I'm opening the door for them to see different cultures. There are over 40 languages spoken in [the borough of] Lambeth alone. You can walk along the street and eat Japanese food, Portuguese food, Indian food ... if you come here you feel like you have escaped London and arrived somewhere else.

Jay's tour begins at Atlantic Road near the Dogstar pub, almost immediately moving on to Railton Road and the frontline of the 1981 riots (Figure 7.9). She takes this opportunity to discuss the riots and to try to help people to understand what prompted them:

> The tour starts here at Atlantic Road and straight ahead is the scene of the riots on Railton Road. So it's a nice start to the tour because we can walk up the street and look at the area and see the ways in which the area has regenerated since the riots. And as we walk along I can explain to them about why the riots happened in '81 and '85, and the reason why is that a lot of the Jamaicans had free run of the area. They could have *shebeens*, which were late-night parties well into the night, and they could sell drugs. And they did this from the frontline, and the frontline was on Railton Road. And there came a time when the police were stopping and searching the young men, and anger built up in the community from that. But I think the main thing that set it off was that they felt that there was racism against them because 'stop and search' was mainly being levelled at young black men. And it's not a nice thing, being stopped in the street and having your pockets

Figure 7.9 Looking along Railton Road towards the site of the 'Frontline' of the 1981 Brixton Riots, 2008. Photographed by Rodney Harrison. Photo: © Rodney Harrison.

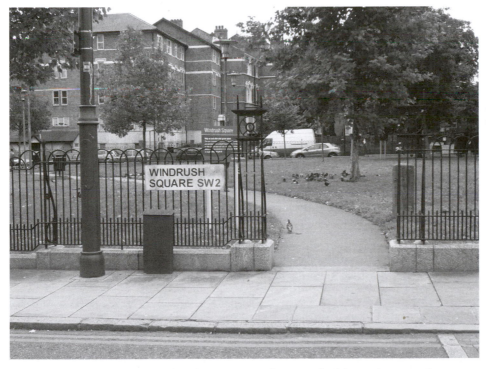

Figure 7.10 Windrush Square, Brixton, 2008. Photographed by Rodney Harrison. Photo: © Rodney Harrison.

turned out. And that was their way of saying they weren't going to take it anymore. And although that's not the way that things should be done, it was like a kettle boiling and at some point it had to go off.

Turning into Kellet Road, Jay highlights the Victorian terraced houses and tells of the community of artists and musicians who squatted in them in the 1960s, and the association of the area with Reggae musician Bob Marley. Walking past the Effra pub, Jay directs her tour towards St Matthew's Square and St Matthew's Church which date from the 1820s. Travelling along Brixton Hill and past the Tate Library, she recounts the association of the Tate family with sugar plantation slavery and the invention of the sugar cube. On Brixton Road she points out Windrush Square (Figure 7.10) to discuss the connection with the first Jamaican community to arrive in London in 1948, and the Ritzy Cinema, the oldest functioning cinema in south London which opened in 1911 as the Electric Pavilion. From there she walks to the Brixton Academy, a major concert venue that opened in 1929, and past Bon Marché, the first department store in the UK when it was opened in 1877.

The tour ends at the Granville Arcade markets which opened in 1938 and form one of Europe's largest Caribbean food markets, and nearby Electric Avenue, the first shopping street in England to be lit by electricity, made famous by the song 'Electric Avenue' released in 1982 by Guyana-born British Reggae singer Eddy Grant.

Commemorating London's African Caribbean and multicultural history

Jay Brown's Brixton Walking Tour is an example of what we would recognise as a mainstream heritage practice – the walking tour. However, both the nature and the location of this tour are far from being mainstream. When most people think of the heritage of London they might think of the Houses of Parliament, Big Ben, Madame Tussaud's and the Tower of London. Jay's walking tour is unique in exposing tourists to a part of south London they might otherwise not experience due to fear or its invisibility from the tourist landscape. But more importantly, Jay's tour puts an emphasis on Brixton's multicultural community and celebrates its distinct British African Caribbean heritage. In doing so, it not only changes the way outsiders view Brixton but it also celebrates Brixton as a place, and helps to build Brixton as a community.

Jay's tour is only one of a number of recent initiatives in black British tourism and heritage in London. In 2003 Nana Ocran published *Experience Black London: A Visitor's Guide*, which included a series of black heritage walking trails and a guide to black heritage sites in London. Steve Martin, author of

Britain's Slave Trade (1999), runs an open-top black history bus tour of London's West End. In an interview with the BBC, he noted

> We have a very narrow attitude of history ... Shakespeare alluded to a multicultural London. But then we got an empire. And with that came a model of history that supported the idea of racial purity. What is most shocking is how little is taught in schools. Children know more about black American history than the heritage of people walking in their own streets.

> (Casciani, 2003)

These initiatives can be thought of as interventions in official heritage practice in the sense that they use official heritage practices to draw attention to an overlooked aspect of heritage. Black and African Caribbean heritage has been largely ignored by official heritage listing and interpretation in London, although more has been done in the wake of the 2007 bicentennial celebration of the abolition of the British slave trade. These small-scale interventions all work towards changing the ways in which tourists and locals view the heritage of London and, by extension, the culture and community of London in the present. Jay's tour puts an emphasis on experiencing Brixton as a community.

> In the tours I say to people 'Open your senses ... Look at what's happening around Brixton.' The tour is about all the senses, so I get people to taste food, if it's patties, or Guinness punch [traditional West Indian food and drink], or fruit in the market.

Understanding and celebrating the multicultural past of Brixton has positive benefits for the contemporary experience of multiculturalism. This helps people to understand multiculturalism as an integral part of the London experience today.

The other important aspect of Jay's walking tour is the way it commemorates and contextualises the 1981 riots. It attempts to remove from Brixton a historical stain that has influenced tourists' and Londoners' perspectives on it as a place. Looking at the riots within the context of British African Caribbean music, food and culture might be seen as an attempt to balance the frequent negative press which presents Brixton and south London in general as a place associated with a complex cultural and ethnic mix that produces high rates of criminal activity. But perhaps more importantly, it reclaims and celebrates the riots as an important historical event that can be argued to have brought about positive social changes.

> When I explain to people they can empathise with the situation and understand why it happened, and then to take them to the scene it's a positive part of the tour. I emphasise the ways in which the riots set

off a chain of events for change, and the ways the community has rehabilitated since then. Looking around you today you will see that Brixton is as trendy as Notting Hill. It's nice for people to come and see and ... understand that out of such a bad thing came all of these good things.

While there remain ephemeral traces of the riots (Purbrich and Schofield, forthcoming), the riot site can largely be thought of as an intangible heritage site, so this form of commemoration as part of a walking tour is perhaps the best way of memorialising the riots. I noted earlier the ways in which heritage as a form of social action is one way in which unofficial heritage practices interface with official forms of heritage, and this case study provides a good example.

Reflecting on the case study

By working with a well-known heritage tourism practice – the walking tour – Jay Brown has developed a heritage activity that has the potential to change perceptions of this infamous part of south London as well as the potential to create a sense of community and locality. As in the previous case study, we are presented with an example not only of the social work that heritage does in producing a sense of the local, but also with an example of grassroots heritage work that might be understood to produce a sense of 'history from below'. The tour is clearly aimed at changing the ways in which people think about the history of Brixton, and the place of African Caribbeans in British history and contemporary culture. However, the tour is about not only making black British heritage more visible but also bringing tourists into Brixton. When people come to Brixton they are investing money back into the community – they shop in the local stores and buy fruit and vegetables in the markets. This heritage tour does part of its social work by attracting tourists to an area they might otherwise avoid because it has had a bad reputation. It also does social work in celebrating and commemorating cultural differences – in particular, African Caribbean culture in Brixton and its important role in making Brixton a unique and distinctive place. This provides a clear example of Appadurai's ideas about the social work involved in the production of locality and its social relations. Jay Brown's walking tour literally creates Brixton as a place by walking people along its streets and unveiling the connections between its community and the neighbourhood. In doing so, it reinforces Brixton as a multicultural community and the social relations that connect the community with the place.

Heritage, social action and place

This chapter has concerned itself with the ways in which heritage might be thought of as a form of social action. The case studies have highlighted two forms of social action. The first case study has described Indigenous

Australians in western New South Wales undertaking a range of unofficial heritage activities at the former mission site of Dennawan as a way of reconnecting themselves with a place from which historically they have been removed. These practices help to form a sense of shared history and community for the Muruwari people in the present. The second case study has looked at a particular walking tour as an intervention in conventional heritage practice. Jay Brown's Brixton Walking Tour and its focus on African Caribbean heritage in south London can be considered a form of activism as it highlights an aspect of the history and heritage of London that has previously been neglected by mainstream heritage tours. The ways in which the tour influences and changes people's preconceptions about the Brixton riots form another way in which it could be seen to be a form of social action. Black British heritage sites have not previously been well promoted, and Jay's tour serves the dual purpose of promoting multicultural and black British heritage while also attracting people to an area that is off the tourist map. This helps to build effective links between people within the community and Brixton as a place by bringing tourism and its positive economic benefits to the community, as well as establishing a set of stories with which the community can reflect on its shared experiences.

Conclusion

While most of the chapters in the book have concerned themselves with official practices of heritage and the ways in which they are employed by the state, this chapter has considered the unofficial practices of heritage that individuals and communities use to build their effective links with each other and with the places that are important to them. It has argued that by challenging the histories produced as part of official heritage practices, these unofficial forms of heritage have the potential to transform a society's understanding of its past and, by extension, its present and future. Such interventions in heritage, alongside the ways in which heritage is used in the everyday construction of the local and the community, demonstrate the significant social role of heritage in society. The following chapter continues this focus on the intangible and unofficial practices of heritage to consider the relationship between heritage and performance.

Works cited

Amit, V. (2002) 'Reconceptualizing community' in Amit, V. (ed.) *Realizing Community: Concepts, Social Relationships and Sentiments*, London and New York, Routledge, pp. 1–20.

Anderson, B. ([1983] 2006) *Imagined Communities: Reflections on the Origin and Spread of Nationalism* (revised edn), London and New York, Verso.

Appadurai, A. (1996) *Modernity at Large*, Minneapolis and New York, University of Minneapolis Press.

Appadurai, A. (2006) *Fear of Small Numbers: An Essay on the Geography of Anger*, Durham, NC, Duke University Press.

Appadurai, A. ([2001] 2008) 'The globalisation of archaeology and heritage: a discussion with Arjun Appadurai' in Fairclough, G., Harrison, R., Jameson, J.H. Jr and Schofield, J. (eds) *The Heritage Reader*, Abingdon and New York, Routledge, pp. 209–18.

Ashworth, G., Graham, B. and Tunbridge, J.E. (2007) *Pluralising Pasts: Heritage, Identity and Place in Multicultural Societies*, London, Pluto Press.

Bourdieu, P. (1986) 'The forms of capital' in Richardson, J.G. (ed.) *Handbook for Theory and Research for the Sociology of Education*, New York, Greenwood Press, pp. 241–58.

Byrne, D. (2008) 'Heritage as social action' in Fairclough, G., Harrison, R., Jameson, J.H. Jr and Schofield, J. (eds) *The Heritage Reader*, Abingdon and New York, Routledge, pp. 149–73.

Casciani, D. (2003) Changing the Guard with Black Tourism, BBC News Online (16 July) [online], http://news.bbc.co.uk/2/hi/uk_news/magazine/3068973.stm (accessed 5 March 2008).

Cohen, A.P. (1985) *The Symbolic Construction of Community*, London, Routledge.

Commonwealth of Australia (1997) *Bringing them Home: Report of the National Inquiry into the Separation of Aboriginal and Torres Strait Islander Children from their Families*, Sydney, Human Rights and Equal Opportunity Commission.

Concise Oxford English Dictionary (2008) (12th edn, ed. C. Soanes and A. Stevenson), Oxford, Oxford University Press; also available online at www.oxfordreference.com/views/ENTRY.html?subview=Main&entry=t23.e11352 (accessed 30 March 2009).

Gupta, A. and Ferguson, J. (1997) 'Culture, power, place: ethnography at the end of an era' in Gupta, A. and Ferguson, J. (eds) *Culture, Power, Place: Explorations in Critical Anthropology*, Durham, NC and London, Duke University Press, pp. 1–21.

Hall, S. ([1999] 2008) 'Whose heritage? Un-settling "the heritage", re-imagining the post-nation' in Fairclough, G., Harrison, R., Jameson, J.H.

Jr and Schofield, J. (eds) *The Heritage Reader*, Abingdon and New York, Routledge, pp. 219–28.

Harrison, R. (2003) 'The archaeology of "lost places": ruin, memory and the heritage of the Aboriginal diaspora in Australia', *Historic Environment*, vol. 17, no. 1, pp. 18–23.

Harrison, R. (2004) *Shared Landscapes: Archaeologies of Attachment and the Pastoral Industry in New South Wales*, Sydney, University of New South Wales Press.

Harrison, R. (2010) 'Minority and multicultural heritage' in Benton, T. (ed.) *Understanding Heritage and Memory*, Manchester, Manchester University Press/Milton Keynes, The Open University.

Martin, S.I. (1999) *Britain's Slave Trade*, London, Channel 4 Books.

Museum of London (n.d.) Caribbean London [online], www.museumoflondon. org.uk/English/Collections/OnlineResources/X20L/Themes/1364/1102/ (accessed 3 March 2008).

Ocran, N. (2003) *Experience Black London: A Visitor's Guide*, London, London Small Business Growth Initiatives.

Purbrich, I. and Schofield, J. (forthcoming) 'Brixton: landscape of a riot', *Landscapes*, vol. 10, no. 1.

Redmond, A. (2001) 'Places that move' in Rumsey, A. and Weiner, J.F. (eds) *Emplaced Myth: Space, Narrative and Knowledge in Aboriginal Australia and Papua New Guinea*, Honolulu, University of Hawaii Press, pp. 120–38.

Robbins, D. (1991) *The Work of Pierre Bourdieu: Recognising Society*, Milton Keynes, Open University Press.

Samuel, R. (1994) *Theatres of Memory: Past and Present in Popular Culture*, London and New York, Verso.

Scarman, L.G. (1981) *The Scarman Report: The Brixton Disorders 10–12 April 1981*, London, Home Office.

Thatcher Foundation ([1978] 2009) Margaret Thatcher TV Interview for Granada *World in Action* ('Rather Swamped') (27 January 1978) [online], www.margaretthatcher.org./speeches/displaydocument.asp?docid=103485 (accessed 2 April 2009).

Veale, S. (1997) *Culgoa NP: A Land Use History*, Sydney, NSW National Parks and Wildlife Service.

Waddington, D. (1992) *Contemporary Issues in Public Disorder: A Comparative and Historical Approach*, London and New York, Routledge.

Further reading

Ashworth, G., Graham, B. and Tunbridge, J.E. (2007) *Pluralising Pasts: Heritage, Identity and Place in Multicultural Societies*, London, Pluto Press.

Atkinson, D. (2008) 'The heritage of mundane places' in Graham, P. and Howard, P. (eds) *The Ashgate Research Companion to Heritage and Identity*, Aldershot, Ashgate, pp. 381–98.

Byrne, D. (2008) 'Heritage as social action' in Fairclough, G., Harrison, R., Jameson, J.H. Jr and Schofield, J. (eds) *The Heritage Reader*, Abingdon and New York, Routledge, pp. 149–73.

Hall, S. (ed.) (1997) *Representation: Cultural Representations and Signifying Practice*, London, Sage Publications.

Hall, S. ([1999] 2008) 'Whose heritage? Un-settling "the heritage", re-imagining the post-nation' in Fairclough, G., Harrison, R., Jameson, J.H. Jr and Schofield, J. (eds) *The Heritage Reader*, London and New York, Routledge, pp. 219–28.

Harvey, D. (2001) 'Heritage pasts and heritage presents: temporality, meaning and the scope of heritage studies', *International Journal of Heritage Studies*, vol. 7, no. 4, pp. 319–38.

Hodges, A. and Watson, S. (2000) 'Community-based heritage management: a case study and agenda for research', *International Journal of Heritage Studies*, vol. 6, no. 3, pp. 231–43.

Newman, A. and McLean, F. (1998) 'Heritage builds communities: the application of heritage resources to the problems of social exclusion', *International Journal of Heritage Studies*, vol. 4, nos 3 and 4, pp. 143–53.

Orr, N. (2006) 'Museum volunteering: heritage as "serious leisure"', *International Journal of Heritage Studies*, vol. 12, no. 2, pp. 194–210.

Robertson, I.J.M. (2008) 'Heritage from below: class, social protest and resistance' in Graham, P. and Howard, P. (eds) *The Ashgate Research Companion to Heritage and Identity*, Aldershot, Ashgate, pp. 143–58.

Smith, L. (2006) *Uses of Heritage*, Abingdon and New York, Routledge.

Chapter 8 Heritage as performance

Susie West and Marion Bowman

The rise of performance studies has drawn attention to the cultural work that is achieved through activities performed as part of daily life, as well as in 'set piece' performances. This has useful parallels with heritage studies' interest in the cultural work that objects, places and practices of heritage are used for. In this chapter the relationship between heritage and performance is explored in three contexts: through performative traditions that are intangible heritage (the first case study by Susie West on carnival in Trinidad); through the invitation that 'official' heritage extends to the visitor to become a performer by the act of making a visit (to Glastonbury Abbey); and through the creation of new performances that assert their status as unofficial heritage (processions). The case study by Marion Bowman focuses on Glastonbury, a town noted for its spiritual heritage of Christianity and alternative/New Age practices. As part of her research into the religious pluralism and spiritual economy of the town, writing from a religious studies perspective, she investigates performative traditions and the creation of new traditions, through contrasting processions.

Introduction

This chapter explores the idea that all societies use performances as the means to cultural ends. We might first think of performances as formal events, where the audience is clearly distinguished from the performer. A performance such as a play or a concert is highly structured: the performers have invested a great deal more time and energy in developing their expertise than most of the audience. The audience, however, has expectations: to be entertained, perhaps, or to be moved emotionally, or maybe just to be able to dress up and be noticed themselves, in which case the audience members are self-conscious about their roles as informal performers. Actually, most official performers would say that an audience is necessary to their work, giving feedback through their collective responses, and providing a sense of occasion that heightens the performers' achievements. Some researchers have taken this two-way relationship further to suggest that many of our daily social activities contain performance elements: we adopt social roles as the context requires, enact our own rituals, or sometimes feel that we have lost the script and have to extemporise. Performance is not just a metaphor here; we will see that 'acting something out' is sometimes the only way society agrees that a real act has taken place. Marriage vows are one example.

The emergence of the idea of performance as a major area of human social activity has come from a number of academic disciplines. Philosophers asking

fundamental questions about human identity have had to consider the role of action: does it come from free will or from essential, determined categories of behaviour? Cultural anthropologists developed cross-cultural investigations of ritual and display in non-western cultures that highlighted ritual as a massive 'container' for all sorts of activity. The usefulness of ritual behaviours was puzzling for researchers looking for tangible functional activities like farming or weaving. The social value of intangible rituals, such as coming-of-age ceremonies, gradually came to be recognised for the identity-making work they produced. Sociologists investigating western societies became interested in how different communities evolved and maintained codes of behaviour. Performance studies emerged from all these questions. Of course, we have been thinking about intangible heritage in this book as part of the investigation into what heritage is for: the cultural uses that communities make of their own heritage and the additional meanings that outsiders find. Examples include the social action 'work' that intangible practices such as the Brixton walking tour and the Notting Hill Carnival create for the black presence in multi-cultural Britain, explored in Chapter 7.

The inter-disciplinary field of performance studies formulated by Richard Schechner in the 1960s and 1970s makes connections between commonsense classifications of performances such as theatre and dance, the small rituals and practices of daily life, including sport, and the grandest ceremonies of state. Performative genres include ritual, play, games, sports, dance, music and theatre, as related forms (Schechner, 2003). These would be recognisable to UNESCO as intangible heritage, as discussed in Chapter 1 (see also Harrison and Rose, 2010). Performance studies, allied to other fields of critical cultural inquiry, identifies actions (including speech) that have the qualities of a performance, and refers to these as performative behaviours. It investigates the cultural work that performative behaviours undertake and the characteristics they exhibit, as well as the engagements that performers and audiences make with each other. In other words, performance studies focuses on interactions between social groups (at the performance of a play, for example) rather than on the reception of literary content (what people do with the text of the play).

Concepts and definitions

For heritage studies, the idea of performance sits well with a critical conception of heritage as a set of practices rather than as merely a set of things, as we have explored through this book. We need to pay particular attention to the idea that human actions make things happen. This might sound rather obvious: if we turn a door handle and push, then the door will open. Physicists can explain how the energy we expend moves an object through space. However, philosophers have long been interested in how intangible actions produce results, particularly through speech. If the door is open but the

doorway has a ribbon across it, we can perform the actions of cutting the ribbon and declaring to a waiting crowd that the door is now open. Physicists do not find this action very interesting but philosophers identify that the speech act of declaring something to be open (here a familiar ritual for inaugurating new public buildings) has done the 'cultural work' of opening the door. J.L Austin was the pioneer in a theory of language that included sentences which in themselves made something happen; he called these sentences performative utterances (Austin, 1965).

Performative behaviours, then, include performative speech, but embrace all social behaviours that are directly communicative. In other words, the point about cutting the ribbon and declaring a new building open is to communicate the 'making' of the public opening, not the functional access through the door. Performative behaviours generate feedback (positive or negative evaluation), often with the intention of making something change by representing a state of affairs. For example, political protests on city streets have been identified as performative behaviours or 'social drama', having all the qualities mentioned above (Turner, 1986).

Reflexivity, affect and embodiment

Performative behaviours are not accidental but intentional, and they have an additional quality of being reflexive. Thinking more about the two-way interaction between performers and audience, we can turn to a useful concept of reflexivity: that action 'acts back' on the subject to effect some change, perhaps in perception, stimulus or the formation of memories. In other words, performers (in the broadest sense of people performing actions) are inevitably affected by their performances as much as their intended audience may be affected. Civil rights protesters in a march probably feel pride and validation from their actions about communicating the need for change. After all, good teaching practice suggests that we learn best by doing, not just by being shown something. This brings us back to the philosophers' investigation of the relationship between mind and body in producing the conscious human subject, the problem of the formation of human identities.

We can explore reflexivity by introducing two more concepts that invoke consciousness: affect and embodiment. These are further reminders that heritage performers are living, breathing subjects. Affect is the expression of emotional tone through body language, including likes or dislikes and moods. Affect is essential to successful social interaction, positive affect coming from positive social interactions. It is a constituent of performative behaviours. When we ask heritage visitors about their experience of the heritage visit and how they felt, we are asking them to describe affect. The pioneer of heritage interpretation, Freeman Tilden, was seeking positive affect in his desire for revelation and stimulation during a heritage visit, discussed in Chapter 5.

Heritage performers, perhaps demonstrating cultural activities to foreign tourists (see Chapter 6), will be exhibiting affect appropriate to their performance as dancers, hunters, singers. Their energy will be communicated to one another and to their audience through affect.

Finally, the communicative behaviours we have been listing as part of performance include perhaps the most obvious, that of embodiment. Speech and movement is after all conveyed through subtle and complex physical adjustments; we experience life through our senses; our identities are massively shaped by our physical bodies. As we saw in Chapter 5 on heritage interpretation, the core principles for successful interpretation to visitors were engagement, stimulation, even challenge: learning through doing. Visitors were most interested in heritage experiences that they could actively explore rather than those they were passively shown. Our interactions with objects of heritage include the multi-sensory experiences of light, heat, space, texture and sounds. This is explicitly produced in formal interpretation schemes that control the heritage environment, whether in purpose-built visitor exhibitions or through the theatrical presentation of the object of heritage with costumed interpreters.

Performative behaviours at heritage visits

You might think back to a heritage visit you enjoyed making recently that exercised your senses. Two friends walked around an outdoor site in the UK that has a permanent collection of outdoor sculpture carefully positioned to use the parkland of a country house to best effect. The Yorkshire Sculpture Park encourages visitors to make their own routes around the considerable green space, a more challenging physical activity than wandering around indoor galleries. It seemed important to the experience that the communicative behaviours we have covered all came in to the 'performative visit', including the sight of visitors appearing in silhouette on the ridge of a low hill where more artworks waited to be discovered. Some of the sculptures enclosed spaces that visitors were invited to enter or that positively excluded access but encouraged snatched glances. Some made visitors look up at the sky; others made patterns on the ground. Actions brought these inanimate objects to life, particularly when stimulated by observing visitors further on already responding to what they encountered. All senses were engaged, as part of a collective experience, and on completing the procession around the parkland there was the final, welcome, ritual of the café visit.

Discourse, transgression and performance

One long-standing question for anthropologists and others investigating societies that have apparently resisted rapid change is why cultural forms in these societies seem to be stable. Why don't performative behaviours make

changes to the performances? A possible answer comes from the work of a prominent philosopher interested in identity questions, Judith Butler. Butler argues that societies evolve limits on the variation in performance acceptable from individuals, known as cultural norms. Repetition of norms inculcates them into individuals, and transgressions are usually punished. Butler is particularly interested in gender identities, arguing that identity categories are created by discourses within societies rather than being 'natural' or self-evident. She uses the example of the birth of a baby, whose apparent sex is called out to everyone in the room. Whatever the biological facts (and we are gradually realising how complicated these can be), the baby's gender is socially bestowed upon her by the performative utterance of calling her a girl. Discourses around how to be a girl will shape that baby's future; the possibility of a girl 'not being a girl' will arise only if her society has discourses that permit other behaviours. Butler suggests that norms change because they have to be repeated, and inevitably slight variations in individual commands and responses occur; crucially, individuals show performative behaviours that are different from the norm because they need to do so to survive, as expressive beings. Transgressions in the search for a gender identity that better fits the individual's sense of self is one example; collective civil resistance against apartheid or colonialism would be other examples. Butler points out that in terms of political resistance to norms, both the left and the right can challenge norms, the left by seeking to widen them and the right by narrowing permissible categories (the 'violence of exclusion', Salih, 2004, p. 11; Butler, 1990; Butler, 1993). We saw a good example of challenging the norms through the success of Notting Hill Carnival in asserting the visibility of black Londoners, discussed in Chapter 7.

Our sense of the meaning of heritage practices throughout this book has been informed by a critical approach to heritage norms (the AHD), how they have come about and how they are being challenged by groups who do not feel included or represented. We have seen how definitions of objects of heritage have gradually become wider, as museums collect socially representative artefacts and UNESCO recognises cultural landscapes and intangible practices (including performative genres), for instance. It is harder to see how the uses of heritage have changed, as discourses around nationalism and the heritage of elites are still powerful arguments for funding and political support. One way to explore changing uses of heritage is to view heritage as a set of practices, as the chapters in this book have done, rather than as a set of things (Smith, 2006).

Practices that are socially communicative, as heritage has to be, are, as we have seen, within the definition of performative behaviours. Some of these practices have been to resist dominant discourses about whose heritage can be recognised or to insist that other categories of heritage can be added alongside. This has not been a quick or easy change of attitudes; as Butler's work

suggests, the point of societal norms is to manage and limit the possibilities of change. People who have travelled away from their homelands and are in diaspora have regrouped around intangible heritage, as something portable, before going on to establish more material signs of their culture in a new setting. The presence of new minority cultures has been seen as transgressive, resulting in oppressive and fearful reactions, but is increasingly able to be celebrated. This positive evaluation, in Schechner's terms, comes about because the heritage performers are willing to push against the norms and assert the value of their cultural productions. In Britain, the Notting Hill Carnival (also discussed in Chapter 7), established to celebrate Caribbean culture and to support a minority community, is probably the most famous example, now said to be Europe's biggest street party. It draws on carnival traditions from Trinidad, which is the subject of the short case study here. Trinidad Carnival is now of interest to the government of the Republic of Trinidad and Tobago, which is seeking to define it as official heritage and to capitalise on its cultural value for the national economy as an exported brand.

Case study: Trinidad Carnival as official and unofficial performance heritage

Carnival is a broad term for popular public celebrations that use music, costume and performance. There are old European traditions, such as the Venice Carnival held in February, that 'turn the world upside down' by transforming damp, dark winter into light-filled celebrations, perhaps with ancient Roman origins. Equally, similar ceremonies that mark key points in the ritual year travelled out of African societies with enslaved peoples to European colonies and took on new forms from their different contexts. These various traditions share broad similarities in the importance of costume and masks to represent new identities, often ones that invert the social order, such as an elected king or queen, or the appearance of devils and monsters. Carnival is a commentary on society, a contained form of disruption when the least powerful workers stop working for a time (perhaps after harvest) and construct a different vision of the world. It has all the elements of performative behaviour with a mission to represent other possible ways of existing: action to change the world.

In the UK, ideas about carnival have tended to be pigeonholed neatly as folk tradition, when practised in smaller rural communities: cross-dressing, dancing, processions and merry making are still associated with points in the farming and Christian year, and this form of disruptive behaviour is not seen as transgressive. A more disturbing carnival emerged as the Notting Hill Carnival, held in an initially impoverished area of central London in the grid of streets just north of Notting Hill tube station. This carnival was held by a

minority, African Caribbean families invited to settle in the UK as part of the postwar labour force. Their experience of the realities of postwar urban poverty and racism marked them out as a community in diaspora and under pressure. Carnival was set up as a means to give the British African Caribbean community a positive focus, to challenge the racism that threatened minority groups by claiming the public space of the streets for a time, and to celebrate the performance traditions of the Caribbean. Over its five decades of annual celebration, Notting Hill Carnival has evolved through good and bad times and the urban area has changed its socio-economic base from one of widespread poverty to increased gentrification and massive increases in property values. It is now accepted as an important signifier of modern British multi-cultural society (Chapter 7). Its performance traditions come from the Caribbean: there are important heritage issues over carnival in Trinidad.

Two hundred years of carnival in Trinidad

Carnival in Trinidad had a complex birth, as the island (and the island of Tobago) was colonised successively by Spanish, French and finally British traders, growing sugar cane with the use of enslaved Africans. Fragmentary documentary records suggest that the key components of Trinidad Carnival existed before the abolition of slavery (1838), and that African music, dance and stick-fighting performance formed the repertoire of an annual permitted carnival, understood by Europeans as a masquerade (in reference to European carnival practices) (Liverpool, 1998). Trinidad has evolved a carnival tradition over more than 200 years. As such, the performances continue to change, notably the choice of characters and costumes and the switch to new music forms, currently Soca (emerging as heavily amplified bass beats, an evolving fusion from calypso).

Contemporary Trinidad Carnival is integrated into postcolonial government funding and is overseen by the National Carnival Commission (NCC), the state-sanctioned governing body for carnival. The NCC has been supporting research and parallel carnival activities since 1998 in an attempt to understand, foster and promote carnival traditions that are being abandoned in favour of new forms. One critic has argued that this state investment in 'old-time carnival' research ignores the majority activities of the carnival performers, which are not categorised as traditional (Scher, 2002, p. 455).

A national strategy for carnival

The NCC has an agenda for carnival. The carnival is a significant contributor to Trinidad's tourist economy, with international tourists of returning Trinidadians and foreigners buying flights and hotel beds, as well as spending directly at carnival locations. As such a prominent national event, Scher

asserts that the government 'sees an increasingly professionalized Carnival as a strategy towards catering to a demanding and competitive tourist consumer', and the qualities of the old-time carnival are seen to be of most value for this strategy. The NCC is developing this strategy by considering the old-time carnival components as a form of cultural intellectual property, able to be protected by international frameworks or even copyright laws (World Intellectual Property Organization fact-finding mission to Trinidad in 1999 in collaboration with UNESCO, known as WIPO 2000, cited in Scher, 2002).

The officially sanctioned components of carnival are being delivered by the Carnival Institute of Trinidad and Tobago, established in 1999 to combine carnival research and craft skills. It aspires to become an accrediting body for the carnivals around the world that have been created by emigrée Trinidadians and thus contain Trinidadian Carnival elements. So the process of defining official heritage for carnival allows the possibility of protection as cultural heritage, and subsequently the possibility of protection as national products (exports).

Philip Scher makes the important point that much of the academic and official discussion of the value of culture and its relationship to its owning community tends to construct culture as being akin to a set of objects 'or at least, to some degree, as independent from the people who perform them' (Scher, 2002, p. 459). Here, the intangible performance practices of carnival have been narrowed down to officially defined artistic (tangible) products. Scher believes that the decision by the NCC to concentrate on the waning practices of old-time carnival has created an official discourse of what Trinidad Carnival is, and that this 'works to exclude a significant portion of the population in part through acts of preservation' (Scher, 2002, p. 461). Set against this problem of exclusion we should also acknowledge, as Scher goes on to do, that postcolonial nations are concerned to establish their own cultural identities and assert their control over their culture which may be seen as still open to exploitation by outsiders. There are powerful nation-building arguments to consider including the need to maintain the uniqueness of Trinidadian culture and national identity. However, the official language behind documenting the components of carnival also creates a set of definitions that are not inclusive of the majority of carnival performers' behaviours now.

This brings up the concept of authenticity in performance and the official concerns to define and preserve an authentic Trinidadian Carnival. Scher goes on to argue that the NCC's selections of what makes up a carnival, focusing on the traditional characters played out in masquerades, is in fact a series of selections from the early twentieth-century favourites. The most disruptive characters (including a character draped in rags stained with menstrual blood) have been dropped and other shifts in fashion during the nineteenth century, which saw the arrival of indentured Indian workers and associated ethnic

tensions, have also been sidelined (Scher, 2002, p. 472). An officially defined old-time carnival is therefore a new construct, formed since the 1990s, that does not answer the plea for the rich cultural history of the nation to be fully recognised.

New traditions

The modern carnival that is not seen as authentic by the NCC emerged from the 1950s to the 1980s, with the rise of Soca music and the increased disappearance of steel drum bands. Women moved from being minority revellers to a majority (80 per cent) by the 1980s, and the class composition became steadily middle class, as the streets became safer and women gained greater economic independence generally and were more able to afford the expenses of costumes and fees. Now the different carnival groups (bands) have memberships in thousands, mostly women in revealing, bikini-based costumes. Groups on this scale develop their own internal distinctions using social attributes like attractiveness, connections and employers (Scher, 2002, pp. 72–9). One of the newer functions of carnival, then, seems to be the networking possibilities for younger women. These performative behaviours are not recognised by official definitions of character-based bands (the historic form); indeed they seem to generate similar responses to those of the disapproving nineteenth-century elites. Arguably this is a sign that Trinidadian Carnival is in good health.

Whose carnival?

Historically carnival has always changed because performers have invented and selected what they wish to represent, and the constituency of the performance has also evolved to include Indian and Chinese male labourers before female Trinidadians in the later twentieth century. The major intervention in carnival came in the last decade of the twentieth century with the formalisation of state interest in the content of carnival, both as a positive attempt to enhance the national reputation and economy, and as a reaction against a perceived erosion of the 'product'. But what is the product? Carnival is not played out from a script; there is no **ur-text** to consult to verify authenticity. How can folk art, without a named creator, be patented?

The uneasy relationship between culture and commerce is perhaps more likely to be won by culture, for a change. How authentic would a carnival of truly mass participation be if only performances approved from a pre-1950 repertoire were allowed? Carnival has always been the performance of an inversion of power relations, and successful state intervention would remove that quality. This is not to argue against historical research and the fostering of craft skills for creating historic carnival artefacts; the curation of the past

allows new generations to make informed choices about their future. However, carnival survives as two days of hard partying by millions of citizens. This performance is successfully resisting official definitions of heritage by continuing to act out current social shifts, one of which is the reshaping of gender roles. As Scher argues, contemporary carnival is as deserving of investigation as the pre-1950 manifestations, and it is a certainty that carnival of 2030 will be different again.

Reflecting on the case study

The case study has argued that carnival, as a performative behaviour, is not fixed. As a Trinidadian export, new carnivals take on new identities in different contexts. As Trinidadian heritage, it is a living tradition in a society that has experienced considerable change in its colonial and now postcolonial existence. Its transgressive purpose is emphasised here to show an inverted set of power relations, initially between white slave owners and their enslaved African workers. However, as a set of performances that need to be comprehensible to their audience, carnival operates within its own norms: stick fights do not kill, blood is fake, the carnival king is still a worker.

Our discussion of the components of performative behaviours has suggested that it is a total experience, drawing in sensory reactions and non-verbal communication. If you have been to a carnival, as a viewer you inevitably become a participant, sharing your response to the spectacle with the party goers and the official bands. In fact, if you do not make a noise and move about, inhale the street-food smells, accept the press of the crowd, it would hardly be a carnival. You adopt norms for the performance of being a visitor here that you would not adopt for the hush of an art gallery. Equally, as Butler pointed out, norms shift and erode as a result of being part of the repeated performances, as we saw for the Trinidad Carnival. Practices that live as performance are the most difficult, if not impossible, to contain because they are profoundly bound up with identity. They make startling propositions for a day, such as that black residents could assert their presence in white London, or that Trinidadian women could take over their streets from the men. Back to daily life after the party, tiny shifts start to accumulate.

Heritage practices that construct 'official' heritage as performance

We have looked at carnival as an example of intangible heritage, centred on performance, that is not easily repackaged as official, tangible heritage. Now we can move towards thinking about performative heritage practices

that *are* found within official heritage. Remembering that the definition of performative includes social communication, these official practices share the aim of interpreting a heritage place to visitors in ways that position visitors as spectators. Ideally, the spectators/audience are in a reflexive relationship rather than feeling inert and passive about the experience.

Theatrical techniques have been used for some time at sites and galleries as part of formal interpretation strategies devised by heritage professionals (see Blenheim Palace re-presentation discussed in Chapter 5). One of the benefits of these techniques is that they introduce human figures into depersonalised spaces, offering visitors a chance to see historic spaces used in historically appropriate ways. Hampton Court Palace (Surrey), a great sixteenth-century royal heritage site, regularly uses costumed interpreters who stage encounters between courtiers and royalty in the great hall and around the courtyards. They interact with each other as if they are sixteenth-century characters but do not interact with modern visitors. The experience of encountering a queen and her train of attendants sweeping imperiously through a doorway still provokes a frisson of excitement as the visitor defers to royalty. A variation on this type of performance at the palace is the occasional use of the original kitchens by professional food historians to demonstrate their research into sixteenth-century cooking. The historians wear appropriate costume and use reconstruction equipment but are happy to interact with visitors, even offering children a chance to turn the massive roasting spit over a fierce fire. Visitors may learn by asking questions or simply come away with a unique impression of food on a grand scale in a pre-modern era. The sensory spectacle reinforces visitors' perceptions of the visit as an embodied experience whose affect produces more interesting memories than wandering through empty rooms.

Actors can be inserted into heritage sites as virtual presences, moving on projected film or on monitors. Kew Palace, in Kew Gardens, London, was an informal retreat for King George III and his family in the later eighteenth century. It was extensively conserved and re-presented as a heritage site in 2006. Visitors hear disembodied voices of actors in character in the ground-floor rooms, which function to introduce the story of the house and its occupants. The top-floor rooms had not previously been conserved since they were last occupied and they were left as they were found, in a state of worn paint and bare boards with a muted and intriguing atmosphere. Here, silent films of actors as royal princesses are projected directly on to eighteenth-century panelling, suggesting a presence quietly moving around with domestic tasks. Although visitors cannot interact with these performances, the silent films are a subtle gesture to past lives. They catch the visitor gaze which might otherwise slide off bare, distressed surfaces.

Of course, actors do not have to be professionals. Staged re-enactments by voluntary groups are a popular attraction at 'living history' events. These arguably show a scale of activity and intensity of action that few official heritage sites could afford to produce. The National Association of Re-Enactment Societies in the UK estimates that 18,000 people are involved in re-enactment groups. For participants, re-enactment is an immersive experience which brings them closer to past minds as well as past actions. It can be a sophisticated approach to 'learning by doing', although as with carnival the fights are staged, the explosions without ammunition. Visitors and performers step into the norms for re-enactment. We might retain our critical distance here, however, and define these as further examples of heritage practices that represent current understandings of past behaviours, however well researched.

Finally, we should turn our attention to the visitor, who has up to this point been a more or less engaged spectator, even though important to the success of the official performers. As leisure visitors to official heritage places, we have exhibited performative behaviours even without costumes or scripts. Our visits are framed by formal presentation strategies that shape our enjoyment, understanding and memories of the visit. The most popular sites are also under the greatest pressure to manage the visitor experience but may compensate for this by the greatest financial investment in the infrastructure to achieve this, from car parks to special exhibitions. Visitors are effectively stage-managed around highly developed sites. This is achieved by devices to direct visitor attentions such as signposts, route maps, audio emanating from the next room. Desire lines are the functional routes between two points, familiar to urban planners and invoked at heritage sites by eye-catching artefacts to draw visitors into the next space or by carpet strips leading to invitingly open doors. Visitors' proximity to objects of heritage is also closely managed, both to enable access and to protect: 'please touch' or 'do not sit on this chair'. We saw how a historic house was edited in presentation, to use a textual metaphor, at Blenheim Palace (Chapter 5).

Visitors are given many cues about how to behave and how to make their visit through visual, textual, occasionally auditory and rarely olfactory prompts. In the following section, Susie West introduces the main case study, by reflecting on her own visit to the official heritage site of Glastonbury Abbey. The town of Glastonbury is then discussed in the subsequent case study by Marion Bowman on the uses of processions.

A performative visit to Glastonbury Abbey

Glastonbury Abbey, Somerset, is presented as a heritage site, an extensive green space (14.5 hectares or 37 acres) with the ruins of the stone monastery in the centre. The site is in the heart of the market town and visitors still enter

through the south gateway of the monastery. The abbey is in ruins after the suppression of all monastic establishments and the institutional break from the Roman Catholic Church under Henry VIII. Glastonbury Abbey was closed in 1539, with the brutal execution of Abbot Whiting, and transferred to Crown ownership to be sold off. A large house was built in the grounds, using the abbey ruins as picturesque garden features. The site was purchased for the state church, the Church of England, in 1907 and has been conserved as a heritage site since then. The abbey ruins have been excavated and some finds are on display. The parkland includes an orchard, wildlife area, ponds and handsome specimen trees.

The formal visitor experience starts in the modern exhibition building. The exhibition space is densely packed with displays, large reconstruction paintings, and explanatory text panels. The lay-out channels the visitor round in chronological order, emerging by an impressive model of the abbey church. Children can examine a wall panel about daily monastic life, with lift-up sections to find the answers to questions. The model and the interactive panel are both invitations to act (by selecting and looking, perhaps discussing), in contrast to the tightly controlled exhibition sections. The exit offers a clear view of the abbey church Lady Chapel as an enticing start to the outdoor experience. If you were with a friend, this is the point where you would discuss where to walk out to first.

Outside, there are more invitations to act. I could take a tour with a costumed guide – one such group is standing around a guide dressed as a monk. I could follow the pathways, guided by signposts at junctions. Or I could wander around on the grass, and find a seat under a tree and absorb the scene. I want to collect all the experiences, so as well as walking the site I go into the tiny St Patrick's Chapel, light a candle and sit down to reflect. Other visitors pick up on the contemplative atmosphere in this space and move quietly. For them, my presence becomes part of the experience. Back outside, families with young children point things out to each other or let the children run on the grass: active fun.

I discover I have missed a theatrical enactment of Henry VIII's challenge to the last abbot back in the ruined church. A painted throne and a pulpit remain either side of a coloured canopy.

Formally maintained sites such as this present many challenges to the imagination. There are strange shapes delineated in the grass by narrow concrete strips, indicating the outline of buried walls. Within the space of the church walls is a series of numbers on plaques set into the grass, the locations of columns. But these are incidental. The key sites for imagination are the Holy Thorn and the grave of Arthur and Guinevere. The Holy Thorn within the abbey grounds is a relative of the thorn tree on a nearby hill that blossoms at Christmas and represents the legendary visit of an associate of Jesus, Joseph

of Arimathea (discussed below in the case study). Glastonbury Abbey's immense success as a pilgrimage centre was based on its claim to be the first Christian foundation in England, a direct link to the life of Jesus. The medieval stories of King Arthur and his knights, as upholders of Christianity, were significant for the region. The Glastonbury monks apparently found the grave of Arthur and his queen in the abbey cemetery and excavated in 1191. This reputed grave is now marked in the grass. The bones were later reburied in the centre of the abbey church in a magnificent tomb. The tomb has gone but its location is outlined and marked with a plaque in the grass within the church. Visitors who are interested in these legends can experience direct, tangible access to these prompts to memory.

The abbey site remains central to local Christian celebrations. However, on a quiet day it is difficult to think of it as other than a heritage site, a private world away from the main street bustle of the town. The intangible associations, with early Christianity and medieval romance, and further complex attributions of ancient spiritual values, are a unique blend of challenges to the imagination. This site comfortably absorbs visitors who want to experience it at different levels, some as modern pilgrims (Christian or other). Its characteristics of scale, space and multiple activities encourage visitors to play out their visit in front of each other. This is heritage as experience, of embodiment, affect, selecting and passing on meanings and values, creating memories.

Case study: creating, performing and contesting spiritual heritage in Glastonbury

Over the centuries and to the present day, a variety of spiritual seekers – people interested in, searching for or experimenting with religious beliefs, insights and lifestyles – seem to have felt 'drawn' to Glastonbury (Bowman, 1993, 2008). Glastonbury is now considered significant by a wide variety of spiritual seekers, including Christians of various types, Goddess devotees, Pagans, Druids, self-styled 'New Agers', Sufis, earth energies researchers, healers and others who feel that they have been 'called' in some way to the town (Bowman, 2005; Ivakhiv, 2001). Glastonbury means different things to different people, and it is contested both *between* and *within* religious groups. Some differences (and rivalries) in world view are played out publicly in traditional forms such as processions, rituals and calendar customs (activities which occur once a year, or according to fixed cycles of time).

Following the vicarious experience of a more traditional heritage visit to Glastonbury in the introductory section above, this case study demonstrates how different religious groups utilise intentional and reflexive performative behaviour, drawing on and creating tradition in order to promote particular

versions of the past and visions of the future. In particular, the use of procession is highlighted as a means whereby competing groups can assert their contemporary claims on Glastonbury. Discourses concerning the creation and experience of sacred space, identity, material culture and authenticity are involved here, and different types of cultural heritage (to use UNESCO categories) such as cultural heritage sites, natural sacred sites, and intangible heritage (including festive events, rites and beliefs, and the performing arts) intersect and interact in this context.

Glastonbury – speculations, claims and history

Since the later part of the twentieth century Britain has experienced something of a boom in both pilgrimage and spiritual tourism, phenomena in many ways exemplified by Glastonbury's unique position in the spiritual and spatial imagination of a variety of religious believers (Bowman, 2000; Prince and Riches, 2000; Ivakhiv, 2001).

It is a constant paradox for a variety of believers that while all the world is deemed sacred, some places are undoubtedly regarded as more sacred or special than others, and Glastonbury falls into this category. Situated in the Somerset Levels, an area once inundated and accessible by water, Glastonbury is dominated by the Tor. This curiously contoured, conical hill is topped by the tower of the ruined medieval chapel dedicated to St Michael (Figure 8.1). Some regard Glastonbury as a significant prehistoric centre of Goddess worship, an association confirmed for present-day devotees by figures of the Goddess they discern in the landscape. For others, Glastonbury's significance lies in the claim that it was the site of a great Druidic university, a centre of learning to which people flocked from all over Europe and beyond.

For many Christians past and present, Glastonbury's status has rested on it being the 'cradle of English Christianity', the point at which Christianity took root in England, allegedly brought there by St Joseph of Arimathea, who in Christian scriptures (John 19:38–42) is said to have provided a tomb for Jesus. According to local legend, Joseph established the first Christian church in the British Isles in Glastonbury. It is claimed that he arrived in Glastonbury after the crucifixion with a staff which he thrust into the ground on arrival at Wearyall Hill; this staff took root and became the Glastonbury thorn which flowers twice a year, in spring and around Christmas (Vickery, 1979) (Figure 8.2).

Each December, in a custom invented or 'revived' in 1929, this legend is celebrated in the Holy Thorn Ceremony and a sprig of the Christmas flowering thorn is sent to the monarch (Bowman, 2006). Joseph is also reputed to have brought with him the chalice used at the Last Supper (sometimes known as the Grail) although in some versions of the legend he brought phials or cruets containing Jesus' blood and sweat (Carley, 1996, pp. 181–4). Some

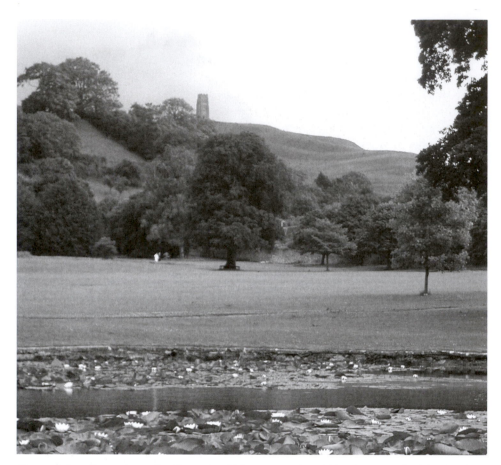

Figure 8.1 Glastonbury Tor from the Abbey grounds, 2008. Photographed by Marion Bowman. Photo: © Marion Bowman.

associate the chalice with the iron-rich waters of Chalice Well, said to run red because the Grail is hidden at the wellhead (see Figure 8.7).

Even more significantly, some believe that Jesus himself came to Glastonbury with St Joseph and that he may even have spent some time living there. This tradition of Jesus in Glastonbury is reflected in the words of the eighteenth-century poet and visionary William Blake:

> And did those feet in ancient times
> Walk upon England's mountains green?
> And was the Holy Lamb of God
> On England's pleasant pastures seen?

> (Blake, preface to *Milton*, 1804–8)

It is frequently claimed that Glastonbury Abbey was subsequently built on the site of Joseph's chapel, usually referred to as the Old Church.

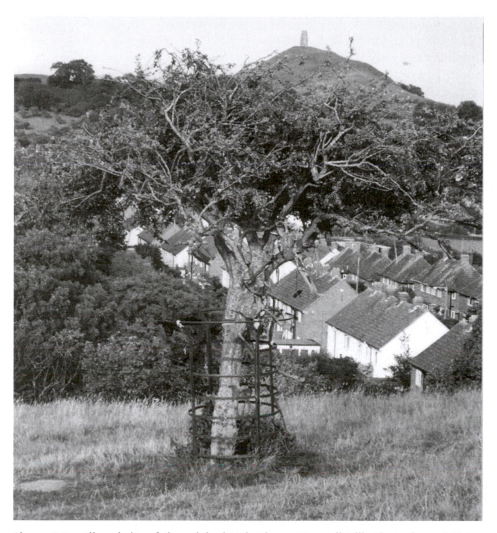

Figure 8.2 Alleged site of the original Holy Thorn, Wearyall Hill, Glastonbury, 2004. Photographed by Marion Bowman. Photo: © Marion Bowman.

Traditionally Glastonbury claimed connections with significant Celtic saints such as Patrick, Bridget, Columba and David in the fifth and sixth centuries. Writing in the twelfth century, William of Malmesbury in his *De antiquitate Glastonie ecclesie* recounted the claim that St Bridget made a pilgrimage there in 488 CE, and reputedly settled on the nearby 'island' of Beckery (now the area known as Bride's Mound), where a chapel was dedicated to her (Scott, 1981). Also connected with this 'Celtic' period is King Arthur, much mythologised sixth-century hero of the Britons against the Saxons. For some, Glastonbury became identified with the Isle of Avalon, the place where Arthur was taken for healing after his last battle (Ashe, 1957), and where, allegedly, he lay sleeping, waiting to return at some time of great national emergency.

Early in the eighth century Ine, King of Wessex, had a church built at Glastonbury and in the tenth century a Benedictine monastery was established there. By the early medieval period Glastonbury Abbey was a major pilgrimage centre, boasting a huge collection of relics and a fine library, much visited by royalty. In 1184, however, the abbey suffered a disastrous fire:

> gone were the fine monastic buildings, Ine's church, the treasured vestments, ornaments, relic collections and books bequeathed by so many abbots and kings, and – most important of all – gone was the Old Church itself, universally hallowed as the first Christian church in Britain.

(Carley, 1996, p. 22)

The first rebuilding work was the construction of the magnificent church of St Mary, usually referred to as the Lady Chapel, allegedly built on the site of Joseph's original church. By the twelfth century various literary as well as oral versions of Arthurian legends were circulating. In 1191 what was hailed as the discovery of the bodies of Arthur and Guinevere in the abbey cemetery seemed to confirm the association between Arthur, Glastonbury and Avalon, and the connection between Joseph of Arimathea, the Grail and Glastonbury. In 1278 King Edward I, 'emphasizing that he was the legitimate successor to Arthur as king of all Britain' (Carley, 1996, p. 36), and Queen Eleanor participated in an elaborate ceremony, wrapping Arthur's and Guinevere's bones in fine cloth and placing them in a black marble mausoleum before the High Altar.

Glastonbury Abbey thus retained its status as a major pilgrimage centre, building up another prestigious collection of relics and books, patronised by royalty, with its magnificent Lady Chapel, the remains of Arthur and a popular shrine to St Joseph. However, the abbey was brutally suppressed at the time of the Reformation; the elderly Abbot Richard Whiting and two monks were dragged through the town and hanged on the Tor in 1539, and the abbey was left to fall into ruins.

Interest in Glastonbury's legendary past and its special status was not entirely eclipsed. One of the most frequently quoted incidents concerning popular interest in the Glastonbury Thorn relates to the change from the Julian to the Gregorian Calendar in 1752 (a calendar reform gradually adopted in Europe, resulting in the 'loss' of eleven days). Hone quotes a report from the *London Evening Post*:

> On Christmas-eve, (new style,) 1753, a vast concourse of people attended the noted thorn, but to their great disappointment there was no appearance of its blowing [blooming], which made them watch it narrowly the 5th of January, the Christmas-day, (old style,) when it blowed as usual.

(Hone, 1827, vol. 2, col. 1641)

Contemporary Glastonbury

The dissolution of the abbey left a very obvious legacy: the space at the heart of the town. Perhaps the 'open' quality – not empty but not full, certainly now only partially occupied by Christianity – has been significant in promoting a variety of contenders for the spiritual heart of Glastonbury (Figure 8.3).

The abbey and its grounds remained in private hands until in 1908 ownership passed to the Bath and Wells Diocesan Trust (Carley, 1996, p. 175), and in 1909 the 'Restoration of Glastonbury Abbey to the Church of England' was celebrated with an elaborate procession and ceremony attended by the Prince and Princess of Wales. The commercial, commemorative aspects of this event were realised, as we see in an advertisement on the back of the souvenir brochure for the royal visit on 22 June:

> Representations of the Holy Thorn to which is attached the Arms of Glastonbury Abbey, are produced in Tea, Salt and Jam Spoons, pendants, hat Pins, Brooches, Menu Holders, Sugar Tongs and Sifters, etc of various sizes and prices.

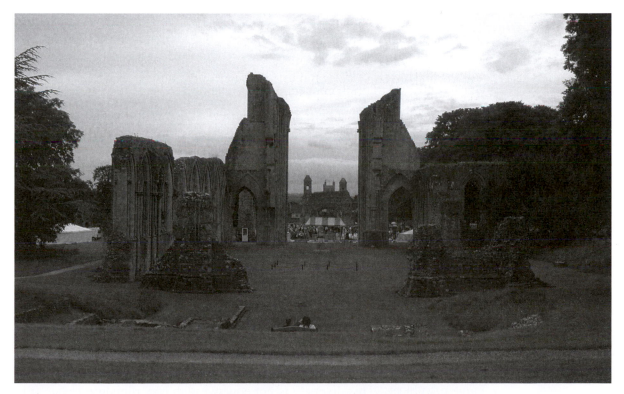

Figure 8.3 Anglican service in Glastonbury Abbey grounds, 2007. Photographed by Marion Bowman. Photo: © Marion Bowman.

However, although some have advocated the restoration of the abbey church, and even the monastery, as we have seen the abbey grounds are administered as a historic site, charging an entry fee, with a museum and visitor facilities.

Meanwhile in 1939 the foundations of a new Catholic church were laid across the road from the abbey ruins, and this was consecrated in 1941. In 1955 the Shrine of Our Lady of Glastonbury was formally 'restored' with the blessing of a new statue of Our Lady of Glastonbury (said to be modelled on an ancient representation of Mary from an abbey seal). Within the church, on either side of the statue of Our Lady, there are panels of the Glastonbury tapestry, depicting famous saints associated with the town (including St Joseph of Arimathea and St Bridget) and the 'Glastonbury martyrs' – Abbot Whiting and the two monks hanged on the Tor. In addition to Anglicans and Catholics, Methodist, Congregationalist, Evangelical and Orthodox Christians have a presence in Glastonbury.

Glastonbury has also been the focus of religious experimentation and speculation of various sorts since the early twentieth century. By the end of the century a great range of religious groups and individual seekers were regarding Glastonbury as spiritually special, the town being hailed (among other things) as the 'epicentre of New Age in England', an important node of earth energy lines, a planetary power point and a site of universal significance (Bowman, 2000, 2005; Prince and Riches, 2000; Ivakhiv, 2001). Various aspects of Glastonbury's past have been reappraised in the light of new approaches to spirituality. As one self-styled 'New Ager' said of Glastonbury's Arthurian connections, for example:

> the whole idea that he lies here sleeping and will rise again, some people interpret that as meaning he'll rise again to lead us into a New Age, a new cycle, a new beginning, a new phase in world evolution.

People immersed in the religious philosophies and praxis of some forms of Hinduism and Buddhism, followers of living gurus, Druids, Wiccans, Pagans of various sorts, healers, people interested in indigenous world views and practices, advocates of a holistic spirituality that transcends old labels and challenges traditional ideas of religiosity, have found their way to Glastonbury, either as visitors or to settle for varying lengths of time. Simultaneously, a unique spiritual service industry has arisen to cater for this varied clientele, including shops that sell 'alternative' and esoteric books, crystals, aids to meditation and yoga practice and 'tools for transformation'. There are shops catering specifically for pagan lifestyles; numerous healers; psychic services such as tarot readings; bed and breakfast establishments offering specialist services; and events, lectures, and workshops on a huge range of subjects. This diversity is not equated with superficiality; rather, it is assumed that people must find and forge their own spiritual path, and that insights from various traditions can and should be valued and interwoven. This is the context in which the following performances of heritage take place.

A tale of two pilgrimages

The renewed possibility of access to the abbey grounds encouraged the revival of pilgrimage activity in the twentieth century. Processions are used to symbolise the completion of the pilgrimage process (Figure 8.4). Following the suggestion of the St Brendon Chapter of the Guild of Servants of the Sanctuary (GSS) in Bristol that 'The Bristol Anglo Catholic Glastonbury Pilgrimage' might be established, along with a similar request from the Church Union in Salisbury, on 28 June 1924 a service was held in the abbey grounds, preceded by a procession from St John's Church (Hext, 2004). In 1926 the West of England Pilgrimage Association was founded, its constitution outlining its purposes as follows:

1 To encourage the practice of pilgrimage and to arrange an annual pilgrimage to Glastonbury Abbey.

2 To declare our adherence to the Catholic Faith as received by the Church of England and to deepen the community of faith and love with those who lived and worshipped at Glastonbury Abbey and other religious sites in past centuries.

3 To support the Glastonbury Abbey trustees by any means in the development and use of the Abbey as a sanctuary for Christians of all denominations and as a centre of pilgrimage.

(Hext, 2004)

The Anglican Pilgrimage has taken place at Glastonbury more or less continuously since the early 1930s, though there were no processions 1940–5. The West of England Pilgrimage Association estimates that the majority of pilgrims in parish parties come from within a 150-mile radius of Glastonbury, although individuals and parties come from further afield. Between the 1960s and the 1980s average attendance increased from $c.5000$ to $c.8000$, with numbers peaking in 1988, the thousandth anniversary of the death of St Dunstan (abbot of Glastonbury before his later appointment as Archbishop of Canterbury), when an estimated 14,000 pilgrims attended. Numbers seem to have declined in the course of the 1990s and at the time of writing (2009) stand at around 1500 to 2000.

In 1993, reflecting the Anglo-Catholic nature of the Pilgrimage Association, the decision was made to exclude women priests from the pilgrimage. As a result of this decision the Anglican parish church of St John felt unable to be part of the pilgrimage, and the procession no longer started inside this church. The Anglican Pilgrimage is attempting to link back to Glastonbury's heyday as a great Catholic pilgrimage centre. The particular conservative/traditional type of Anglicanism dominant in the Pilgrimage Association regards itself as the legitimate successor to the Catholic tradition there, albeit as a reformed form of Catholicism.

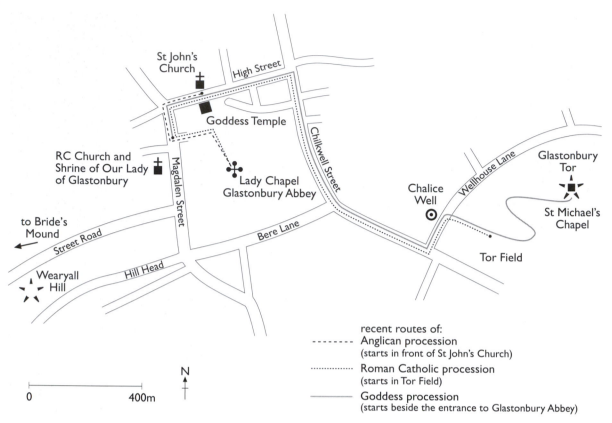

Figure 8.4 Recent routes of the Anglican, Roman Catholic and Goddess processions in Glastonbury.

In recent years the Anglican Pilgrimage has usually taken place on the second Saturday in July. The pilgrimage procession sets out from in front of St John's Church, proceeds down the High Street, past the market cross, and into the abbey grounds. The procession is visually striking and colourful; there are male priests and bishops in regalia, robed male and female choristers, and banners from the participating churches (Figure 8.5). Hymns are sung for the duration of the procession. While this would be commonplace in Ireland and other parts of Europe, it is still a relatively rare spectacle for mainland Britain. Non-clerical participants tend to line the High Street to photograph and admire the procession then join in behind it to enter the abbey grounds, while other residents and visitors often simply stop to watch the spectacle.

The pilgrimage procession should also be seen in Glastonbury's broader socio-religious context. At times in recent decades when Christianity has appeared embattled in general society, and specifically in relation to the great variety of 'alternative' spiritual activity in Glastonbury from the 1960s onwards, the pilgrimage, and in particular the procession, has functioned as a means of Christianity reasserting its claim on Glastonbury. Many find it refreshing and invigorating to be part of a large, public band of Christians in a

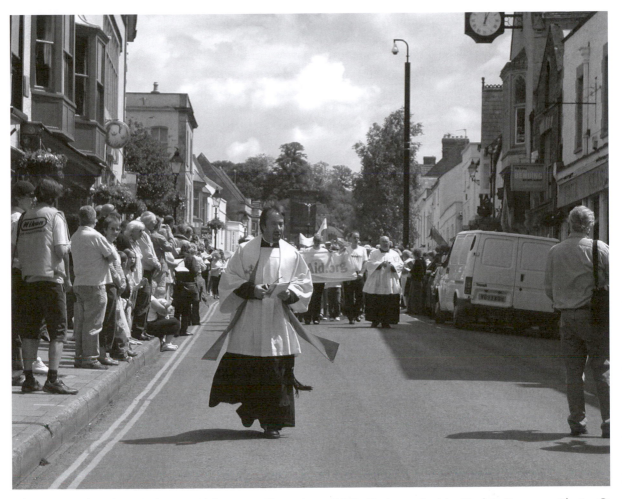

Figure 8.5 Anglican Pilgrimage, High Street, Glastonbury, 2007. Photographed by Marion Bowman. Photo: © Marion Bowman.

place where they believe Christianity first took root in England. One regular attendee described it as 'the Church cheerfully militant'. The element of Christian witness and the assertion and highlighting of Glastonbury's Christian heritage is extremely important to participants. The Anglican Pilgrimage thus strives to revive the tradition of pilgrimage disrupted by the Reformation, claiming continuity with it and stressing its Catholic credentials, but it is also about restoring Christianity to the heart of Glastonbury.

The Roman Catholic presence in Glastonbury also supports a Catholic Glastonbury Pilgrimage. Although I refer here to the 'Anglican Pilgrimage' and the 'Catholic Pilgrimage', both refer to themselves as 'the Glastonbury Pilgrimage'. Not surprisingly, St Mary's Catholic Church claims continuity with pre-Reformation Glastonbury and describes its shrine as 'a successor to the ancient Shrine of Our Lady of Glastonbury'.

Catholic pilgrimage activity re-started here from the late nineteenth century onwards, but the regular Clifton Diocesan Pilgrimage was revived in the 1950s. The pilgrimage primarily attracts people from Somerset, Gloucestershire and Wiltshire. Its high point came in 1965 on the occasion of the crowning by an apostolic [papal] delegate of the statue of Our Lady, which attracted around 18,000 people. While in the past attendance averaged at 3000, recently it has halved. Although initially the Mass at the end of the procession was celebrated in a field behind St Mary's, following the construction of a supermarket on the site in the 1980s the Catholic Pilgrimage began to use the abbey grounds for the celebration of Mass. As the Catholic Pilgrimage took place on a Sunday and the Anglicans held their event on a Saturday, it made sense for both pilgrimages to be held on the same weekend. Many have seen the weekend of pilgrimage activity as a very positive development, and advocate the development of one pilgrimage as an ecumenical gesture. However, the separation of the pilgrimages in 2008 indicates that this pattern is not fixed.

The Catholic Pilgrimage traditionally starts with hymn singing in Tor Field, at the foot of the Tor, followed by a procession with the statue of Our Lady of Glastonbury, past Chalice Well, all the way down the High Street and into the abbey ruins, with Marian prayers and hymns recited throughout (Figure 8.6). This starting point for the Catholic Pilgrimage is to highlight and commemorate Abbot Whiting and the two other monks hanged at the time of the dissolution. As one Catholic woman remarked, 'The Tor has particular significance for us.' Thus, while there are visually similar aspects between the Anglican and Catholic Pilgrimage processions – the display of banners, and an obvious hierarchy of male clerics – significantly more of the town is encompassed by the Catholic Pilgrimage than the Anglican one, and differences in emphasis are obvious. Both physically and metaphysically the Catholic Pilgrimage might be said to cover more ground. While the myths of Joseph of Arimathea and Jesus are important to many Catholics who live in and visit Glastonbury, there is a more tangible and immediate past to connect with, that of Glastonbury as a great centre of Marian devotion, and Glastonbury as a scene of brutality against and staunch defence of 'the true faith'. In recent years the emphasis of the Catholic Pilgrimage has shifted more from the martyrs to the celebration of devotion to Our Lady of Glastonbury, and there was a particular irony in 2003 when the female Anglican vicar of St John the Baptist, who could not take part in the Anglican Pilgrimage, was invited to participate in the Catholic Pilgrimage as a symbol of Christian unity. Nevertheless, a distinctive spiritual heritage is publicly expressed and celebrated in the Catholic Pilgrimage.

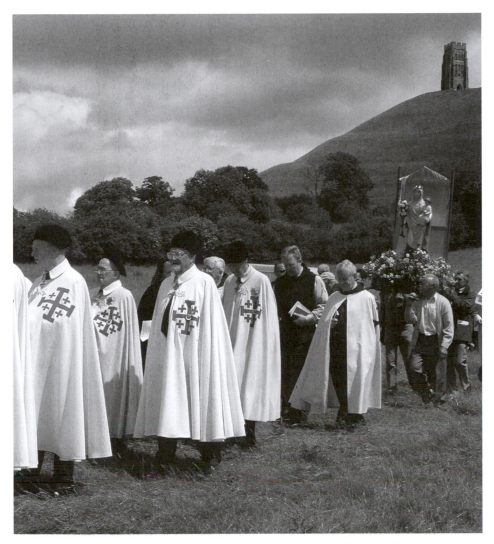

Figure 8.6 Statue of Our Lady of Glastonbury and Catholic Pilgrimage procession setting out from Tor Field, 2007. Photographed by Marion Bowman. Photo: © Marion Bowman.

On the one hand, then, both the Anglican and the Catholic Pilgrimages use the traditional form of a procession to link with the past, highlighting Glastonbury's Christian heritage and importance. This could also be seen as an attempt to re-claim Glastonbury for Christianity, and by celebrating Mass in the abbey grounds to put Christianity back into the physical heart of Glastonbury. On the other hand, the pilgrimage events, and in particular the procession routes, also throw into sharp relief theological, denominational, historical and personal differences between Christians who view the past – and by extension the present – through rather different doctrinal lenses. The Anglican Pilgrimage is now physically outside the

Anglican church in Glastonbury; the Catholic Pilgrimage procession covers different spatial and historical ground. Note also that the Anglican-owned abbey site continues to operate as a heritage site on these days, charging entry to the pilgrims and not excluding non-pilgrim paying visitors from the site during the Christian events.

In Christian pilgrimage to Glastonbury there is celebration of Glastonbury's person-centred sacredness (Jesus, Joseph of Arimathea, Celtic and other saints associated with the site) as well as the commemoration of Glastonbury's status as a great pilgrimage centre in the Middle Ages. Christian pilgrimage in Glastonbury is undoubtedly subject to some contestation (Bowman, 2004), but in form, the annual pilgrimage weekend with its processions, banners, crosses, statues, singing and ritual activity, looks very much the model of traditional pilgrimage – despite the fact that both are largely twentieth-century revivals/inventions.

Having looked at the Christian use of procession to make connections with the past, I now turn to the parallel universe of Goddess spirituality in Glastonbury.

Proclaiming the Goddess in Glastonbury

One of the most obvious developments in the spiritual scene in Glastonbury in the later part of the twentieth century was the growth of Goddess spirituality. Goddess spirituality combines and reflects a number of contemporary spiritual trends, such as great interest in and honouring of indigenous, nature-oriented traditions as well as a longing to recapture pre-Christian, pre- or non-patriarchal forms of religiosity. There is often an honouring of the earth as sacred, reflected in a ritual year closely linked to the passing of the seasons, and a positive view of the material world in relation to the spiritual. Some of its roots lie with the growth of feminism from the 1970s, highlighting what were regarded as the limiting roles frequently assigned to women theologically and practically in traditional religiosity. However, it is worth noting that speculation about pre-Christian worship of the divine feminine was already circulating at the start of the twentieth century in Glastonbury (see Benham, 1993).

Thus, for many people Glastonbury nowadays is above all a centre of Goddess spirituality, and it is considered a significant, ancient, sacred site of Goddess worship. In the very landscape of Glastonbury some discern great landscape figures of the Goddess. Within one such Goddess figure, they claim, her vagina, the centre of her cult in Glastonbury, was where the Lady Chapel of Glastonbury Abbey was subsequently sited, a deliberate act of usurping and attempting to suppress the power of the Goddess. The Tor forms one breast of this figure, and the thirteenth-century earthquake that destroyed an earlier St Michael's Chapel is seen as the Goddess simply shaking off this unwelcome accretion. Some say the Tor itself is a figure of the Goddess, with Chalice Hill as

her belly, and the red waters of Chalice Well her menstrual flow (Figure 8.7). Devotions to the Virgin Mary and more particularly to St Bridget in Glastonbury are seen by many involved in the Goddess movement simply as Christian continuities of the Goddess worship which they feel can now be restored in its own right. Priestess, author and long-term Glastonbury resident

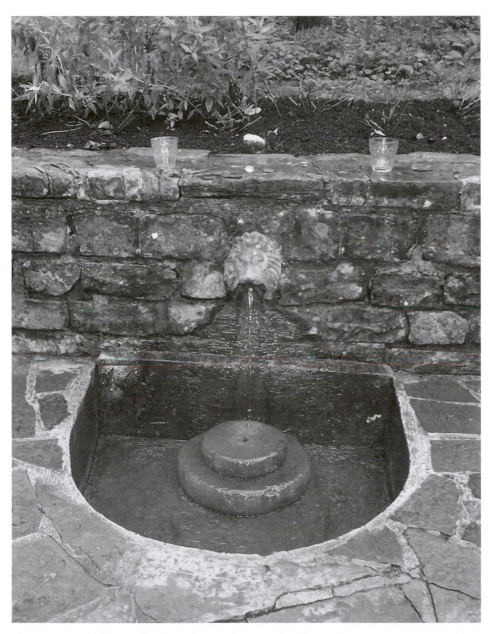

Figure 8.7 Chalice Well, Glastonbury. Photographed by Marion Bowman. Photo: © Marion Bowman.

Kathy Jones claims, for example, 'Where we find St Bridget we know that the goddess Bridie was once honoured' (Jones, 2000, p. 16).[1]

Goddess spirituality in Glastonbury is very buoyant and visible, from shops on the High Street to the Glastonbury Goddess Temple which opened in 2002 and was the first Goddess Temple in England to be officially registered as a place of worship, in 2003. One of the most significant developments in the town's Goddess movement has been the Glastonbury Goddess Conference. The first conference was held in 1996, co-organised by Kathy Jones and Tyna Redpath (owner of The Goddess and the Green Man shop). The conference, now considered by many to be a Glastonbury institution, is always held to coincide with Lammas (1 August), one of the significant days on the 'Celtic' or eight-fold calendar observed by many contemporary pagan groups. The conference regularly features speakers, performers and participants from the USA, Europe and elsewhere. An exuberant, international gathering, the organisers feel it gives the wider Goddess community the opportunity to come together from all over the world, sharing ideas, insights and enthusiasm, creating and participating in rituals. They also hope that the Glastonbury Goddess Conference experience will inspire participants to go home and celebrate/rediscover the divine female in their own locations, ideally establishing more Goddess Temples there.

However, while there is an almost missionary, outward-looking aspect to the conference, there is undoubtedly a seriously territorial, Glastonbury-related agenda, demonstrated in the most public tradition connected with the conference, the Goddess procession. This started as a procession through the streets of Glastonbury on the last day of the conference (Sunday), originally with a large effigy of the Goddess pulled in a cart. Jones claimed that the inspiration for the procession came from an 'old Celtic image' of a cart with huge wheels and a figure of a Goddess in it. However, since the theft of the cart, lighter, wicker Goddess figures have been used. The procession also features large, colourful banners depicting a range of female deities, reflecting the tendency within the contemporary Goddess movement to regard as aspects of the universal sacred female all Celtic, Egyptian, Near Eastern, Greek, Roman, Indian, African and other indigenous goddesses, Bodhisattvas in female form and the Virgin Mary. (These banners, the work of American artist Lydia Rule, are taken around the world to be used in various Goddess-related celebrations.) Images of female deity are carried and some of the banners depict the Virgin Mary, but in contrast to the Christian processions the participants are largely female and there are no male authority figures. The Goddess procession has its serious moments, but on the whole it is far more ludic than either of the Christian events, with the overwhelmingly female

[1] The spelling of Bridget is varied, appearing as Brigit, Brigid, Bridie and Bride; here for the sake of consistency I use Bridget and Bridie, the most commonly adopted forms in Glastonbury, unless quoting others.

participants often flamboyantly dressed, and Goddess chants and songs sung with gusto en route (Figure 8.8). When the conference first started it was attracting around 200 people, but numbers have reached 400–500. It does attract a considerable amount of attention, both locally and in the media.

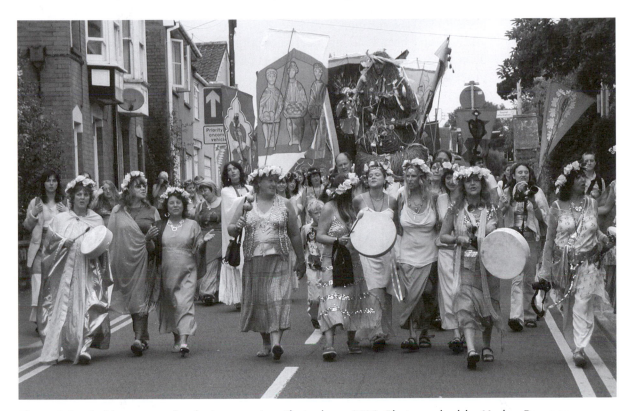

Figure 8.8 Goddess procession in town centre, Glastonbury, 2006. Photographed by Marion Bowman. Photo: © Marion Bowman.

Jones had from the start regarded the procession as a means of 'claiming space' for the Goddess, a way of saying that 'this belongs to Her'. It used to go anti-clockwise, on a less public route, but after 2000 it went clockwise, leaving from the Town Hall (beside the entrance to the abbey), up the High Street 'circumambulating the abbey', in contrast to the Christian processions, calling in at Chalice Well then proceeding up the Tor. It became, in effect, a mirror image of the Christian pilgrimage processions, in particular the Catholic Pilgrimage procession which traditionally starts from the Tor and proceeds to the abbey. There is also a very practical reason for routing the procession up the narrow High Street: that way more people see the procession, and the participants look greater in number.

In 2004 when the conference theme was 'Celebrating Bridie and the Maiden Goddess', for the first time procession activity was staged on Thursday rather

than Sunday, and was much longer than ever, with the image of Bridie being taken to four sacred sites during the course of the afternoon and evening. In addition, on Friday afternoon the image of Bridie was taken out again, the route this time taking the procession past the Catholic church, up and over Wearyall Hill, to Bride's Mound, which had been beautifully decorated for the occasion. Thus, through a variety of processional activity, not only has Glastonbury been reclaimed ceremonially for the Goddess, but St Bridget has been 'restored' to her pre-Christian state. In 2008, for practical reasons the procession did not go up the Tor, so instead of dispersing up there, the procession came back down the High Street, mimicking the Christian events. It is a self-conscious characteristic of the Goddess movement at Glastonbury that their traditions evolve and respond to changing circumstances.

The past in the present

In the process of creating and enacting spiritual heritage, the procession is a particularly useful tool. Processions can be used to celebrate and commemorate, to protest and contest, to include and exclude, to display and convey messages and meanings on a variety of levels. Both Christians and Goddess devotees regard Glastonbury as a significant site and for that reason want to be there in the public, celebratory and assertive manner provided by procession.

Processing in Glastonbury for some means literally following in Jesus' footsteps. Christians are using the pilgrimage processions to celebrate and to claim continuity with Glastonbury's legendary and historical Christian past, and to reclaim the town, particularly the abbey, for Christianity. However, in the different ground they cover physically, and by including or excluding particular groups, the processions ironically highlight the disputed territory of contemporary Christianity. Meanwhile, the Goddess community is fighting patriarchy with pageantry, using the procession as a means of re-possessing Glastonbury for the Goddess, re-asserting 'Her' presence in the town. In producing practically a mirror image of the Christian pilgrimage processions, the Goddess community has been physically encompassing Christian Glastonbury and spiritually reclaiming aspects of the Christian tradition there.

There are obviously many facets to the use of processions in Glastonbury, by both Christians and Goddess devotees. Both groups regard Glastonbury as significant and for that reason want to be there in the public, celebratory and assertive manner provided by procession. Both Christians and the Goddess community are using the procession, and traditional accoutrements such as statues, banners, costume and song, as vehicles for declaring their allegiances and staking a claim in contemporary Glastonbury. Each summer, however, different spiritual heritages are being proclaimed and pursued. Perhaps in this

context, as Lowenthal claims, heritage 'is not an inquiry into the past, but a celebration of it ... a profession of faith in a past tailored to present-day purposes' (Lowenthal, 1997, p. x).

Reflecting on the case study

Chapter 1 discussed the ways in which official discourses of heritage became formalised from earlier, informal practices of selecting and representing states of knowledge within knowledge-producing groups, such as the early antiquaries. These states of knowledge had particular relevance to the construction of national identity. We can see an important strand of national identity being played out at Glastonbury, through the accretion of narratives about the earliest Christian identities here and the miraculous properties of material reminders, such as the Holy Thorn. The importance of place in these narratives is over-riding.

One of the complex aspects of the case study is the profound discontinuity in the significance of Glastonbury as a place of Christian pilgrimage following the suppression of the monastery and before its revival in the early twentieth century. Now its significance is managed through the two main church traditions, one aligned with the nation as the state church and the other aligned with the pre-suppression Roman Catholicism of the abbey (treated as being in opposition to the Protestant nation until the nineteenth century). In contrast, the Goddess processions are entirely new to Glastonbury although their knowledge-producing group understands them within a very ancient context. In other words, while their histories look very different, these processions have in common their understanding that these are the right practices in the right place for identity making.

Experience and imagination

This chapter has drawn out the intangible and tangible aspects of performance, showing how performance reproduces objects of heritage in a variety of ways. We can now return to the idea of embodiment, thinking more about the ways in which our own experiences of physically engaging with objects of heritage affect us. More usually, conservation practices are concerned with how physical engagement affects tangible heritage: earlier chapters have stressed the role of conservation practices in managing acceptable levels of physical change. However, there is also another strand running through this book concerning the imaginative challenges that tangible heritage sets us. The case study in Chapter 2 looked at new ways of dealing with missing or entirely new work in old buildings: the solution for the Benjamin Franklin house, surviving only at foundation level, was to

give visitors a set of open-air spaces to walk into, inviting them to look up to roof levels and look down through layers of flooring. This is a set of experiences which leaves a far more powerful imprint on the mind than is gained by reading about it here. Chapter 4 on museums and Chapter 3 on natural heritage remind us that while limits are set on how much most of us can engage with wilderness or fragile textiles, visitor access is expected. Chapter 5 on interpretation emphasises how professionals try to expand visitors' intellectual understanding, but it could equally be read as a discussion of how to expand visitor engagement through embodied experiences.

None of this, of course, is written into AHDs: the criteria for World Heritage significance have nothing to say about values for embodied experiences. But heritage sites, of global or lesser significance, are at their best when we feel a response before we think it.

Heritage should of course expand to include difficult heritage, the heritage of destruction, repression, underground politics (see further discussion in Benton (ed.), 2010). The history of the brutal suppression of Glastonbury Abbey is itself difficult heritage for some Christians. Going out to experience the places where the most destructive activities of humans against fellow humans have taken place is a different order of activity: it invokes the idea of bearing witness, a highly performative action. Nobody expects to leave the places of past human suffering untouched by emotion, but the particular impact of the experience comes from the experience of being under the same sky, standing on the same point, a sense of retracing footsteps. All of these are embodied experiences, reinforced by the sensations of emotion. Away from these places, we carry memories. You might reflect that intangible memories are retained through neural structures – our heritage experiences making their physical place in the brain.

Conclusion

As Chapter 1 noted, there are many ways to write an outline history of heritage, and the thematic approach adoped in that chapter (tempered by chronology) parallels the use of themes to structure this book. Our concluding theme of performance, the socially communicative act, is furthest away from the recitation of official charters and frameworks which were a necessary underpinning for our introduction to heritage processes. Official understandings of heritage place performative heritage – whether festivals, music styles, craft traditions or body art – in the most challenging category of heritage: intangible heritage. The challenge comes from the problem of reconciling the social life force that produces these performative acts with the bureaucratic need to document, define, measure and conserve: how can this

take place without changing the nature of the performance? As the Trinidad Carnival case study has suggested, two different understandings may be produced: the official notion of Trinidad Carnival, and the unofficial and still changing current of activity.

In Glastonbury the two spiritual traditions, Christian and Goddess, are both inside their respective formal structures of group organisation and thus can be understood to be official in that sense, although not brought into official heritage designations. However, they both rely entirely on popular support by members of the groups for their success: no formal decree from central authorities could guarantee the continued attendance of participants or, indeed, of spectators. Could we imagine UNESCO designating Glastonbury as a focal point of intangible spiritual heritage? I think this would relate well to the aims of the intangible heritage programme, and yet how would the ebb and flow of religiosity to which the case study has alluded be formally supported and encouraged? As the critique of the origins of the AHD shows, heritage processes have their limits.

Works cited

Ashe, G. (1957) *King Arthur's Avalon: The Story of Glastonbury*, London, Collins.

Austin, J.L. (1965) *How To Do Things with Words* (ed. J.O. Urmson), Oxford, Oxford University Press.

Benham, P. (1993) *The Avalonians*, Glastonbury, Gothic Image Publications.

Benton, T. (ed.) (2010) *Understanding Heritage and Memory*, Manchester, Manchester University Press/Milton Keynes, The Open University.

Bowman, M. (1993) 'Drawn to Glastonbury' in Reader, I. and Walter, T. (eds) *Pilgrimage in Popular Culture*, Basingstoke and London, Macmillan, pp. 29–62.

Bowman, M. (2000) 'More of the same?: Christianity, vernacular religion and alternative spirituality in Glastonbury' in Sutcliffe, S. and Bowman, M. (eds) *Beyond New Age: Exploring Alternative Spirituality*, Edinburgh, Edinburgh University Press, pp. 83–104.

Bowman, M. (2004) 'Procession and possession in Glastonbury: continuity, change and the manipulation of tradition', *Folklore*, vol. 115, no. 3, pp. 273–85.

Bowman, M. (2005) 'Ancient Avalon, New Jerusalem, heart chakra of Planet Earth: localisation and globalisation in Glastonbury', *Numen*, vol. 52, no. 2, pp. 157–90.

Bowman, M. (2006) 'The Holy Thorn ceremony: revival, rivalry and civil religion in Glastonbury', *Folklore*, vol. 117, no. 2, pp. 123–40.

Bowman, M. (2008) 'Going with the flow: contemporary pilgrimage in Glastonbury' in Margy, P.J. (ed.) *Shrines and Pilgrimage in the Modern World: New Itineraries into the Sacred*, Amsterdam, Amsterdam University Press, pp. 241–80.

Butler, J. (1990) *Gender Trouble: Feminism and the Subversion of Identity*, New York and London, Routledge.

Butler, J. (1993) *Bodies the Matter: On the Discursive Limits of 'Sex'*, New York and London, Routledge.

Carley, J.P. (1996) *Glastonbury Abbey: The Holy House at the Head of the Moors Adventurous*, Glastonbury, Gothic Image Publications.

Harrison, R. and Rose, D.B. (2010) 'Intangible heritage' in Benton, T. (ed.) *Understanding Heritage and Memory*, Manchester, Manchester University Press/Milton Keynes, The Open University.

Hext, J. (2004) A History of the Glastonbury Pilgrimage [online], http://gpa. cannysites.com (accessed 3 April 2009).

Hone, W. (1827) *The Every-Day Book, and Table Book*, 2 vols, London, William Tegg and Co.

Ivakhiv, A.J. (2001) *Claiming Sacred Ground: Pilgrims and Politics at Glastonbury and Sedona*, Bloomington and Indianapolis, Indiana University Press.

Jones, K. (2000) *In the Nature of Avalon: Goddess Pilgrimages in Glastonbury's Sacred Landscape*, Glastonbury, Ariadne Publications.

Liverpool, H. (1998) 'Origins of rituals and customs in the Trinidad carnival: African or European?', *The Drama Review*, vol. 42, no. 3, pp. 24–37.

Lowenthal, D. (1997) *The Heritage Crusade and the Spoils of History*, Cambridge, Cambridge University Press.

Prince, R. and Riches, D. (2000) *The New Age in Glastonbury: The Construction of Religious Movements*, New York and Oxford, Berghahn Books.

Salih, S. (2004) 'Introduction' in Salih, S. (ed.) with Butler, J. *The Judith Butler Reader*, Malden, MA and Oxford, Blackwell Publishing, pp. 1–8.

Schechner, R. (2003) *Performance Theory*, Routledge Classics, London and New York, Routledge.

Scher, P.W. (2002) 'Copyright heritage: preservation, carnival and the state in Trinidad', *Anthropological Quarterly*, vol. 75, no. 3, pp. 453–84.

Scott, J. (1981) *An Early History of Glastonbury: An Edition, Translation and Study of William of Malmesbury's 'De Antiquitate Glastonie Ecclesie'*, Woodbridge, Boydell Press.

Souvenir of Royal Visit [to Glastonbury Abbey] (22 June 1909), Glastonbury.

Smith, L. (2006) *Uses of Heritage*, Abingdon and New York, Routledge.

Turner, V. (1986) *The Anthropology of Performance*, New York, PAJ Publications.

Vickery, A.R. (1979) *Holy Thorn of Glastonbury*, West Country Folklore, no. 12, London, Toucan Press.

Further reading

Anderson, J. (1984) *Time Machines: The World of Living History*, Nashville, American Association for State and Local History.

Bagnall, G. (2003) 'Performance and performativity at heritage sites', *Museums and Society*, vol. 1, no. 2, pp. 87–103.

Bridal, T. (2004) *Exploring Museum Theatre*, Walnut Creek, CA, Alta Mira Press.

Carlson, M. (2004) *Performance: A Critical Introduction* (2nd edn), London and New York, Routledge.

Goodacre, B. and Baldwin, G. (eds) (2002) *Living the Past*, London, Middlesex University Press.

Green, G.L. and Scher, P. (eds) (2007) *Trinidad Carnival: The Cultural Politics of a Transnational Festival*, Bloomington and Indianapolis, Indiana University Press.

Grimes, R. (ed.) (1995) *Readings in Ritual Studies*, Upper Saddle River, NJ, Prentice Hall.

Grimes, R. (2006) *Rite Out of Place: Ritual, Media and the Arts*, Oxford, Oxford University Press.

Jackson, A., Johnson, P., Rees Leahy, H. and Walker, V. (2002) *Seeing it for Real: An Investigation into the Effectiveness of Theatre and Theatre Techniques in Museums*, Manchester, University of Manchester Centre for Applied Theatre Research.

Malcolm-Davies, J. (2004) 'Borrowed robes: the educational value of costumed interpretation at historic sites', *International Journal of Heritage Studies*, vol. 10, no. 3, pp. 277–93.

University of Manchester (2006) Performance, Learning and Heritage, www.plh.manchester.ac.uk/ (accessed 7 May 2009).

Uzzell, D.L. (1989) 'The hot interpretation of war and conflict' in Uzzell, D. (ed.) *Heritage Interpretation: 2nd World Congress on Heritage Presentation and Interpretation, Selected Papers*, vol. 1: *The Natural and Built Environment*, London, Belhaven, pp. 33–47.

Wallace, T. (2007) 'Went the day well: scripts, glamour and performance in war-weekends', *International Journal of Heritage Studies*, vol. 13, no. 3, pp. 200–23.

Glossary

aesthetic concerned with sensory (primarily visual) judgements of beauty, taste and value.

antiquarian person who collects and studies antiquities, before modern disciplines and research methods.

archives collections of written materials in any form.

authentic see **authenticity**

authenticity a measure of the extent to which a thing might be considered to be the remains of the original. It has an ethical connotation – 'authentic' is the opposite of 'fake' or 'sham', both of which assume deception.

biodiversity variety of species in a biological system. Biodiversity can be threatened by industrial farming, uncontrolled hunting or other factors. Reduction of biodiversity is considered dangerous for a number of reasons, including overdependence on a few species and reduced resistance to disease. It is often also considered ethically and aesthetically desirable to maintain biodiversity.

canon set of things that embody a standard by which others may be assessed, for example the literary or artistic canon. In heritage terms, it refers to a set of heritage places which are actively selected to embody the values of a group using official heritage criteria, and which exemplify the values of distinction and taste in their selection. See also **representative**.

collective memory the way in which a society or social group recall, commemorate and represent their own history (as opposed to personal memory).

community value see **social value**

conservation in the UK, the processes of maintenance and protection from destruction or change, usually with some legal sanctions. In the USA, the term 'preservation' is used.

criteria in heritage terms, a list of conditions that must be met prior to listing on a statutory heritage register, such as the **World Heritage List**.

cultural heritage object, place or practice of heritage that is of human origin. The term is often used by way of contrast with **natural heritage**.

cultural landscape humanly modified landscape believed to be of importance due to the interplay of natural and cultural influences. A distinct category of cultural landscape was recognised in the revisions to the **World Heritage Convention** in 1992.

designation the identification and description of a heritage object, place or practice in order to confer legal protection. Sometimes the term inscription is used. See also **nomination** and **listing**.

diaspora the geographical spread of people outside their country of origin, either through forced or voluntary migration.

diorama museum display using artefacts or replicas in realistic setting, often with painted backdrop.

discourse lit. speech or discussion; often used in a more theoretical context to describe a form of communication that requires specialised ('inside') knowledge.

dissonance the potential for heritage meanings to exclude (by implication) other meanings held by other stakeholder groups.

English country house large house or mansion, originally built as the centre of a large estate (landholding) as the owner's residence, intended to house an extended household of family and domestic servants, with extensive outbuildings for food preparation and storage. Usually surrounded by formal gardens and an open area of parkland, in contrast to the farms on the estate. The wealthiest families owned several country houses on estates around the UK, as well as owning or renting substantial houses in London. Referred to colloquially as **stately homes**.

ethnographic scientific description of human groups (economy, society, culture), foundation method of anthropology as the comparative study of human groups.

heritage register a statutory list of objects, places or practices of heritage significance. See also **World Heritage List**.

indigenous people ethnic group who occupied a geographic area prior to the arrival and subsequent occupation of migrant settlers. The term may be used in some circumstances to include groups who may not have been part of the 'original' occupation of an area, but who were part of an early historical period of occupation prior to the most recent colonisation, annexation or formation of a new nation-state. The terms 'first nation' and 'Aboriginal people' are also often used.

inherent the idea that the values of a heritage object, place or practice are inseparable from its physical qualities.

inscription see **designation**

intangible heritage something considered to be a part of heritage that is not a physical object or place, such as a memory, a tradition or a cultural practice, as opposed to **tangible heritage**.

interpretation the process of communicating information to the general public about a particular heritage object, place or practice.

land claims in heritage, this term is often used to describe indigenous claims for **land rights**.

land rights property rights pertaining to land. In heritage, the term is most often used to describe the legal rights of indigenous peoples in land and associated resources.

listing the process whereby heritage objects, place or practices are given the protection of the law by being placed on a statutory list. The term 'scheduling' is sometimes used in relation to archaeological sites in the UK. See also **nomination** and **designation**.

locality the location and particular qualities of a place.

native title see **land claims**

natural heritage plants, animals, landscape features and biological and geological processes that are not humanly modified. The term is most often used in opposition to **cultural heritage**.

nomination the process by which places are put forward for **listing** on a **heritage register**.

official heritage state-sponsored or controlled processes of heritage **listing** and management. The term is often used in opposition to the term **unofficial heritage**.

oral history the transmission of history by verbal means. Often a feature of non-literate cultures.

oral tradition see **oral history**

presentation the total approach to presenting a heritage site to visitors, including **interpretation**.

preservation see **conservation**

provenance verifiable history of ownership or creation of an object, used by museums to assist in distinguishing between originals and fakes and to establish legal title.

representative model of heritage in which types of heritage object, place or practice are collected so that individual examples come to stand for the whole. This model inverts conventional understandings of heritage as the best, biggest, oldest or most rare, and assesses the significance of heritage in terms of the extent to which an object, place or practice is most typical of the range of types being considered. Often discussed in opposition to the **canon**ical model of heritage.

representativeness the extent to which one heritage site could stand as an exemplar of its type.

reserves areas of crown- or state-owned land that are designated for particular purposes. One use of this term refers to land set aside for conservation of plant and animal species as nature reserves. Another use refers to land formally designated for occupation and use by **indigenous people**.

restoration in heritage parlance, returning something to an earlier condition, sometimes involving the removal of later additions or alterations and the replacement of lost elements. See also **authentic**.

sacred sites places that have spiritual significance. The term is often used in settler societies to describe places that are believed to have spiritual significance to **indigenous people**.

significance in heritage terms, the relative importance of one heritage object, place or practice when compared with another.

social value the value of a heritage object, place or practice to society. The term is most often contrasted with other types of heritage values (e.g. **inherent** or intrinsic values) that are determined by experts, and is closely linked with the concepts of **community values** and **intangible heritage**.

stately home large house or mansion built as a status symbol in the country. See also **English country house**.

tangible heritage physical heritage, such as buildings and objects, as opposed **to intangible heritage**.

unofficial heritage objects, places or practices which are not considered to be part of the state's official heritage, but which nonetheless are used by parts of society in their creation of a sense of identity, community and/or locality. The term is often used in opposition to the term **official heritage**.

ur-text an original or earliest version.

Venice Charter the International Charter for the Conservation and Restoration of Monuments and Sites, which was drafted at the Second International Congress of Architects and Technicians of Historic Monuments in Venice in 1964 and adopted by ICOMOS in 1965.

World Heritage Convention the Convention Concerning the Protection of World Cultural and Natural Heritage, adopted by the General Conference of UNESCO on 16 November 1972, which established the World Heritage List and the process for listing **World Heritage sites**.

World Heritage List list of places considered by the World Heritage Committee to have outstanding universal value. The list was established by the 1972 UNESCO **World Heritage Convention**.

World Heritage site a place listed on the **World Heritage List**.

Acknowledgements

Grateful acknowledgement is made to the following sources for permission to reproduce material in this book.

Page 137: Museums, Libraries and Archives Council (MLA) (2004) 'Museums/Gallery Visiting', *Visitors to Museums and Galleries*, p. 5;

Page 142: Watson, N.J. (2007) 'Shakespeare on the tourist trail', *The Cambridge Companion to Shakespeare and Popular Culture*, pp. 199–223. Copyright © Cambridge University Press 2007, reprinted with permission.

Page 214: Figure 6.4, Photograph of the North Cape and the midnight sun, 2003. Photographed by Yan Zhang, accessed from Wikipedia, 2 February 2009. Photo: © Yan Zhang. Permission is granted to copy, distribute and/or modify this document under the terms of the GNU Free Documentation Licence (http://en.wikipedia.org/wiki/Wikipedia: Text-of-the-GNU-Free-Documentation-License). Version 1.2 or any later version published by the Free Software Foundation; with no invariant Sections, no Front-Cover Texts, and no Back-Cover Texts.

Every effort has been made to contact copyright holders. If any have been inadvertently overlooked the publishers will be pleased to make the necessary arrangements at the first opportunity.

Index

Page numbers in **bold** refer to illustrations.